ORNAMENT, FANTASY, AND DESIRE

IN NINETEENTH-CENTURY

FRENCH LITERATURE

ORNAMENT, FANTASY, AND DESIRE IN NINETEENTH-CENTURY FRENCH LITERATURE

RAE BETH GORDON

PRINCETON UNIVERSITY PRESS · PRINCETON, NEW JERSEY

Copyright © 1992 by Princeton University Press
Published by Princeton University Press, 41 William Street,
Princeton, New Jersey 08540
In the United Kingdom: Princeton University Press, Oxford

Library of Congress Cataloging-in-Publication Data

Gordon, Rae Beth, 1940–
Ornament, fantasy, and desire in nineteenth-century French
literature / Rae Beth Gordon.
p. cm.
Includes bibliographical references and index.
ISBN 0-691-06927-1 (CL)
1. French literature—19th century—History and criticism.
2. French language—19th century—Figures of speech.
3. Psychoanalysis and literature. 4. Fantasy in literature.
5. Desire in literature. I. Title.
PQ283.G67 1992
840.9′007—dc20 91-41016 CIP

This book has been composed in Adobe Caslon

Princeton University Press books are printed on acid-free paper
and meet the guidelines for permanence and durability of the
Committee on Production Guidelines for Book Longevity
of the Council on Library Resources

Printed in the United States of America

1 3 5 7 9 10 8 6 4 2

For Jesse

THE POET IS CARVER [*CISELEUR*],
THE CARVER IS POET.

—Victor Hugo, for Froment-Meurice

CHRISTIAN: "I LOVE YOU."
ROXANNE: "YES, SPEAK TO ME OF LOVE . . ."
CHRISTIAN: "I LOVE YOU."
ROXANNE: "YOU'VE GOT YOUR THEME. . . .
EMBROIDER! EMBROIDER!"

—Edmond Rostand, *Cyrano de Bergerac*

Contents

Illustrations

Acknowledgments

THE INITIAL CONCEPTION for a book on ornament dates from 1982, and during that time many friends and colleagues read portions of this manuscript. For their time and for the valuable suggestions they offered, I express my sincere thanks to Tobin Siebers, Christopher Prendergast, Eric Gans, Laurence Porter, Marshall Olds, Nancy Vickers, and Elizabeth Goldsmith, who each read a chapter of the manuscript in its early stages. I am also grateful to Louis Marin, Lucette Finas, Susan Canning, and Geoffrey Harpham for the insights that came out of our discussions of ornament. I owe special thanks to Ross Chambers, Laurence Porter, and Allan Pasco, who read the entire manuscript and provided much help in suggesting ways to reorganize the material. Additional help with editorial matters was given by Annette La Rose and Richard Lewis.

I am also much indebted to the Research Foundation at the University of Connecticut, which granted me a Summer Research Fellowship in 1988 and which has been most generous in providing support for photographs, permissions, and travel. Thanks go too to Deborah Crary for her able assistance in typing the final version of the manuscript. A semester as Visiting Scholar in the Department of Romance Languages and Literatures at Harvard University also allowed me to complete research on the final chapter in the fall of 1988 and to present this work in Barbara Johnson's Seminar on Literary Theory.

I express my appreciation to the librarians at the Bibliothèque Nationale, the Bibliothèque Historique de la Ville de Paris, the Institut de France, the Widener and Fogg libraries, and to Anne-Claude Lelieur, head curator at the Bibliothèque Forney. In addition, I would like to thank the following museums for allowing me to reproduce art objects from their collections: the Musée d'Orsay, the Metropolitan Museum of Art, the Victoria and Albert Museum, the Musée Gustave Moreau, the Musées d'Archéologie et d'Arts Décoratifs de Liège, the Musée Pasteur, the Kunstgewerbemuseum, the Museum of Modern Art, and the Musée Horta.

Portions of chapters 2, 3, 4, and 5 have appeared in the following journals, which have graciously granted me permission to reprint revised versions of this material: *Romanic Review* for chapter 2, much of which appeared in vol. 73, no. 1 (January 1982); *La Rivista di Estetica* for portions of chapter 3 in no. 12 (1982); *Le Bulletin de la Société Théophile Gautier* for portions of chapter 3, and two pages of chapter 4 in no. 6 (1985); and *Art Journal* for portions of chapter 5, reprinted with revisions from vol. 45, no. 2 (Summer 1985): 105, 108, 109–111.

I thank the publishers for permission to use translations taken from these works: Ernst Behler and Roman Struc, *Dialogue on Poetry and Literary Aphorisms* (University Park and London: Pennsylvania State University Press, 1968), 53, 83, 86, 96, 102, 103. Copyright © 1968 by the Pennsylvania State University Press. Reproduced by permission of the publisher; William Warmus, *Emile Gallé: Dreams into Glass* (New York: Corning Museum of Glass, 1984); and Leo Bersani, *The Death of Stéphane Mallarmé* (Cambridge: Cambridge University Press, 1982).

Robert Brown at Princeton University Press has shown interest in this project since its inception in 1982 and has patiently seen it through to its conclusion. I thank him for his patience and advice. Beth Gianfagna's attention to detail helped to successfully guide the book through the final stages of production. I also thank Princeton editor Dalia Geffen for her meticulous attention to detail.

Many friends offered support and encouragement along the way; I would especially like to thank Gail Finney, Stephen Provizer, Marianna Piñeda, Phyllis Cove, and Marie Naudin for their advice and support.

Preface

EVERY CULTURAL MOMENT has its own understanding of what comprises ornament based on the set of artistic conventions in place at the time. The French nineteenth century saw many shifts—and even upheavals—in attitudes toward ornament, and by the fin de siècle ornament was at the center of vehemently argued aesthetic debates. The initial conception for this book came out of the awareness that an extraordinary number of nineteenth-century texts—French, German, English, American—participated in the evolution of a concept of ornament and, as I came to believe, influenced and were influenced by theories of decorative composition. Analogies were most emphatically thought to exist between art and literature by many nineteenth-century writers. Far from excluding the realm of the decorative arts, these analogies drew most heavily on artisanry. Victor Hugo, to name but one example, dedicated these lines to the goldsmith Froment-Meurice (about whom both Nerval and Gautier wrote): "The poet is carver /The carver is poet." From a larger perspective, the nineteenth-century belief that all works of literature and art belonged to a *Kunstwollen* justifies the search for parallels and the conviction that cultural habits inform both endeavors.

The Introduction to this book provides some background in the decorative arts that many literary scholars should find helpful. Since the focus of this work is on ornament in literature, the wealth of art historical material has had to be greatly reduced; I nonetheless hope that the many bibliographic references will lead the reader to explore these questions further.

Chapters 1 through 7 take up a specific decorative figure or composition as it is manifested in particular texts. The function of ornament is further explored from a psychoanalytic or psychiatric point of view. Ornament is continually used to express and work out various dynamics of object relations in the text; it is invariably the site of emergence of desire in these texts. Finally, the ornamental (object, composition, or figure) reflects the syntax and composition of the text in which it ap-

pears. The Conclusion briefly summarizes and discusses the two threads that link all the literary analyses: ornament as desire and ornament as self-reflexive textuality.

The above argument is woven into my own text in a somewhat non-linear manner: the reader is asked to expect some twists and turns. I have tried to remain true to the dictates of nineteenth-century ornament, which did not shun the arabesque, nor the proliferation of framing ornament into the central tableau, nor the occasional ambiguity between figure and ground. This playfulness, which has quite serious implications, was largely responsible for ornament's charm, as well as for the heated debates it provoked.

ORNAMENT, FANTASY, AND DESIRE

IN NINETEENTH-CENTURY

FRENCH LITERATURE

❧ AN INTRODUCTION TO ORNAMENT ❧

Ornament is . . . a decoration or adornment; it can have no
independent existence practically.—*Ralph Wornum, 1873*

[Decorative art] is born of the search . . . for delights of the eye and
of the ear . . . without the necessary intervention of ideas or
sentiments . . . without any other pretension or claim
than to please.—*Eugène Véron, 1878*

Everything, in nature, is ornament. . . . From a simple agent of
embellishment, and in taking on the . . . character proper to the
transmission of ideas, ornament has been transformed and elevated
by its principle even to becoming the complete essence of art.
—*Félix Bracquemond, 1885*

THE PROBLEM OF DEFINITION

Virtually every definition of ornament connotes the inessential, the
superfluous, or the superficial, the "merely" decorative. Ornament, as
commonly understood, is an accessory designed simply to please and
is therefore fundamentally without meaning, if not morally reprehen-
sible.[1] If this book redefines ornament, it does so not in terms of a fixed
definition, but rather within a circumscribed cultural moment and
place: France from 1830 to 1900. I therefore began by looking at defini-
tions and elaborations of the concept in the writings of aestheticians,
and then proceeded to examine the use of ornamental language and the
description of decorative objects in the texts of five writers. In this way,
a definition of ornament in literature became possible based on its func-
tion, shape, and place in the text. The shape and position of ornament
in literary texts of the period adhere closely to notions about decorative
composition put forth by contemporary designers and aestheticians, but
the way ornament *functions* in literature anticipates psychiatric and aes-
thetic research on decorative form. Or, more accurately, it anticipates
the way psychiatry, perceptual psychology, and aesthetics converge in
the fin de siècle. Accordingly, although I will be confronting problems
and shifts in the understanding of the word *ornament*, I will place heavy

emphasis on the function of ornamental objects and language in narrative and poetry. I believe that one of the primary functions of ornament is to carry meaning and intent that have been suppressed or excluded from the central field. It is able to do so because it does not normally receive focused, conscious attention from the reader. In this book, I will argue that certain French texts of the nineteenth century figure themselves self-reflexively as ornament, and that the ornamental becomes the site of the emergence of desire repressed elsewhere in these texts. Further, relatively marginalized in Romantic writing, ornament comes to invade the text in fin de siècle writing.

The underlying question regarding ornament is this: how do we distinguish the essential from the inessential? If indeed ornament is an embellishment or enrichment of the essential structure of an object, then surely it must be possible to locate this demarcation.[2] The difficulty of this project will become apparent from the following nineteenth-century discussions.

Definitions of ornament differed widely between 1830 and 1900, but the aestheticians who interest me here agreed on three interconnected points. First, ornament not only is at the origin of art, it also includes its most essential principles. (Already, the profile of a paradox is glimpsed: if ornament is defined as the inessential aspect of form, how can it contain the essential aesthetic qualities of form?) Second, it is possible (and desirable) to distinguish ornament from decoration, but distinguishing decorative art in general from nondecorative art is nearly impossible.[3] (The difficulties of definition loom larger.) Third, it is socially and aesthetically important to destroy the hierarchical view that places fine arts over decorative arts.

Jules Bourgoin states that decoration can be either inherent to the form (of the object) *or* added to it. But he makes this qualification: ornamentation is "the power of invention and creation beyond the *necessary and utilitarian* form" (*Théorie*, 4; emphasis mine). That is why ornament is "purely and solely" art and why it is closely associated with the movement of art for art's sake in literature. Gautier believed that ornament was an art form in which "the accessory must *play as important a role* as the principal subject."[4] We see how the terms *accessory* and *principal subject* can shed their traditional meanings, and do so through their function in a given work. So, while one can agree on what passes for the principal subject (perhaps on the basis of the amount of space it occupies or its mimetic qualities), that subject is not the sole

vehicle for meaning or effect. For Félix Bracquemond, painter, print-maker, ceramicist, and theorist, art is an abstraction—not a copy—of natural form, and its essence is the "ornamental principle." Simply put, the latter is the *agent* of transformation in the metamorphosis of nature into art. It is what Mallarmé will call "la totale arabesque": the essential movement of the composition that defines the artist's personal vision of the object. It is a manifestation of the artist's power of imagi-nation in the face of nature and as such reunites the palpable and the ineffable. Far from being something added on to structure, it is the core of that structure. "The ornamental conception . . . is of even greater importance than the natural structure of the object represented. And this is due to the fact that the former *provides* the structure that gives the work its importance."[5] (Some twenty years later, Wilhelm Worrin-ger makes a similar statement: "Art does not begin with naturalistic constructs, but with ornamental-abstract ones.")[6] The term *ornament* has a higher import than the common definition given to it, for it can be applied to all works of art (Bracquemond, *Du Dessin*, 166). It is ornament that provides the "character and writing" of artistic style (ibid., 186). Ornament furnishes the principles of composition and style: *it is the underpinning of a work of art, not an addition to it.* What is more, it "transmits ideas," a capital notion I will examine in a later section. That is why Bracquemond poses this question at the beginning of each study: "Where then is the limit between decorative art and art that is not decorative? And first of all, what are these arts? . . . It is 'ornamental art' that one must think and say."[7]

"This division [between art and decorative art] is more conventional than real and it would be difficult in many cases to know where fine art ends and where the art of ornament begins" (*Le Grand Larousse du XIXe siècle*, 1886). As to the supposed superiority of the beaux arts, Gautier states simply that, of all the arts, ornament, "to which one commonly does not attach a large enough philosophical importance, . . . contains the greatest degree of creativity."[8] In response to the common bias that classes the decorative arts as a "minor" art form, Jules Ziegler asked, "Why, from the humble departure point of the potter, should we thus arrive at the examination of purely scientific and philosophical ques-tions?" For Ziegler, moreover, the "great law of ANALOGY" ties together all human productions to the works of Creation.[9]

What emerges from these definitions of ornament is a general effort not to view ornament as a fragment or inessential part of the princi-

pal structure, but rather to find the way in which it is inseparable from it. This idea—in bold contrast to the traditional idea of ornament, which continued to hold its ground in some circles—is taken up in many nineteenth-century texts. In Nerval's *Sylvie*, the "infinite embellishments" of the lacy structure caused me to wonder if one could "speak of embellishment when the object under study consisted only of that[.] We begin to understand how such an object questions any notion of the norm."[10] Nerval, Gautier, Mallarmé, Huysmans, and a few aestheticians were in the forefront of a reevaluation of ornament. But—and this is crucial—as they embraced ornament's capacity to be a structuring element in their texts, they simultaneously capitalized on the general perception of ornament as peripheral and nonsignifying (for purposes of expression that I will shortly spell out). Huysmans and Rachilde are exceptions to this double-sidedness, and with them begins the demise of ornament's expressive power. We will thus see ornament move from an *apparently* peripheral position in Nerval and Gautier (visible primarily in framing devices, digressions, and descriptions of decor) to a precisely marked structuring function in Mallarmé before becoming the core of language and composition in Huysmans.

Should the theory and practice of the decorative arts seem an unlikely domain from which writers of the stature of Nerval or Mallarmé might take their inspiration, one has only to look at the considerable interest these craftsmen of literary form displayed in tapestry, lace, book design, frames, furniture, costume, and so on. Like the other writers studied here, they were vitally concerned with the theory and role of the ornamental. Although many writers of the period had a more than passing interest in the decorative arts, those I have chosen to analyze contributed to the standing and appreciation of these arts through journalism.[11] A concrete involvement in the decorative arts was, in fact, a criterion for inclusion in this book. Moreover, the ornamental quality of their literary texts will be shown to constitute what is most radically innovative in their writing; it lies at the crux of their modernity. Nerval, Gautier, Mallarmé, Huysmans, and Rachilde: two paths can be traced through these names; one leads from Romanticism to Symbolism and the other leads from Romanticism to Decadence. Some of the difficulties in differentiating Symbolism from Decadence will fall away if we simultaneously follow the evolution in prose style and poetic language and the evolution of the role of ornament in these writers.

The Historical Context

During the period 1830 to 1859, several important events and move-
ments were taking place in the decorative arts. The foremost was of
course the arrival of the Industrial Revolution in France. The concom-
itant loss of the crafts tradition would penetrate and personalize the
larger Romantic topos of loss in Nerval. There was a new wave of in-
terest in Pompeii and Herculaneum at the beginning of the century,
and the restoration of the site (by the French) continued to intrigue
writers who used this setting for their tales, where they emphasized in
particular the arabesque decorations (*grottesche*) that characterized the
aesthetic sensibility of this lost world. The Gothic Revival in architec-
ture and interior decoration (fig. 1) also revived interest in Romance,
and in the ornamental and heavily symbolic character of heraldry
and illuminated manuscripts. The period saw a proliferation of prayer
books illustrated with manuscript ornaments copied from different
centuries. Although by 1840 the Renaissance had largely supplanted
the Gothic as the primary source for design, the interest in medieval-
ism did not end with the "Romantic period." Mérimée's *Etudes sur les
arts du moyen-âge* appeared in 1867. The Petit Cénacle's rediscovery of
Watteau and the rococo (due in particular to Gautier) greatly in-
fluenced the aesthetics of that group.[12] The restoration of the Alhambra
(1828) and the related 1836/1845 publication by Owen Jones (*Details
and Ornament from the Alhambra*) (fig. 2) triggered an appreciation
of and fascination with Islamic art forms. Viollet-le-Duc, the leading
exponent of Gothic style in France, remarked in 1858 that archaeology
was attracting the best young students of the arts because it "excites
their intelligence."[13] Finally, the London Universal Exhibition (the
Exposition Universelle of 1851) aroused massive debate over the role
of crafts in the age of the machine, over the aesthetic education of
the masses in which the "applied arts" were to play a fundamental role,
and over the search for a "national style." A concrete result of this
ferment was the resurgence of interest in ceramics. Poems, plays, and
even a novel (Champfleury's *Le Violon de faïence*) were written about
ceramics![14] Gautier, who wrote articles on all of the above-mentioned
aspects of the decorative arts, claimed to stand alone with Jules Zieg-
ler in contributing to a theory of aesthetics for ceramics. Ziegler's
book, *Etudes céramiques* (1850), is in fact a remarkable inquiry into

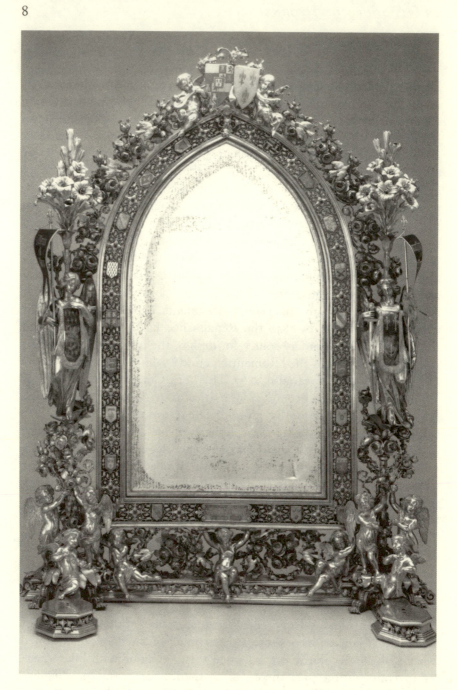

1. Froment-Meurice, "Toilette de la Duchesse de Parme," mirror with Gothic frame, 1847.

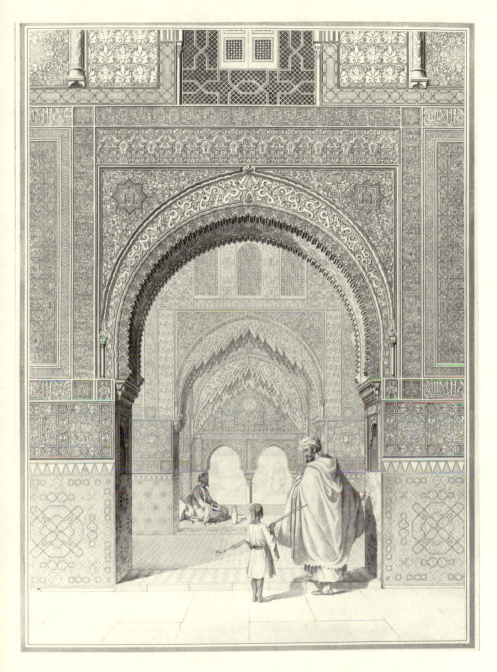

2. Owen Jones and Jules Goury, detail of the Alhambra. *Plans, Elevations, Sections, and Details of the Alhambra*, 1842–45.

Charles Fourier's notion of universal analogy as applied to the art of ceramics.

The period 1860 to 1900 is marked by the continuing debate on the destiny of the decorative arts in the industrial age, as witnessed by the shift in nomenclature from *arts industriels* and *arts appliqués à l'industrie* to *arts décoratifs*. Charles Blanc's *Grammaire des Arts du dessin* (1867, 1870, 1876, 1881, 1888, 1895) was serially published between 1860 and 1866 in *La Gazette des Beaux-Arts*, a journal that Blanc founded and edited. The decorative arts occupy a large place in *La Gazette*. The *Grammaire* was widely regarded as the most important work on practical aesthetics published in France (his *Grammaire des Arts-décoratifs*, 1882, shared the same principles as the earlier work).[15] Blanc was influenced (as were Nerval and Gautier) by Victor Cousin's and Lamennais's aesthetic theories (1830 and 1841). There arose an increasingly loud cry for a style that would reflect the period, rather than simply appropriate past period styles. This cry reached its highest pitch in the 1880s when a new style had already emerged in England, Belgium, and Holland. The French version of Art Nouveau would come into being only in the following decade. In the meantime, though, new concepts in form gleaned from Japanese art (the first Paris exhibit of Japanese art was in 1867) were already being applied on a large scale. These were asymmetry and use of the unexpected in design, economy of means combined with richness of material, and a strong emphasis on the *expressivity of line*. *Le Japonisme* had a larger importance: it awakened an appreciation for the purely formal, nonfigurative elements of art. This could only improve attitudes toward ornament. In fact, from midcentury on, the direct imitation of nature was considered the proper realm of the fine arts and inappropriate in the decorative arts.

Finally, in the second half of the century, ornament would be compared to both music and movement. This is not surprising, given the above-mentioned emphasis on pure form; repetition, alternation, and eurythmy form the basis of ornament. Jules Bourgoin, for example, termed one of ornament's elements "la cinématique."[16] Jean D'Udine calls ornament and music "pictorial and auditory equivalents of dance," and names gesture the foundation of aesthetic expression.[17] If we consider the huge importance that *la musicalisation* and mobility would assume in modernist poetics of the 1880s, we begin to see how a theory of ornament could become central to writing/textual production.

Each of the five ornamental patterns I have chosen for study is important historically: interlace and the arabesque (Islamic art, Gothic

Revival), the decorative frame and the trompe l'oeil of figure/ground reversals (foci of theories of decorative composition from the mid-nineteenth century on), and horror vacui (Islamic, Persian, and Byzantine design, Art Nouveau).

THE QUESTION OF LIMITS

As John Ruskin wrote in *The Seven Lamps of Architecture* (1849), the only thing that distinguishes decorative art from other art is the fact that it is suited to a fixed place. But, he added, *all* great art has been suited to a fixed place. In an 1858 article, Gautier elaborated on this position to show how this very limitation inspires genius in the decorative arts. The "frame" supplied by a particular architecture forces the artist to "position his subject in every possible way" to make it fit, hence arriving at a more condensed and unexpected composition.[18]

In *La Revue des Arts Décoratifs*, founded in 1880, articles return again and again to the lack of boundaries between fine art and decorative art. One critic states that it is extremely difficult to define decorative painting precisely and absolutely because all the criteria at hand—conditions of execution, "the limits one must not transgress" in the field of the decorative—are subject to discussion. "These conditions are so variable, this field so vast and these limits so elastic, that one would have to possess didactic criteria which are entirely lacking to us" (Gasnault, "Tableaux anciens"). Here we see to what extent the idea of limitations—or more accurately, their untenability—is tied to the impossibility of defining the decorative. In 1878, many would have agreed with the distinguished aesthetician Eugène Véron when he clearly separated decorative art from "expressive art." "It is essential to distinguish between them . . . every lively and sincere emotion—in dominating the decorative character of an object—suppresses it, for expressive art is recognized by its emotion."[19] Véron's view of ornament follows the traditional line, which defines decorative art as the search for visual or auditory pleasure "without the necessary intervention of ideas or feelings" (ibid.). For him, Italian music, with its trills and flourishes, seeks only to amuse the ear and is thus "decorative." Similarly, Parnassian poetry, with its subordination of thought and emotion to the complication of rhyme and sound patterns, is "decorative poetry." He hastens to add that he is neither disdainful nor suspicious of decorative art "as long as it stays within its proper limits, which are the gracious, the pretty, the

beautiful, and as long as it doesn't propel itself into the strange . . . the old-fashioned or the artfully false." For it is "false and contemptible" only when it exceeds the boundaries assigned to it. (In fact, as we will see, the writers studied here are drawn to ornament precisely because it *can* so readily figure the strange, the aura of the past, and the "faux": illusion, artifice, the imaginary.) Clearly, the theme of the boundary and its transgression is a key to the way the century looked at ornament. Yet, as I mentioned, certain limitations imposed on form trigger the creative impulse to reach new heights. The way to transcend limits imposed from without is to set up limits within. Indeed, the same battle is fought by the writers in the period who display the greatest interest in ornament. The writers studied in this book all try, albeit in very different ways, to exceed the limits thought to be inherent in the literary genre they practiced. And they do so by constructing formal problems within the text which act as self-imposed constraints (for example, the decorative frame, the extended metaphor, trompe l'oeil designs, or repeating patterns). Thus, each text is an exploration of the limits of the decorative and a push beyond those limits. In each case, the text plays with the notion of the boundary and its transgression, and ornament serves as a vehicle for a statement of new aesthetic principles.

THE GRAMMAR AND LAWS OF ORNAMENT

Despite the difficulty in distinguishing decorative art from nondecorative art, one can deduce a working definition of the decorative and of ornament from books that set down a "grammar of ornament" wherein the "laws of ornament" are detailed.

A grammar of ornament must specify which figures constitute the repertoire. They include the *rinceau* (foliage or scrollwork), volute, border, *grecque* (fret), *fleuron* (finial or tailpiece), *cartouche*, trophy, and arabesque. As Bracquemond understood it, they were simple and immutable and served as "armatures destined to support those diverse vegetations . . . that have constituted the [various] styles" (*Du Dessin*, 164).

"The whole grammar of ornament consists in contrast, repetition and series," wrote Ralph Wornum in 1873.[20] Ziegler sets forth a similar grammar: repetition, alternation, and *intersecance* (one of many neologisms he coined, *intersecance* signifies the extension of a eurythmic cadence and the interruptions it produces in marking measure from one plane to another). Repetition is such an important element that

something can become ornamental by simple repetition (Ziegler, *Etudes*, 176). The "laws of ornament" that preside over the three forms of ornamental syntax above are eurythmy and complication. A rhythmic, cadenced series in accord with other series (eurythmy) would necessarily be defined as ornamental. Eurythmy is thus a law in the interests of harmony; complication is a law that takes into account quite a contrary aesthetic desire. "Complication charms us in presenting to our eyes the material formulae of intelligence at work . . . raising itself to divinity by the infinite perception of figures . . . and [their] relationships" (*Etudes*, 163). Charles Blanc quotes Ziegler and adds that one experiences a "singular pleasure in unraveling a scrawl which one thought illegible and recognizing the secret arrangement that only complicated what . . . had seemed an inextricable confusion."[21] The apparent disorder in Islamic art in fact obeys a rigorous order (fig. 3). Islamic visual art resembles narrative style in "interminable" Arabian tales where complicated imaginary events are intertwined, and where the readers' pleasure lies in losing themselves along with the narrator, then in untying the plot. (Blanc, *Grammaire*, 58). Later in the century, Paul Souriau will also compare Islamic art to prose style. Arab music is "absorbing and monotonous, like those arabesques where one gets lost contemplating the complex, infinite interlace . . . [comparable to] undulating syntax or phonetic chains in prose" (Souriau, *Suggestion*, 48–49). Gautier admires Moslem invention for its figures that "decompose ad infinitum in ever-new combinations and meanderings; they serve to express dreams of the infinite."[22] The intense interest in the Orient will prove to be of great importance to the evolution of ornament in the realm of the Imaginary.

The notion of *confusion* (distinct from that of complication) is also important in nineteenth-century aesthetics. Confusion can be usefully employed to set off regularly ordered proportions and eurythmic series. Ziegler writes that the need for confusion is such that in periods where French gardeners tried to enslave nature with laws of symmetry and regularity, "this need . . . was carried over into ornament." Moldings and furniture became twisted and contorted (*Etudes*, 164). He goes on to note that as soon as the Directoire style mandated straight lines in furniture and ornamentation, then gardens again became the "sanctuary of confusion; they answered needs *which are in man's instinct*" (ibid., 166; emphasis mine). Otherwise put, libidinal impulses, when repressed in one area, have to go elsewhere. In the texts analyzed in this book, they invariably go into ornamental objects, decor, or diction. Ziegler's

3. Jules Bourgoin, Islamic design, *Eléments des Arts arabes: Le trait des entrelacs*, 1873.

remarks imply the question of why ornament signifies and how it comes to express unconscious desire. And it is this question I will address now.

ORNAMENT AS SYMBOL

"Straight or curved, horizontal or vertical, parallel or diverging, all lines have a secret rapport with feeling [*sentiment*]" (Blanc, *Grammaire des Arts du dessin*, 532). One of the most influential analyses of expressivity in line was written by Gustav Fechner, whose work was well known to French aestheticians. His "Introduction à l'esthétique" (*La Revue philosophique de la France et de l'étranger* 6 [1878]) dealt precisely with the expressive power of lines and shapes based on the association of ideas.[23]

"Ornament is all that remains of symbols" (Bracquemond, *Du Dessin*, 171). In antiquity, ornaments—gems, for example—were emblems that carried a profound sentiment or a religious signification. Imitation of nature was subordinated to the expression of an idea. Ornaments were "forms of writing, thoughts made visible" (Blanc, *Parure*, 337). This was also true of the Middle Ages, when symbolism was particularly prevalent in heraldry and in Christianity.[24] The Renaissance saw the beginning of the decline of the symbol, which by 1875 had "lost its dignity" (Bracquemond, *Du Dessin*, 339). In 1901, Henry van de Velde would proclaim: "In the place of the old symbolic elements which can no longer have evocative power, I will substitute new, enduring elements of beauty."[25] It is important to note that the final loss of ornament's symbolic value was concurrent with its newfound status as central (in Art Nouveau). Its proliferation in literature as well as on Parisian façades ensured its trivialization.

Both complication and confusion have a symbolic dimension: the first symbolizes the idea of infinity (see above), and the second expresses excess, *vertige*, and a Promethean striving.

> There is something monstrous, excessive . . . [about India, a] dizziness of mad sumptuousness, this unleashed debauchery of splendor, . . . and this confusion of all the blinding wonders of nature, sparkling colors . . . as if he who was wearing [this Indian costume] wanted to . . . feel all creation palpitating on his shoulders. (Gautier, "Les Barbares modernes," 356)

And if the apparent chaos of abstract, Indian interlace ("invented, drawn from nothing, the prototypes . . . nonexistent in nature") sig-

naled the fecundity of human genius, this riot of color and shapes is an appropriation of the natural world. In fact, the function of ornamental confusion in Gautier is not simply to add charm or *bizarrerie* to regular proportions, but to throw the spectators into a vertiginous debauchery of the senses, propelling them into the vortex of creation. "Vertigo overtakes one . . . the mix of colors . . . becomes . . . an unimaginable gamble (Gautier, "Les Manufactures"). *Tant pis* if the confusion overwhelms structure: "The quantity and the confusion of details don't allow one to distinguish the general lines. . . . There is . . . an inexhaustible profusion such as one finds in nature."[26] Here Gautier goes beyond the "laws of ornament" prescribed by his contemporaries who look merely for "capricious complication of forms . . . the modern taste"[27] or "a confusion of forms . . . cleverly calculated to be the equivalent of a hidden order . . . of an amiable disarray" (Blanc, *Parure*, 286). What Gautier and Nerval seek in ornamental confusion is a second creation that will rival nature. Ornamental distortion can produce monstrous new forms, as in Romanesque sculpture.[28] Not only can ornament be structural, as some aestheticians in the nineteenth century believed, but in its excessiveness it can push through the limits of natural form to invent the hitherto unseen.

From the 1860s to the 1880s, compositions of this sort were perceived by aestheticians of the decorative arts as causing a feeling of agitation and malaise; we will see that Gautier and Huysmans, exploiting ornamental form as a symbol of creative energy or of the decomposition of energy, deliberately sought this effect in certain texts. The unconscious weight of decoration as symbol would be explicitly proclaimed in 1900 by the furniture maker and glassmaker Emile Gallé. "The [decorative] work . . . synthesizes an unconscious and *all the more profound* symbol."[29]

FANTASY, DREAM, AND EROS

Charles Blanc writes that repetition in Arab music creates a mounting dreaminess that can metamorphose from the initial pleasure to a "sort of moral drunkenness." And in a discussion of imaginary perspectives, he writes that fantastic architecture will "lull the imagination, [and] amuse the spirit" in addition to intriguing the gaze. Its unexpectedness and *bizarrerie* transport the viewer into "the empire of fantasy and dream."[30] The power of ornament to induce a state of "dreaminess" will

be explored with more exactitude as psychiatric theory is brought to bear on this aspect of aesthetics. In our own century, Henri Focillon has written: "Form prolongs and diffuses itself throughout our dreams and fantasies."[31] It is ornament's link with the unconscious, with subjective phantasy,[32] that is at the core of my analysis throughout this book. The following quotations will demonstrate how strongly late-nineteenth-century theory supports my thesis.

The nineteenth-century thinker who examined this link with the most acuteness was Paul Souriau, professor at the University of Nancy, a city where both Emile Gallé and Dr. Hippolyte Bernheim were practicing at the time. Hence, it is not surprising that Souriau's aesthetics should have been imbued with theories from the decorative arts and from psychiatry. Bernheim's psychiatric theory and practice remained entirely founded on hypnotism and suggestion. Souriau believed that one's powers of invention were greatest in a state of "dreamy somnolence." One can also invent new figures at will through voluntary hallucination: "Our imagination has the power to modify the visual field so as to make different figures according to its whims. . . . [And] by a greater effort, it can transfigure real objects to produce true hallucinations" (Souriau, *Suggestion*, 82). Moreover, if there is an art that, "*more than all others*, gives free rein to fantasy and caprice, it is decorative art. All of the illusions that figurative imagination enjoys playing with are employed in decoration" (ibid., 94; emphasis mine). Souriau cites counterchange ornaments and grotesques where human form metamorphoses into ornament, two phenomena I analyze in Gautier and Mallarmé. This play of appearances lends *movement* and life to the figures. It also induces hallucination and *vertige*. Japanese, Chinese, and Greek culture have understood decoration as the art of inserting the imaginary into the real, and this fusion invites fantasy. What pleases us in aesthetic contemplation is not contemplation as such, but the hypnotic state it induces (see ibid., 56). Souriau also underlines the role of the unconscious in aesthetic judgment. Fascination "determines our aesthetic judgments and taste with all the more force the less we suspect its functioning: the quality proper to all suggestion is the relationship between its effectiveness and the degree to which it is not conscious" (ibid., 35).

But this state can be dangerous: it can become more than simply vertiginous. The temptation toward absolute loss of consciousness is great, says Souriau, and the vertige is nearly fatal. Throughout the century, aestheticians of the decorative arts warned against an excessive

propensity to fantasy. A loss of limits in ornament can mean madness
(see chapter 7). Souriau recognizes that ornament can create anxiety and
obsession. Nonetheless, again and again, he invites the reader to fanta-
size on ornamental decor. Decorative line "invites illusion. Why not
lend oneself to this game?" (ibid., 60). Or: "Imagine these bizarre gar-
lands detached from the wall they are decorating; spread out on a table
like a real object, this would send a shiver up one's spine."[33]

Souriau describes two forms of ambiguous experience in the con-
templation of ornament: (1) the Subject imagines that the figures deco-
rating the surface of an object are real, but the illusion is incomplete,
and he or she takes pleasure in looking at an object that is "half real,
half fictive" ("this vase of real porcelain where an imaginary lizard is
crawling" [*Suggestion*, 53]); (2) one can make this illusion appear and
disappear at will, causing a trompe l'oeil. The object fades away as one
concentrates on the figure, but when the shape of the object is brought
back into prominence the figures flatten out and resume their status as
incrustation, or strokes of color. Ornament not only invites one to hesi-
tate between one figure and another, or between figure and decor, but
also encourages an interplay between reality and imagination.

> Without any other means of expression than line and color, the abstract
> decor can give us poetic impressions. . . . If in addition the decorator has
> taken care to lead us in the path of hallucination by the bizarre or para-
> doxical structure of the object decorated, by the magic of color, by the
> play of light, of transparency and reflection, the charm will be complete,
> and the images that we truly have before our eyes will take on an unreal
> aspect, a beauty of apparition and mirage. (Ibid., 75)

It should be clear from the preceding passages that the study of orna-
ment had become relevant to a new field of inquiry: perceptual psychol-
ogy. Indeed, the founding of Gestalt psychology is generally attributed
to Christian von Ehrenfels, who first described the *Gestaltqualität* in
1890, three years before Souriau's *La Suggestion dans l'art*. Because rep-
resentation on decorative objects does not seek to be naturalistic, more
is left to the imagination and the viewer experiences more pleasure.

For Souriau, ornament works on the viewer either by fascination or
by fading into the background, where it is perceived almost sublimi-
nally. Anton Ehrenzweig makes a similar observation: "These inarticu-
late form elements tend to evade us because [they are] *frills* [yet they
have] great significance for our unconscious depths."[34] This is, as I have
already stressed, my central thesis in the present study. Ornament be-

comes the privileged location for the expression of desire because it is peripheral. Peripheral perception, writes Ehrenzweig, "serves no better purpose than to be repressed from the surface memory image and to feed dream-like hallucinations of which we hardly ever become aware" (*Psychoanalysis*, 173n). The highly valorized appearance of movement in ornament has its corollary in unconscious thought processes. What the mind enjoys in looking at ornamental metamorphoses is not the images per se, but "the movement of thought which passes from one to the other" (Souriau, *L'Imagination*, 60). This movement is assimilated to that of the mind in dream states. Therefore, an important new function of ornament would be to suggest the very movement of unconscious thought.

Subjective phantasy, floating between dream and material sense stimuli, sought expression in the sorts of decorative designs that question perceptual certainties. The world of fantasy, dream, erotic impulses, Id phantasy, thus found a mirror in the irresolution of figure and ground (which would become a hallmark of modernism in painting at the end of the century, but which had always been a mainstay of decorative pattern).

By the end of the century, the correlation between ornament and Eros was explicit (in the paintings of Gustav Klimt, for example). Here is the sort of decorative border Huysmans proposed that his friend Théo Hannon use for an erotic poem: "With framing devices, flourishes and tail pieces . . . and bright reds like a new clitoris, one would have something unexpected and quite curious."[35]

In each chapter I propose a different ornamental pattern as the expression of desire. Nerval's interlace is used to tie together Subject and Object, while his arabesque expresses a metaphysical desire for transcendence. In Gautier, fetishistic erotic phantasies are located in the decorative frame; in *Jettatura*, proliferating ornament figures the hero's unconscious desire to devour the woman. Similarly, the erotic charge of Mallarmé's poetry is located in the decorative objects that punctuate his texts. Chapter 3 examines the psychoanalytic dynamics of Object relations in general, as these dynamics are manifested in ornamental patterns or objects. In many of the texts studied, ornament appears at a pivotal moment, a moment where a surplus of drives or psychic impulses exceeds rational representation. This excess or overburdening of signification is absorbed by the ornamental objects in the decor or by linguistic conceits.

Huysmans goes further than any writer in the century in creating the

textual equivalent of horror vacui. The extreme complication of his syntax is an attempt to fill a metaphysical void that is metaphorized in several ways in both *A Rebours* and *En Rade*. In *Là-Bas*, sexual perversion is superimposed on this metaphysical desire. In the overall effect of horror vacui, Huysmans's prose resembles Islamic or Byzantine art and some forms of Art Nouveau.

Ornamental Prose

"It is . . . one of the signs of the spiritual climate of our century that the arts aspire, if not to supplement each other, at least to reciprocally lend each other new strengths" (Charles Baudelaire). Before examining some of the specific parallels that can be drawn between prose style and the decorative arts, I want to point out two general *points de rencontre*. Throughout the nineteenth century, writing emulated painting and tried to incorporate pictorial qualities. "Each day poetry encroaches further on painting's territory" (Souriau, *La Suggestion*, 189). Annette Kahn correctly states that writers, artists, and critics in the century were acutely conscious of relations between the visual arts and literature.[36] This fact, although widely known, has not yet been seen to extend to the decorative arts. A second parallel can be drawn. Perhaps the most salient fact in the nineteenth century's history of the decorative arts is the predominance of borrowing from past styles. Until around 1885, invention was simply an ingenious recombination of preexistent elements. Nerval's intertextual borrowings from the Renaissance and the seventeenth and eighteenth centuries are so excessive that they create an utterly novel approach to textuality. Gautier, too, often adopts a rococo, medieval, or Oriental decor and tailors his style to the period. And more than half of *A Rebours* is composed of "quotations" from preexistent works of art. Since many of these borrowings in the three writers impose themselves as such on the reader, they create an awareness of the self-reflexive dimension of the text. And that dimension is, as we will see in each chapter of this book, closely linked to ornament.

But what, specifically, characterizes ornamental prose style? Rhythmic cadences, repetition of phonemes, and syntactic structures (for example, alliteration, assonance, rhyme, anaphora), wordplay, overwrought imagery, metaphor, simile, extended metaphor, oxymoron, and other figures of rhetoric. These traits may be used to create an atmosphere of playfulness, revery, high emotion, or bombast. As Ernst

Gombrich stressed in his richly rewarding book on the decorative, the attacks on the excesses of decoration, on its virtuosity, were first framed in terms of an opposition between ornate Asiatic oratory and "pure" Attic rhetoric. All of the antagonism and suspicion directed at ornament in the decorative arts will also be leveled at ornamental texts.

Maxime du Camp lambastes his contemporaries of the mid-nineteenth century in these terms: "One accumulates images upon images, hyperbole on hyperbole, periphrase on periphrase; one juggles with words, . . . one carries in outstretched arms one hundred kilos of epithets . . . one speaks in order to say nothing. Where, then, are the writers? I see only virtuosi."[37]

An interesting essay by Walter Bagehot from this period, "Wordsworth, Tennyson, and Browning; or, Pure, Ornate, and Grotesque Art in Poetry," undertakes to define *pure, ornate*, and *grotesque*. It will serve us well in amplifying upon the enumeration of linguistic ornaments given earlier. In pure art, the whole appears at once "and through the detail, but the detail itself is not seen; [pure art] works with the fewest strokes [necessary]."[38] "The extreme opposite to this pure art is what may be called ornate art. . . . It wishes to surround the type with the greatest number of circumstances which it can bear. It works not by choice and selection, but by accumulation and aggregation" (Bagehot, *Literary Studies*, 362). We recognize this as the traditional notion of decadent literature (this essay dates from 1864). Bagehot goes on to list nearly all of the qualities I have mentioned as prized by theoreticians of the decorative arts, only here they are viewed pejoratively. First, the *imagination* has a prominent role: ornate art gives a fascination to things which they don't possess in reality. Second, *trompe l'oeil and illusion* are present: "Nothing is described as it is; everything has about it an atmosphere of something else" and "ornate art is fit . . . for describing illusions." Third, *excess*: ornate art is "somehow excessive and overrich." Fourth, *confusion*: "a gay confusion that doesn't exist in the real world." Fifth, *seduction*: a predominance of "alluring details which . . . excite but impair confidence." Finally, the moral reprobation that adheres to the effect these characteristics have on the reader is considerable. Bagehot blames ornate writing because it is "not chaste in itself or chastening to the mind." In addition, we feel that there is some hidden want in it, and this is a "want of definition" (in other words, it possesses the capacity to exceed categories). Pure art on the other hand gives us "*a pleasure justified* as well as felt" (362, 364, 365, 364; my emphasis). Ornate art gives us pleasure, but a dangerous and perverse pleasure, "a

mist of beauty, an *excess* of fascination, a *complication* of charm" (ibid., 365; emphases mine): the very effects Ziegler, Gautier, and Souriau praise. As we might expect, the field of seduction and pleasure calls forth an analogy with the feminine, and with ornament's appeal to women readers. "Women too (as well as young men) . . . ever prefer a delicate unreality to a true or firm art. A dressy literature, an exaggerated literature seem to be fated to us" (ibid., 389).[39]

There is some good in ornamental writing, though, according to Bagehot, and that is its ability to depict the unreal or to deal with *half-belief* (in ghosts, for example).

Like so many literary critics, Bagehot subscribes to the moralistic belief that simplicity is a virtue and complexity a fault. I have alluded to complication and excess as virtues in the decorative arts.[40] In fact, certain nineteenth-century critics lament the relative diminution of these qualities in contemporary work. Caravage de Polydore (1560–1630?) is praised in *La Gazette des Beaux-Arts* for his "abundance of forms [and] overburdening of figures and ornaments. . . . No [contemporary] goldsmith would dare to approach these redundant moldings, these impossible reliefs, these interlaced serpents, twisted in the folds of unbridled acanthus leaves."[41] No goldsmith except, of course, Gautier, Nerval, Mallarmé, and Huysmans, the first and last often referred to as "orfèvres de la langue". What was no longer conceivable in the decorative arts of 1860, what was too "feverish" and paroxysmal, would be taken up in literature. For literature was now in a "period of intellectual exuberance" and a "paroxysm of production" (ibid.) that the decorative arts would experience again only in the 1890s. Poetry, as Gautier claims in *Les Grotesques*, is "dependent on extravagant conceits."[42] What specific forms do excess and complication take in the texts to be analyzed?

ORNAMENT AND EXCESS

Rhythmic repetition ties together the diverse threads of Nerval's *Sylvie*, a lacelike tissue that is both complex and diaphanous. Because of the latter quality, its vertiginous complexity becomes apparent only as one tries to follow the interwoven pattern of narrative and phonic threads. The numerous digressions or arabesques in "La Main enchantée" make of a simple tale a highly playful and complex exercise in structure. It doubles back on itself through ironic reflections, just as the arabesque doubles back on itself before branching out into new arabesques. This

description of interlace (*entrelacs*) in Bourgoin's *Eléments des Arts arabes* could easily be applied to Nerval's prose: "One is overtaken by dizziness, looking at these tangles of straight and curved lines that form a concrete, harmonious whole, but whose manner of combining seems to disappear under scrutiny."[43] Gautier's fantastic tales create an "excess" that is a sort of middle ground or *entre-deux*; it emerges out of an absence of limits/boundary between dream and reality, frame and tableau. Gautier's *Jettatura* is perhaps the most vivid portrayal of the problem of excess in ornament and its refusal to observe limitations. In this tale, the gaze of the hero devours the Object of desire by enveloping her with ornament. *Jettatura* offers an elaboration of the notion of ornament as dangerous, seductive, and fearful: ornamental vision is the evil eye. Mallarmé's use of textual *ornements à double jeu* creates an excess or overlap where two images change places with each other. We saw that Paul Souriau, a contemporary of Mallarmé, proposed an analogy between these images and metaphor, lending credibility to the idea of a verbal ornamental counterchange (Souriau, *Suggestion*, 212). In Huysmans's *En Rade* and *Là-Bas*, excess is figured as a form of decomposition that attacks the decor and sexual desire, creating designs that are both repulsive and ornamental. Rachilde's peculiar form of excess is in the image of sexuality she depicts in *Monsieur Vénus*. There, sexual arousal depends on both ornamental decor and on an excess of feminine qualities in the male Object of desire. A sort of trompe l'oeil is effected in this novel by means of the interchange and reversal between the heroine and Jacques, alias Monsieur Vénus. Excess in these last three novels, moreover, takes on another face, that of hysteria. Accordingly, in the last chapter of this book, I will propose and describe specific relationships that I have discovered between ornament and hysteria.

According to scientific experience, the brain generates visual patterns of great complexity. Gombrich remarks that if the flickering visions seen under the influence of hallucinogenics are normally suppressed by our conscious mind, it is perhaps due to our need to visually order the world (Gombrich, *Order*, 123).[44] Complexity and decorative excess are felt to be dangerously chaotic. Many of the ornamental texts of the nineteenth century are precisely in service of a desire contrary to the one Gombrich cites, a desire to unleash this dazzling visual panoply of beautiful and bizarre patterns. The powerful hypnotic effect of such flickering designs is evoked in this review by Gautier: "This extraterrestrial light made up of reflections, scintillations and phosphorescences, . . . one can't tear one's eyes away."[45] Not surprisingly, descrip-

tions of these configurations are frequent in hysterical patients of the fin de siècle. Finally, the phenomenon of synesthesia, so important in Symbolist and Decadent literature and often linked to ornamental images there, is classified by Dr. Gatian de Clérambault and others as pathological. I will return to these texts in chapter 7. Psychiatric observations of hypnagogic states, hallucinations, and other abnormal states were to suggest parallels with the effects of ornamental objects and decor on the psyche. Henceforth the dangers that were previously *only felt* to exist in ornament seemed now certainly linked to madness. John Ruskin, for example, wrote that his love of clouds, filigree, netting, and so on, was "not shared with wise men."

ORNAMENT AND EVIL

But moral condemnation of ornament is made on other grounds as well. The linking of ornament and evil with the operative intermediaries of excess and seduction is as old as ornament itself. One has only to think of the valorization of plainness in manner and attire in the Amish and Mennonite communities, or the seductive and even treacherous ways of femmes fatales like Salomé or Helen of Troy, depicted (by French artists) dripping with ornament. Ornament "is wanton where it is not positively perverse."[46] In ancient Greece, the figure of the artisan and of ornamental objects carried with them a constellation of notions that included artifice, ruse, trap (the labyrinth of Daedalus), seduction, charm, veil, secret. Artisanal technique—*technè*—was sacralized in Plato's *Timaeus* even as it was regarded with mistrust. Prometheus wears the cap of the Artisan, and the crown of Pandora was carved by Hephaestus. With Circe, Thetis, and Arachne, the relation of ornamental objects to magic and metamorphosis was brought out more explicitly. The ability to metamorphose was, moreover, expressed through certain sought-after characteristics in these objects: shimmering, brilliance, mirroring, and other forms of polymorphism. Even when ornament is mimetic, it retains its fallacious character (in the illusionistic "cow" inhabited by Pasiphaë in order to seduce the bull who thereby fathered the Minotaur) or its ruse (the Trojan horse). Attitudes toward these qualities were carried over into language, as we have seen. The Atticists were vehemently opposed to the embellishments of rhetoric in the Asiatic style because elaborate rhythms, clever or meandering turns of phrase, and overwrought imagery mislead all too easily. Ruse and the

ability to lead astray are facilitated by language that spellbinds one with its seductive forms and textures, supposedly diminishing the faculties of logic, reason, and taste. Sophistry may rely on ornament: both are undulating, complicated lines capable of leading one away from the paths of virtue, from the straight and narrow. Cicero acknowledged the value of the plain style but maintained that linguistic display also had its place. This is the highly influential theory of decorum, and we have seen that nineteenth-century critics did not fail to establish the conditions of decorum under which ornament was acceptable.

Indulgence in ornamental patterns and objects is tolerated and even nurtured in, say, French classicism because the privilege of the center is always maintained (fig. 4). It is when the central figure is threatened with usurpation that moralizing about ornament begins. Periods that place an extremely high value on order based on a central figure or symbol—around which all else is structured—will regard as decadent those forms of expression that refuse this design. Neoclassicism's view of the rococo is an example of this form of tyranny. Caprice became "a crime, [and] the design principle of heterogeneity . . . was relegated to the ornamental cartouche, colorful embroidery, intricate *boiserie*, and to the English garden. In short, the leveling and decentering visual language of incongruity was shunted to those 'free' feminine spaces skirting the edges of male hierarchy."[47] As Rousseau expressed it at the end of the eighteenth century, "Ornamentation is no less foreign to virtue, which is the strength and vigor of the soul."[48] The most condensed and radical statement of this attitude in our own century was made, as I mentioned earlier, by the Viennese architect Adolf Loos in "Ornament und Verbrechen" (1908). As early as 1898, in the "glory days" of modern style or Art Nouveau, and just before the Viennese Secessionist movement took hold, Loos launched his battle cry against ornament. "The lower the cultural level of a people, the more extravagant it is with its ornament, its decoration. . . . But we must overcome the Indian in us. . . . To seek beauty only in form and not in ornament is the goal toward which all humanity is striving."[49]

In 1908, the accusation was more hyperbolic. "Those who are tattooed but are not imprisoned are latent criminals or degenerate aristocrats. If a tattooed person dies at liberty, it is only that he died a few years before he committed a murder."

Loos then juxtaposed the erotic qualities of ornament with its criminal nature. "The urge to ornament one's face, and everything within one's reach is the origin of fine art. . . . All art is erotic."[50] Ornament's

4. Le Brun, embroidered wall hanging, "Spring," c. 1685. The Metropolitan Museum of Art, Rogers Fund, 1946. (46. 43. 1)

detractors recognize all too well how powerful an effect decor can have on society. Even today—albeit in a highly self-conscious manner—an advertisement for the magazine *Décoration Internationale* (on the inside front cover of the July 1985 issue) reads: "Monte Carlo, Place Vendôme, the beautiful is never far from places where one can lose one's soul. Brilliant, futile, and sometimes dangerous, from time to time the beautiful . . . is a game." The page bears the title "Beau comme l'excès." Beautiful like excess.

Art Comes Out of the Woodwork

An assumption of the present study is that the style of the writers who surrounded themselves with decorative objects could not help but reflect those objects. Gautier expresses this idea when he writes about the painter-decorator Meissonier's house "with its copper lighting fixtures, with its tapestries, its blue and white porcelain, its carved furniture. . . . It is there that his painting lived while waiting for his person to arrive."[51] Van de Velde says essentially the same thing when he states, "The decor always ends up having its way with us. We obey, despite all our efforts, its permanent suggestion."[52]

Thus, as decor shapes perceptual habits and, later in life, artistic production, so the texts analyzed here have recourse to ornament when the writer wishes to illuminate the dynamics of perception or signal the artisanal nature of textual production. I have outlined some of the problems of perception to be studied in this book; each chapter focuses on a different vision of the world as molded by ornament. Similarly, the relation of ornament to self-reflexive discourse is underlined in my analyses. One of the aspects of decorative composition is the emphasis laid on *relationships*, not on individual motifs.[53] The effect and, we now see, the meaning of the composition emerge out of the global structure. This may seem contradictory to the commonly held idea that decorative or ornamental writing emphasizes the detail and that the overall effect of ornament on language is one of fragmentation. Of the writers studied, this is true only of Huysmans, and then only in one of the three texts considered. This particular parallel with writing will pull literature away from focus on plot and character to locate meaning in the structure of the text. Van de Velde insisted on the structural value of ornament through the force of its line: "It is only secondary if it is not organic, if it is not connected to the form, [if it is] without a compli-

mentary and structural activity."[54] The reader's capacity to "register re-
lationships rather than individual elements" is challenged (Gombrich,
Order, 49). The foregrounding of structure is related to the role of orna-
ment as textual self-reflection, and an overview of that function will
constitute the Conclusion of this book.

"It is of the essence of ornament that in its products the *Kunstwollen*
of a people finds its purest and most unobscured expression. It offers . . .
a paradigm from which the specific peculiarities . . . can be read off.
It ought to constitute the point of departure and the fundament of
all aesthetic consideration of art" (Worringer, *Abstraction*, 51). Just as
the urge to ornament is at the origin of art, the problems raised by
ornament are at the very heart of aesthetic experience: limits and their
transgression, illusion and seduction, pleasure and tension, harmony
and confusion, excess, marginality, and the notion of "pure art." The
theoretical and stylistic method of the decorative arts influences the
entire composition and final style of the texts I will analyze in this book.
Far from being a trivial flourish in the history of nineteenth-century
aesthetics, ornament is a reflection on the nature of art and on the
dynamics of perception and desire.

PART I

Romanticism

The Enchanted Hand: Schlegel's Arabesque in Nerval

La ligne mystérieuse et fantasque courait, se tordait,
s'allongeait . . . et prenait toutes les formes d'une géométrie impos-
sible; et cela nous faisait plus rêver . . . que les plus belles formes de la
nature, les types les plus purs et les plus magnifiquement complets.
—*Mérimée, "Les Arabesques d'un tapis"*

These marvels of art, in their organic infinitude and inexhaustible
plenitude of form, resemble nothing so much as the creations of
nature itself.—*Friedrich Schlegel*, Letters from a Voyage

Confusion is chaotic only when it can give rise to a new world.
—*Schlegel*, Ideas, *no. 71*

Le génie n'aperçoit pas un chaos sans qu'il lui prenne envie d'en faire
un monde.—*Nerval*, Préface à Faust, *1830*

SCHLEGEL'S ARABESQUE

In one of the dreamlike, visionary scenes in Gérard de Nerval's *Aurélia*,
the narrator wanders through an "unfinished structure" where he sees
artisans modeling a monstrous animal animated by a fiery stream "[qui]
se tordait, pénétré de mille filets pourprés . . . [et] se revêtait d'une
végétation instantanée d'appendices fibreux" ([which] twisted about,
penetrated by a thousand purple threads . . . [and] clothed with an in-
stantaneous vegetation of fibrous appendages). This chef d'oeuvre
seems to him to contain the secrets of divine creation. What is more,
the artisans are shaping ornaments that are self-engendering: "Les or-
nements n'étaient ni martelés ni ciselés, mais se formaient, se coloraient
et s'épanouissaient comme des plantes métalliques qu'on fait naître de

certaines mixtions chimiques" (The ornaments were neither hammered nor carved, but rather took on shape and color and blossomed like metallic plants that one brings into existence through certain chemical combinations).[1] These twisting, expanding forms, or arabesques, are at once a paradigm for divine creation and artisanal production. The arabesque, as this study of "La Main enchantée" will show, is the site of both metaphysical striving and the figuration of writing.

The vision in *Aurélia* follows the narrator's awareness of himself as double: "actor" and "spectator." This splitting of the self is made literal in the hero's "mad" experience of seeing his hostile Double; seen from the perspective of the theories of Friedrich Schlegel, this might be construed as a form of Romantic irony.[2] Ironic doubling in the text inspires a decorative vision of arabesques, and a study embracing several writers would confirm the necessary juncture of these two narrative strategies in Romantic fiction. These visions of excess always take place at a moment of psychological revelation in the hero, often when the split of the Subject into hero and narrator or hero and alter ego is most keenly felt. This ironic structure, combined with the "infinite freedom" of open-ended, self-engendering form "in the process of becoming," makes such texts "true arabesques."[3]

Schlegel considered the arabesque to be "a very definite and essential form or mode of expression of poetry" (Behler, 96). Although he did not dissect the formal characteristics of the arabesque as I will do here, his extensive use of it to describe the essential characteristics of Romantic imagination and poetry (in the Aristotelian sense of the word) stems from an appreciation of the ornamental motif as it appears in Pompeii and Herculaneum, on the ceiling of Raphael's Vatican loggias, in Gothic ornament, and in the Orient.

The arabesque is the most ancient and tenacious of ornamental motifs. Aloïs Riegl showed its origin to lie in the Egyptian lotus.[4] Its prestige as *ursprungliche Form* is of capital importance, as is its geographic origin. The depth of interest in the Orient (on both the scholarly and the phantasmal planes) was as central to Schlegel's inspiration as it was to Nerval's and Gautier's.[5] Schlegel, nearly a century before Riegl, considered the arabesque to be the "oldest form of human imagination." To be precise, it was, for Schlegel, the phenomenological mode of expression of the Imagination, for the latter is experienced as *Witz*, and the arabesque is the most ancient and typical form of *Witz*. In seeking to lay the groundwork for a "new mythology," the philosopher turned to the arabesque for its model:

> Here I find a great similarity with the marvelous wit of romantic poetry which does not manifest itself in individual conceptions but *in the structure of the whole.* . . . Indeed, this artfully ordered confusion, [and] this wonderfully perennial alternation of enthusiasm and irony which lives in even the smallest parts of the whole seem to me an indirect mythology themselves. The organization is the same, and certainly the arabesque is the oldest and most original form of human imagination.[6] (Behler, 86; emphasis mine)

As if the prestige of being not only the outward expression of the Imagination, but also its most ancient form, were not enough to confer upon the arabesque the title of the Essential Romantic Figure, its capricious meanderings are, for Schlegel, simultaneously an expression of Nature. In addition, the suppleness of its line and its caprice are able to embrace the twists and turns, the spontaneity and chance encounters of life itself. A series of arabesques reproduces life's profusion and endless variety, what Schlegel calls its plenitude or abundance (*Fülle*) and its "chaos." "The world of poetry is as infinite and inexhaustible as the riches of animating nature with her plants, animals, and formations of every type, shape, and color" (Behler, 53). In order to figure this plenitude, the "romantic kind of poetry" must remain "in the state of becoming; that, in fact, is its real essence: that it should forever be becoming and never be perfected. . . . It alone is infinite, just as it alone is free."[7]

Romantic writing must take as its subject the quest for this *Fülle*. It figures forth the intuitive leap into this experience in the person of the hero who seeks to define himself, who "takes shape" before our very eyes, and out of whose often incoherent encounters with life, love, and desire emerges a vision of infinite richness and mystery. On a different level, the text must reproduce in its style these same connections and variety which bespeak the totality of existence. Romantic poetry as "eternally becoming" allows us to witness the production of the text as it unfolds, changes course, and remains open to further development. Thus the reader follows along the same sinuous, intricate, and seemingly chaotic paths to the vision as does the hero. The quest of the Subject of the narration is, then, a *mise en abyme* both of the writer's style (and the writing process) and the reader's peregrinations within the total structure of the text, itself a reflection of the inexhaustible plenitude of the universe.

This openness and expansiveness may be likened to the Romantic

ideal of enthusiasm, and the "eternal alternation of enthusiasm and irony" of *Witz* is perfectly mimed in the arabesque, which, "in perennial alternation, expand[s] and return[s] to itself" (Behler, 83). The line both curls inward in a gesture of closure and swings outward again to engender new arabesques. The figure's capacity to branch out into other arabesques gives it the appearance of being self-engendering, and its open-ended ramifications imply a form in the process of becoming. The formal properties of the arabesque are remarkably well suited to Romantic poetry, for the organic literary text will not only unfold out of itself, but will also shape itself. At the same time, the movement back into itself figures the necessary element of reflexivity or irony in Romanticism, just as the forking off into a second arabesque figures irony's double discourse. Indeed, the multi-directionality of these two opposing movements makes the arabesque a uniquely polysemic figure. In contemplating the actual shape of the arabesque, one begins to understand why Schlegel wrote that he "held the arabesque to be a very definite and essential form or mode of expression of poetry" (Behler, 96).

Finally, the arabesque's tendency to create an ambiguity between figure and ground, and to obfuscate the relation of its parts, also has a structural corollary in Romantic literature: the technique of digression. Digression also contributes to freedom of movement, unfolding, and openness.

Riegl also showed that the arabesque form had evolved from the lotus motif to the palmette, to the scroll, and to the acanthus leaf before taking on the shape of the arabesque per se. The metamorphosis of the figure therefore moved from an organic form in nature to the evocation of the written word and later returned to the motif of the acanthus leaf. Thus, it represents both a *Naturprodukt* and a *Kunstprodukt*, as Schlegel claimed. However, despite its suggestion of both natural and textual objects (one of the main functions of the arabesque in Near Eastern architecture was to work in combination with epigraphy), the arabesque in its final state is pure form, nonreferential ornament, in contrast to the artistic depiction of the human body or of natural objects found in, say, lace patterns. It is a "formal language . . . removed from the beauty of earthly gardens."[8] Yet it retains the prestige of an organic, natural form, though one not bound by mimetic constraints (fig. 5 and see fig. 14, left). It therefore allows the artist/poet to explore and make manifest the freedom of the imagination. Here is a cogent description of this aesthetic freedom as Nerval expresses it in *Voyage en Orient*.

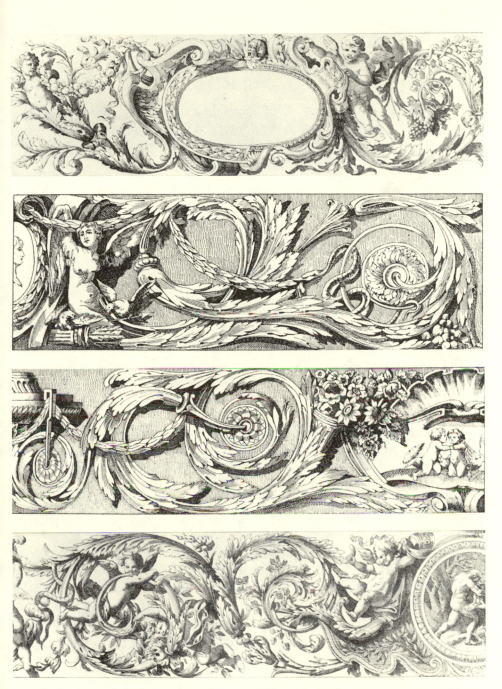

5. Lepautre and De La Fosse, friezes with arabesque ornament, seventeenth and eighteenth centuries. Drawings by L. Libonis, in his *L'Ornement*, 1895.

Quand tu dessines un de ces ornements qui serpentent le long des frises, te bornes-tu à copier les fleurs et les feuillages qui rampent sur le sol? Non: tu inventes, tu laisses courir le stylet au caprice de l'imagination, entremêlant les fantaisies les plus bizarres.[9]

[When you draw one of these ornaments that snake along the friezes, do you limit yourself to copying the flowers and foliage that crawl on the ground? No: you invent, you let the stylus run along with the caprice of the imagination, intermingling the most bizarre fantasies.]

As this passage from Nerval implies, the play of the arabesque line both triggers and comes out of fantasy.

OVERSTEPPING BOUNDARIES

In Nerval, the arabesque appears in imagery and as a structuring device. The proliferating structure of narrative open-endedness, remarkable in Nerval's oeuvre, has its parallel in the profusion of ornamental objects and descriptions that constitute, in large part, the "extravagance" and fantastic atmosphere of *Voyage en Orient, Aurélia,* "Octavie," and "La Pandora." As I stated in the Introduction, ornament's place is usually confined to the decor, where it occupies a subordinate position and status. Here, however, ornament breaks those bonds in a movement of proliferation, effecting an interpenetration of narrative and decor, of figure and ground. This tendency will be encountered again in Gautier and in Huysmans. In each writer, however, this structure (or de-structuration) is mobilized to achieve different ends. In the "Schlegelian" Romantic text the erasure of the distinction between the decorative arabesques that make up the background and the characters who people the foreground throws the text into a primordial chaos. This loss of limits prepares the way for breaking the bonds of reason, a necessary step in finding true poetry within chaos. "For this is the beginning of all poetry, to cancel the progression and laws of rationally thinking reason, and to transplant us once again into the beautiful confusion of imagination, into the original chaos of human nature" (Behler, 86). On the autobiographical level, the risks inherent in the loss of limits (and an excessive ramification of meanings) were lived out in a very real way by Nerval, whose visions of ornamental excess crossed over from fantasy to reality.

Although Schlegel saw only positive virtues and aesthetic gains in a life and oeuvre predicated on these notions, it has also been possible to see nonsensical or even threatening gestures. A decorative artist warned in 1847 that "today's arabesques . . . are so distanced [from nature] that one can only find models for them in the Chimera engendered by sleep. . . . Let the draftsman beware of abandoning himself to all the caprices of an unruly imagination; there are certain limits that reason and taste never allow overstepping."[10] In a preface to a French edition of Hoffmann's tales, Sir Walter Scott wrote that "[he] spent his life . . . tracing, without rules or measure, bizarre and extravagant images . . . they are the dreams of a feeble mind, besieged by fever."[11] Moreover, the words Scott used in a *Fortnightly Review* article to lambaste Hoffmann's technique are astonishingly similar to those Schlegel used to describe the marvelous qualities (nonreferentiality, capriciousness, freedom) of the arabesque: "The reader must content himself with watching the author's sleight of hand, as he would watch the somersaults and the metamorphoses of Arlequino, without seeking any meaning, nor any other aim than the surprise of the moment."[12]

Curiously, it is in a text of Nerval and not of Hoffmann that sleights of hand and somersaults are explicitly named and serve to illustrate the syntax of the narrative, as well as the shaping of the protagonist.

THE ENCHANTED HAND

In "La Main enchantée," the lightness, deftness, and wit of the arabesque are reflected in the legerdemain of the Bohemian, a juggler (the French *escamoteur* is simultaneously one who juggles and one who—also through sleight of hand—picks pockets). It is not he, however, who is first introduced to the reader; nor is it the hero, Eustache Bouteroue. Nerval chooses to open his tale with a page-long description of two magnificent architectural ensembles: the Place Royale (now the Place des Vosges) and the Place Dauphine. The first receives as much attention as the second (the setting for part of the story), but the narrator will never return to it; it serves no purpose other than to demonstrate the capriciousness of the narrative line. Another arabesque of the narrative line is created by presenting a secondary (albeit important) character long before the hero and his alter ego, the Bohemian, appear on the scene. The development of and commentary on this character, a magis-

trate, balloon out of all proportion to his function in the plot, but the
fact that all of this is a digressionary prelude is evident only when the
narrator announces in chapter 3 that he has been "outrageously prolix"
and that it is time for the story to begin.

Godinot Chevassut is a convivial, facetious magistrate "[qui] aimait
à hérisser sa conversation de pointes, d'équivoques et de propos gail-
lards" ([who] liked to spike his conversation with witticisms, double
meanings and lusty declarations).[13] In other words, he revels in lan-
guage as wit, as irony, and as the transgression of propriety's bound-
aries. The narrator points to another means of subverting society's
boundaries. "Il faut dire . . . que les larrons de ce temps-là étaient moins
ignobles . . . et que ce misérable métier était alors une sorte d'art. . . .
Bien des capacités refoulées au dehors et aux pieds d'une société de
barrières et de privilèges se développaient fortement dans ce sens" (It
should be said . . . that the thieves of that time were less ignoble . . . and
that this miserable trade was a sort of art then. . . . Many of the capaci-
ties cast outside and at the bottom of a society of barriers and privileges
developed markedly in this direction) (478). Here is an art exercised in
the margins of society that enjoys freedom from constraint. No quality
is esteemed more highly by him than wit and agility (*l'esprit et l'adresse*).

> Et nulle part il ne trouvait ces qualités plus brillantes et mieux dével-
> oppées que chez la grande nation des tire-laine, matois, coupeurs de
> bourse et bohèmes dont la vie généreuse et *les tours singuliers se dérou-
> laient* tous les jours devant lui *avec une variété inépuisable*. (480; empha-
> ses mine to stress parallels with the arabesque)

> [And nowhere did he find these qualities more brilliant and better de-
> veloped than among the great assembly of thieves, pickpockets and
> Gypsies whose generous existence and *unique tricks unfurled* before him
> each day *with an inexhaustible variety*.]

His hero is, of course, François Villon, poet and thief, and among his
favorite books is *Le Jargon*. Simple folk "d'esprit peu compliqué" are
odious to Chevassut. He would like to see an ironic reversal in the
straight and narrow dictates of the law; when serious larceny was dis-
covered, "one would hang not the thief, but his victim." "Il pensait y
voir le seul moyen de . . . faire arriver les hommes du siècle à un progrès
suprême d'esprit, d'adresse et d'invention" (He thought he saw therein
the only way to . . . have the men of this century arrive at a supreme
degree of progress in wit, agility and invention) (ibid.). Chevassut now

disappears from the narrative, and Nerval's return to him eight chapters later forms another syntactic arabesque.

The magistrate is the flip side of the juggler, whom we shall meet shortly, for the hero, an apprentice draper, has just delivered new leggings to Chevassut and is now about to cross the Pont Neuf, a traditional gathering place for fortune-tellers, artists, jugglers, and musicians. "C'était au centre d'une de ces petites plate-formes en demi-lune. . . . Un escamoteur s'y était établi . . . [avec un] nez assez long et très bossu . . . mais fort retroussé . . . [et] un grand chapeau de feutre à larges bords, extrêmement froissé et recroquevillé" (It was in the center of one of those half-moon-shaped platforms. . . . A juggler/prestidigitator had set up there . . . [with a] rather long, crooked nose . . . but very turned up at the tip . . . [and] a big, wide-brimmed felt hat, extremely bent and curled up) (484–85). One notices the preponderance of the curvilinear in the description of the juggler (even his nose is in the shape of an arabesque). The forms in his physiognomy are immediately linked to an easy adroitness: "quelque chose de souple et de dégagé dans les gestes et dans toute l'attitude du corps" (something supple and free in his gestures and in the whole corporeal posture) (485). After an initial display of sleight of hand, he proposes to foretell the future for a coin. His last client happens to be the draper, Eustache Bouteroue, whose "long and naive face" is examined attentively by the Bohemian before he "reads" the following destiny in Bouteroue's hand: "Chose bizarre! . . . qu'une existence si simple dès l'abord, si bourgeoise, tende vers une transformation si peu commune, vers un but si élevé! Ah! mon jeune coquardeau, vous romprez votre coque; vous irez haut, très haut" (How bizarre! . . . that an existence, at first so simple, so bourgeois, should tend toward such an uncommon transformation, toward such an elevated goal! Ah! my young gallant, you will burst through your shell; you will rise high, very high) (486).

It should be noted that the first function of the *escamoteur* (to conceal and transform through the agility of the hand) is doubled by a second: to narrate, to reveal—but in such a way as to conceal—the truth, through the agility of speech. His double-talk is ironic: Eustache will indeed ascend to great heights: he will be hanged. Even Bouteroue's name indicates a turning at the end. His tricks are visual and semantic (*coquardeau, coque*): as prestidigitator, his gestures are "supple and free" with an unexpected twist (like the arabesque); as narrator, his agility resembles the suppleness of Nerval's language in its semantic substitutions, its insertion of slang, its wordplay, and its irony. The witty ara-

besque is the embodiment of irony, just as "irony is the soul of ara-
besque form" (Schlegel, *Notebooks*, in Polheim, 272).

In addition to linguistic play, Nerval's style deviates from the straight
and narrow of traditional short-story narration in its use of digres-
sion. In addition to the expansion of the initial digression, there are sev-
eral asides that might be qualified as digressions, as well as an entire
chapter ("Où l'auteur prend la parole") clearly labeled as one. Schlegel
was aware of digression's considerable capacities to derail a text, to
destroy complacencies about beginnings, endings, and straight lines.
The meandering multi-directionality of a digressive narrative is often
re-presented *en abyme* by the hero's geographical wanderings. Nervalian
heroes are exemplary in this regard: they wander from country to coun-
try, from town to town, from path to path. "J'allais et je revenais par des
détours inextricables" (I left and returned by inextricable detours). The
hero's alter ego in "La Main enchantée" is no exception to this para-
digm: he is a Gypsy. The meandering road is sometimes described quite
precisely as an arabesque: "Le chemin du Nord est un chemin tortu,
bossu, qui fait un coude considérable" (The north road is a twisting,
crooked road that takes a considerable detour). And the labyrinth of
paths is often lined with the no-less-labyrinthine arabesque: "Les
ronces et les clématites avaient accroché leurs capricieux festons"; "des
acanthes tortillées autour des cactus"; "la rivière / Comme un serpent
boa, sur la vallée entière / Etendu, s'élançait pour les entortiller" (Bram-
bles and clematis had caught their capricious festoons; acanthus twisted
around cactus; the river / Like a boa, over the entire valley / Stretched
out, thrust forward to entwine them).[14]

But to uncover the presence of a digression, one must first be able to
identify another narrative thread as being the principal one. (Un)fortu-
nately, the arabesque-like proliferation of threads in Nerval's texts
makes this task impossible, defeating the reader's desire and tendency
to erect a traditional structure of teleological progression with begin-
ning, middle, and end. As Schlegel pointed out, "digressive" narrative
is at once extremely modern and a return to the structure of the medie-
val romance. It is revolutionary in both senses of the word.

On a par with Diderot, Sterne, Tieck, Schlegel, and Hoffman,
Nerval complicates linear development to the point where, as we saw,
he accuses himself of outrageous prolixity. "Je crois qu'il est l'heure de
tirer la toile" (I think it is time to raise the curtain [and let fall the canvas
backdrop in the theater so that the action may begin]) (481). This ex-
pression cannot help but recall the earlier slang expression *tire-laine* (a

thief who robs people of their clothes), which appeared on the preceding page, juxtaposed with *coupeurs-de-bourse* and *bohèmes*. Thus, the parallel between thievery and arabesque storytelling begins to impose itself on the reader's consciousness.

I have already noted the ambiguity inherent in the term *escamoteur*. It would appear that all of these folk admired for their copious wit and agility are avatars, transformations, of the writer. Indeed, Villon, a link between poetry and thievery, is mentioned in this very context on the page that precedes the reflexive comments of the author. I propose that these figures and their exploits furnished Nerval with an ironic discourse on the text and its means of production, fulfilling Schlegel's project that "such a theory of the novel would have to be itself a novel that would reflect imaginatively every eternal tone of the imagination" (Behler, 102). While the verb *tirer* has many meanings, in both of these expressions the sense is to pull out or to extend. That is exactly how the narrator has been operating up to now: he pulls material out of a hat, which has no apparent relation to what will follow, and he extends material beyond all normal bounds. In fact, *tirer à la ligne* means to pad a text by a technique of digression. Thus, the agile hand belongs to the juggler, the wanderer, the thief, the trickster, and the writer, all of whom dwell in the margins of society, just as the decorative arabesque is usually found in the margins of a manuscript. *Faire des tours* is a talent of the writer/trickster, just as it describes the spatial development of the arabesque and the syntax of reflexiveness. Metaphorically pullers and cutters of cloth, they are the ideal to which Eustache, an apprentice draper—and therefore semantically linked to them through *toile, laine*, and *coupeur*—must aspire.

The qualification "apprentice" is important, for "La Main enchantée" recounts a Schlegelian *Bildung* every bit as ironic as it is serious in its playfulness. From the naive, straight path, Eustache's life will progress to the ornamental complication and wit of the arabesque. His destiny, as deciphered through the lines of the hand, progresses from the straight line (his perfect honesty and excellent character are to be deciphered as naive credulity and "ideas rather lacking in fluidity") (489) to the agitated arabesques of a hand endowed with magical properties (thanks to the ointment of the Bohemian) and to the final upward curve of the gallows.

When Eustache returns to the carreau des Halles, he finds his fiancée, the daughter of the draper for whom he works, engaged in conversation with a handsome soldier. The description of the Object of

desire relies on the airy undulations of the curvilinear motif: Javotte is "toute pleine de grace, . . . et légèrement ployée en avant, comme la plupart des filles de commerce dont la taille est élancée et frêle" (full of grace, . . . and arched slightly forward, like most of those salesgirls whose waist is slender) (489). The soldier is her nephew whom she hasn't seen in seven years (Eustache reflects that he "exceeds all physical proportion suitable to a nephew") (490). Javotte is especially admiring of the soldier's form and the decorative splendor of his uniform. As they stroll off together, leaving Eustache to mind the store, they form a tableau of decorative curlicues wrapping around the columns support-ing the arcade that frames them: "Ce caquetage de jeune fille, coupé à temps égaux par le pas sonnant du cavalier, cette forme gracieuse et légère, qui sautillait enlacée à cette autre massive et raide, se perdirent bientôt dans l'ombre sourde des piliers" (This young girl's chattering, broken at rhythmic intervals by the sounding step of the cavalier, and this light and gracious form that skipped [jumped] along enlaced to this other, massive and straight, were soon lost from view in the shadow of the columns) (491). Just as Javotte's adeptness at embroidery is explicitly tied to her agility of speech, her movements are but another, corporeal expression of the same light and witty figures associated with the gestu-ral, decorative, and linguistic arabesque.[15]

What is more, an authorial intrusion cuts into the couple's dance with these words, making Javotte's steps a *mise en abyme* of narrative technique: "Nous avons jusqu'ici emboîté le pas à cette action bour-geoise . . . et maintenant, malgré notre respect . . . pour l'observation des unités dans le roman même, nous nous voyons contraints de faire faire à l'une un saut de quelques journées" (Until now we have followed in the steps of this bourgeois action . . . and now, despite our respect . . . for the observation of the unities [of time, space] in the novel, we see ourselves forced to impose on one of them a leap of a few days) (491). Readers are taken out of the fictional illusion to be reminded they are reading the story, not living it. Schlegel used the Greek term *parabasis* for this form of arabesque. The construction of narrative illusion can be exploded in various ways: by foregrounding the narrative techniques themselves, either by authorial intrusion or by the highlighting of struc-ture, or by using irony to pull the reader out of the fiction. Although each of these techniques is a form of arabesque, Schlegel terms the first and last of these methods *parabasis*.

Eustache, provoked into a duel by the taunts of his newly wedded wife's nephew, decides to seek the aid of the Bohemian. At the applica-

tion of a magic ointment, his hand "se tordit et s'allongea . . . comme un animal qui s'éveille" (twisted and grew longer . . . like an animal waking up) (501). This "awakening" into the form of an arabesque is accompanied by the escamoteur's chanting of Latin words simulating those used for baptisms (this is to be Eustache's rebirth). The next day his hand, pulling his arm forward to parry the soldier's sword, "se démenait d'une rude façon . . . ses mouvements avaient une force et une élasticité prodigieuse" (carried on wildly . . . its movements had a prodigious force and elasticity) (502). Naturally—or supernaturally—he runs his adversary through. Unable to put the duel out of his mind, haunted by the death of his rival, he sees before him a grotesque vision of a thousand gallows from which "pendait au bout d'une corde un mort qui se tordait de rire horriblement" (hung a corpse who twisted horribly from laughter) (504), a vision of arabesques in a decorative, if gruesome, *grotesquerie*. Eustache tells his story to the magistrate Chevassut and appeals to the man's cordial dealings with Javotte and her father. Unfortunately, even as the magistrate is assuring him of his intention to aid him, the enchanted hand applies a majestic slap on the man's cheek.

Au moment de prendre humblement congé de lui, Eustache s'avisa de lui appliquer un soufflet à lui faire effacer la figure. . . . Le pauvre Eustache fut si épouvanté de cette action qu'il se précipita aux pieds de maître Chevassut, . . . jurant que c'était quelque mouvement convulsif imprévu, où sa volonté n'entrait pour rien et dont il espérait miséricorde . . . mais à peine fut-il sur ses pieds qu'il donna, au revers de sa main, sur l'autre joue, un pendant à l'autre soufflet . . . Chevassut courut . . . mais le drapier le poursuivit, continuant la danse . . . dans les élans où sa main l'entraînait, il semblait un enfant qui tient un grand oiseau par une corde attachée à sa patte. L'oiseau tire par tous les coins de sa chambre l'enfant effrayé. . . . Ainsi le malencontreux Eustache était tiré par la main à la poursuite du lieutenant civil, qui tournait autour des tables et des chaises . . . outré de rage et de souffrance. (505)

[Just as he was humbly taking leave of him, Eustache took it upon himself to apply a slap that was hard enough to erase the man's face. . . . Poor Eustache was so horrified by this act that he threw himself at the feet of Master Chevassut, . . . swearing that it was some convulsive, unexpected movement, completely unwilled by him and for which he begged mercy . . . but hardly had he risen to his feet than he offered, with the back of his hand, a pendant to the other slap . . . Chevassut ran . . . but the draper pursued him, continuing the dance . . . in the sallies

where his hand pulled him, he seemed like a child who is holding a big
bird attached to a string by his foot. The bird pulls the frightened child
around every corner of the room. . . . Thus the unfortunate Eustache
was pulled by his hand in pursuit of the civil servant, who ran around
tables and chairs . . . beside himself with rage and pain.]

The arabesques of the dance curve around tables and chairs, pulled by
the *élans* of the hand, while the repetition of the verb *tirer*—juxtaposed
here, as elsewhere, with textile/fabric—subtly evokes the textual ara-
besques of the writing hand. Furthermore, the leitmotif of the string or
rope, introduced in chapter 3 in the context of the magistrate's worn
leggings (and therefore justified by the draper's trade), is called into play
here through the insertion of a simile. The incongruity and unexpect-
edness of this image (the frantic large bird) at this moment of the narra-
tive make it a mini-digression. Indeed, the haphazard directions in
which the bird pulls the string and hand are precisely how we conceive
of digression. But just like the various manifestations of the verb *tirer*,
this digression can be knotted into the rest of the narrative fabric
(metaphorized by the "noeuds d'aiguillette" Javotte embroiders). In-
deed, the string pulled hither and thither by the bird's frenzied move-
ments is what has become of the weave in the worn leggings ("elles
montraient la corde"). Like the worn-out conventions of short story–
telling, they have been discarded in favor of a new weave composed of
airy arabesques. Soon the rope will shape itself into a knot around the
hero's neck as the narrative reaches its denouement. But before the
textual knot is tied, the various cords of hemp in the tale cavort and
twist themselves into decorative configurations. The macabre prolifera-
tion of gallows ropes twisted by the laughter of hanged men, along with
the other grotesque elements of the tale, is immediately woven into a
literary allusion to the grotesque of Merlin Coccaïe. The arabesque
(here, as grotesquerie) does double duty: it figures one of the hero's
steps to metaphysical transcendence and it mirrors textuality or, more
precisely, the reflexive character of this text.

Slapped into prison, Eustache meditates on the peripeteia of his
adventure: "[L'escamoteur] avait distrait ainsi un de ses membres de
l'autorité naturelle de sa tête; d'où toutes sortes de désordres devaient
résulter forcément" ([The prestidigitator] had in this way detached one
of his members from the natural authority of his head; and hence all
sorts of chaos were naturally bound to be the result) (506). The hand
has received its power and anarchic liberty by its being detached from

reason (precisely the freedom Schlegel alludes to in his *Rede über die Mythologie*). But for Schlegel, the chaos of the *unendliche Fülle* (infinite plenitude) must coexist in the same work with *unendliche Einheit* (infinite unity). This paradoxical mixture will soon be represented in "La Main enchantée."

The juggler visits the hapless draper in his cell and explains to him that in view of the latter's failure to pay for magical services rendered, the charmed hand will be accepted in lieu of money. The hand of a hanged man, purchased before his death and severed from the body, makes all latches fall, all locks open, and anyone present immobile. Our previous pairing of juggler and thief is confirmed. The existential and aesthetic connotations of breaking barriers and transgressing limits attach themselves to the figure of the thief—a figure the discourse of the text has already elevated by lending it the arabesque form. "Quelle belle invention!" cries Eustache.

After a brief digression by the author (who steals the stage from his characters and plot) in the chapter self-consciously entitled "Où l'auteur prend la parole," the tale draws to a close. Eustache is about to make "ce grand saut sur rien" (that great leap into nothingness) as the executioner prepares to place the rope around his neck "avec autant de cérémonie que si ce fut la Toison d'or . . . car ces sortes de personnes . . . mettent d'ordinaire beaucoup d'adresse et même de grâce dans les choses qu'ils font" (with as much ceremony as if it had been the Golden Fleece . . . for such men . . . ordinarily put much adroitness and even grace into the things they do) (511). The draper, in an attempt to forestall the final curtain, begins to recite another prayer, but the executioner loses patience and "la corde . . . coupa en deux [sa] repartie" (the rope . . . cut in two [his] reply) (ibid.). The cutting—this time not of cloth but of body from reason, life from death—effects a division that is semantically soldered here to speech. And it is not only Eustache's speech that is cut in two (like ironic discourse), but also his physical person. Though his body is now inanimate, "sa main s'agita joyeusement" (his hand moved about joyously) (ibid.). The spectators, "qui ont cru la pièce finie, tandis qu'il reste encore un acte" (who thought that the play was finished, while another act still remained) (ibid.), turn back to stare in wonderment. The hand continues its "chaotic movements" and slaps the executioner's face. Drawing a formidable knife from his vest, the latter, "en deux coups, abattit la main possédée" (in two slashes, cut off the possessed hand) (ibid.). "Elle fit un bond prodigieux et tomba sanglante au milieu de la foule qui se divisa avec frayeur; alors, faisant encore

plusieurs bonds par l'élasticité de ses doigts . . . elle monta jusqu'à l'embrasure de la tour où le bohémien l'attendait." (It made a prodigious leap and fell bleeding into the middle of the crowd, who divided in two with fear; then, making several more leaps thanks to the elasticity of its fingers . . . it climbed up to the crenel of the tower where the Gypsy was waiting for it) (511–12). The prodigious leaps (*bonds*) of the hand coincide exactly with the *rebondissement* of the plot, just as the hangman's knot is superimposed on the tale's denouement.

If this ending is ironic, then an irony of irony is Nerval's own suicide by hanging. Nerval's belief in metempsychosis, coupled with the depressing realities of his life at the time he killed himself, make it impossible to determine whether the act was one of despair or of joyful hopefulness. Schlegel wrote that "the hidden meaning of sacrifice is the annihilation of the finite because it is finite. . . . In the enthusiasm of annihilation, the meaning of the divine creation is revealed for the first time" (*Ideas*, 131). The creation/destruction/re-creation of the *Bildung* of the hero is parallel to the creation/destruction/re-creation in the tale's Romantic irony. Because of Nerval's emotional investment in the transcendental, magical worlds represented in his prose, his use of irony carries a poignancy not present in other practitioners of the short, witty genre of the *sotie* or *facétie*.

It should be noted that there is a division on the part of the spectators in response to the division effected in the protagonist. I have demonstrated the analogy that exists between the latter's hand and that of the writer; if the spectators correspond in some way to the readers of the tale, then this division may be seen to reflect the repartitioning of readers' responses to "La Main enchantée." This bifurcation/proliferation begins with the branching out of titles for this text: Nerval substituted for "main enchantée," "main de gloire" and "main possédée" (the latter was ascribed to the tale's fictitious source). Just as the significations of a given title predispose the reader to certain expectations, complicated here by three choices, so the "conclusion" of this text (which we will examine shortly) leads the reader out onto a number of divergent paths. The reception of the tale mirrors the elasticity of the arabesque.

Like the "somersaults" for which Sir Walter Scott denigrated Hoffmann, like the leaps from one period to another Nerval ironically underlines in "La Main enchantée," the arabesques of the hand are the expression of the unbridled freedom of the imagination, of *Witz*'s leaps of prophetic intuition. Like a juggler, Nerval deftly flips the story over to reveal, beneath the light, ironic development, the underside that is

death: the ultimate leap (into nothingness) or into the infinite, the *unendliche Fülle*. This final legerdemain is an arabesque, simultaneously turning back onto itself (the closure of death) and unfurling in a prodigious series of leaps and upward élan toward the spiritual realm.

The text, then, contains a theory of its textuality—of its own weaving—just as Schlegel's poetics proclaimed it must do, charting a course from a "naive" linear design to the inventive turns and surprises of the arabesque.[16] The *Bildung* of the hero is synonymous with the freeing up of the hand. It is his hand that becomes witty, free, unpredictable, eternal. Yet this hand never ceases to be controlled by the escamoteur, the narrator of its destiny. He (and perhaps all Romantic narrators like him) accedes to the mystical realm of the Infinite, since it is he who is able to coax order out of chaos. The plot Nerval has devised in "La Main enchantée" allows him to describe the chaotic and the spontaneous (Eustache's hand), contrast it to the linear and unwitty (Eustache), and show how both are manipulated by the person who pulls the strings (the Bohemian). And, as I have shown, the fortune-teller/juggler/prestidigitator is in every one of these guises perfectly crafted to represent the narrator of the tale. The *Bildung* in the text embraces all three figures: hand, prestidigitator, writer/narrator. The grotesque elements in the story achieve a wholeness and unity associated not with the grotesque but rather with the arabesque. This transmutation is symbolized in the move from the independence of the detached hand as disjointed grotesque, to its transcendence of death and decay, and finally to its clear-cut use as a magical instrument in creating the multiform art of the prestidigitator.[17]

The Hand as Fetish

The detachable nature of the hand and its magical properties cannot help but evoke the fetish (from the Portuguese *Fetisso*, a *chose fée*, an enchanted object or one that is used for prophecies). But if it is a fetish, whose is it and what function does it serve?

Perhaps the enchanted hand is Nerval's fetish, a response to an experience of fragmentation and disintegration (attested to by the multiple splitting of the self and the consequent loss of identity). Disintegration is felt to be not only within the self, but also in textual products, and thus the fetish would both acknowledge and deny that experience by endowing the object (the hand) with an unlimited power of creating

unity through writing. The enchanted hand can be seen as an example of the *corps morcelé* (the body in bits). Furthermore, a connection exists between hanging and the *corps morcelé* in Nerval's personal mythology. Fascinated as he was by the cult of Isis, initiation rites, and the Mysteries, this connection would have been forged through Osiris, whose death by hanging and dismemberment was followed by Isis's search for the fourteen pieces of her husband's body in the Nile. The principal ceremony of the initiation rites was in fact the search for and re-creation of the body of Osiris. Both "La Main enchantée" and *Sylvie* have fourteen chapters. The implications of this experience for desire, for displacement into ornament, and for writing will be studied further in chapter 3.

Let us recall Schlegel's idea that the arabesque "manifests itself not in individual conceptions but in the structure of the whole." Thus, the hand/arabesque only *seems* a detached fragment; it strives for a witty interconnection and must therefore be seen as structuring the entire text. Here one can draw an analogy with the form of expression cultivated by Schlegel, Schleirmacher, and Novalis: the philosophical fragment. It is closed in on itself "like a porcupine," yet loosely interconnected with other fragments and therefore open (Athenäumsfragment no. 206). Nerval was alone among the Romantics in France to cultivate the use of the fragment, systematically incorporating it into the novella and short story. By embracing the idea of the fragment, the writer can play with the potentially infinite combinations of textual elements. (The chapter headings "Croix et misères" and "Misères et croix" are a criss-crossing example of this mobility.) Nerval's desire to recover a lost unity is treated ironically by this sort of breaking apart where writing is dismemberment, each unit detached and free to jump around in the text. At the same time—and here the metaphor of string, lace, or weaving is important—the various fragments are worked into the larger pattern of arabesques in a new kind of textual unity—a chaotic plenitude—one that remains ever mobile. The modernity of such a concept is obvious.

But Nerval's juggling of titles should already have made us aware that it would have been possible to superimpose *main coupée* on *main enchantée*. For what has the narrator been doing to "enchant" the simplistic story line if not continually cutting into the plot with digressions, temporal leaps, and ironic asides? The traditional reading perceives all of these arabesques as frills or embroidery that might just as easily be cut away from the fabric of the "story." This technique of writing, just

like that of weaving, appears as a leitmotif throughout the text. Pullers and cutters of cloth, writers alternately cut into the narrative and stretch it out. And in the case of digression they do both simultaneously. The arabesque is an expression of organic growth (chaos, plenitude, becoming) and unity, two ideals of Romantic writing. Nerval's digressions, authorial intrusions, turnabouts, and *tours de passe-passe* are a tour de force that demonstrates his control over a narration in which the manipulation of these elements only serves to emphasize the "prodigious elasticity" of the overall design.

The text's final open-endedness is engineered by means of the authorial intrusion/*parabasis* I have already mentioned ("Où l'auteur prend la parole"). It contains a short digression and a factitious reference to the source of the tale. This digression leads to a false end point, for this source is incomplete and is useful only for its reference to yet another text.

> Les personnes qui désirent savoir tous les détails du procès d'Eustache Bouteroue en trouveront des pièces . . . qui sont à la bibliothèque des manuscrits. [Here Nerval inserts a digression concerning another trial.] Il n'est question que du duel . . . et non du charme magique qui causa tout ce désordre . . . mais une note annexée . . . aux autres pièces renvoie au *Recueil des histoires tragiques* de Belleforest . . . et c'est là que se trouvent encore les détails qu'il nous reste à donner sur cette aventure. (509)

> [Those parties who wish to know all of the details of the trial of Eustache Bouteroue will find the documents . . . which are at the manuscript library. (Here Nerval inserts a digression concerning another trial.) They only concern the duel . . . and not the magical charm that caused all of this confusion . . . but a note attached . . . to other documents refers to Belleforest's *Recueil des histoires tragiques* . . . and it is there that more details that we must give on this adventure may be found.]

Finally, the narrative closes not with Nerval's words, but with the words of his imaginary source, Belleforest:

> Cette aventure annotée, commentée et illustrée fit pendant longtemps l'entretien des belles compagnies comme aussi du populaire . . . mais c'est peut-être encore une de ces baies bonnes pour amuser des enfants . . . et qui ne doivent pas être adoptées légèrement par des personnes graves et de sens rassis. (512)

[This annotated, illustrated adventure with commentary was for a long time the entertainment of good company as it was also of common folk . . . but it is perhaps another of those humbugs meant to amuse children . . . and that should not be lightly taken up by serious people with common sense.]

First, we are told that the tale has been prized by nobility and plain folk alike; suspicion and doubt are then cast upon these judgments by the suggestion that the events recounted are complete humbug (*une baie*). Nerval plays with enthusiasm and irony to induce an unexpected turnabout in the reader's response to the text. Thus, on the levels of narrative voice, plot, and reception, arabesques structure the text's conclusion. In each case, the reader is referred outside of the tale in a movement of expansion and continuity.

With this last arabesque, Nerval places the onus on the readers, who must now decide how the text is to be received. They may decide it should be read as a witty arabesque, or, on the contrary, their "seriousness and common sense" may prevent them from enjoying this sort of play. By underscoring the question of how the text is to be received, Nerval encourages the readers to double back on their reading in a critical manner. In doing so, the readers participate in the same form of Romantic irony as the writer: both are involved in, and detached from, the work.

I have shown how the Bohemian functions as a reflection of the writer. In addition, he is a Wanderer and thus a personification of the form of digression. The spatial antithesis to digression, and the free spirit of the arabesque that informs it, also has its symbol in the text: it is the prison into which Eustache is thrown. But the Bohemian also lives in what was once a prison (le Château Gaillard), in a round tower (*tour* signifies, in addition to tower, trick or turning). This purposeful juxtaposition cannot help but evoke the topos of the Romantic prison that is a refuge of the Imagination.[18]

Dangerous Ramifications

I think it is not a coincidence that Schlegel's vision of infinite expansivity found a home in a writer who sacrificed his own hold on "reasonableness" to art, who, in order to have access to what Hoffmann called "the Kingdom of Marvels," had to know madness and imprisonment as

well. Beyond the clichéd link often made between madness and the image of the Romantic artist, I am trying to point out a connection between a complete mental involvement in certain ornamental forms and patterns of expression and a tendency toward abnormal states of consciousness, a disturbance of normal perception, and the surfacing of unconscious thinking. Indeed, each chapter of this book will return to a different form of these experiences. Here is what Nerval wrote after he was released from his first internment for mental illness:

> At bottom, I've had a very amusing dream, and I miss it; I even ask myself if it wasn't *truer* than what alone seems explicable and natural today; but as there are doctors and commissioners here who keep watch that one doesn't extend the field of poetry at the expense of the public byways, they only let me leave . . . after I had agreed . . . that I had been ill.[19]

In opposition to the mental clinic where Nerval was "imprisoned" is the writer's image of poetry as a potentially limitless field whose expansion poses a threat to those who would contain it (because they undoubtedly recognize its ties with chaos) and keep it off the public byways.

Nerval had written to Jules Janin just two months earlier (24 August 1841) to complain bitterly about the obituary Janin had published subsequent to this first attack (committed four times for psychotic episodes of schizophrenia and delusions of grandeur, this time Nerval had been presumed dead). Janin later modified his reporting to state that Nerval was simply "locked up" and was a "sublime madman." "So that, my dear Janin, I am the living tomb of Gérard de Nerval. . . . I will try to become reasonable; that is to say, I hope to give up the sad job of being a writer" (*Oeuvres* 1, 912). What more moving declaration is possible of the inseparable bond between the abandonment of reason and Romantic poetry?

One of the most poignant and unquestionably mad documents written during Nerval's internments is also a visual and linguistic patterning of arabesques. This text, called the "Généalogie fantastique," is an apparently chaotic but majestically interconnected series of proper names that narrate Nerval's quest for personal origin.[20] Yet, just as in his poetry and prose, which often present themselves as a quest for origins through a return to mythic sources, to the places of childhood, or through metempsychosis, the place of origin is always revealed as the point of departure for a new outgrowth or direction. The "Généalogie" presents the digressionary and semantic arabesques spatially and plasti-

6. Gérard de Nerval, *Généalogie fantastique*, 1851.

cally as the other texts could not (fig. 6). Nerval draws a bulbous tree whose branches and leaves are made up of names that trace filiations (for the most part imaginary) to noble families and to Nerval's *lieux fétiches*. The deconstruction (or dismemberment) of the father's name (Labrunie) moves simultaneously in the direction of an origin and in the direction of an ever-expanding dissemination (recalling the closure and expansion of the arabesque). These nominal ramifications, the names and places with which Nerval forged his personal and mythic identity, form a text that demands to be read in all directions and senses (*dans tous les sens*) at once. Like a pattern of arabesques, the text takes one path after another, and starts out again to be grafted onto other outgrowths. This delirium is the Schlegelian project carried to its ultimate conclusion.

Fantasy, embodied in the form of the arabesque, is a flight from quotidian reality into a higher realm, that of pure aesthetic freedom. Thus bursting the bounds (the *coque*) of reason, this penetration beyond its borders must necessarily entail risk. One of these risks is with mental equilibrium; the other is with life itself. For Nerval, the multiplicity of fictional and biographical threads became the rope with which he hanged himself, tying his destiny to that of Osiris (*Les Chimères*) and of Eustache Bouteroue. The radical implications of the arabesque are those of ornament in general: it works to break down limits (between figure and background, frame and subject, fragment and continuity) as it elevates the notion of pure, nonrepresentational art, thereby according a limitless freedom to the hand of the artisan/poet. The arabesque breaks through traditional boundaries between narrator and subject, reader and subject, decor and characters, irony and enthusiasm. Juggling these elements, unlocking doors like a thief in the night, the writing hand destabilizes previous notions of form in the novella and short story.

Confusion, we remember, was an element prized by French theoreticians of the decorative arts. This element is taken up here in the form of chaos, a positive concept for both Schlegel and Nerval. Looking back at the two parallel quotations of the two writers in the epigraph to this chapter, we can now see how Nerval put into practice the idea that the genial artist could mold chaos into the world of a unified work of art. The enchanted hand figures the hand of the writer, but also the hand of the artisan, who can be linked to the thief as well as to poetic creation and to divine creation. One of Nerval's identifications was with Prometheus, thief of fire, who wore the cap of the Artisan (see "La Pan-

dora"). The hand stands for a gestural art that enjoys a demonic energy: spontaneous, unstoppable, ever on the move.

The enchanted hand of Gérard de Nerval sought to re-create the "magical network" that, in the beginning of creation, emerged out of nothingness. Its shape is envisioned as an arabesque pattern, "[qui] se déroule dans l'infini; il s'écarte et revient sur lui-même, se resserre et s'épanouit, et sème au loin les germes des créations nouvelles" ([which] unfurls in the infinite; it spreads out and comes back on itself, contracts and opens out, and sows from afar the seeds of new creations) (*Aurélia, Oeuvres*, 410). Nerval's textual network, too, is composed of arabesques, both in the internal design of each text and in the vast intertextual ramifications between these texts. Thus he succeeded in creating a work in the process of becoming and that "spreads out in all directions in ever-continuing development" (Schlegel, *Notebooks*, in Polheim, 272).

Lace as Textual Metaphor in Nerval's *Sylvie*

Moi, je m'étais brodé sur toutes les coutures. —Du moment que
j'avais cru saisir la série de toutes mes existences antérieures . . . la
chaîne était brisée et marquait les heures pour les minutes.
—*Nerval, preface to* Les Filles du feu

L'homme poursuit noir sur blanc. Ce pli de sombre dentelle qui
retient l'infini, tissé par mille . . . assemble des entrelacs distants où
dort un luxe à inventorier.—*Mallarmé*

ESSAYS CENTERED on the idea of self-reflexive writing began multi-
plying at about the same time as certain texts by Nerval were enjoying
a remarkable rise in critical attention (*Les Chimères, Aurélia,* and *Sylvie*).
Nonetheless, the presence of a thematics of writing in the last two
chapters of *Sylvie* has not encouraged many critics to linger on the
self-reflexive aspect of the novella.[1] I propose that *Sylvie* contains a
metaphor for its composition and mode of production—lace and lace
making—and that, in the paradigm /lace = text/ words like *embroidery,*
tapestry, thread, braid, garland, handiwork, denouement, and so on,
should be included. It is a model metaphor that one finds woven into
the entire oeuvre but elaborated particularly in *Sylvie*. (I have thus cited
from other texts where these metaphors are found.) The novella is in
fact constantly enriched and complicated by this intertextuality; it is
one of the principal stylistic traits responsible for rendering the *appar-*
ently transparent style of *Sylvie* so opaque. In addition, the metaphor is
heavy with connotations for the identity of the Subject, the *je*. This was
the case in "la Main enchantée," where the arabesque served to meta-
phorize narrative technique and the evolution of the hero's identity. We
will see ornament play the same dual role in each chapter of this book.

The etymology of the term *text* (from the Latin *textus, texere*) provides sufficient justification for the logic of my metaphor /lace = text/. That a text should implicitly refer to weaving by the "interweaving" of its narrative "threads" is a notion generally accepted by most critics today. But one should never lose sight of the fact that this position strongly suggests the idea that the text is in the process of highlighting its own mode of production, and thus reveals its self-reflexive nature.

But if the metaphor /fabric = text/ seems undeniably well founded, critics, in their application of the concept, have not underlined the distinctive features that account for the *specificity* of different sorts of fabric, nor have they noted the extremely diverse modes of production of fabric. And clearly, lace is quite removed from other fabrics in many ways. Before studying *Sylvie* in detail, I propose to examine the qualities that are specific to lace.

Let me state at the outset that in the manner in which lace is made, in the forms it elaborates, and in the use that has traditionally been made of it (in other words, in both its form and its function), I see social, psychoanalytic, and aesthetic connotations. In the period in which Nerval situates the novella, the lace-making industry was beginning to disappear. The principal center of the industry had already moved from Chantilly to Normandy, and the text retraces the movement of fading and evanescence in its structure. The desire to preserve traditions and the anguish connected with their loss are clearly marked in Nerval; these concerns lend considerable importance to lace and to the folk song.

Sylvie's fall from grace in the narrator's eyes must be attributed to two facts: she no longer sings the old ballads of the Valois and she is no longer a lace maker. In a fragment ("Emérance," 462–63, in the 1974 Pléiade edition), which is generally accepted as a preliminary sketch for *Sylvie*, the heroine is a seamstress. In the chapter of *Promenades et souvenirs* entitled "Heloïse," it is a young embroiderer who is designated as the Object of the hero's first love poetry.[2] Finally, Sylvie is a lace maker. Formerly, she carefully copied old patterns in her work (in exactly the same manner as the writing Subject constantly refers to his literary models and to models inspired by the visual arts: *Werther, La Nouvelle Heloïse*, Dante, Francesco Colonna; Watteau, Boucher, Greuze). Sylvie's shift from the industry of handmade lace to machine-made gloves has not failed to elicit sociohistorical commentary having to do with the effects of the Industrial Revolution.[3] Materiality is contrasted to this vanishing vision of the Valois represented by lace by way of this

shift. In fact, not only lace, but ornament in general in Nerval, tied, as I will show, to loss and absence, stands in marked opposition to nineteenth-century commodities culture.[4] Despite this understanding of Sylvie's important talent as artisan, however, the significance that the profession of lace maker might carry for the identification of the *je*-poet with Sylvie remains curiously absent from analyses of the novella. The hero's efforts to identify with almost all of the characters in the narrative (Aurélie, Adrienne, Rousseau, the *frère-de-lait*, or milk-brother) create a fragile sense of completion that reverses itself into fragmentation and loss of identity. In other words, the text is structured by mirroring and repetition, which reverse themselves all too readily into lacks or holes. As soon as Sylvie abandons lace making, she no longer sings the old songs and can no longer serve as the poet's mirror.

These are the most striking qualities belonging to lace: (1) the artistic nature of its fabrication, (2) its luxuriousness, (3) its use in religious or lay ritual, (4) its ability to imitate natural objects, (5) its airy and fragile nature, and (6) the importance of empty spaces—holes—in its composition and texture. With the exception of the last two characteristics, lace shares these qualities with embroidered fabric, out of which, moreover, needle-lace (as opposed to bobbin-lace) came. It is precisely for this reason that I will insist on one point in particular: fragile and diaphanous, because of its finesse and the delicacy of its threads, lace is composed as much of holes as of threads (figs. 7, 8).

The refinement of this handiwork has always placed it among the most prestigious signs of luxury. Lace was originally understood as a sign of aristocratic distinction rather than as adornment. Thus the semiotic function of this fabric at first took precedence over its beauty; or rather, its aesthetic value is inextricably tied to its semiotic status. Let us recall the importance of nobility in Nerval's universe. Aurélie is compared to a queen three times, she plays the role of a princess in the theater, and the blood of the Valois kings runs through Adrienne's veins. As for Sylvie, "she is nearly a *demoiselle*" since she began crafting fine lace.[5] Under Louis XIV, in fact, this "precious handiwork" became an indispensable part of the costume; what is more, great artists like Titian in Italy and Le Brun in France created patterns. Its fragility and its status as a luxury article ensure that lace is never thought of as utilitarian. It does not protect the body from the elements, and it does not even protect it from immodest exposure. For these reasons lace must be classified as the fabric in which the aesthetic dominates the utilitarian to the highest degree. It approaches *the status of pure ornament* in the

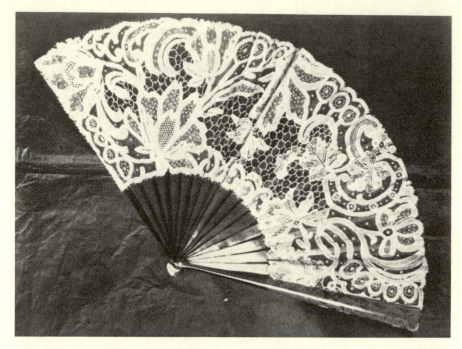

7. Fan, Chantilly lace.

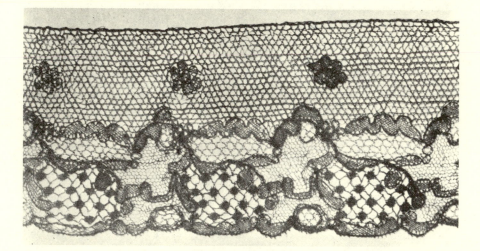

8. Black Chantilly lace.

linguistic and metaphysical sense Mallarmé will envision some years after Nerval. Lace is always found in festivals and in sacred rituals. One need only be reminded of the primordial place that *la fête* and *le sacré* occupy in Nervalian narrative to understand how lace might be granted a privileged position there.

The structure of lace may be compared with the Nervalian text from several points of view: transparency; continual repetition of the same themes; the interweaving of themes, characters, and sounds; and the way several aspects of the text are knotted together. And, finally, it would be impossible to overemphasize the importance of holes and gaps in the construction of the narrative and of lace. These "holes" are often signaled by dashes or by three points of ellipsis. Memory gaps as well as fissures in the fabric of time abound in *Sylvie*. If the Subject of the narration appears to desire continuity and tries to reestablish it in the temporal weave, the temporal structure that the writing Subject composes reproduces, on the contrary, discontinuity: the only experience of time that we truly own. Nonetheless, analogies between the characters and places of the narrative surreptitiously create a network that, combined with the repetition of the same sounds and words, reinstates a rhythm of eternal return.[6] *Sylvie* exhibits a continuity that exists within and beyond discontinuity.

A certain number of details on the technique of lace making will prove useful for the elaboration of the analogy /text = lace/. Lace is either bobbin-lace (multiple threads) or needle-lace (single thread). The first technique is that referred to in *Sylvie*. Bobbin-lace is produced on a little board covered with a cushion upon which the threads are distributed. The lace maker crosses these threads by moving each of the wooden spools or bobbins to which they are attached, and then marking the point where they cross with a pin that serves as a guide for following the pattern. Four bobbins are always simultaneously in motion and it is by the way they are inverted, crossed, or sent backward that the different stitches are produced.[7]

The aspects of lace making that are important in the present context are: (1) *The agility* required to manipulate from 300 to 500 bobbins (black Chantilly uses 340). In this context, one might note the remarkable quantity of pictorial, musical, mythological, and literary allusions that in no way destroy the finesse of the textual network. (2) In bobbin-lace, *the simultaneous weaving of ground and figures (motifs)*. This implies that the two are inseparable. This technique can create an ambiguity in figure and ground, like that created by arabesque designs. This sort of

ambiguity will continue to play a major role in ornament and in litera-
ture in the fin de siècle. In fact, the allusions I have just mentioned form
the "ground" to the events in *Sylvie* but are entangled with them to such
an extent that it would be futile to try to describe the characters, land-
scape, or movements of the Subject of the narration without their com-
ing to the fore. Without them, it would indeed be impossible to *follow*
the narrative thread; in taking them into account, the reader is obliged
to see how exceptionally complex the textual design is. (3) *The crossing
of threads*. Not only are the most complicated motifs made by crossing
the threads, but the spaces between the motifs are filled in by regularly
criss-crossed threads. This constitutes one of the most essential move-
ments in lace. One sees a similar operation in the way the writer
"crosses" the identities of Aurélie and Adrienne on the one hand, and
Adrienne and the hero on the other.[8] Aurélie is in metaphorical relation
to Adrienne, with the initial exception of one element: the fact that she
is an actress. But when Adrienne plays the lead role in a medieval
mystery play and Aurélie is compared to an Amazon, the crossing of
the semes "chaste" and "carnal" succeeds in knotting the two figures
together even more tightly. It also causes a new (retroactive) attribu-
tion of the values adhering to each of them. It is true that this sort of
construction—crossing and inversion—is not unique to Nerval; he
nonetheless remains one of the writers who used it most insistently.
The same holds true for the repetition of motifs and temporal/spatial
return, undoubtedly linked to his well-known obsessions about me-
tempsychosis and about his "double." (4) *The repetition of motifs*. The
repetition of syntagms in the first chapter ("Je sortais d'un théâtre,"
"sortant du théâtre" [I was leaving a theater, leaving the theater]), of
semes ("nous buvions l'oubli . . . ivres de poésie et d'amour"; "buvons,
aimons"; "une apparition bien connue illuminait l'espace vide"; "torche
. . . éclaire l'ombre un instant de ses trainées d'étincelles" [we drank of
oblivion . . . drunk on poetry and love; let's drink, let's love; a well-
known apparition illuminated the empty space; torch . . . lights up the
darkness for an instant with its stream of sparks]) is elevated to a new
level with the displacement of Adrienne in Aurélie, or with the repro-
duction of the same setting from one chapter to another. (5) *The return*
of each pair of threads several stitches backward in order to pick up
other threads with which they will advance together in the work. The
revelation that Aurélie is a repetition of Adrienne effects the following
return: it is in fact Aurélie who appears first in the novella, whereas it

is Adrienne who precedes her in the chronology reconstituted by the Subject. Also, the thread "actress" that links the two figures returns from chapter 7 (the mystery play) to chapter 3 ("Aimer une religieuse sous la forme d'une actrice!... et si c'était la même! —Il y a de quoi devenir fou!" [To love a nun in the form of an actress!... and if they were the same person! It's enough to make one mad!]), and finally to chapter 1, which focuses on Aurélie. From then on, the thread "actress," having picked up the threads of the two women together, will advance with this pair in the text: in chapter 8, the play that the Subject writes for Aurélie reenacts his love for Adrienne; the actress plays the role of the novice. In chapter 14, he learns of Adrienne's death during a theater performance starring Aurélie. This mode of construction, in contrast to embroidery, and a fortiori to ordinary fabric, is unique to lace. (6) *The oblique and the nonlinear*. The criss-crossing is often done on an oblique angle. In *Sylvie* this effect is obtained through the use of italics, by digression, and by the Subject's geographical wanderings. Intertextuality also produces this effect in exploding narrative linearity.[9] To the Subject's wandering corresponds the discontinuity of the temporal structure.[10] (7) *Knots* (see below). (8) *The imitation of a traditional pattern*. Of capital importance in lace, this is revealed to be equally important in Nervalian writing. I have already noted that Nerval patterns his text on the work of numerous writers, painters, and composers.

Bobbin-lace, especially prevalent in Chantilly, Caen, and Le Puy, demands a manual dexterity of the highest order. How is it possible not to suppose a delicacy of spirit that might accompany this ability? The art and subtlety of this artisanal creation can also be read in the nomenclature of lace: "point d'esprit," "perler," "fantaisie."

Needle-lace grew out of embroidery, and it too is suggestively poetic. The *punto reticello*, for example, is worked on a fabric where the threads are pulled out once the piece is finished. One thinks of two of Nerval's letters that concern the composition of *Sylvie*: "Je reviens de Chantilly où j'étais allé pour prendre un paysage ... nous ferions un autre morceau sous un autre titre ... la seule hâte me fait travailler, comme toujours. Sinon, je *perle* trop" (I'm back from Chantilly where I'd gone to "jot down" a landscape ... we'll make another piece under another title ... haste alone makes me work, as always. If not, I *polish* [purl] too much). The letter written five months earlier, however, describes quite a different difficulty: "Je n'arrive pas. C'est déplorable. Cela tient peut-être à vouloir trop bien faire. Car j'efface presque tout à mesure que

j'écris" (I can't do it. It's awful. Perhaps it's the result of wanting to write too well. For as I advance, I erase nearly everything I've written).[11] The first letter cited has to do with the delicate—indeed, precious—work of ornamenting and embellishing, work that is meticulous and *pointilliste*, like lace making. The second has to do with the act of *undoing* threads. It seems as though a single desire (wanting to do something too well) produces two gestures at opposite poles from each other: *perler* (polish or purl; in italics in the text) or *effacer* (erase). They are, moreover, the two salient features of the text. Lace, too, is a paradoxical coexistence of extreme embellishment and gap, where the preciosity of an arabesque is surrounded by holes.

Nerval's interest in collecting and preserving folk traditions extended to porcelain, embroidery, leather work, and folk songs, as well as to lace.[12] However, it is not a matter of claiming that Nerval was trying to imitate lace in this text, but rather that he was searching for a form that one could conceivably compare to lace, for both would refer to a single vision, a single semiotic model. And, in the search for this unknown textual form, Nerval would have been led—perhaps without realizing it—to take as a model that which already existed and, indeed, had a venerable and mysterious past in the heart of his beloved Valois.

LACE AND SONG

Sylvie produced "de la dentelle plus belle qu'à Chantilly" (lace more beautiful than lace made in Chantilly) (254). The interior rhyme can be heard as a performance of the music or song in Chantilly. In fact, the presence of the name Chantilly, as we will see, provokes an exacerbation of rhythmic effects, of assonance and alliteration. It is therefore not surprising to find that the horizontal threads of Chantilly lace are called *fond chant*, "chant" being the abbreviation in the lace industry for Chantilly. Lace, song, and poetic prose can be conceived of as corresponding aesthetic forms.[13]

One can uncover a multitude of allusions to weaving accompanied by singing in *Sylvie* (and woven throughout the oeuvre). In his first evocation of the *fête de l'arc*, in the "long-since-forgotten province," the Subject of the narration describes "les jeunes filles qui tressaient des guirlandes . . . en chantant" (young girls who braided garlands . . . while singing) (244). He himself weaves together laurel branches after Adrienne's song. In both scenes weaving is superimposed over song. (Tradi-

tionally, moreover, lace makers sing as they weave, and these songs are known as "Chansons de Dentellières.")

The importance of the voice and of singing in Nerval's work is well known. In describing Aurélie, it is "la vibration de sa voix si douce et cependant si fortement timbrée [qui le] faisait *tress*aillir de joie et d'amour" (the vibration of her voice so soft and yet possessing such a strong timbre [that made him] thrill with joy and love) (241). Adrienne's voice is "fraîche et pénétrante, *légèrement voilée* comme celle des filles de ce pays brumeux" (fresh and penetrating, *lightly veiled*, like that of the girls of this misty country) (245). Some years later, when she plays the role of a spirit in a religious allegory at the Abbey of Chaâlis, "sa voix avait gagné en force et en étendue, et les *fioritures infinies du chant italien brodaient* de leurs gazouillements d'oiseau les phrases sévères d'un récitatif pompeux" (her voice had gained in force and in amplitude, and the *infinite flourishes of the Italian style embroidered* the severe phrases of a pompous recitative with their birdlike warbling) (257). I have emphasized the word choice in each citation to bring out the intertwining of song and weaving.

Placed in contrast to the "severe phrases" of an ordinary *récit* is a particular sort of song that the writer tries to describe here and that he wants to reproduce in the style or—more accurately—in the texture of *Sylvie*. This same contrast is referred to again in the chapter entitled "Retour" where the figure of Sylvie suffers a tremendous loss of value because of her abandonment of lace making and folk singing. " 'On ne chante plus cela.' . . . 'Sylvie, Sylvie, je suis sûr que vous chantez des airs d'opéra!' —'Pourquoi vous plaindre?' —'Parce que j'aimais les vieux airs, et vous ne saurez plus les chanter.' Sylvie modula quelques sons d'un grand air d'opéra moderne. . . . Elle *phrasait*!" ("That isn't sung anymore." . . . "Sylvie, Sylvie, I'm sure you sing operatic airs!" —Why complain?" —"Because I loved the old tunes, and you won't be able to sing them anymore." Sylvie modulated a few notes of a great aria from a modern opera. . . . She *was phrasing*!) (265; emphasis Nerval's). The exclamation point and the italics carry the force of the Subject's great disappointment, just as the dashes signal his sense of loss. It is precisely at this moment of the narrative that his mind returns to the "apparition de Chaâlis [Adrienne] restée dans [ses] souvenirs" (apparition of Chaâlis embedded in his memory) and that he asks Sylvie to repeat the song that Adrienne once sang.[14]

Note the juxtaposition, in the description of Adrienne's voice, of the words "song" and "embroidered," as well as "infinite flourishes," which

recall the complicated arabesques traced by lacy threads. It is out of these embellishments that lace is composed. Yet, can one use the word *embellishment* when the object under study consists of nothing else? One begins to realize that such an object will throw into question any notion of "norm." If Nerval's style attains a remarkable equilibrium and harmony, and if it has often elicited the adjectives "pure" and "limpid," it nonetheless reveals a marked attraction for ornamentation (as I have defined it here and in the preceding chapter). These forms sometimes push his style toward the illegible, toward the "livre infaisable" (unwritable book) of the preface to *Les Filles du feu.*

The fragment Nerval qualifies as a "livre infaisable" follows the passage I have placed in an epigraph to this chapter. Moreover, it contains many allusions to weaving as writing. "L'infernal réseau d'intrigues où les récits de la Rancune viennent de m'engager; . . . l'ingrate [Aurélie] qui est cause de mes malheurs n'y aura-t-elle pas mélangé tous les fils de satin les plus inextricables que ses doigts d'Arachné auront pu tendre autour d'un pauvre victime? . . . Le beau *chef-d'oeuvre!*" (The infernal network of intrigues in which I've just been trapped by la Rancune's stories; . . . the ungrateful woman [Aurélie] who is the cause of my misfortunes, won't she have entangled all the most inextricable satin threads that her fingers of Arachne could have tied around a poor victim? . . . The beautiful *masterpiece!*) (157; emphasis mine).

L'Etoile, thus, weaves a *toile.* The word "chef-d'oeuvre" had already figured in the Preface ("si j'étais parvenu à concentrer mes souvenirs en un chef-d'oeuvre" [had I been able to concentrate my memories in a masterpiece]), also in the context of literary production, and this time specifically in that of Nerval. And in this formidable network of correspondences, in this *toile d'araignée* that is Nervalian writing, there are threads that allow one to connect the Aurélie of the Preface to the Aurélie in *Sylvie.*

The "Froide *Etoile*" of the Preface is "une *perle* de grace" of whom the public asks:

'Sont-ce de vraies *perles* . . . qui ruissellent parmi ses blonds cheveux cendrés, et *ce voile de dentelle* appartient-il bien légitimement à cette malheureuse enfant? N'a-t-elle pas honte de ses *satins brochés* . . . ? Tout cela est d'un gout suranné qui accuse *des fantaisies* au-dessus de son âge.' Ainsi parlaient les mères, en admirant toutefois un choix constant *d'atours et d'ornements* d'un autre siècle qui leur rappelaient de beaux souvenirs. (154; emphases mine)

["Are they real *pearls* . . . that run amidst this ash-blond hair, and does *this lace veil* truly belong, legitimately, to this poor child? Isn't she ashamed of her *brocaded satins* . . . ? All that is in an out-of-date taste that attests to the whimsies [or lacework *fantaisies*] of an older woman." Thus spoke the mothers, all the while admiring a constant choice of *attire and ornaments* from another century, which recalled to them their loveliest memories.]

This particular aesthetic preference is also Nerval's in *Sylvie*: "Qu'on me pardonne ce style vieilli" (May I be pardoned this outdated style) (272). The function of these questions is to underline the undecidable nature (artifice/reality) of the performance—that of the *Etoile* and of the writer as weaver—a performance that nonetheless allows one to relive what was most "real" in one's life.

Ornament, like theater, is used by Nerval to highlight the mixture of artifice and reality that makes up the Subject's relationship to the world. (In theater, real people represent fictional characters; in ornament, real objects represent unreal objects.) Ornament is seductive: it confuses and shuffles the frontiers of the true and the false, a problematic that Nerval constantly explores. In "Octavie," the erotic and mysterious young woman who embroiders church ornaments is surrounded "d'étoffes brillantes, de fleurs artificielles . . . miroirs, clinquant . . . des ornements de fausses pierres" (by brilliant fabrics, by artificial flowers . . . mirrors, tinsel . . . ornaments of false stones) (288–89). The description of her voice resembles that of Adrienne's: "C'était . . . des gazouillements pleins de charme" (It was . . . warbling full of charm) (289). The Subject's reaction is the same as it was in chapter 7 of *Sylvie*: "Je m'arrachai à ce fantôme qui me séduisait et m'effrayait à la fois" (I tore myself away from this phantom who at once seduced and frightened me) (ibid.). In *Sylvie*: "Ce souvenir est une obsession peut-être! Heureusement voici la voiture qui s'arrête . . . j'échappe au monde des rêveries" (This memory is an obsession perhaps! Fortunately the coach is stopping . . . I escape from the world of reverie) (258). It is after the description of the ornamental flourishes in Adrienne's singing at Chaâlis that the narrator exclaims: "En me retracant ces détails, j'en suis à me demander s'ils sont réels ou bien si je les ai rêvés" (In retracing these details, I wonder now whether they are real or whether I've dreamed them) (257).

The convergence of embroidery and of vocal ornamentation mirrors the aspect of the text that Nerval calls "trop perlé." Each time that singing is represented, the writer emphasizes vocal ornament. For ex-

ample, "La mélodie se terminait à chaque stance par ces trilles chevrôtants" (The melody ended each stanza with these tremulous trills) (245). The trill is the most frequently used ornament in music: it curls around the melodic line in the same way as a series of alliterations or another play of phonemes entwines the syntagmatic line of a text. Nerval valorizes melisma, timbre, and trill: "Une voix jeune . . . qui . . . arrivait aux *traits* et aux fioritures les plus hardis. . . . O jeune fille à la voix *perlée*! . . . ce timbre jeune, ces désinences tremblées à la façon des chants naïfs de nos aïeules, me remplissent d'un certain charme!" (A young voice . . . that . . . managed the most daring *strokes* and flour- ishes. . . . Oh *pearly* voiced girl! . . . this young timbre, these quavering inflections in the style of the naive songs of our grandmothers, fill me with a certain charm!).[15] He notes "l'éclat de ces intonations pures et naturelles, de ces trilles empruntés au chant du rossignol ou du merle";[16] "de sa bouche, il ne tombait que des *perles de mélodie* . . . comme les oiseaux . . . ce timbre si pur . . . *sous cette mantille*" (the refulgence of these pure and natural intonations, of these trills borrowed from the song of the nightingale or of the blackbird; from her mouth, only *pearls of melody* fell, like birds . . . this timbre so pure . . . *under the mantilla* (emphases mine).[17]

The act of embellishing, purling, and tracing arabesques—be it in singing, in weaving lace, or in literature—pervades Nerval's aesthet- ics. To the trill (*le trille*) corresponds the *treille* (the latticework that offers a support for intertwining vegetation destined to embellish a wall). The act of making lace, of donning lace or embroidered clothing, or of singing ties the Object of desire to the Subject of the narration. Lace, interlace found in nature, song, all function as metaphors of link- ing, of liaison. They are a response to the lack of reciprocal affective ties between Subject and Object. I will return to this function of ornament in chapter 3.

It must be mentioned that in the novella, as in *Angélique*, the text that precedes it in *Les Filles du feu*, Nerval felt it important to insert frag- ments of old ballads from the Valois. Moreover, these "ritournelles" introduced into the text of *Sylvie* offer a perfect example of the couple repetition/gap. For if these songs are for the most part composed of the repetition of a refrain (and the function of repeating enters doubly into play, because their content is almost always a *mise en abyme* of the events of the narrative), they nonetheless effect a break or rupture in the conti- nuity of the narrative. This rupture is brought about by the change of tone and by the addition of rhyme; a distinctive typography and the

isolation of the song fragment from the surrounding text by the whiteness of the indented line serve to further accentuate this cleft in the prose fabric. As is often the case, rupture goes hand in hand with embellishment. An extremely frequent stylistic element in Nerval's writing—the use of italics—partakes of the same dynamic. Like the dashes and the three points of suspension one finds sprinkled throughout *Sylvie*, italics should be classified as a form of "hole" but one that makes a hole in the text by means of an embellishment.

The text that follows *Sylvie* in the collection of short prose pieces is "Chansons et légendes du Valois." It should be read as an appendix to the novella. In this text, Nerval cites a few verses of a "naive nuptial song" (such as the one in *Sylvie*): "Enfin vous voilà donc —A votre époux liée, —Avec un long fil d'or —Qui ne rompt qu'à la mort!" (Finally there you are, tied to your spouse by a long, golden thread that only death can break asunder!) (275). In a fragment cited later, gold and threads are also central, but there it is no longer a question of tying together; instead it is by untying, taking apart the stitches, that the Subject deceives death: " 'Donnez-moi mon couteau d'or fin, que je découse ce drap de lin!' Aussitôt delivrée de son linceul, la belle revient à la vie" ("Give me my knife of fine gold, that I might take apart this cloth of linen!" Once freed from her shroud, the lovely maid comes back to life) (278). This fragment is taken from a song that must have haunted Nerval, for he cites it six times. It is the one Adrienne sings after the round dance in front of the château and, therefore, the prefatory song in the corpus of songs in *Sylvie*: "Le roi Loÿs est sur son pont."

CHANTILLY

This brief account of the role that voice and folk songs played in Nerval's writing will serve as a prelude to the study of the proper noun that links voice and lace: Chantilly. In chapter 13, the penultimate in the novella, the name Chantilly is associated by contiguity to the names Schiller and *seigneur poète* (the latter is the appellation given to the Subject of the narration at this pivotal moment in the text where he is first shown as a poet). Once again, the imitation of models (here Schiller, elsewhere Watteau, Greuze, folk songs, and pieces of lace) is emphasized. Models are a way to preserve tradition, but paradoxically they lead to the creation of a resolutely new form of writing.

Without getting lost in the intertextual folds of this writing, it is

nonetheless fruitful at this point to take a less direct route in continuing our reflections on Chantilly lace and poetic production. In *Promenades et souvenirs*, a text that can be compared with *Sylvie* from many points of view (return to the Valois, childhood memories, song fragments, lost love), the last chapter is entitled "Chantilly." The first sentence containing the name Chantilly begins thus: "On monte vers Chantilly" (One goes up toward Chantilly). The development that follows will demonstrate that the contiguity of *vers* and *Chantilly* is not accidental. Indeed, versification abounds in this chapter. There are interior rhymes ("chères petites rivières," for example), rhymes for the eye (Chantilly, brille, ville), and a veritable exacerbation of alliteration: "Où je me suis *p*resque noyé *p*our n'avoir *p*as voulu *p*araître *p*oltron devant la *p*etite Célénie!" "il y a, dans *c*es *s*ortes de villes, quelque chose de pareil à *c*es *c*ercles *d*u purgatoire *d*e *D*ante immobilisés *d*ans un *s*eul *s*ouvenir" (Where I nearly drowned for not wanting to appear cowardly in front of little Célénie! there is, in these sorts of towns, something similar to those circles of Purgatory of Dante, frozen in a single memory) (142, 144). There is an astonishing alliteration on the letter *c*, and it is especially by the insistence on the capital *C* that this play becomes visible. The *C* has its point of origin in the name Chantilly, and then radiates out into the following series of proper nouns: Chantilly, Célénie (twice), Commelle, Coye, Clermont-sur-Oise, Célénie (again), Chapelle-en-Serval, Charlepont, Chantilly (twice), Condé, Clio, Condé (three times), and Courteil. Chantilly is then compared to *Ver*sailles: "Chantilly est comme une longue rue de *V*ersailles. Il faut *v*oir *c*ela l'été, par un *s*plendide *s*oleil, en pa*ss*ant à grand bruit *s*ur *c*e beau pa*v*é qui résonne" (Chantilly is like a long street in Versailles. One has to see this in summer, in full sunlight, loudly passing by on this fine, resonating pavement) (143). It is not only the pavement that resonates in the sentence.

Moreover, in a single word—*souvenirs*—one can find all the elements that traverse the chapter "Chantilly." One finds the anagrams *vers* and *sous* (and aren't we witnessing a versification in this prose that is at work in an underground manner?), and—what is very pertinent to my reflections on lace—in the key word *souvenirs*, the letters *S* and *V* detach themselves by dint of their initial position in the first two syllables. They are interlaced with the suite of *C*'s and thus produce a double unrolling of threads, the *S*, *V* and the *C*'s, which trace their design on the page.[18] Note the following alliterations that surround the word *souvenirs* in this chapter: "*V*élleda du *v*ieux pays des *S*ylvanectes . . . *S*erval"

(this name, which contains the anagram *vers*, inevitably reminds one of *Nerval*);[19] "les *v*oix ré*s*onnent harmonieusement dans les *s*alles *s*onores"; "l'aspect *v*énerable des *v*ieux *s*eigneurs qu'ils ont *s*ervis" (the voices resonate harmoniously in the sonorous rooms; the venerable aspect of the old lords whom they have served) (again, the anagram *vers* and a reference to vocal resonance); the above-cited "Chantilly est comme une longue rue de *V*ersailles. Il faut *v*oir." The sequence *S, V* in *souvenirs* has reversed itself into *V*(er)*S*. What is more, one notes that the sentences that contain this particular alliteration carry the same vocabulary I have connected to lace and to the search for a textual form that would be capable of transmitting a lost past.

But the insistence of the letter does not stop there. It will be remembered that the first example of alliteration in *V, S* given earlier contained the name Sylvanectes; the passage from Sylvanectes to Sylvie is easily accomplished, the two having the common root that denotes forest. The key word *souvenirs* appears in the same sentence. Now, the subtitle of *Sylvie* is *Souvenirs du Valois* (*S, V*, or even *S, v, s, V, s*). In fact, if one analyzes the names Chantilly and Versailles in the following way, the "leftover" elements will, short of one letter, produce SYLVIE.

Chant / illy illy

 = SYL(V)IE

Vers / ailles (a)illes

Sylvie functions as the memory of *Promenades et souvenirs,* just as the text published for the first time in 1854 is the memory of the 1853 novella.

Thus, the anagram founded on the proper names SYLVIE and VALOIS and on the key word SOUVENIRS will be disseminated in the chapter "Chantilly," designing the sort of delicate tracery one finds in a piece of lace.

WEAVING THE ANAGRAM

The play of anagrams discovered in *Promenades et souvenirs* is also present in *Sylvie*; it emanates, as I have already suggested, from the title and subtitle of the novella. Such markers or resonators in the text, by their rhythm or by the design they create, throw the ruptures or discontinuities—the places where the thread has broken—into higher relief. In the only passage where Sylvie is *seen* in the process of making

lace, the alliteration in *V*, *S* is highly visible. Here we can follow the work of repetition, inversion, crossing, and enlacing of the two elements (*V* and *S*) beginning with their starting point together in a proper noun. Note also the passage of the verb *reprendre* to the verb *raconter*, that is to say, the passage from the work of lace making to that of textual production.[20]

> Le jour en grandissant chassa de ma pensée ce *vain souvenir* et n'y laissa plus que les traits rosés de *Sylvie.* "Allons la réveiller," me dis-je, et je repris le chemin de Loisy.
>
> *V*oici le *v*illage au bout de la *s*ente qui côtoie la forêt: *v*ingt chaumières dont la *v*igne et les roses grimpantes festonnent les murs. Des fileuses matinales, coiffées de mouchoirs rouges, travaillent, réunies devant une ferme. *Sylvie* n'est point a*v*ec elles. C'est presque une demoiselle depuis qu'elle exécute de fines dentelles, tandis que *s*es parents *s*ont restés de bons *v*illageois. Je *s*uis monté à *s*a chambre *s*ans étonner personne; déjà le*v*ée depuis longtemps, elle agitait les fuseaux de *s*a dentelle, qui claquaient avec un doux bruit *s*ur le carreau *v*ert que *s*outenait *s*es genoux. "*V*ous *v*oilà, pare*ss*eux, dit-elle a*v*ec *s*on *s*ourire di*v*in, je *s*uis *s*ure que *v*ous *s*ortez seulement de *v*otre lit!" Je lui racontai ma nuit pa*ss*ée *s*ans *s*ommeil. (252)

[As the day advanced, it chased from my thoughts this vain memory and left only the rosy lineaments of Sylvie. "Let us go and wake her," I said to myself, and resumed my walk to Loisy.

Ah, here is the village at the end of the path that skirts the forest: twenty cottages with walls festooned with vines and creeping roses! In the early light, some women, with red kerchiefs on their heads, are spinning in company before a farmhouse. Sylvie is not among them. She is almost a young lady, since she makes fine lace while her relatives remain simple villagers. I went up to her room without creating any surprise; she had been up for a long time and was busily throwing the bobbins of her lace, which clicked with a cheerful sound on the square green cushion that lay on her knees.

"Here you are, lazy bones," she said, with her divine smile; "I am sure you are just out of bed." I recounted my sleepless night to her.]

At the beginning of the following paragraph, the word *souvenirs* reappears, as though it were necessary to rejoin the threads; the resultant symmetry frames the dissemination of the letters *V* and *S* in the above passage.

Piercing, Cutting, Festooning

The passage immediately preceding the one just cited concerns the Subject of the narration's desire to see Adrienne, now hidden behind convent walls. The sense of lack and the gap experienced in the Subject's life can be easily read here. As is always the case in Nerval's writing, landscape and architecture mirror psychic and metaphysical states: "Les hautes masures de l'abbaye de Thiers *découpaient* sur l'horizon leurs pans de murailles *percés* de trèfles et d'ogives ... les ruines *ébrechées*" (The high tumbledown walls of the abbey of Thiers were *silhouetted* [cut out] on the horizon, their slopes *pierced* with trefoils and pointed arches ... the *gaping* ruins") (251; two of the words I have emphasized that connote psychic disarray—"découpaient" and "percés"— belong to the vocabulary of lace-making technique). When the idea occurs to him to scale the highest point of the rocks in order to spy over the walls, the hero "in reflecting upon it" stops himself as though from committing a profanation. The quest for the Lost Object will indeed be "reflected," first in the landscape, and then in writing technique.

The day, the road to the village, and finally the vine and roses that festoon the walls of the thatched-roof houses are substituted for "vain souvenir." "Festoon" is a pivotal word, because it leads from nature to *la fête*, and finally to one of the techniques of lace making. A festoon, in embroidery or in lace, is a series of round or pointed arcs; it cannot but remind one of *la fête de l'arc*, the event/memory that incites the Subject to return to the Valois. The word *festonnent* in the scene where Sylvie is making lace launches the first letter of the second alliterative pair in the weave: *F, D* (forêt, festonnent, fileuses, coiffées de, devant, ferme, demoiselle, depuis); these new threads are brought together in *fines dentelles* and *fuseaux de sa dentelle* (they reappear elsewhere in the text as *doigts de fée* (fairy fingers).[21]

In chapter 3, before the Subject of the narration decides to return to the Valois, it is this memory of Sylvie that comes to mind:

Je revois sa fenetre où le pampre s'enlace au rosier, la cage de fauvettes suspendue à gauche; j'entends le bruit de ses fuseaux sonores et sa chanson favorite:

> La belle était assise
> Près du ruisseau coulant. (247)

[I see her window again, where the wild vine is interlaced with the rose bush, and the cage of warblers is hanging on the left; I hear the click of her sonorous bobbins, and her favorite song:

> The maiden was sitting
> Beside the running stream.]

This short passage, as well as the others just cited, highlights the constant intermingling in the text of art and nature (in the present case, the art of lace making).[22] First, the interlacing of vine branch with roses forces the reader to see this correspondence (in "El Desdichado" it is the trellis where the vine *s'allie* with the rose). Second, the bars (*les grilles*) of the suspended cage allow comparison with the *grillé* of lace; in addition, the *fauvettes* (warblers), like the *fuseaux* (bobbins), are suspended. As we are now used to seeing, the activities of lace making and singing go hand in hand (the adjective *sonores* confirms the association and echoes the warblers' song). The complicity between lace and landscape, or—pushing the *meaning* of these correspondences a bit further—the *mise en abyme* of an interlacing of text and lace found in nature, is repeated in each of the three chapters where lace making is explicitly referred to (chapters 3, 5, and 6). On the contrary, in the chapters set in the Valois that show us a Sylvie as glove maker, no description of this interlacing appears. Finally, in the passage cited from chapter 3, the phonic series in *S*, *F* (culminating in *ses fuseaux* and *sa chanson favorite*) are interlaced in such a way as to reproduce the flowing lines of the song, while the song fragment reproduces the tableau of Sylvie sitting at her cushion (*le carreau*) from which flows the white river of lace woven by her "fairy fingers."

UNTYING THE THREADS, WRITING ABSENCE

If one pays close attention to the song fragments in the text, one finds them to be a rich source of meaning for the principal narrative. Related to the act of taking apart (*découdre*) the burial cloth of fine linen ("Le Roi Loÿs est sur son pont") is the legend of Count Ory and a young peasant girl he is determined to possess; she asks for his knife in order to cut open the knot that ties her dress together and pierces her own heart with it. *Knot* is rich in connotations for the text as lace: it is the convergence of several narrative threads, the superimposition of characters who resemble each other, and the tangled relationships between

myth, literary models, and plastic models in the narrative. If the folk song is a "knot" of meaning (libidinal, historic, and aesthetic), "opening the knot" and "taking apart the burial cloth of fine linen" are metaphors for untying the threads of narrative that compose these knots. Undoing the threads, though, is not only the job of the reader.

The work of the writer in this context consists of constructing gaps and discontinuities, along with the threads of the narration, that produce an effect of fading or vanishing where the threads will seem to disappear before the eyes of the reader, just as the past, childhood loves, and provincial life of a decade ago disappear before the very eyes of the Subject of the narration. The text becomes a chimera in order to translate a chimerical vision of the world. At the same time, though, untiringly, the writer weaves and ties together mythic and aesthetic filiations that are meant to preserve the lost past.

Sylvie ceaselessly describes this process of textual construction: weave / take apart / reweave. Let me recall the letter Nerval wrote to Victorien de Mars describing the composition of the novella: "For as I advance, I erase nearly everything I've written." It is not, however, in *Sylvie* but in *Angélique* that Nerval refers most explicitly to this sort of work.

"Et puis…" (C'est ainsi que Diderot commençait un conte, me dira-t-on.)
—Allez toujours!
—Vous avez imité Diderot lui-même.
—Qui avait imité Sterne…
—Lequel avait imité Swift.
—Qui avait imité Rabelais.
—Lequel avait imité Merlin Coccaïe…
—Qui avait imité Petrone…
—Lequel avait imité Lucien. Et Lucien en avait imité bien d'autres. . . . Quand ce ne serait que l'auteur de l'*Odysée*, qui fait promener son héros pendant dix ans autour de la Méditerranée, pour l'amener enfin à cette fabuleuse Ithaque, dont la reine, entourée d'une cinquantaine de prétendants, défaisait chaque nuit ce qu'elle avait tissé le jour. (*Oeuvres* 1:249)

["And then . . ." (That is how Diderot began a tale, one will point out to me.)
—Go ahead anyway!
—You've imitated Diderot himself.
—Who had imitated Sterne…

—Who had imitated Swift.
—Who had imitated Rabelais.
—Who had imitated Merlinus Coccaius...
—Who had imitated Petronius...
—Who had imitated Lucian. And Lucian had imitated many
others. . . .
And even if it had just been the author of *The Odyssey*, who has his hero
wander around the Mediterranean for ten years in order to finally lead
him to this fabulous Ithaca, whose queen, surrounded by fifty suitors,
undid each night what she had woven during the day.]

This passage (itself plagiarized from Charles Nodier) shows how insis-
tently Nerval links the repetition of literary models, syntax, the dash
and three points of ellipsis (the textual "holes"), and the idea of a text
that undoes itself in order to communicate absence and in order to be
constantly rewoven.

A simple inversion (from masculine to feminine) suffices to make the
following parallelism appear:

Writer—Subject of the narration (weaver) Penelope (weaver)
Adrienne (the Absent One)Ulysses (Absent)

One can cross the threads to obtain this:

Subject (voyage, continual wanderings)⟍ ⟋Penelope (weaver)
Adrienne (Aria[d]ne who holds———————⟋⟍———Ulysses (voyager)
 the thread of *rien*):
 ad rien / ad rem)

The title of this chapter in *Angélique* (the last chapter, and therefore the
one that immediately precedes *Sylvie* in the collection) is "Réflexions";
the reflections of the writer—on his own identity, on that of the Object,
or on the act of writing—inevitably produce a series of reflections.
These repetitions are always accompanied by blanks, gaps. The absence
of the love Object motivates the Subject to weave, and the repetition of
this absence must be an adequate representation of lack. If the referral
from author to author seems to stop with Homer, this is soon perceived
to be in error: it stops there only to focus on Penelope, like Sylvie or
Adrienne a character in a narrative, and, like them, one who is identi-
fied with weaving. The referral from text to text is shown to be infinite;
the very place one would like to call the place of origin is labeled *fabul-*

eux, a place of fables. It is this painful knowledge (that the desire to arrive at a resting place, a place of origin anchored in reality, is destined to be futile) that brings about the Subject's contemplation on the symbolic gesture of writing.

CONCLUSION

Toward the end of *Sylvie*, the Subject explains to Aurélie that his love for her is based on an older love: "Nulle émotion ne parut en elle. Alors je lui racontai tout" (She showed no emotion. So I told her everything) (271). The presence of the word *nulle* triggers the other side of the Nervalian coin, *tout*. This *tout* belongs to narration ("je lui *racontai* tout"). Writing offers itself as a response to the absence of love and must be composed as much of holes as of threads. *Sylvie* begins with these words: "Je sortais d'un théâtre où tous les soirs je paraissais aux avant-scènes en grande tenue de soupirant. Quelquefois tout était plein, quelquefois tout était vide" (I was leaving a theater where every evening I made an appearance in full dress as a suitor. Sometimes it was all full, sometimes it was all empty). The anaphoric construction of the second sentence superimposes the words *full* and *empty*: out of two antithetical terms, Nerval has created two interchangeable terms. One might even say that all of *Sylvie* is already contained in the title, the subtitle (*Souvenirs du Valois*), and the title of the first chapter ("Nuit perdue"). The emptiness of loss is subsumed by the plenitude of memory, which is subsumed by the presence/absence of textuality.

Among the textile models that a text can refer to, lace seems to be, thanks to its holed texture, perfectly suited to express this double configuration that forms the matrix of the text. The model I am proposing allows one to follow the interlacing of the numerous, repeated motifs, movements, and gaps that form the chimerical texture of *Sylvie*.[23] "Telles sont les chimères qui charment et égarent au matin de la vie. J'ai essayé de les fixer sans beaucoup d'ordre, mais bien des coeurs me comprendront. Les illusions tombent l'une apres l'autre, comme les écorces d'un fruit, et le fruit c'est l'expérience. Sa saveur est amère; elle a pourtant quelque chose d'âcre qui fortifie, —qu'on me pardonne ce style vieilli" (Such are the chimera that charm and lead one astray in the morning of life. I have tried to fix them without too much order, but many hearts will understand me. Illusions fall away, like the peels of a

fruit, one after another, and the fruit is experience. Its taste is bitter, but it has an acidic flavor that acts as a tonic, —may I be pardoned this obsolete style) (271). "Charment" implies the incantatory repetition of poetry moving toward its ritual sources, while "égarent" may be counted among the forms of discontinuity I have traced. *Chimères* is the name that the writer chooses to qualify his text; not only does it describe the evanescent quality of *Sylvie*, but it links the text to the eight poems, *Les Chimères*, at the end of the collection *Les Filles du feu*. This intertextual reference underlines the lyrical, poetic, and hermetic character of the prose at the same time as it breaks open the narrative frame to include the semantic riches of the sonnets. This self-reflexive contemplation continues with "may I be pardoned this obsolete style," marking once again the element of working from preexistent models. This nostalgic reference to a period past is in the paradigm of repetition: note, conse-quently, the presence of the dash (or gap) that precedes it.

In considering lace as a metaphor for text in *Sylvie*, one comes to visualize the structure of the narrative in a less abstract way. I have suggested a new reading of *Sylvie* (usually seen as a *Bildungsroman* with a negative denouement) by taking into account the way in which the text "talks about itself." In that way, loss and experience in general are the materials out of which the textual fabric is woven. Characters and temporal strata appear and disappear, loosely interlaced like the threads of a piece of lace. The success of this project transcends the negative experience on which it is based. The chain of signifiers substituting for the Lost Object is manipulated by the writing Subject with a newfound force, and the inventiveness in his patternings creates a new form. In an early version of *Aurélia*, Nerval wrote, "Otez une fleur, une dentelle, une boucle, tout cela, mais tout cela s'y trouve. Le ravage est même prévu et sous lui s'organise un (centre?). Série d'artifices" (Take away a flower, a piece of lace, a curl, all that, yes, all that is present. The havoc [ruin] is even forecast and under it a [center?] is organized. Series of artifices).[24] If contemporary criticism has often embraced the analogy / fabric = text / it has seldom gone beyond the stage of mere suggestiveness ("the threads of the narrative," "the weave of the text," and so forth). But Nerval's predilection for textile metaphors, the fact that many of his heroines sew, weave, and embroider, the importance in this oeuvre of popular tradition and in particular of artisanry, and especially the fact that Sylvie is a lace maker should suffice to make one sensitive to the importance of lace in this text.[25] Moreover, the anagrammatic play be-

ginning in the title *Sylvie* and generating in its descent the subtitle, *Souvenirs* and *Valois*, would seem to announce, from the first page, the signifying power of interlace in a text that never stops examining the process of writing and its own style.

Trills, Frills, and Decorative Frames for the Object of Desire

There is reason, it is said, in the roasting of eggs, and there is philosophy even in furniture.—*Edgar Allan Poe*

Ornament is the adoration of the joint.—*Louis Kahn, architect*

La volupté chante . . . dans l'intérieur de la femme par les ornements de l'appartement.—*Les Goncourt*

ORNAMENT AS VEILED LANGUAGE OF DESIRE

As the reader may recall from the Introduction, in mid-nineteenth-century France, decorative art, "more than all others," was perceived as giving "free rein to fantasy and caprice" (Souriau, *Suggestion*, 94). Since ornament stimulates the Imaginary, it is only natural that one should often find it associated with desire. Thus, in nineteenth-century texts, one will find ornament playing an equally important role in the fantastic tale and in descriptions of the Object of desire.

Ornament takes on a new symbolic dimension in attaching itself to the Object of desire as a material extension of the person. It becomes the metonymic representation of that Object. All of the ornaments with which the Object adorns herself—embroidered, lacy, or sequined fabrics, jewelry, and ribbons—serve to veil, and thus protect, the person. They inevitably pose an enigma to the desiring Subject: who or what lies in wait for him behind the veil, in the center of the spider's web, beyond the blinding brilliance of the gems, or in the shimmering metamorphoses of silk? *Behind, in the center, beyond*: my choice of words reveals a desire to get beyond or behind the ornamental surface. But, as

psychoanalysis has taught us, the Object (and reality in general) reveals itself in the most indirect ways possible, and when it does, it is to be found right on the surface of things (albeit in the margins of discourse), in a superfluous flourish thrown in for no apparent reason.

But ornament can function as a relay between Subject and Object in diverse dynamics, not simply as metonymy for the Object. In this chapter, I will consider the role of ornament as part object, fetish, Lost Object, and transitional object.

In *Sylvie*, Nerval used lace and lacelike objects to construct a bridge between Subject and Object, to tie the two together in the field of the Imaginary and allow them to meet tenuously and momentarily in reality. Interestingly, in both Freudian psychoanalysis and Winnicott's object relations theory one finds string, thread, or woven fabric playing an important role in the construction of a psychological rapport between Subject and Object.

THE TRANSITIONAL OBJECT

D. W. Winnicott describes the dynamics between form and sensation in infants. First, infants have the illusion that the mother's breast belongs to them, even that it is a part of their own body. The breast seems to be under their omnipotent control. "In another language, the breast is created by the infant over and over again. . . . A subjective phenomenon develops in the baby, which we *call* the mother's breast. The mother places the actual breast just there where the infant is ready to create, and at the right moment."[1] A potential or "transitional" space is thus created where the child receives "the illusion that there is an external reality that corresponds to the infant's own capacity to create. In other words, there is an overlap between what the mother supplies and what the child might conceive of" (*Playing*, 22). From birth, then, human beings face the problem of defining themselves in relation to what is perceived as objective (sensation, materiality) and what they conceive of subjectively (form, ideality). Certain objects in the baby's life—the coverlet or its satin border, the teddy bear—have their place in this *entre-deux*.[2] They are *transitional objects*. They have a texture and vitality of their own and furnish a soft, reassuring presence to the infant, who endows them with a life that is intimately linked to the baby's own. These objects have their own form and material existence, which are

external to the infant, but nevertheless they are perceived as being guided in large part (but never completely) by the child's subjective, creative phantasies. These objects may be likened to experiences that occur in the potential or transitional space. They represent a neutral zone that will remain free from the question, Did you invent this object, or was it presented to you from outside yourself?

This dynamic resembles one Schiller described in a poem that Nerval translated, "Christophe Colomb." He calls it "Schiller's magnificent idea about Columbus." "Va devant toi, et, si ce monde que tu cherches n'a pas été créé encore, il jaillera des ondes exprès pour justifier ton audace; car il existe un Eternel entre la nature et le génie, qui fait que l'une tient toujours ce que l'autre promet" (Go forth, and if this world you seek has not yet been created, it will spring forth from the waves to justify your daring; for there exists an eternal Accord between Nature and Genius, the one always keeping the promises made by the other).[3] This is the Romantic, Promethean idea of reality brought into existence by the imagination, an idea that is not, as we see, far removed from the transitional experience viewed from the position of the child. The following examples are also transitional phenomena:

> An infant's babbling and the way in which an older child goes over a repertory of songs and tunes while preparing for sleep come within the intermediate area as transitional phenomena, along with the use made of objects that are not a part of the infant's body yet are not fully recognized as belonging to external reality. (*Playing*, 13)

Passages on song and vocalizing will demonstrate how Nerval incorporates the rhythmic cadences and tessitura of a singing style he associates with a distant past and with his childhood. Reproducing these rhythms in his prose is a way of experiencing the same sort of phenomenon Winnicott describes above. Like the objects Winnicott names, the voice in Nervalian texts is sensation and is experienced as material (coming from without), as well as evanescent and ephemeral (lending itself to transformation by subjective phantasy).[4]

Separation from the mother can influence the use of transitional objects. "Just before loss [of the child's internal representation or memory of the mother] we can sometimes see the exaggeration of the use of a transitional object as part of *denial* that there is a threat of its becoming meaningless" (*Playing*, 15). In illustration, Winnicott gives a clinical example of a boy's use of string:

> The . . . boy had become obsessed with everything to do with string, and in fact whenever [the parents] went into a room they were liable to find that he had joined together chairs and tables. . . . String can be looked upon as an extension of all other techniques of communication. String joins, just as it also helps in the wrapping up of objects and in the holding of unintegrated material. In this respect string has a symbolic meaning for everyone. . . . As a denial of separation string becomes a thing in itself, something that must needs be mastered. (*Playing*, 17, 19)

The relevance of this example to Nerval's interest in lace making may not at first appear evident, yet his emotional and artistic reliance on the "fil d'Ariane" cannot be doubted (see chapter 2). Recalling the homonymy between *Ariane* and *Adrienne*, the reader may more easily accept the writer's use of the intertwined narrative threads as a response to loss (Adrienne's departure for the convent, then her death). In addition, there is a very clear statement in *Promenades et souvenirs* as to the loss of the writer's internal representation of the mother. "Je n'ai jamais vu ma mère: ses portraits ont été perdus ou volés" (I never saw my mother: her portraits were either lost or stolen).[5]

Why should ornament be so apt to function as a transitional object? First, because in making it, the artisan—unhampered by mimesis—can freely express inventiveness and flights of fancy. Second, the artisan exercises a certain control over the material, but the material dictates to a great extent the form of decoration. *Homo faber* and *homo ludens* both interconnect with the object. Like Winnicott's transitional objects and the toys that later take up their role, ornament—both tactile and imbued with subjective phantasy—is situated at the intersection of the subjective and objective worlds of the individual. Finally, it is perhaps no coincidence that the majority of ornamental objects functioning as transitional objects in Nerval's texts are composed of fabric and therefore recall the infant's use of the transitional object par excellence, the soft coverlet or its satin border, which the infant sucks, caresses, and otherwise manipulates.

The strict correspondence between weaving and singing that I noted in chapter 2 reappears in Nerval's journalistic writing on the theater. "Now, let us pay homage to the delicious melodies that M. Auber has embroidered on the rich fabric of the *Domino noir* (libretto by Scribe)."[6] And there too the vocal ornament, the trill, is underlined. "As a singer . . . she has proven . . . that she knows how to act and, by her method

of vocalizing, of making a trill, of weaving a sound . . . in a word, she has proven that she knows how to sing."[7] The singer in this case is the woman Nerval made his idol and his muse, Jenny Colon. In life as well as in fiction, vocal ornament and weaving ("filer un son") receive the full force of the most profound sentiment in the desiring Subject. The material reality of the Object's voice overlaps with the Subject's re-creation of it in writing, writing that—in this case—he *presents* to her, as she has directed her voice to him as theater critic and editor of *Le Monde dramatique*.

Similarly, the braided crown knotted together with ribbon, offered by the young hero to Adrienne "in exchange" for her singing, effects a link between them ("Je posai sur la tête d'Adrienne cet ornement dont les feuilles lustrées éclataient sur ses cheveux blonds aux rayons pâles de la lune" [I placed on Adrienne's head this ornament whose lustrous leaves gleamed above her fair tresses in the pale rays of the moon]) (246). He later offers a crown of garlands to Sylvie to the same effect. Woven objects invariably function as connection between Subject and Object. What is more, these ornaments (crown, ribbon) are traditional motifs in lace and embroidery. Nerval's friend Gautier, too, uses thread as a symbol of a lover's attachment. In "Fil d'or" (1844, music by Th. Labarre, lyrics by Gautier), "J'allais partir. Dona Balbine se lève et prend sa bobine / Un long fil d'or à mon bouton [et à mon coeur] sa main le noue" (I was getting ready to leave. Dona Balbine rises and takes her bobbin / She knots a long golden thread to my button . . . [and my heart]).[8]

THE LOST OBJECT

In his 1920 essay "Beyond the Pleasure Principle," Freud describes a game, *fort-da*, invented by his eighteen-month-old grandson. The baby tosses out a spool attached to a long string until it disappears under his bed. It is *fort*, away, like his mother, who has gone out. Then he pulls it back into sight and utters a joyful *da!*, here. This "continually repeated performance" represents the mastering of a painful separation by the creation of a verbal game where the child controls the presences and absences of the mother. The presence of the Lost Object is half made up of absence. The manipulations of the spool (or text) are activated in the chasm of emptiness created by the loss. In Lacan's words, "it is with

his object—the reel and thread—that the child leaps across the frontiers of his domain transformed into an abyss [a well] and that he begins his *incantation*" (my emphasis).[9] In this way, for Freud, Lacan, and Winnicott, as well as for Nerval and Gautier, thread offers itself as an ideal symbol for the Subject's relationship to the Object.

The convergence between lace making and singing dates from the earliest form of lyric poetry in France: the *chansons de toile*, written to occupy noblewomen as they wove or embroidered. The two activities intersect again historically around 1840 when the oral tradition of folk ballads and the artisanal tradition of lace making begin to disappear from the Valois.[10] As I have stated, it is not surprising that Nerval should associate both of them with his childhood and with the very early loss of his mother.

> [Mon père] avait perdu sa femme et ne pouvait s'empêcher de pleurer, en s'accompagnant de la guitare, aux paroles d'une romance qu'elle avait aimée, et dont *j'ai toujours retenu ce passage*; . . . des grâces *d'un autre temps*. Il faut aller à Saint-Germain pour *retrouver . . . les charmes effacés de la société d'autrefois.* (*Promenades*, 131; emphases mine)

> [(My father) had lost his wife and could not help crying as he accompanied himself on the guitar, at the words of a ballad she had loved, from which *I have always retained this passage*; . . . the graciousness *of another era*. One has to go to Saint-Germain *to find again . . . the lost charms of a bygone society.*]

It is one of these old romances that Adrienne sings in *Sylvie*: "D'une voix fraîche et pénétrante . . . elle chanta une de ces anciennes romances . . . la mélodie se terminait à chaque stance par ces trilles chevrôtantes que font valoir si bien les voix jeunes, quand elles imitent par un frisson modulé *la voix tremblante des aïeules* (In a fresh and penetrating voice . . . she sang one of those old ballads. . . . The melody terminated at each stanza with those quivering trills that show off to such advantage young voices, when with a quavering modulation they imitate *the trembling voice of the grandmothers*) (*Sylvie*, 245; emphasis mine). There can be no doubt that this form of trill is a vestige of a lost, originary presence: that of the *terre maternelle* and of the mother. The trill is the trace of what is irremediably absent, the Lost Object. A chain of interior rhymes in *Sylvie* presents itself in this light: *mère, terre, airs, chimères*.

Chaque fois que ma pensée se reporte aux souvenirs de cette province du Valois, je me rappelle avec ravissement les chants et les récits *qui ont bercé mon enfance*. La maison de mon oncle [maternelle] était *toute pleine de voix mélodieuses* ... j'en ai donné plus haut quelques fragments. *Aujourd'hui je ne puis arriver à les compléter, car tout cela est profondément oublié; le secret en est demeuré dans la tombe des aïeules.* (Emphases mine)[11]

[Each time that my thoughts return to the memories of this province of Valois, I recall with delight the songs and stories *that cradled me in my infancy*. The house of my (maternal) uncle was filled to the brim with melodious voices ... above I've cited some fragments. *Today, I can't manage to complete them, for all of that is profoundly forgotten; their secret has stayed behind in the tomb of the grandmothers and their mothers before them.*]

Thus, throughout his life, Nerval will experience a blissful and nostalgic joy in hearing female voices reproduce the timbre and cadences he heard in his infancy. In a letter to his father a year before his death, Nerval writes that "il y a des voix qui me rappellent mon enfance" (there are voices that remind me of my childhood) (*Oeuvres*, 1148).

The expressions *faire revivre, toute pleine, remplit,* and *renaissance* would seem to indicate that the particular quality of the voice Nerval describes is adequate to an originary presence. However, this is the case with neither the voice nor weaving, which must always be undone and repeated. The voice, like lace, exhibits a pattern of holes cadenced with repetition, for the specific form of trill *chevrotant* Nerval refers to is a repetition of the same note interrupted by breaks (like a goat's or sheep's *baaa-aa-aa*).[12] Nerval's poetic prose resurrects this pattern as phonic chains re-create this vibratory effect, as in the passage where the narrator listens to Aurélie sing (chapter 1 of *Sylvie*). And there one can follow a semantic evolution from *vide* to *vie* to *vibration*. The alliterative chain in S, V that I traced in chapter 2 includes *Sa Voix*.

The originary separation from or loss of the mother creates the split in the Subject. The relation to the Object as Other is engendered by this radical gap or separation, since the Subject feels himself to be lacking and erects the function of the Lost Object in this lacuna. "There is a hole, and this hole is called the Other."[13]

When the narrator of *Sylvie* returns to the Valois of his childhood, now irremediably lost, changed by the Industrial Revolution, he goes to the home of his maternal uncle, where he was raised. The uncle is dead,

survived by a one-hundred-year-old parrot (bird of the incantatory, repeated word). He continues his pilgrimage and arrives at the *rond-point de la danse*. *Rond-point* (apsis, circus) is a series of rounded stitches in lace making (*feston*, festoon, or *roue*, wheel); it is also highly evocative of the breast. Next to this *rond-point* is the empty tomb of Rousseau, a spiritual and literary father to Nerval. The narrator exclaims, "O sage! tu nous avais donné *le lait des forts*" (Oh sage! you had given us *the milk of strong men*) (262; emphasis mine). In echo to the opposition of "round-point" and empty tomb, ivy *festoons* the *gaps* between the disintegrating steps. The notion of loss and erasure appears throughout the chapter. The final image, though, creates a transitional space where Subject and Object meet. Sylvie is remembered in her "chapeau *de paille*, dont le *large ruban flottait pêle-mêle avec ses tresses* de cheveux noirs. Nous allions boire du lait à la ferme suisse. . . . Elle ne dansait qu'avec moi" (*straw* hat, whose *long ribbons floated carelessly amid the tresses* of her black hair. We used to go and drink milk at the Swiss farm. . . . She danced only with me) (ibid.; my emphases). The lacing together of a woven object with the beloved's "woven" hair is doubled by the lacing together of the two adolescents. Milk and interwoven objects—juxtaposed here—operate as transitional objects, in distinction to the dynamics of Lost Object manifest in the rest of the chapter.

Like the trill, ornamental fabric and braided objects can also function as transitional phenomena *or* as representations of the Lost Object; they remain in the narrator's memory as her only trace:

On me fit descendre en secret dans une chambre où la figure d'Héloïse était représentée par un vaste tableau. Une épingle d'argent perçait le noeud touffu de ses cheveux d'ébène, et son buste étincelait comme celui d'une reine, pailleté de tresses d'or sur un fond de soie et de velours. Eperdu, fou d'ivresse, je m'étais jeté à genoux devant l'image; une porte s'ouvrit, Héloïse vint à ma rencontre. . . . Elle ne put rien me répondre. . . . O douleurs et regrets de mes jeunes amours perdus Héloïse est mariée aujourd'hui; . . . à jamais perdue . . . pour moi: —le monde est désert . . . sur les débris de mon néant! Revenez pourtant douces images. (*Promenades*, 138–39)

[They secretly had me go down to a room where the figure of Heloïse was portrayed in a huge painting. A silver pin pierced the tufted knot of her ebony hair, and her bust glittered like that of a queen, sequined with golden braids on a background of silk and velvet. Distraught with love,

mad with drunkenness, I had thrown myself on my knees before the image; a door opened, Heloïse came to meet me. . . . She could find no reply. . . . Oh pain and regrets of my lost young loves. . . . Heloïse is married today; . . . forever lost to me: —the world is deserted . . . on the debris of my nothingness! Return, nevertheless, sweet images.]

This chapter of *Promenades et souvenirs* begins with the lines "La pension que j'habitais avait un voisinage de jeunes brodeuses. L'une d'elles . . . fut l'objet de mes premiers vers d'amour" (The boardinghouse where I was living had a neighborhood of young embroiderers. One of them . . . was the object of my first love poems) (138). In a chapter where the connection between *brodeuse* and *amour* is set forth in the first sentences, it is not difficult to see that the network—pierced, knot, golden tresses, sequins, silk, velvet—will inspire the same desire. In this text deeply marked by the Lost Object (as in *Aurélia*) one is witness to the fragmentation of the self Lacan describes (here the Lost Object is the mother; in *Aurélia*, it is the mythicized actress/singer Jenny Colon). In the next section, I will explore a psychoanalytic theory of tying the self back together.

Weaving Back Together the Fragments of the Self

The pertinence of the concept of the Lost Object seems particularly appropriate in *Aurélia*, a text built around the figure of a woman who calls forth the plaint "Eurydice! Eurydice! Une seconde fois perdue!" (Lost a second time) (*Aurélia*, 385).

Before this second loss, the narrator dreams he is in the house of an ancestor; there, the figure of the absent or dead mother is accompanied by the activity of weaving (or weaving back together):

Il y avait dans l'air une fraîcheur et un parfum des premières matinées du printemps. Trois femmes travaillaient dans cette pièce, et représentaient, sans leur ressembler absolument, des parentes et des amies de ma jeunesse. . . . La plus âgée me parlait avec une voix vibrante et mélodieuse que je reconnaissais pour l'avoir entendue dans l'enfance . . . et je me vis vêtu d'un petit habit brun de forme ancienne, entièrement tissu à l'aiguille de fils tenus comme ceux des toiles d'araignées. . . . [Il] sortait de leurs doigts de fée [et j'étais comme] un petit enfant devant de grandes belles dames. . . . Je me vis dans un petit parc où se prolongeaient des

treilles en berceaux . . . à mesure que la dame qui me guidait s'avançait sous ces berceaux, l'ombre des treilles croisés variait encore pour mes yeux ses formes et ses vêtements. (Ibid., 372–73)

[There was a coolness in the air and a perfume of the first mornings of spring. Three women were working in this room and represented, without absolutely resembling them, the relatives and girlfriends of my youth. . . . The oldest was speaking to me with a vibrant and melodious voice that I recognized for having heard it in my childhood . . . and I saw myself clothed in a little brown old-fashioned outfit, entirely woven of needle-lace with threads as thin as those of spider webs. . . . [It] emerged from their fairy fingers [and I was like] a little child before tall, beautiful ladies. . . . I saw myself in a little park where trellises in bowers stretched out before me . . . as the lady who guided me advanced under these bowers, the shadow of the crossed trellises again varied for my eyes its forms and her clothing.]

The content of this passage is so clear as to require no exegesis, except, perhaps, for the first and last sentences. The initial image evokes the archaic stage of infancy,[14] while in the last image, the narrator states that the form and lace-patterned clothing of the woman who has taken charge of him vary *for his eyes*. This seems to me an excellent example of subjective phantasy mingling with the Object thanks to the intermediary of the trellis (*treille* is a near homonym of *trille* and is associated with lace in *Sylvie*), just as the little lace outfit functions as an intermediary between the Subject and the oldest of the "tall, beautiful ladies" in the preceding paragraph.

The Kleinian psychoanalyst Hannah Segal has written of art's role in repairing, piecing back together the fragmented parts of the self. Certainly, this is what writing is charged with doing in texts like *Sylvie* and *Promenades et souvenirs*. According to Kleinian theory, infants split off parts of themselves in a paranoid-schizoid position (originating in the first few months of life, but present to varying degrees in adult life), projecting these aggressive or paranoid parts onto the Object. The Object is then split into a "good breast / mother" and a "bad breast / mother." Klein believes that "the ego is incapable of splitting the object—internal and external—without a corresponding splitting taking place within the ego. . . . It is in phantasy that the infant splits the object and the self, but the effect of this phantasy is a very real one [in later object relations]."[15] We can see an identification of Nerval's frag-

mented Subject with the land where he was raised (*la terre maternelle*) in this phrase from "La Bohème galante": "chants d'une province aujourd'hui coupée en mille morceaux" (songs of a province that today is cut up into a thousand pieces).

I have noted the reciprocal movement on the part of the Subject when lace, embroidery, or vocal ornaments are "offered" to him: he in turn weaves a crown, a poem, or a network of interlaced sounds. The *feuilles lustrées* of the laurel crown offered to Adrienne become the *feuilles illustrées* of the text, whose last chapter is even entitled "Dernier feuillet." It is here that the narrator, now explicitly named as writer, revisits Sylvie and shares a last activity with her. Together they read. The effort throughout Nerval's oeuvre to link things together, and especially to link Subject and Object (a desire that echoes in the names of two of his heroines: AuréLIE and AuréLIA), is last seen in the act of reading. *Lier* becomes *lire*. "Telles sont les chimères qui charment et égarent au matin de la vie. . . . Les illusions tombent l'une après l'autre, comme les écorces d'un fruit, et le fruit c'est l'expérience. Sa saveur est amère; elle a pourtant quelque chose d'âcre qui fortifie" (*Sylvie*, 271). So begins the last chapter of *Sylvie* (quoted and translated in chapter 2). It can be read now in light of object relations theory, giving a stronger, more primitive sense to the metaphor "morning of life" and lending a slightly different flavor to *a-mère*. The illusions of subjective phantasy are shed in part, but raw materiality is peeled away too. Illusion *marries* matter (the fruit), thanks to the interweaving of the simile. The *fruit of experience* is precisely this marriage, a fortifying nourishment, to be sure. The transitional objects have now been incorporated into the texture of writing, and the relation of the Subject to his world is worked out in the space of the text.[16] "Entre le monde externe et le monde interne un lien" (Between the external world and the internal world, a link) (*Aurélia*, 413).

The pleasure attached to the contemplation of ornament has at times been criticized as "childish" (Gombrich, *Order*, 166–67). Perhaps we are now able to see some of the profound reasons it may indeed be connected to the earliest experiences of one's childhood. (Is it any wonder, given the incredible import of ornamental objects for Nerval, who lost his mother in his infancy, that he "spent his last louis on a gilded chest, a piece of silk damask, a lamp . . . that attracted him; [that] in the winter, he was capable of pawning his overcoat to buy a turquoise pin or a cabalistic ring"?)[17]

The Decorative Frame of Arabesques:
Part Object and Fetish

Charles Blanc wrote that "the art of composing frames . . . [is] dictated by the laws of emotion or feeling" (Blanc, *Grammaire* [1882], 215). But let us recall the admonition in the 1847 *Nouveau Manuel complet du dessinateur*: "Let the designer guard against all the caprices of unbridled imagination." Arabesque designs, so prevalent in the decorative frame, in shifting their model from nature to dreams and chimera (the realm of the unconscious) carry a danger that was not lost on aestheticians and critics of the time: their propensity to extravagance, infinite extension, and perceptual confusion often leads to a loss of limits.

The Object of desire, like the framing ornament, is often composed of arabesques, serpentine forms with no clear beginning or end; and the incorporation of the Object's sinuous lines into the Subject's writing is fraught with danger. These risks are with the integrity of the self. In "La Pandora," an enigmatic text Nerval referred to as a "sirène" (the text is seen as possessing the serpentine shape of the Object of desire), the Subject is the victim of such an experience.

The first segment of the text poses the fundamental enigma of Pandora, who is not man, woman, androgyne, young, or old, but all of those: "Enfin la *Pandora*, c'est tout dire, car je ne veux pas dire tout" (Pandora says it all, for I don't want to say everything).[18] From the beginning, a verbal gap or silence is proposed as a textual response to an excess of signification. Similarly, on the level of the *spoken* word, the erotic force of this seductress will reduce the Subject to a babbling incoherence. This silence is also the effect of repression: there is a hidden desire or a fear too terrible to confront in the text. Yet the text, like ornament, "says it all" by its very form ("la *Pandora*, c'est tout dire"). The text *is* a "sirène," as Nerval said, and this *figura serpentinata* expresses desire, impulses, and drives in a way that words cannot (fig. 9).

The second fragment of text, "Maria-Hilf," juxtaposes Vienna and its environs with Saint-Germain, where goats graze on "green acanthus." At Schoenbrun Palace, the Subject is rapt in adoration for the chimera where he hoped to "[s']allaiter à leurs seins de marbre éclatant" (drink at their breasts of sparkling marble) (ibid.). But after the initial presentation of these maternal images of nourishment, the representations of Pandora—always framed by arabesques—are, on the con-

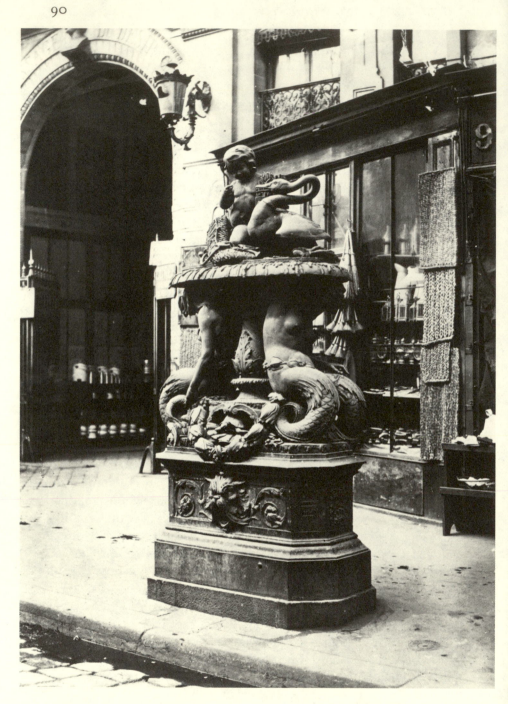

9. Fountain with mermaids, in front of the Passage du Désir, Paris, c. 1870.

trary, of a threatening figure. In the first scene, she is seen as merely mysterious:

> Je me plaisais beaucoup dans le boudoir de la Pandora . . . les délicieuses pattes de mouche de son écriture s'entremêlaient follement avec je ne sais quels arpèges mystérieuses qu'elle tirait par instants des cordes de sa harpe, dont la crosse disparaissait sous les enlacemens d'une sirène dorée. Tout à coup elle se jeta à mon colet m'embrassa. (349)

> [I very much liked being in the boudoir of la Pandora. . . . The delicious spidery scrawl of her script entangled itself dizzyingly with the indefinable, mysterious arpeggios that she drew from the strings of her harp, whose scroll disappeared under the entwinings of a gilded siren. Suddenly she threw herself upon my neck and kissed me.]

Her harp, her playing and writing, her movements, clothing and hair, all are arabesque.

> Il fallut encore que la séduisante Pandora nous jouat un tour à sa façon. Elle apparut en costume des plus légers, avec un caraco blanc brodé de grenats. . . . Ses cheveux nattés en forme de lyre se dressaient sur sa tête brune ainsi que deux cornes majestueuses . . . tirant à elle le cachemire. . . . Elle dansa ensuite le pas du schall. (353)

> [The charmingly seductive Pandora again had to play us a trick in her fashion. She appeared in an extremely scanty costume, with a white camisole jacket embroidered with pomegranates. . . . Her hair, braided in the form of a lyre, stood erect on her brunette head just like two majestic horns . . . drawing to her the cashmere shawl. . . . She then danced the shawl dance.]

It should be noted that the motif of the pomegranate is not only a sexual symbol, but also the most prevalent form taken by the arabesque in the Renaissance, and that cashmere shawls are always of paisley—arabesque—design. The Subject's reaction to both these scenes is one of complete verbal disarray and of a sense of total lack of being. In the first, he realizes that he is ill-equipped to keep the date Pandora has promised him for the following day, for his "purse" is empty: "Mais ma bourse était vide. —Quelle honte! vide, hélas!" (But my purse was empty. —How shameful! Empty, alas!) (350). The metaphoric use of *bourse* is well known. This interpretation of the Subject's dismay seems warranted by the exclamation points, the repetition of the word *empty*, and the dashes so often used by Nerval to express lack. In the second

scene, he forgets his lines in the charade that follows Pandora's perfor-
mance, and "le sourire glacée des spectatrices" (the frozen smile of the
women spectators) (353) fills him with terror. Castration anxiety and the
resultant sense of disintegration will soon be countered by the use of the
fetish. He flees from the salon and, shamefaced, takes refuge in a tav-
ern, where he writes to Pandora. The style of the letter (and of the text)
represents an attempt to incorporate, and thus master, the sinuous, en-
igmatic forms the Object takes: "J'écrivais à la déesse une lettre de
quatre pages d'un style abracadabrant . . . j'osai même m'attaquer à ses
pieds serpentins que je voyais passer insidieusement sous sa robe (de
brocart)" (I wrote to the goddess a four-page letter in a bewildering
style . . . I even dared to attack her serpentine feet that I saw moving
insidiously under her [brocade] dress) (354). The connection between
writing and the fetishistic attention to the woman's feet is not illogical.
His desire must be taken *au pied de la lettre*. The rhythm of syllables in
Nerval's prose resembles the undulation of *pieds* in a verse line: like the
feet, it is serpentine.

The text unceasingly focuses on body parts; the Object is not per-
ceived as a whole (perhaps because her excessiveness and all-inclu-
siveness prohibit it). From the breasts of marble to the serpentine
feet glimpsed under the dress, the Subject's desire fastens upon the part
object. The part object is "an anatomical part whose availability for
phantasy is inseparable from its apparent capacity to become detached
and circulate in a chain of substitutions."[19] Symmetrically, the text too
is composed of fragments, many of which could easily be transposed.
What is more, some of these part objects are fetishized: they become
the *exclusive* recipient for the Subject's libido. A fetish is always some-
thing detachable from the object (the shawl, the pomegranates, the way
the coiffure and feet are perceived). According to Freud's theory of the
origin of the fetish, when the male child first perceives that his mother
is lacking a phallus, his assumption that it must have been cut off in-
spires a castration phantasy. The fetishized object represents the
mother's phallus, and its use is a disavowal of what he has seen but
cannot bring himself to believe. In fact, Nerval complained to Dumas
(publisher of *Le Mousquetaire*, in which "La Pandora" was to appear)
that the printer had failed to include the "en tête," thus cutting the
mermaid in half ("vous avez coupé la sirène en deux—j'apporte la
queue" [you've cut the mermaid in two—I bring the tail]). Even though
Gérard "brought the tail," he was still aware that what he had given
Dumas was a text of "bizarre fragments" that were typeset "[sans] queue

ni tête" (*Oeuvres*, 1190, 1192). Even if we resist a Freudian interpretation for the word *queue*, the anxiety regarding fragmentation and the desire to perceive a dismembered body as unified and whole remains, and that is certainly pertinent to an analysis of the fetish. "The fetish is a metonymic displacement *onto something insignificant*, that is highly meaningful, and it is this displacement which maintains the lack of being in the subject's relation to others."[20] My emphasis in this quotation is to show why ornament can so easily be used as fetish. In addition to this blurring of the distinction between essence and attribute, both ornament and fetish shift focus from the center to the border and from representation to symbolization. In this text, the Subject's lack of being is surely tied to the fetishistic way ornament is used. The dream that comprises the next segment will confirm this notion.

"Elle avait disparu pour l'éternité. J'étais en train d'avaler quelques pépins de grenade. Une sensation douloureuse succéda . . . je me trouvais étranglé. On me trancha la tête" (She had disappeared for all eternity. I was in the process of swallowing some pomegranate seeds. A painful sensation ensued . . . I was strangled. They cut off my head) (355). The Subject *literally* incorporates one of Pandora's arabesques—the pomegranate motif on her dress. The phantasized incorporation of this fruit, a well-established erotic symbol, causes the Subject's castration phantasy. If the fetish is, as Freud proposed, a representation of the Subject's castration anxiety at the sudden awareness that his mother does not have a phallus, then the Subject's incorporation of the fetish object should endow him with an even greater sense of being in possession of it. This is not the case in "La Pandora." The lack of being that the hero previously felt is only intensified by the ridiculous aspect of this attempt:

> J'étais mort tout de bon, si un perroquet passant à tire-d'aile, n'eût avalé quelques-uns des pépins de grenade que j'avais rejetés. Il me transporta à Rome sous les berceaux fleuris de la treille du Vatican, —où la belle Impéria tronait à la table sacrée. . . . A l'aspect des plats d'or, je me sentis revivre, et je lui dis: 'Je te reconnais bien Jésabel!' (355)

> [I was doomed for good, had a parrot flying by not swallowed some of the pomegranate seeds that I had coughed up. They transported me to Rome under the flowering bowers of the Vatican trellis, —where the beautiful Imperia sat enthroned at the sacred table. . . . At the sight of these golden plates, I felt myself live again, and I said to her: "I recognize you very well, Jezebel!"]

The hero is rescued from catastrophe by the same bird of repetition we saw survive the demise of an entire world of childhood in the Valois. Here too the bird repeats . . . the act of incorporation. There is a variant for "sous les berceaux fleuris," and that is "*dans* les berceaux," a telling first impulse to use a preposition that would ambiguously place the Subject in his infancy/cradle/bower (see the use of this word in the previously cited passage in this chapter). Here, it is not the arabesque but the sight of nourishment that makes the Subject "come alive again." Ornament as fetish is clearly *not* a substitute for "le lait des forts" (the milk of strong men) or the lost voice of the mother. It is, in fact, placed in opposition to nourishment, cradle, life. The ornaments that functioned as transitional objects and as a vestige of the Lost Object were aimed toward reintegration of the self; the ornaments that function as part objects and fetish serve only to intensify the feeling of fragmentation and lack of being. Nerval's use of the fetish as representative of the Object of desire—certainly appropriate in a text centered on the figure of a phallic, castrating woman—is an expression of an intensely destructive impulse with no corresponding re-creation such as we saw in "La Main enchantée." It is a despairing and perverse fixation on Eros as Thanatos. This is in perfect accord with the ambivalence of the Subject's relation to the fetish; veneration alternates with the desire to destroy. Another aspect of the fetish is the importance of its secret nature; it is the sole possession of the Subject, and he can enjoy it only in secret. This would help to explain the enigmatic quality of "La Pandora" immediately inscribed on the first page of the text with "la *Pandora*, c'est tout dire, car je ne veux pas dire tout," as well as in the quotation of the hermetic anagram engraved on the stone of Bologna, *Aelia Laelia*. At the end of "La Pandora," the "siren" offers her famous box to the hero: it is full of *poupées de Nuremberg*, those "charming" automatons to which E.T.A. Hoffmann also has recourse (for example, in "The Sandman"). Perhaps the "secret," the repressed desire in this text, has to do not only with the fetish as exclusive recipient of desire, but with this fetish object as dehumanized, inanimate, dead, composed of movable parts that the Subject can manipulate at will. These strange figures of the Object of desire remind us of the ease with which literary imagination can transform the animate into the inanimate. The ornamental figure of the arabesque is often used in the depiction of this troubling desire in both "La Pandora" and in the texts of Gautier to be analyzed (this is also the case in Hoffmann and Poe). A similar metamorphosis will take place in the fin de siècle with the *femme-fleur* and other constructs of the Object

of desire as ornamental object. The presence of these figures not only points to an evolution in the relation of Subject to Object that will, by the 1890s, supplant the other forms of object relation I have described in this chapter, but it will mark the logical end point of the concurrent evolution of the other major function of ornament in nineteenth-century literature, that of signaling a text as self-reflexive.

FRAMING GAUTIER'S "TAPISSERIE AMOUREUSE"

Between 1820 and 1860, many books were illustrated by lithographs that framed the text. Célestin Nanteuil, a close friend of Nerval and Gautier and member of the Petit Cénacle, created drawings and lithographs composed of a frame of "fairylike embroideries" of minuscule, intertwined figures.[21] In addition to his book illustrations, he furnished the densely packed ornamental frame for Nerval's theater journal, *Le Monde dramatique*, which glorified Jenny Colon (fig. 10). Gautier wrote, "he excelled at framing his poetic, dramatic and novelistic characters in ornaments similar to Gothic reliquaries . . . [and] chimerical animals . . . that he invented at the tip of his pen, for he possessed an inexhaustible capacity for fantasy" (Champfleury, *Etudes*, 5). Nanteuil's apprenticeship was "more literary than plastic" (*Etudes*, 4), but one can guess that the writers who worked closely with him were inspired by his ideas as well. In the following description, we can see the relation of his ornamental designs to Eros: "the scrollwork of bizarre angels, of hunchbacks, of armored knights, of women twisted and ravaged by passion" (*Etudes*, 3). Finally, he relied exclusively on his imagination, for "when he tried to draw from nature, he was worthless" (*Etudes*, 5). The decorative frame, unlike ornaments in a transitional space, appears (at least provisionally) to be the exclusive realm of the Imaginary.

Meyer Schapiro has written that "the frame sets the picture surface back into depth and helps to deepen the view; it is like a window frame through which is seen a space beyond the glass. The frame belongs then to the space of the observer rather than of the illusory, three-dimensional world."[22] If we apply this observation to the frame narratives in Gautier's short stories, then we would expect to discover a greater amount of subjective phantasy, especially phantasy of the identificatory sort in the frame.

In the texts I will be studying in this section, we will see that Gautier uses the frame precisely as a space where the ambiguity between

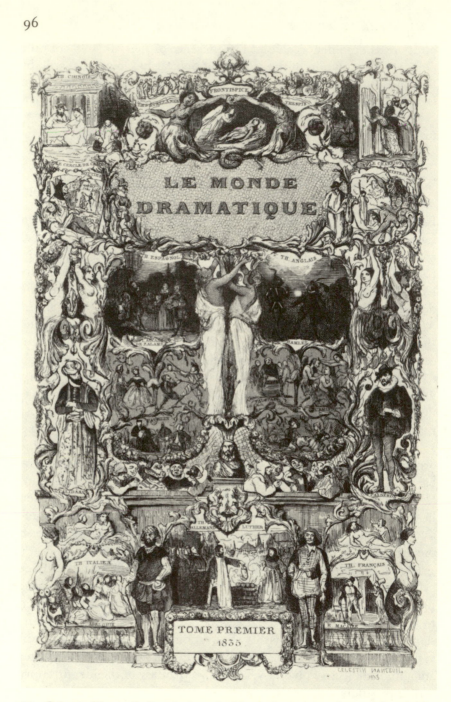

10. Célestin Nanteuil, frontispiece, *Le Monde Dramatique*, journal founded by
Gérard de Nerval.

"reality" and "illusion" can best be constructed. This principle will be all the more valid in the fantastic tale where boundaries are multiplied to include dream/supernatural/art/reality. However, this ambiguity is framed in so obvious a way—that is, it is framed as a play of elements within an aesthetic object—that the element of "reality" has little force.

In both fantastic tales to be analyzed, the ornamental object—inseparable from the Object of desire in a way we have not yet seen—emerges from an extremely ornamental decor that serves as its frame (fig. 11). At the same time, this frame is part of a series of frames having different narrative functions. A frame may mark off and frame the central tale; it can place frame and framed in tension with each other, or it may work to eliminate the notion of frame altogether. This play or tension between different narrative planes has much to do with the Subject's relation to the Object of desire, as well as with the boundaries mentioned earlier.

In addition to crafting innumerable examples of texts that focus on the part object (for example, "Le Pied de momie"), Gautier openly proposes the fetish as the inevitable proof of the lover's desire for the Object in "Diamant du Coeur" (*Emaux et Camées*). "Tout amoureux, de sa maîtresse / Sur son coeur ou dans son tiroir / Possède un gage qu'il caresse. . . . L'un d'une chevelure noire / . . . a pris un boucle que moire un reflet bleu d'aile de geai. . . . Un troisième . . . cache un gant blanc, de forme étroite, / Où nulle main ne peut tenir. . . . / Celui-ci baise le pantoufle / Que Cendrillon perdit un soir" (Every lover, near his heart or in his drawer, possesses a pledge of his mistress that he caresses. . . . One has taken a lock of black hair . . . that the reflections of a blue raven's wing makes shimmer like watered silk. . . . A third . . . hides a white glove so narrow, no hand can fit in it. . . . This one kisses the slipper that Cinderella lost one evening).[23] If Gautier is known for fetishizing the woman's clothing at the expense of her person, how much more of a fetish results when the clothing *and* the person are composed of decorative fabric, when they are both tapestry?[24]

In "Omphale: Histoire rococo" (also published as "Omphale ou la tapisserie amoureuse"), the desire we saw circulate in the margins of the Nervalian text is foregrounded. There it is simultaneously displayed and trivialized by an ironic, precious style. In parallel fashion, ornament—impregnating the decor, the Object of desire, and the style—is also foregrounded. And that is precisely why it ceases to function for the reader as the relay for desire.

11. "Esmeralda," wallpaper, 1831.

The hero, aged seventeen, lives in a little house in back of his uncle's rococo residence, framed by a wildly overgrown garden. In the center of his beautiful room, a room he excitedly declares he has all to himself, there is an ornamental shellwork clock on a pedestal inlaid with ivory and mother-of-pearl, and a Venetian glass around which "une guirlande de roses pompon circulait coquettement" (a wreath of ornamental roses coquettishly twined), thus framing his image (see fig. 19).[25] The images of self-containment and mirroring are in keeping with theory on the fetish. The fetish is often a part of a narcissistic universe.[26] The rococo decor also provides a frame for a tapestry "dans le style le plus *Pompadour* qu'il soit possible d'imaginer" (in the most *Pompadour* style imaginable) (104–105). This tapestry represents Omphale, queen of Lydia in the legend of Hercules.

Before looking at the adventures of the hero and Omphale in the central tableau, it is necessary to underline the position of the uncle in the framing narrative. He is first represented by his property "dans un état de dégradation complète" (in a state of extreme dilapidation) (103). This metaphoric representation of the uncle is soon made more explicit: "Cette pauvre ruine d'hier . . . avait l'air d'un de ces vieillards précoces, usés par de sales débauches" (This poor ruin . . . seemed to resemble one of those precociously old men worn out by filthy debauchery) (104). Then he is referred to as someone who has the most aristocratic disdain for literature (whereas the hero will become an author of fantastic tales). Indeed, he poses a threat to both the germinations of the fantastic and the first erotic experiences of his nephew, for he abruptly breaks into the central tableau to remove the tapestry (exercising his property rights) in order to put an end to the nightly trysts with Omphale (trysts that will later become fodder for the hero's tales). Moreover, there are many indications that suggest the uncle is a paternal figure, a rival. The tale opens with the words "dans le jardin de mon oncle . . . il y avait un pavillon . . . [au] nom de *Délices*" (in my uncle's garden . . . there was a pavilion . . . named *Délices*) (103). The figure of the mother is evoked by the pavilion whose "murs faisaient ventre" (walls were bulging out [like a stomach]) (ibid.). Facing the tapestry of the blond Omphale, moreover, is a portrait of one of the uncle's old mistresses. Finally, the dilapidated aspect of the uncle's property suggests that his debauchery is a thing of the past, and that it is time that his young charge took his place in this domain: "C'était une fabrique assez lamentable á voir que les *Délices* de mon oncle" (The *Délices* of my uncle presented a rather lamentable aspect) (ibid.). Thus, the frame may well contain an Oedipal

rivalry that remains somewhat obscured in the telling of the tale, in contrast to the exhibitionistic desire of the center.

Even before the Subject's desire focuses on Omphale, it is his room that functions as the Object of desire:

> Quand je me trouvai dans cette belle chambre, chambre à moi, à moi tout seul, je ressentis une joie à nulle autre seconde. J'inventoriai soigneusement jusqu'au moindre meuble; *je furetai dans tous les coins et je l'explorai dans tous les sens . . . heureux comme un roi* . . . tant j'étais impatient de jouir de ma nouvelle demeure. (107; emphasis mine)

> [When I found myself alone in this fine room, my own room, all to myself, I felt a joy second to none. I made a careful inventory of everything, down to the smallest piece of furniture; *I rummaged in every corner and explored the room in every way possible . . . happy as a king* . . . such was my impatience to take pleasure in my new home.]

I have noted the Subject's insistence on exclusive possession of the room (with bulging walls); the uncle is explicitly mentioned in the next sentence.

Omphale, composed entirely of woolen or silk threads, has ash blond hair that falls nonchalantly along her supple and undulating neck. "Ses petits pieds, vrais pieds d'Espagnole ou de Chinoise . . . étaient chaussés de cothurnes demi-antiques, lilas tendre, avec un semis de perles. Vraiment elle était charmante!" (Her little feet, true realizations of the typical Andalusian or Chinese foot . . . were shod with half-antique buskins of a tender lilac color, sprinkled with pearls. Truly, she was charming) (105). In addition to the fetishized feet, the text notes her white shoulders, hand, pout, nostril, cheeks, and beauty mark. The charming figure responds to the hero's desire by defeating the boundaries of the framed tapestry in which she is enclosed. "La tapisserie s'agita violemment. Omphale se détacha du mur et sauta légèrement sur le parquet; elle vint à mon lit" (The tapestry became violently agitated. Omphale detached herself from the wall and leaped lightly to the floor; she came straight toward my bed) (108). To the stupefied hero, she remarks, "'Cela te semble étrange de me voir ici et non là'" ("It seems strange to you to find me here instead of there") (109). The leap outside the frame is what constitutes the fantastic element in the text. In the context of Freud's theory of the fetish, this may read as commentary on the state of mind necessary to maintain "belief" in a fetish object. The fetish (as maternal phallus) is known to be impossible and yet believed in. The uncanny

(*unheimlich*) and traumatizing moment when reality is discovered, and yet belief persists, takes place in Gautier's text when Omphale walks backward so as not to reveal the tangle of threads that forms her back.

This leap into the center from the marginal place normally accorded to ornament is replayed in "La Cafetière" (to which I will shortly turn). However, because of the extravagant presence of ornament in the room, and in the description of the hero, the tension that might have existed between margin and center has already been effaced. In the same way, the narrative frame of outside reality to which the uncle seemed consigned gives way, and the uncle erupts on the scene of the framed narrative; there, he confirms that the woman in the tapestry is in fact capable of literally seducing his nephew, for he asks how she could have fallen for such a *morveux* (a snotty-nosed kid) and complains that she had promised to behave herself (112). He has the tapestry rolled up and carted away. The tension characterizing the fantastic—the hesitation between dream, reality, and supernatural event—disappears at the same time as the potential force of the Oedipal conflict (until then veiled).

The representation of Omphale is in fact a mythologized portrait of a marquise of the time of Louis XV. Her husband is depicted with the features of Hercules, spinning flax at the queen's feet. As the second title of the tale ("Omphale: Histoire rococo") hints, the ornamental Object of desire is a *mise en abyme* of the text itself, or at least, of the act of writing. This ornamental object is, as I have indicated, the Subject's initiation into Eros *and* into writing. Hercules is spinning inside a woven tableau inside a text that weaves together frame and tableau, ornamental figures and "human" Subjects. The analogy between Hercules and the Subject is also manifested in the pink ribbon around the distaff he holds (the hero's reflection is encircled by ornamental roses), and the fact that both love Omphale. Note that he weaves at the queen's feet. The Subject, too, focused his attention on her feet in weaving his tale. Out of the fetish is woven the text.

Some years later, the hero, now a writer, sees the tapestry at the shop of a *brocanteur*. He doesn't have enough money in hand to purchase it, and when he returns, the "rouleau . . . couvert de toiles d'araignées" (rolled-up tapestry . . . covered with cobwebs) (113) has been sold. The ornamental form, *rouleau*, is also a support for writing. The Subject does not appear overly moved by this second loss, and indeed the libidinal investment in the Object seems to have been displaced into the pleasure of writing the tale, itself a decorative object (une histoire rococo). And it is *this* ornament that forms a guarantee for the other: it

has "gardé intact ce délicieux souvenir" (kept intact this delicious memory) (ibid.). This may be seen in opposition to the dilapidated "property," the *Délices*, of the uncle. The visual representation of this displacement was already seen in the tapestry: Hercules' phallic staff wound with thread. The name Omphale is the metamorphosis of sexual force into aesthetic enjoyment, be it into tapestry or ornamental text.[27]

Like Pandora, the Object of desire offers up a series of part objects to be fetishized. Here, however, the Object of desire is entirely indistinguishable from the decorative object. The same phenomenon is true in "La Cafetière" (fig. 12).

The hero, a young painter, arrives with two friends at a house in the country where they are to spend the night. The journey there frames the central tableau and represents the realm of reality. In parallel fashion, a framing segment at the end returns to reality and day. At night, though, the portraits in the rococo room where the hero falls asleep are unlocked from their enclosing frames and jump down to dance to the strains of music played by reanimated figures in a tapestry. Forms and movements compose decorative patterns that frame the Object of desire. The armchairs move "leurs pieds tortillés d'une manière surprenante" (their twisted, contorted feet in an amazing way), while silken dresses are "froissées dans ce tourbillon dansant" (wrinkled in the dancing whirlwind) to the tones of "un déluge de notes et de trilles si pressés et de gammes ascendantes et descendantes si entortillées" (a deluge of notes and trills so quick and of [such wriggling] descending and ascending scales).[28] As was the case in "Omphale," the second frame—which contains the description of the rococo room—is the passage from reality to dream or the supernatural and also to the Object of desire. Therefore, it is neither completely external nor internal to the central tableau. The furniture "surchargés d'ornements de rocaille" (overburdened with rocaille ornament) (250) is already imbued with the same erotic drives and otherworldly mystery one sees in the framed tableau.[29] In Nerval and Gautier, ornament *brings on* the marvelous or the fantastic. And this vision brings about the artistic production of the Subject. The Object of desire is a decorative object, a porcelain coffeepot that takes the form of a woman during the ball. At the ball's end, though, she falls and the coffeepot is broken into a thousand pieces. In the last sequence of the tale, the Subject executes a drawing of the coffeepot that causes his host to exclaim how much it resembles his dead sister, Angela. At that moment the hero sees that what had seemed a porce-

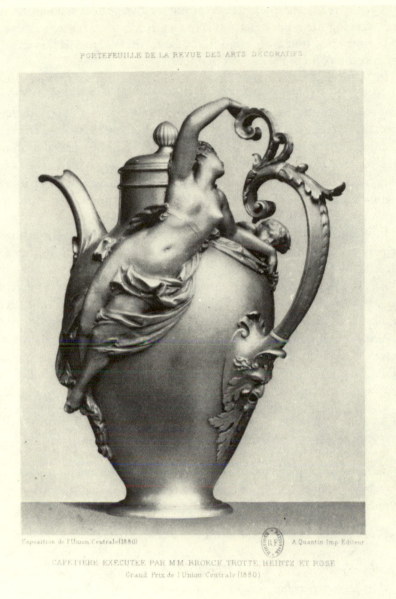

Exposition de l'Union Centrale (1880) R F A Quantin Imp Éditeur

CAFETIÈRE EXÉCUTÉE PAR MM. BROECK, TROTTE, HEINTZ ET ROSE
Grand Prix de l'Union Centrale (1880)

12. Broeck, Trotte, Heintz, and Rose, coffeepot, Grand Prix de l'Union
Centrale des Arts Décoratifs, 1880.

lain pot is really the melancholy profile of the perfect woman he had seen dancing the night before. It is in fact the ability to exercise this sort of trompe l'oeil that is required in the fantastic tale, just as it is encouraged in the contemplation of ornament.

In "Omphale," the frame tended to disappear; here framing is emphasized. The Object of desire is circumscribed by a series of frames that designate her role as aesthetic object, even as her ability to act is severely restrained. This early tale, published only two years before Gautier formulated his theory of *l'art pour l'art* in the preface to *Mademoiselle de Maupin*, effaces the utilitarian aspect of the decorative object in question, the coffeepot, in order to underline the primacy of its aesthetic virtues. More clearly than in the first tale, the Object of desire is a pure pretext for the aesthetic production of the Subject.

In Nerval's texts, ornament was a subterranean, structuring filigree or network in the text and functioned as bridge between Subject and Object. In Gautier's texts, ornament is foregrounded, and like the Object it emerges out of the narrator's subjectivity and has no external existence of its own. The libido is withdrawn into the self, and that is perhaps why libidinal investment is minimal.[30] The disappearance of libidinal investment is evoked quite clearly in "Le Club des hachichins," where, thanks to *kief* (hashish), the contours of the ornate, framing salon evaporate and where "Romeo hachichin eût oublié Juliette" (Romeo hashish-eater would have forgotten all about Juliet).

> Aussi je regardais d'un oeil paisible, bien que charmé, la *guirlande de femmes* idéalement belles qui couronnaient la frise de leur divine nudité; je voyais luire des épaules de satin, étinceler des seins d'argent . . . onduler des hanches opulentes, sans éprouver la moindre tentation. . . . Par un prodige bizarre . . . je me fondais dans l'objet fixé, et je devenais moi-même cet objet. (Emphasis mine)[31]

> [Thus I was watching peacefully, though charmed, the *garland of ideally beautiful women* who crowned the frieze with their divine nudity; I saw satin shoulders glisten, silver breasts sparkle, opulent hips undulate, without experiencing the least temptation. . . . By a bizarre form of magic . . . I melted into the object I was staring at, and became myself that object.]

Nerval's texts incorporated the ornamental qualities of the Object, but because of the way the Object was used, the texts retained a large degree of Otherness. Even when the Object is fetishized (in "La Pandora"),

she remains outside the Subject's total control. In addition, the Subject's desire to devour the Object and the phantasized punishment he depicts in the tale reflect very primitive drives that give the text its erotic tension. (These drives reappear in Gautier's *Jettatura*, a novella to be studied in detail in the next chapter.) This is not the case in the short stories of Gautier. The last verses of "A une robe rose," another poem in *Emaux et Camées*, furnish an illustration of the way the Subject produces and replaces the ornamental character of the Object: "Ces plis roses sont les lèvres / De mes désirs inapaisés / Mettant au corps dont tu les sèvres / Une tunique de baisers" (These rosy folds are the lips / Of my unappeased desires / Placing on the body from which you wean/sever them / A tunic of kisses). His lips/desire *are* her ornament. "Weaned" of any vital connection to the Object, the Subject frames her with a parergon of kisses: a tunic of his making, a text. Thus, he is self-sufficient and no longer needs the Object. And the verb *sevrer*, to wean, in the familiar form of the second person is *sèvres*, offering an irresistible pun on another genre of decorative object-woman, the one Gautier paints in "La Cafetière": Sèvres porcelain.

The aspects of mirroring and self-sufficiency in ornament as fetish (the fetish object is used as a mirror or as a production of one's own making), inevitably joined to the fact that the fetishized parts of the Object are treated as detachable, place these ornaments under the control of the Subject. Manipulator of his fetish, "the essential thing is that the subject believe himself to be the sole animator of his desire."[32] The ability to control the Object is sought in response to a feeling of separation. It is, in fact, a denial of that separation; thus the *sèvrage* becomes the hard, impermeable, brilliant decorative object, Sèvres porcelain.

Where ornament figured the *Object* of desire in Nerval and incorporated the structure of lack, ornament figures the *site* of desire in Gautier, with the decorative object/text itself supplanting the Object of desire (all the more desirable when it is inanimate). But a problem remains: in "La Main enchantée," the hand as fetish is under the control of the narrator; in "La Pandora" it is not. Something about the signifier behind the fetish is dangerous for the Subject in the latter. Not only death but the loss of inner fire and virile force is threatened in "La Pandora." In "La Main," the danger was death, but not the narrator's death, only his hero's. In addition, the *mandragore / main de gloire* magically assured sexual potency. Ironically, many of the metaphysical issues at stake in the Schlegelian arabesque (chaos, annihilation/death, fragmentation) were to become all too real for Nerval, but in 1832, eight years

before his first psychotic break, the fragments of the self/text could still be held together by the network of arabesques without producing the sort of tension, conflict, and pain one feels in *La Pandora*, or even in the margins of *Sylvie*. Thus, there is a direct relationship between the way ornament is used to represent desire and the way the writer is affected by the content of the ornamental figure. This means that we need to be interested in not *why* ornament means different things at different times to different writers, but *how* they use ornament at various times to new ends.

The Evil Eye: Ornamental Vision as the Sublime

Gautier . . . le plus robuste artisan de la langue moderne.—*Banville*

Gautier darde vivement son regard sur le non-moi.—*Baudelaire*

Nous nous réduisons autant que possible à n'être qu'un oeil
détaché. . . . Voir, c'est possséder.—*Gautier*

GROTESQUES AND THE SUBLIME

In Gautier's *Jettatura*, the fundamentally ambiguous nature of orna-
ment is radicalized: as pleasurable aesthetic contemplation—a feast for
the eyes—and as dangerously seductive. This was already the case in
Nerval's "La Pandora," but what makes the Gautier text more radical is
both its focus on the problem of the gaze and the clarity with which it
posits the opposition (or identity) of visual delectation and death. This
couple is made evident, poised on the second page of the novella, in the
quotation "*Vedi Napoli e poi mori*," highlighted by its status as cliché, by
the use of italics, and, of course, by the shift into a foreign tongue. The
phrase's familiarity makes the signified—death—innocuous, while the
emphasis is placed on the ecstasy of the aesthetic moment. Despite
these and similar strategies of attenuation, the terrifying and beautiful
experience of the hero's gaze remains intense throughout the novella,
revealing the emblematic nature of this quotation linking death to the
gaze.

All of Gautier's critics have focused on the pervasive emphasis on
immobilization of form and marblelike rigidity in his writing. Much of
this criticism has drawn attention to the elimination of emotion in the
poetry and prose. But the emotion repressed elsewhere in Gautier re-
surfaces in *Jettatura*, materialized as ornamental vision, here as a primi-

tive, destructive drive. The chaotic superabundance of ornament de-
picted here—the pure pleasure of extravagance and excess—is analyzed
in terms that appear nowhere else in the novellas and short stories. In
no other text does one feel the very real and frightening peril of aban-
donment to decorative proliferation, to voracious consumption by the
vision and language of ornament. And here one sees the libidinous
meaning of the insistence in the text of all those *langues*, or tongues: the
Italian tongue, the Neapolitan dialectical tongue, the language of
cliché, and the tongues of flame that devour the dancer under the hero's
gaze.

The features of the hero, Paul d'Aspremont, are a mixture of oppo-
sites, and he has "l'affreux privilège de réunir les miasmes morbides, les
électricités dangereuses" (the fatal power to collect and concentrate
dangerous electricity and morbid miasmas).[1] As a Frenchman, he func-
tions as an intermediate figure—or meeting place—of the two geo-
graphical settings of the novella, north (England) and south (Naples).
He is also the *lieu de passage* between life and death: his mother died
while giving birth to him. Finally, in the short stories of Gautier, the
oscillation between dream and reality constitutes the thematic core, and
the hero remains a mystified spectator to this shifting of levels. In con-
trast, in *Jettatura*, Paul incarnates a dreamlike, supernatural being at the
heart of reality. (A pivotal moment of self-recognition causes him to
exclaim: "Le rêve existe autant que la réalité" [Dream has as much claim
to existence as reality] [427].) In short, Paul is a walking oxymoron.

Other oppositions are transgressed in *Jettatura*, and the fact that they
are in aesthetic categories is of considerable concern in a story about
(ornamental) vision. The first of these is the breakdown of the division
between the decor, normally meant to frame the characters and action,
and the latter two narrative elements. Here, the decor is given an equal,
if not predominant role. In the tableaux of decor, one is struck by the
numerous descriptions of a frame or border and the unusually acute
attention given to this peripheral structure. This is stressed even more
by the frequency of words like *bord*, *cadre*, *ceigner*, and so on. Sometimes
the border transgresses its position to overrun the object it frames, as
in the foam-crested wave that dashes itself against the promenaders in
the novella's opening. It is Paul's gaze that causes this ornamental, if
violent, spectacle, just as it causes the heroine, Alicia, to be enveloped,
and then incorporated into the decorative vegetation that would nor-
mally remain a simple frame. Similarly, the narrator first has Paul

emerge from a small enclosed space, explicitly referred to as a *cadre*. His initial circumscription only makes the proliferating force of his gaze more powerful. In both cases, the dynamic is the same: the action of framing is followed by the action of intermingling and confusing figure with frame. In addition, the confusion between figure and frame here is more emotion-laden than it was in the short stories because of the fatal consequences it bears for the Object of desire. This is a disturbing tendency of ornament, which often constructs a frame only to disrupt it. The text thematizes and dramatizes this aesthetic problem, thus underscoring the emotional impact such compositional tensions create in the viewer/reader. And it is particularly in a text where the reader *becomes* a viewer that this effect is most intense.

The second fundamental opposition located in an aesthetic category is the image of the grotesque, the embodiment of a clash of irreconcilable opposites. The grotesque has been seen as an excessive relationship between antithetical parts. This excess is at the point of their overlapping and therefore effaces the hypothetical border between them.[2] Thus, the tension between borders and their transgression, as well as the problem of excess, lies at the heart of *Jettatura*'s structures and themes. As a paradoxical admixture of traits, Paul himself epitomizes the grotesque. In addition, his groom is "a sort of fifteen-year-old man," who is described as a gnome in uniform, resembling a hunchback, flat-faced, and with eyes as gentle as a toad's. Moreover, the Neapolitan setting offers many grotesque images: the youths who swim "like fish or marine deities" partake of the most typical grotesqueries, half human and half animal; the contortions and exaggeratedly vociferous speech of these Southerners resemble the overweening expressiveness and irregularity of the grotesque; even the heroine's staid British uncle wears an outfit that is described as grotesque. Therefore, it was inevitable that Pompeii be used as decor for one of the novella's important scenes. Beyond its usefulness in providing local color, it is a site where the remains after the catastrophe are evoked most typically by the grotesques that particularized the wall decorations. Since the rediscovery of Nero's Domus Aurea in the Renaissance, these abstract arabesque decorations have, as we have seen, inspired numerous artists and writers.

The insistent presence of the grotesque in the novella is important for the following reasons: first, the grotesque is a subcategory of ornament; second, the grotesque provokes a double reaction of aesthetic

fascination (astonishment) and terror (albeit a comic terror), the very qualities ascribed to the sublime; third, the grotesque can be shown to enjoy a complementary relationship with the sublime: indeed, it may be seen as the sublime turned inside out, or perceived from a slightly different angle.[3] Finally, these two rhetorical strategies, one linguistic and the other visual, come into play; the oxymoron and the overflow of ornament into the tableau it is meant to surround are manifestations of the principal structure of the sublime: a *débordement* (overflow) that defeats the very notion of border. This fullness or excess is in the mind: "In the sublime, we tax the utmost powers of the imagination, and drive it as far as ever it can reach in its presentations, so as to enlarge the size of the measure."[4] And it is in the object: the colossal is "almost too great for representation."[5] The object of the gaze in *Jettatura* is positioned squarely on the border, a border that is put forth only to be transgressed (like the frame, neither inside nor outside the work of art).

It is the idea of the evil eye and the ornamental vision it projects as a manifestation of the sublime that I would like to examine now. The moments of the Kantian sublime may be outlined as follows: (1) The perception of an object characterized as "sublime" causes the habitual harmonious relation of Subject to object to collapse, for the imagination is incapable of arriving at a representation of the object. Examples of this sort of object involve absolute greatness and may include wild irregularity, infinitude, or fearful might. (2) This inadequacy causes a feeling of displeasure. (3) But if the faculty of sense fails, reason comes to the fore with its idea of absolute totality, the unconditioned, the infinite, and so on. The elevation of nature beyond our reach is regarded as equivalent to a presentation of ideas. (4) Reason's ideas are also "unattainable" because they cannot be imagined or presented in sensible form, yet they are "called into the mind by that very inadequacy itself which does admit of sensuous presentation" (*Critique*, 92). Therefore an analogy is set up with the impossibility of representing the sublime object in the imagination. This analogy establishes a metaphorical relationship between the Subject's mind (that is, the concepts of reason) and the sublime object in nature. Both are seen as superior in the same way. The feeling of a supersensible quality within us—the feeling of the sublime—gives us pleasure: "The object is received as sublime with a pleasure that is only possible through the mediation of displeasure" (109). The imagination wins by losing, and in abandoning itself to a law other than its own, gains in extension and force. "In contemplation of

[sublime objects], the mind abandons itself to the imagination and to a reason placed in conjunction with the imagination, and merely broadening its view, it feels itself elevated in its own estimate of itself" (104–105). This mental movement "may be compared with a vibration, that is, with a rapidly alternating repulsion and attraction produced by one and the same object" (107). Similarly, in the dynamic sublime, the object (volcano, abyss, storm) may be fearful, but the Subject's awareness of his/her own secure position in regarding it produces joy. Danger and fearfulness, the challenge to our strength, elevate us by the experience of danger overcome and the finding of a superior power in ourselves. "In our mind, we find a superiority to nature, even in its immensity" (109).

The object now symbolizes the mind's relation to a transcendent order. In *Jettatura*, the prophylactic ornamental amulets used to counteract the evil eye incorporate the eye's feared/desired powers in their design, hence transferring some of these powers to their owners, who reproject them outward against Paul. As the principal sublime object in the text, Paul is the focus of attraction and repulsion.

"Un saisissement et une admiration qui n'est pas sans quelque terreur" (A shock and an admiration that is not devoid of terror) (*Mademoiselle de Maupin*) is often Gautier's reaction when confronted with a work of supreme genius. He who looks on beauty is awestruck, doomed.[6] Astonishment and terror, the two hallmarks of Burke's sublime, are first experienced by the writing Subject (Gautier), before becoming effects of the fictional Subject's (Paul's) gaze. The object creates a feeling of inadequacy in the Subject, overwhelming him with terror and admiration. In the effort to accommodate what is inherently ungraspable, Gautier transforms this lack into a feeling of the possession of a transcendent power of the object, first through the medium of his character, then through the artistic manipulation of the very elements that inspired the admiration mingled with terror.

On the Border

On the first page of the novella, the narrator describes the very thing the hero's gaze will eradicate: enclosure and the security it provides. "Sur le tillac, dans l'enceinte reservée aux premières places, se tenaient les Anglais tachant de se séparer les uns des autres le plus possible et de tracer autour d'eux un cercle de démarcation infranchissable" (On the deck, in

the enclosure reserved for first class, were the English, attempting to keep as large a distance as possible from each other and to trace an uncrossable circle of demarcation around themselves) (379). In the next passage, it is the female recipients of the gaze who are enclosed, emphasizing three features the text will repeat with insistence: the framing "spirals of hair," the gauze veil, and the woman's "long, white teeth" (380).

As the ship nears port, the admirable spectacle the Bay of Naples presents is rendered by the narrator (the hero has not yet made his appearance). The shimmering nuances of this passage offer a good example of ornamental vision, but not yet of its conjuncture with the catastrophic sublime that will only be represented by the hero's gaze.

> Il faisait beau; les vagues bleues se déroulaient à larges plis. . . . La fumée du tuyau, qui formait les nuages de ce ciel splendide, s'en allait lentement en légers flocons d'ouate, et les palettes des roues se démenant dans une poussière diamantée où le soleil suspendait des iris, brassaient l'eau avec une activité joyeuse. (381–82)

> [It was a glorious day; the blue waves came in gentle ripples. . . . The vapor from the smokestack, which formed in clouds in this splendid sky, gradually dissolved in snowy flakes, while the paddle wheels, revolving in a diamond shower where the sun hung its iris, churned the water with a joyous agitation.]

A passenger who "ne s'était pas fait voir" (had not shown himself) during the entire crossing emerges from his cabin. "Soit que le mal de mer l'eût retenu dans son cadre, soit que par sauvagerie il n'eût pas voulu se mêler au reste des voyageurs" (Whether he kept to himself on account of seasickness, or whether it was because, due to his untamed, wild nature, he did not care to mingle with the other passengers, is not known) (382). The hero's initial position in the frame, like that of ornament, is there only to be negated by the untamed quality that often pushes it outside (in contrast to the English tourists, who remain in their enclosed space). The expression of his eyes is "truly undefinable":

> S'ils se fixaient sur quelque personne ou quelque objet, les sourcils se rapprochaient, se crispaient, et modelaient une ride perpendiculaire dans la peau du front: les prunelles, de grises devenaient vertes, se tigraient de points noirs, se striaient de fibrilles jaunes; le regard en jaillissaient aigu, presque blessant. (382–83)

[If they fixed themselves on someone or something, the eyebrows contracted, frowned, and formed a perpendicular wrinkle in the forehead: from a pale gray the pupils became green, tinged with little black dots, streaked with yellow fibrils; the gaze that sprung forth from them was sharp, almost painful.]

What is so troubling in this gaze? The answer is couched in the legend to which the narrator has recourse in his attempt to encompass the unsettling mien of the hero. "La légende parle d'un peintre italien qui, voulant représenter l'archange rebelle, lui composa un masque de beautés disparates, et arriva ainsi à un effet de terreur bien plus grand" (There is a legend that tells of an Italian painter who, wishing to represent the archangel, composed a mask of incongruous beauty, and in this manner gave his portrait a far more terrible expression) (382). This is a mix of incommensurate concepts, beauty and terror: it is first the hero who is perceived (by the narrator, then by the Neapolitans) as a vehicle for the sublime.

We have moved from a structure of enclosure that betokens neat divisions to a transmutable structure that eludes precise perceptual comprehension.

The Eye of the Artist

Gautier himself was a *peintre manqué*; as an adolescent, he spent all his leisure time painting and drawing, and his family was certain he would grow up to be a painter. This vocation can be felt in his art criticism and his unflagging concern with the decorative arts, as well as in his desire to achieve a "transposition of the arts," that is, to make his writing rich with the possibilities normally found in the plastic arts. *Jettatura* was published first in installments in 1856, then by Michel Levy in 1857, and by Charpentier in 1863. It was precisely during those years that Gautier took over the direction of *L'Artiste* (December 1856–1858), proclaiming, "We therefore bring to *L'Artiste* the passion for art."[7] That this passion was founded on a deep, intuitive understanding of ornament, and a conviction that it was far more important than his contemporaries believed it to be, is made clear in the article of the 28 February 1858 issue of *L'Artiste*.

In leafing through this magnificent volume, we have reflected on this singular art that is called *ornament* and to which one does not commonly

attach a sufficiently great philosophical importance. Of all the arts, it is the one that contains the greatest degree of creativity. . . . It exists apart from and outside of everything else, with its forms that are infinitely variable, and for which no precise model can be found. . . . [The craftsman of ornament] begins a flower that is more or less realistic; but the pistil twists into a bizarre gold tendril/spiral, the stalk lengthens into scrollwork . . . with an inexhaustible and charming strangeness. Ornament is at once the most chimerical art and the most natural: it partakes of the innate ideas of man. . . . The most difficult task in the world is to imagine something that does not exist. Ornament tries to solve this problem and invents a world of creation alongside creation.[8]

The eye of the ornamentalist brings into existence the manifold (Gautier even uses the term "infinite") forms that one normally sees only in dreams: "Less concerned with signification than all the other arts, ornament, with its undulations of line, its twisting, decorative design of branches and its capricious flowerings, awakens the ideas of unknown forms belonging to dreamworlds." But this creation of "chimera" and "monsters" is a product of the artist's ability to discover "new combinations and arrangements" (ibid.).

And now a clear connection can be pointed out between Gautier's important doctrine of *l'art pour l'art* and his patronage of the decorative arts: The Preface to *Mademoiselle de Maupin* was a reaction to the tendency of the time to refer a text outward to a political or moral issue, thereby superimposing on art these concerns. Decorative design and Gautier's writing neither depend on nor refer to anything outside of themselves; *both are self-reflexive*. Yet ornament does signify in *Jettatura* and this message refers to death and terror. That is why Gautier's theory of ornament is to be classed not in the category of the Beautiful but in that of the Sublime.

Very late in the text, the evil eye is likened to the eye of the painter. As Paul kneels at the heroine's side, he asks that she let him "get drunk on [her] ineffable beauty" and "capture every detail like a painter" (466). If Paul believes in his "fatal ability to transform reality" with his gaze, so does Gautier: "Thought is an interior hammer that models forms the way goldsmiths do" (*Caprices*, 172). Moreover, an examination of Gautier's art criticism reveals the effects of the evil eye to be uppermost in what he most values in painting as well as in the decorative arts. Gautier's aesthetic criticism, like his own writing, oscillates between playful mobility and marblelike rigidity. For example, of Eugene Isa-

bey, he writes: "[His] brush stroke . . . sparkles, scintillates, wriggles like the belly of a fish in water, in flashes, in reflections, in mobile sequins . . . a sea that is always trembling . . . [and] embroidered with foam."[9] Sculpture and sculptural form are valued above all for the extreme discipline required of the artist and for their triumph over transcience. In a commentary on Pradier's marble statue *Nyssia*, Gautier is honored "to see one of [his] sentences carved in marble" since he has been "the disciple of these pure models, from which [he has] tried to recall . . . the white images."[10] Both reviews were written just a few years before *Jettatura*.

Returning to Kant's aesthetics, we may take up the aesthetic distinction between errant beauty (in the frame) and idealized form. For Gautier, it is ornamental form, techniques, and materials that offer the perfect examples of both. Furthermore, when Gautier enters the exposition hall of the *Exposition d'Industrie*, he is struck with a religious tremor that "was not without a sort of terror." He then goes on to describe this vision of the world's future, composed of the very ornamental configurations we will find at work in *Jettatura*: "Wheels with serrated teeth, tubes turned into spirals, . . . intertwining steel bars, complicated and mysterious machines, sparkling with steel and copper, . . . seemed to us endowed with life."[11] It is the decorative elements of these "monsters of bronze" that make them seem alive. In this four-page article, Gautier praises opulence, shimmer, caprice, ingenious invention, fantasy, stunning luminosity, and designs that are "more confused than the silk that wicked fairies gave to imprisoned princesses to untangle" (ibid.). These qualities are those of Paul's gaze. Elsewhere, he states that the artist, Froment-Meurice, knew how to infinitely vary the fantasy creations of the world of ornament "where the woman surges forth out of the flower's chalice, where the chimera terminates in leaf work, . . . where the arabesque tangles to its heart's content its interlace and complications" (see fig. 5).[12] This is precisely how the hero's gaze will enmesh Alicia in the decor—be it leaf, flower, or labyrinth.

The *Schaulust* of the *jettatore* is identical to the sublimated visual pleasures of the art critic. The evil eye is not only interchangeable with *l'effet-ornement*, it is also the eye of the true artist. *Vedi Napoli e poi mori* alerts us to the possibility that it is not only *being looked at* by the evil eye that brings about death, but also *to look at* intensely, to see behind the veil, to come face to face with the spectacle of the sublime, of ornamental splendor.

Gautier himself believed in the reality of the evil eye, as his daughter, Judith Gautier, has written. Decorative objects in his apartment served as amulets or fetishes against its threat. Gautier's fear of emptiness—"Oubli et néant, c'est tout l'homme" (*Maupin*)—has been commented on by several critics (Tennant, Schapira, Burnett),[13] and I am convinced that he uses decorative prose to cover over this fear, but the opposite fear is present as well: that he will be punished for seeing *too much*. The ordinary person views the writer of ornamental prose with suspicion, contempt, or incomprehension. The artist's vision singles him out, makes him different, and therefore makes him a target for the evil eye accusation. Thus, the excessive visual acuity possessed by both the artist and Gautier as an art critic and writer is comparable to the gaze of the evil eye.

Point of View

Gautier's emphasis on point of view in a novella on the sublime, perhaps pernicious, power of vision radicalizes the very notion of point of view, drawing out consequences that exceed habitual considerations of this narrative technique. Point of view becomes imbued with questions of good and evil, danger and pleasure, life and death. A later reference to the "angles" by which the eye projects its force will confirm that point of view takes on a moral status here.

Since *Jettatura* is not a first-person narrative, it is possible to distinguish the conditions and effects of Paul's gaze from those of the narrator and the other characters.

The "spectacle" of the embarcation belongs strictly to the group of idlers on the shore, but the next paragraph details the narrator's point of view: the "assault" on the ship and its tourists, considered as "prey" by the "riffraff" furiously rowing toward them. That the hero does not initally share in this point of view is made clear by the following paragraph:

> Le jeune homme aux cheveux auburn avait, pour mieux saisir les détails du point de vue qui se déroulait devant lui, posé son lorgnon double sur son nez; mais son attention detournée du spectacle sublime de la baie par le concert de criailleries . . . se concentra sur les canots: sans doute le bruit l'importunait, car ses sourcils se contractèrent, la ride de son front

se creusa, et le gris de ses prunelles prit une teinte jaune. Une vague inattendue . . . ourlée d'une frange d'écume se brisa sur le quai en millions de paillettes, . . . et fit, par la violence de son ressac, s'entrechoquer si rudement les embarcations, que trois ou quatre *facchini* tombèrent à l'eau. (383–84)

[The young man with the auburn hair, in order to see better, had placed his eyeglasses on his nose; but his attention was distracted from the sublime spectacle by the concert of yells and shrieks . . . [and] concentrated itself on the boats; no doubt the noise annoyed him, for his brows contracted, the wrinkle in his forehead grew deeper, and the pupils of his eyes turned from gray to yellow. Unexpectedly, a huge, foam-crested wave dashed itself furiously on the quay in a million sequins . . . and by the violence of its shock, it made the small boats crash into one another, tossing three or four *facchini* into the water.]

It is difficult to determine whether the impression that the bay is "sublime" belongs to the narrator or the hero. I believe it is simply there as a prompter: to have us perceive all the more easily the connection between the sublime and the effects of the hero's ornamental vision in the sentences that follow. The "sublimity" of the view of Naples is on the same order of cliché as the proverbial *Vedi Napoli e poi mori*. The effects created by the hero's gaze are altogether more powerful, more "violent," than the narrator's point of view. The "assault" on the steamer first belongs to the narrator; it is not until it becomes the hero's vision that the aggression, turned against the object, becomes quite beautiful and spectacular. These effects are evenly divided between a glittering ornamental profusion and a near-catastrophic upheaval of nature. Vesuvius, of course, is always in the background as an ominous reminder of real catastrophe.

The reader learns the reason for Paul's trip to Naples from a letter waiting for him at his hotel. The letter is from a young Englishwoman, Alicia, who eagerly awaits his visit, she and her uncle having arrived in Naples some months earlier.

Paul's carriage ride from his hotel to Alicia's villa offers further examples of the distinction between the narrator's vision and that of the hero. "Il regardait vaguement la mer limpide et bleue, où se distinguaient, dans une lumière brillante, et nuancées par le lointain de teintes d'amethyste et de saphir, les belles îles semées en eventail" (He glanced carelessly at the limpid sea with its fan-shaped sprinkling

of islands, lit brilliantly by the sun and tinted with amethyst and sapphire) (388).[14] But "son âme n'était pas là" (his soul was elsewhere); this delicate outlining of detail belongs to the narrator, and is, in fact, quite different in quantity and impact from the hero's gaze. The long, closely painted scenes of the villa and Alicia that follow are to be attributed to the hero's gaze. The ornamental element already observed continues to predominate, but it is now intertwined with rather threatening images. These images foreshadow not only the pivotal moments in the plot, but also the aggressivity of the hero's gaze in general: "Des aloes épanouissaient leurs feuilles pareilles à des lames de fer blanc et pointues comme des poignards . . . une haie de cactus, dont les pousses faisaient des coudes difformes et entremêlaient inextricablement leurs raquettes epineuses" (Aloes spread out their leaves like blades of white iron and pointed like daggers . . . a cactus, whose shoots were grotesquely bent and who inextricably intertwined their thorny rackets) (389). "Inextricably intertwined" is, on the one hand, ornament's ability to proliferate, forming visually fascinating designs, and on the other, the aggressive undertone of these designs. The web of "inextricably intertwined" forms fatally suffocates the object it encloses:

> C'est à peine si, à travers les interstices de ces frondaisons luxuriantes, l'oeil pouvait démêler la façade de la maison . . . derrière ce rideau touffu. . . . Orangers, myrtes, grenadiers, limons . . . [leurs] branches . . . se donnaient la main d'un bout de l'allée à l'autre, ou pénétraient familièrement dans les chambres par quelque vitre brisé . . . les végétaux exhubérents se donnaient le plaisir d'une débauche . . . ils reprenaient la place que l'homme leur dispute. (389–90)

> [Between the interstices of this luxuriant foliage, the eye could scarcely make out the façade of the house . . . behind this thick, leafy curtain. . . . Orange trees, myrtle, pomegranate, citron . . . [their] branches . . . joined hands from one end of the path to the other, or penetrated familiarly into the bedrooms by some broken pane . . . the exuberant vegetation offered itself the pleasure of a veritable debauchery . . . it was reclaiming the place that man tries to take from it.]

Here it is merely the house that is suffocated and penetrated; soon it will be Alicia. Note the personification of the vegetation ("joined hands," "offered itself the pleasure"). The identification of the hero with this vegetation is subtly inscribed in the same adjectives that were used

to describe his hair and the color of his eyes when they became "sharp and wounding": "Trois ou quatre enormes figuiers étalaient ... leurs larges feuilles d'un vert métallique avec une vigueur de végétation tout africaine" (Three or four enormous fig trees displayed ... their large leaves with an exuberance of vegetation that was quite African) (389). In this way, Paul's "ornamental vision" is intimately allied to the fearful and sublime forces of nature.

"Cette terrasse ... était en effet fort pittoresque, et mérite une description particulière, car Paul d'Aspremont y reviendra souvent, et il faut peindre le décor des scènes que l'on raconte" (This terrace ... was in fact quite picturesque, and merits its own description, for Paul will often return there, and one must paint the scenes that one narrates) (391). This "authorial" declaration serves as a warning. Let the reader make no mistake; the descriptive passages are not "filler," or "merely decorative," nor should they be skimmed over in favor of plot. We have moved from the narrator's point of view to that of the hero and finally to that of the author, who cautions us that there is to be no escape from ornamental detail.

Symphony in Infinite Whiteness

The tableau of the setting has taken two pages; the introductory description of the heroine will occupy only one, as though to corroborate the foregoing aesthetic principle of narrative design. The rhetorical device of hyperbolic accumulation (as in a Renaissance emblem) used to depict the first feature of her physiognomy betrays an undeniable link between Gautier's narrator and Gautier himself: "Une peau d'une blancheur éblouissante à rendre jaune le lait, la neige, le lis, l'albâtre, la cire vierge, et tout ce qui sert aux poètes à faire des comparaisons blanches" (A complexion of dazzling whiteness that rendered yellow the whiteness of milk, of snow, of the lily, of alabaster, of clear wax, of all those things a poet turns to to make comparisons of whiteness) (391–92). This self-reflexive, intertextual allusion to the "Symphonie en blanc majeur" again plays with the notion of the narrator as distinct from the author.

The vaunted whiteness of the heroine's skin, then, surpasses any artistic representation that might be made of it (just as the expression of the hero's eyes was "undefinable"); the sine qua non of the sublime

is that it presents what is unrepresentable in representation. The mere capacity to conceive of the sublime makes evident a faculty of mind that transcends every standard of sense.[15] The narrator's initial move is to present his heroine and hero as unrepresentable, posing that very challenge. But what exceeds representation will nonetheless be conveyed by the hero's ornamental vision.

> Ses yeux d'un bleu sombre *frangés* de longs cils qui palpitaient sur ses joues roses comme des *papillons noirs* . . . ses cheveux tombant en *volutes brillantes* comme des *rubans de satin* de chaque côté de ses joues et de son col de *cygne*, témoignaient en faveur de ses romanesques figures de femmes de Maclise, qui à l'Exposition universelle, semblaient de charmantes impostures. Alicia portait une robe de grenadine à *volants festonnés* et *brodés de palmettes* rouges, qui s'accordait à merveille avec les *tresses de corail* à petits grains composant sa coiffure, son collier et ses bracelets; cinq *pampilles* suspendues à une *perle* de corail à *facettes* tremblaient au lobe de ses oreilles petites et délicatement *enroulées*. (392; I have italicized the decorative elements in this passage.)

> [Her deep blue eyes, *fringed* with long, dark lashes that hovered on her cheeks like *black butterflies* . . . her hair falling in *brilliant volutes* like *satin ribbons* down her swanlike neck . . . proved the possibility of Maclise's romantic figures at the Universal Exhibition which are usually held to be but dreams. She wore a dress of grenadine, *embroidered with red palm leaves*, which accorded well with the *strings of coral* that were *woven* in her hair, her necklace, and her bracelet; from her delicate *shell-like* ears hung *pendants* suspended from a *pearl* of cut coral.]

The decorative form of the hair, *volutes brillantes*, presented quite clearly as a frame for the face, calls forth rather naturally the vestimentary decoration that forms the frame for the body. Just as the satin ribbons seemed a continuation of her hair, the sinuosity of form in the dress is taken up again in the heroine's ears. This interrelationship of person and decoration will be increasingly accentuated.

The recourse to Maclise, as to Hogarth, Hoffmann, and Levassor a few lines later, underscores a certain anxiety on the part of the narrator. How is representation of such exceptional, unique (and in the case of the men, grotesque) characters possible? The answer appears to be, thus far, by allusion to existing artistic representations. But this is no solution at all, shown by the tautology of Gautier's representation of the

"truth" of the former representation (without which he cannot erect his own). As I have said, the primary quality of the sublime is to present what is unrepresentable. The tautology exposes a lack, created by the eruption of the sublime and the imagination's failure to represent it. There are various responses to this lack, ways of literally getting around it. One of these is to surround it with the kind of ornamental furor I have been analyzing. Thus, ornament carries the intensity, the desires, and the emotions of fascination and terror that have proven unrepresentable in the Object. Thus, the figure of Alicia is extended into the framing decoration that henceforth carries the affect connected to the person.

Appropriately enough, these are the first words of dialogue that follow the four-page description: " '*Voyez* comme je me porte bien maintenant et comme je suis belle! *Regardez* mes couleurs . . .' " ("*See* how well I am looking and how pretty I am! *Look* at my rosy color") (393; emphases mine). This is an invitation—a demand, in fact—to be looked at, to be seen. The detail and length of description the reader has been summoned to heed carefully is the author/narrator's way of saying, "look," "see." But they are also prolepses of the text's central problem: the evil eye.

Although the question of the evil eye will become explicit only in a later chapter, what immediately follows contains numerous hints for anyone versed in the lore. As Paul remarks on Alicia's imposition of a "cruel" separation of six months, "son regard s'arrêtait avec une fixité étrange sur la jeune fille" (his gaze settled on her with a strange fixity) (394). Suddenly the color is drained from Alicia's cheeks, and she becomes whiter and begins to tremble. As Paul rises, she recovers herself and her color returns. All three then enjoy a sherbet under the ceiling of vine branches. Finally, the servant Vicè, "with tightly curled hair," leads Paul through the "labyrinth of the garden," discreetly making the sign of *mano cornuta* against his power.[16] Once again, the text connects the eye's menace with the surrounding decorative shapes.

The Violence of Displacement

Paul's trip back to his hotel is the pretext for some extremely decorative imagery, preceded by the affirmation that the beauty of the evening "is incomparable." Incomparable as the evening's beauty may be, the narra-

tor immediately compares it to existing artistic representations: crudely exaggerated Italian gouaches framed in black. That these representations are artistic clichés is interesting indeed. In *Jettatura*, however, the very blatancy, exaggeration, or familiarity of the cliché is in no way contradictory to its claim to truth. The way the cliché functions is similar in some ways to the way ornament functions: taken for granted in the decor as a familiar object, it is not analyzed for meaning. Ornamental objects are Kant's "leere Gegenstand ohne Begriffe" (an empty, concept-free object), and an artist or writer seeking expression for what is perceived as "undefinable," "ineffable," or otherwise unavailable to representation might turn to abstract ornament as an ideal receptacle. And that is because it is not possible to express certain ideas or emotions, except by lodging them in forms that are perceived as nonsignifying. The diminished linguistic force of the cliché can serve a similar purpose: "Vedi Napoli e poi mori" is taken to mean simply that after you've seen the unsurpassable beauty of Naples, you have lived fully and you can die a happy person. *Jettatura* draws out a much stronger meaning: to really see such splendor is to call upon death. Death *must* follow upon such an experience.[17] The gaze does violence to the order of the cliché, turning it inside out to reveal the radical, covered-over meaning.

Paul retires to his bed, pulling around himself the gauze curtains of mosquito netting, and falls asleep. He dreams that his ship is just putting in at the Naples dock, and Alicia, very pale, with profound regret and pain, motions to him not to disembark. Folds of gauze frame the hero, just as they enfold the feminine Objects of desire: Alicia and, later in the tale, the ballerina. It is a further decorative parallel between them and the hero, between the Subject and the Object. When we look behind the veil of gauze (in French, *gaze*), we find the gaze. The presence of English words in the text and the decor of London and Richmond justify this bilingual play. *Gaze* (the decorative fabric) / gaze reinforces the link between ornament and the eye. Moreover, to find gaze in *gaze* partakes of one of the essential qualities of ornament, and of the cliché: the importance of the superficial, of surface work, which is so highly visible that one no longer sees it.

Waking from the troubling dream, Paul calls to mind the reassuring, "charmingly puerile" first meetings and courtship. A close examination of the text, however, reveals that these scenes already carried the sharp menace that elicited the evil eye. Note the emphasis placed on ornamentation in these scenes:

Il revit la maison . . . tapissée d'églantine et de chèvrefeuilles . . . la robe
. . . ornée . . . la branche de jasmin qui roulait dans la cascade de ses
cheveux comme une fleur de *la couronne d'Ophélie*, emportée par le *cour-*
ant, et ses yeux d'un bleu de velours, et . . . de *petites dents de nacre* et *son*
col frêle qui s'allongeait . . . la cheminée festonnée . . . les fauteuils de
chêne à pieds tournés [et] bras garnis . . . le tapis étalait ses rosaces. (396;
emphases mine)

[He once more beheld the house, covered with vines of honeysuckle and
lilac . . . the . . . dress, ornamented . . . the branch of jasmine that en-
twined itself in her hair like a flower in *Ophelia's crown*, carried away by
the *current*, and her velvety blue eyes, and . . . little *mother-of-pearl teeth*
and her frail, *elongated neck* . . . the festooned mantelpiece . . . the oak
armchairs with curved legs (and) decorated arms . . . the carpet strewn
with roses.]

The verb choice *revoir* (instead of *se souvenir* or *se rappeler*) ties the
ornamental profusion of the gaze more clearly than before to Paul; Al-
icia's illness is brought on by the suffocating envelopment of this deco-
ration, the manifestation of his ornamental vision. Curious visual tricks
deepen the initial hint of death in the transformation of Ophelia's leafy
couronne to the *courant* in which she drowns. "La piano *allongeait* sa
rangée de touches *pareille à des dents de douairière*" (The piano *stretched*
forth its row of keys *like the teeth of a widow*) (397). Alicia's mother-
of-pearl teeth become widow's teeth (*dents de douairière*), as the verb
allonger (for the piano's "teeth" and Alicia's neck) pulls the heroine
deeper into the decor, here the piano. Alicia, enveloped by the honey-
suckle-covered manor house and framed by the ivy of the fireplace, is
immediately compared to a "trembling leaf." The movement of incor-
poration is then made explicitly oral when her pearly teeth cut into a
slice of ham resembling a "leaf of paper." "Elle coupait à l'emporte-
pièce de ses dents perlées une rose tranche de jambon mince comme
une feuille de papier" (With her pearly teeth, she tore apart a pink slice
of ham, thin as a leaf of paper) (398).

Paul's perception of the woman's pointed, cutting teeth is countered,
then reflected by his regression to an oral, cannibalistic phase where it
is he who causes the woman to be devoured; the instrument of his
incorporation is the gaze. For, finally, the cutting teeth are themselves
"ingested" by the decor: "Des millions de petites perles gelées scintil-
laient sur le gazon vert du boulingrin" (Millions of little frozen pearls
glistened on the green lawn of the bowling green) (ibid.). The Object

of desire, transformed into an ornamental object by the force of the gaze, is mortally displaced into the frame, where she is incorporated into a surfeit of lush, ornamental vegetation. Paul's evil eye drains the color and vitality from Alicia, transferring them instead to the decor, just as Gautier often drains his characters in order to invest his attention in their clothing and decor.

The next morning Paul looks out from his balcony onto a vista that encompasses the sea, Vesuvius, and the villas of Sorrento (among them Alicia's).

> Le ciel était pur, seulement un léger nuage blanc s'avançait sur la ville, poussé par une brise nonchalante. Paul fixa sur lui ce regard étrange. . . . D'autres vapeurs se joignirent au flocon unique et bientôt un rideau épais de nuées étendit ses plis noirs. . . . De larges gouttes tombèrent . . . et en quelques minutes se changèrent en une de ces pluies diluviennes. . . . La foule surprise se dispersa. (399–400)

> [The sky was clear, but a thin white cloud was approaching the city, impelled by a gentle breeze. Paul fixed his eyes upon this cloud (with) that peculiar expression. . . . Other vapors joined this single cloud, and soon a heavy curtain spread out its black folds. . . . Large drops began to fall . . . and soon (became) one of those terrific rain storms. . . . The crowd, taken by surprise, dispersed.]

The unrepresentable purity of Alicia's white skin, enveloped by the airy, white gauze and framed by the white villa, is displaced into the *ciel pur* and *léger nuage blanc*. They attract the intense concentration of Paul's gaze, provoking the "catastrophic" tempest, consummate manifestation of the sublime. The suddenness of the tempest, the near-instantaneous metamorphosis of the calm landscape and sky (a vista that, one will recall, nonetheless contains Vesuvius's threat of eruption), calls to mind the ever-changing features of the hero. Functioning first as a manifestation of the sublime—as one who calls forth the feeling of the sublime in others—the hero shows a propensity for the cast of mind requisite to the sublime. It will be noted that a number of objects—many of which would not generally be perceived as sublime—bring about for Paul the intensity, melancholy, pleasure, and displeasure of the sublime experience. These objects cause the mind to abandon itself to the idea of absolute greatness, totality, and infinitude. The immensity of the sea, the fearful might of Vesuvius, the infinite stretch of the landscape, the tempest—all are objects that commonly elicit a sublime feeling in one.

However, it is the fusion of the decorative impulse with the sublime that distinguishes Paul's vision from those around him. It is that link, too, which distinguishes Gautier's treatment of the sublime from Kant's, since Kant places ornament in the category of the Beautiful as opposed to that of the Sublime.

In an early work, Kant divides the sublime into three kinds: the terrifying, the noble, and the splendid. He divides the beautiful into the properly beautiful, which is internal as well as external and contains a considerable admixture of the sublime, and the merely pretty, which is outward only.[18] This text was his only discussion of aesthetics before the *Third Critique of Judgement*, which appeared almost thirty years later. In the 1763 work, he specifically sets apart from the three subdivisions "a certain spirit of minutiae which exhibits a kind of fine feeling but aims at quite the opposite of the sublime" (Kant, *Observations*, 71). This would exclude much of Gautier's ornamentalism in *Jettatura* that I have called sublime; however, I have demonstrated how the proliferating structure and overwhelming effects of these minutiae can rightly be categorized as such.

In considering the examples of ornament in this chapter that Gautier perceived as sublime, it might be well to look at the way Gautier introduces an essay on one of the nineteenth century's most important artists, Paul Baudry. The article concerns Baudry's decoration of the Paris Opera, under construction at the time of writing: "It is a great pleasure for us to walk through an edifice in ruins or in construction. . . . As a child, we found an inexpressible charm of curiosity and terror in following the heroines of Ann Radcliffe . . . through the maze of . . . secret and underground passageways."[19]

This vision of the labyrinth is the fitting entrance into the mysteries and splendor of the "purely decorative" ("Baudry," 8). That the decorative does not preclude the terrifying sublime may be seen in this fresco of Orpheus, torn to bits "by the Bacchantes, harder to tame than tigers, and who, the murder committed, abandon themselves wildly to their orgiastic round dance, symbol of the dance of their sex" ("Baudry," 18).

Fear is an element here (as in *Jettatura*) that is intensified yet finally overcome through the decorative. Like the prophylactic amulets in the novella, ornament is a mirror and an organizing force, a cure for chaos, violence, and the sublime. The sublime overwhelms the mind's limitations, as ornament presents overwhelming visions created by the artist's mind. This is why we must necessarily have both Paul's terror-provok-

ing (sublime) vision and the narrator's palliative (beautiful-sublime) vision. In this movement of the "decorative sublime" to include aspects of the beautiful, Gautier has created an original theory of the sublime. As Thomas Weiskel states, "The sublime began where the conventional systems, readings of landscape or text, broke down and it found in that very collapse the foundation for another order of meaning."[20] Ornament is another order of meaning within the narrative, and that is precisely why Gautier turns to it so often.

When things in nature, such as the whiteness of Alicia's skin, elude his control, one response is to displace the qualities onto something innocuous and easily manipulated (in this case, the calm vista). The effects of the sublime that ensue (the destructive forces of the sudden storm) hence are no longer overwhelming to the Subject; *on the contrary, they emanate from the Subject*. Another response, which we have also seen, is to surround the unrepresentable vision with an astonishing proliferation of ornamental shapes until it is seemingly absorbed and subdued by the decor. Yet another response, one we will encounter later in the text, is to fuse totally with the sublime object. In these ways, the fascinating but terror-provoking abyss that opens up between the Subject and the sublime object is covered over.

It is interesting to note that of those exposed to Paul's sublime and fearful gaze, only Alicia experiences the feelings of pleasure/displeasure and of fearfulness/fear overcome. The others experience only displeasure and fear. Pleasure and the mastery of fear, on the other hand, are gotten from the manipulation of the ornaments (the amulets suspended from a chain worn around the neck) that counteract the gaze by miming its effects.

The Composition of Excess

In the schematic presentation of the Kantian sublime given at the beginning of this chapter, I referred to the double feeling of attraction and repulsion (*Anziehen/Abstossen*) brought about by the same object. As Derrida succinctly puts it, "There one has an excess, a surplus, a superabundance that opens up an abyss" (Derrida, *Vérité*, 148). The vibration of the poles attraction/repulsion turns up in the ambivalent manner in which the Neapolitans regard the evil eye. As Count Altavilla, Paul's rival, explains to Alicia, "Le fascino est l'influence pernicieuse qu'exerce la personne *douée*, ou plutôt *affligée* du mauvais oeil" (*fascino* is the per-

nicious influence exercised by the person who is *endowed* with, or rather *afflicted* by, the evil eye) (413; emphases mine). Since Alicia has no idea what "mauvais oeil" signifies, Altavilla's definition of *fascino* "explique l'inconnu par l'inconnu" (explains the unknown by the unknown) (413). One may compare this "explanation" to the use of the representational tautology to combat the effects of the sublime (objects that exceed the powers of representation defined in terms of preexisting representations that, in turn, are guaranteed "truth" by virtue of their equivalency to the unrepresentable object): certain phenomena are so awesome they elude translation and can be approached only by signs that appear to refer to other signs, yet in fact refer simply to themselves. Altavilla is obliged to offer a variety of examples and analogies explaining the evil eye, yet Alicia remains unconvinced that it is anything but a superstition, claiming that the fantastic, the mysterious, the occult, and the inexplicable have very little hold on her. The count's last recourse is to call on a universally accepted truth, "la puissance de l'oeil humain" (the power of the human eye) (416). He then cites phenomena that "no eye" can see (for example, disease, electric fluid on a lightning rod). Why not concede that the eye can emit an invisible ray or fluid that is fatal or propitious "d'après la mode d'émission et l'angle sous lequel l'objet le reçoit?" (according to the mode of emission and the angle in which the object receives it?) (ibid.). "Je veux bien admettre son existence pour un moment"; Alicia is "momentarily willing to accept the existence of such an ocular electricity" (ibid.).

The count's argument has succeeded by the same movement of reversal that operates in the sublime: the eye is powerful, but there are invisible phenomena that exceed its grasp and the grasp of all sense organs. Somehow, a like phenomenon becomes the property of the eye, not just any eye, but an exceptional eye—a sublime or evil eye—depending on "the angle in which its gaze is received." In other words, the proof of the eye's power is founded on its lack of power. This ocular force may be fatal or propitious, but in *Jettatura* the former option prevails. Even knowing this, one is seduced or "fascinated." I propose that one is seduced by the prospect of possessing such a power (hence the evil eye's attraction as witnessed by Altavilla's slip of the tongue, "*douée du mauvais oeil*") and—in that this fascinating might is mimed in the key ornamental objects in the text—seduction becomes equally the property of the eye, of its ornamental vision of sublimity, and of the ornamental objects that mirror the gaze.

The hero's gaze is seduced by ornament in the decor and in Alicia's

dress, hair, and features. In return, he introjects these qualities and re-projects them outward. The idea of projectile in the word *Jettatura* (*jeter*) resonates with the idea of projection as well as with aggression, and the frequency of words like *arrow, dart*, and *dagger* in the context of the gaze only serves to underline this etymology.

The proliferation of ornamental form appears as the effect of Paul's gaze. It is therefore logical that the talismans used to attract this gaze are ornamental objects themselves. These "trinkets" shift the direction of and then momentarily absorb the eye's "evil" rays (an operation akin to introjection). They ward off the eye's malignant force and, as orna-ments, they draw in one's gaze (fig. 13). The heroine's last name, Ward,

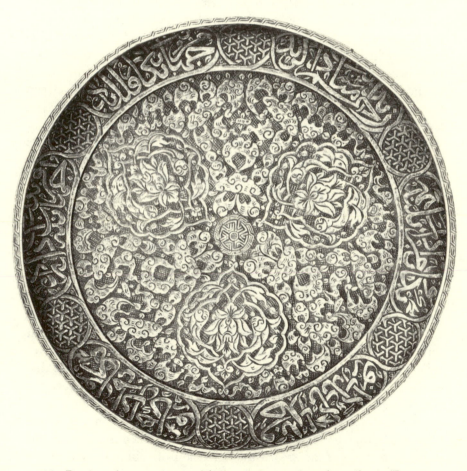

13. Persian plate, 1496–97, with inscription against the evil eye: "Let no wound from the evil eye reach you."

works as an anagram that condenses this double function (attraction/repulsion) of the decorative amulets: WARD off / DRAW toward. (It also evokes the talent of the draftsman, the artist.)

The gaze is both ornamental and phallic; so are the objects used to counteract it. Count Altavilla is a dandy whose impeccable dress is further ornamented by expensive gems. The "bizarre trinkets" worn to counteract the evil eye are introduced in this context. Later that day, after having met Paul, he sends Alicia "une monstreuse paire de cornes de boeuf de Sicile, transparentes comme le jaspe, polies comme l'agate, qui . . . se terminaient par de menacantes pointes . . . le piton en l'air" (an enormous pair of Sicilian bull's horns, transparent as amber, and polished like agate . . . and tipped at the ends with threatening black points) (405). Clearly, ornament functions here as does the experience of the sublime: a force that transforms fear into might. It manages to do this by making itself a mirror of the fearful object (indeed, the qualities "transparency" and "polished" suggest glass). Not only does Paul's gaze have the phallic character of a projectile, but his irises contain "writhing snakes." In addition, the Latin word *fascinum* means both fascination by the evil eye and phallus, and Priapus was a phallic Roman god who was also known as Fascinus. More directly connected to this novella, Pompeian murals exhibited figures with huge, erect phalluses, and these were less erotic than they were charms against the evil eye.[21]

If we return to the concept of the mathematical sublime, we see that it is tied to the problem of excess and, as I have stressed, this problem not only is at the heart of an aesthetics of ornament, but constitutes one of its most "dangerous" aspects.

In the sublime, there is movement, limitlessness, and an excess that exceeds representation. These are precisely the qualities seen thus far in the ornamental vision of the hero and the narrator: the vibratory trompe l'oeil of metamorphosis (present in descriptions both of Paul and of nature), the excess of ornament adorning the Object, the excessiveness of the grotesque, and the seemingly limitless proliferation of ornamental patterns in the decor. The experience of excess in the sublime is in direct correlation with the mind's limitations; the result is a feeling of being overwhelmed, of being *too full*. But this sense of *débordement* is very likely created by the Subject's need to install an established order in the images and ideas that enter the mind. Many forms of ornament circumvent traditional ideas of order. Indeed, the central problem of ornament is its tendency to proliferate and thus overwhelm the structural underpinning of the figure it initally set out to embellish. In the

Introduction we saw that this loss of limits is expressed frequently in articles on the decorative arts.

In the aesthetics of ornament, the dynamic of limitation and excess is embodied by the frame, notably in ornament's tendency to overrun the frame in which it is originally placed. The structure itself is heavy with meaning (transgression of boundaries, uncontrolled proliferation, chaos), and becomes all the more so when the context is one of desire. We have been discussing excess in terms of quantity (thus a parallel was drawn with the mathematical sublime), but it is by no means the only form prevalent in ornament. Brightness, glitter, sumptuousness, and complexity are elements one encounters in *Jettatura* as well as in Gautier's articles on painting and the decorative arts. The combined effect of these representations of excess, and of these excessive representations, is vertiginous. It is an effect Gautier continually attributes to the decorative arts.

What is evil in the evil eye is the way in which excess combines with ornament: with it, the hero wreaks havoc on the world, creates chaos, albeit a seductively beautiful chaos (the tempest at sea, the storm), and annihilates the object by overwhelming it with these forms. Chaos, which belongs to the order of the Sublime in Kant, infiltrates the order of the Beautiful, where Kant places ornament. By making ornament function in both Kantian categories, Gautier has opened up a new aesthetic mode. We have seen that an explosion of ornamental imagery accompanies the catastrophes in the text: Paul's gaze capsizes the rowboats and the unexpected wave is hemmed with a fringe of foam that breaks up into millions of sequins. Kant writes that the sublime cannot be "contained in a sensuous form" per se because it is sparked by the ideas of reason that are "excited and called into the mind by that very inadequacy itself which does admit of sensuous presentation" (Kant, *Critique*, 92). Thus the broad ocean agitated by storms cannot be called sublime; it is "raised to the pitch of a feeling which is itself sublime" because of its enhancement by "a rich stock of ideas" stored in the mind. *Clearly, this "stock of ideas" comes from the decorative arts.*

The fatal influence of Paul's ornamental vision is detailed in a flashback before we see its outcome in regard to Alicia. In London, he had often gone to the ballet to see a young ballerina. "Armé de son lorgnon" (Armed with opera glasses), his gaze followed her in a whirlwind of dance movements, marking her lustrous hair and the gleaming, marblelike legs lifting "leurs nuages de gaze" (their clouds of gauze). One

night, she pirouetted too close to the "étincelante ligne de feu" (line of gas jets). Her airy costume "palpitai[t] comme des ailes de colombe" (fluttered like the wings of a dove) and caught fire. For a few seconds, "[elle] dansa quelques seconds comme un feu follet au milieu d'une lueur rouge" ([she] danced like a firefly amidst a red glow) (429). The text reads: "Elle était *dévorée* vive" (She was devoured alive). Gautier might well have inscribed *décorée vive*. A ballerina, of whom Gautier was enamored, did in fact catch fire and die on a London stage in his presence.

The conclusive proof that Paul is a *jettatore* is furnished by his chancing upon a book, Niccolo Valetta's treatise on the *Jettatura*. The phenomena described there are undeniably those he has been experiencing.

Il se mit devant une glace et se regarda avec une intensité effrayante: cette perfection disparate . . . rayonnait sinistrement dans le fond noir du miroir; les fibrilles de ses prunelles se tordaient comme des vipères convulsives; ses sourcils vibraient, pareils à l'arc d'où vient de s'échapper la flèche mortelle; . . . la pâleur marmoréenne de la peau donnait encore plus de relief à chaque trait de cette physionomie vraiment terrible. Paul se fit peur à lui-même: il lui semblait que les effluves de ses yeux renvoyées par le miroir, lui revenaient en dards empoisonnées: figurez-vous Méduse regardant sa tête horrible et charmante dans le fauve reflet d'un bouclier d'airain. (426)

[He placed himself before a mirror and gazed at himself in awestruck terror: this incongruous perfection . . . radiated in a sinister way from the black depths of the mirror; the fibres of his eyeballs wriggled like convulsive vipers; his eyebrows quivered like the bow that has just shot forth the poisoned arrow, (and) the marble pallor of his skin made every feature of this terrible countenance stand out in bold relief. Paul was afraid of himself. He imagined that the reflection of his eyes in the mirror was casting poisoned darts at him: picture to yourself Medusa gazing at her charming but fearful countenance in the wild reflection of a brass shield.]

The shifts of angle of vision are multiple in this passage. First, Paul becomes a sublime object of contemplation for himself, but the feeling that this object is more than a highly ornamental portrait—even a really terrifying one—capable of endangering him, causes the secure distance requisite to the negative pleasure of the sublime to disappear.

Instead, it is the reader who is called upon to take over the experience of the sublime with the apostrophe/vocative "figurez-vous." It is the reader who preserves the requisite distance while envisioning the terrifying spectacle. This spectacle is imaged forth, as we have come to expect, by means of a reference to existing texts, paintings, and sculptures, here, of the Medusa. The mirroring metal shield belongs to the domain of the decorative arts, and therefore falls into our paradigm of decorative objects that mirror the force of the evil eye. The oxymoron "horrible et charmante" is not only a presentation of the unfathomable, but also precisely that paradox operative in the sublime as put forth in *Jettatura*. Furthermore, the clichéd use of "charmant" as a descriptive term for "lovely" falls away under the intensity of the gaze to reveal its far stronger etymological meaning. But the final shift of angle is in the image of Medusa/Paul staring at her/his own gaze in the mirror, ostensibly finding in it the same fear and fascination we have been examining.

Freud interprets the *Medusenhaupt* as a representation of the fear of castration (decapitation) and its attendant overcompensation in the image of a proliferation of penises/snakes.[22] In other words, excess is an effect of lack. This structure of lack and excess is also present in what we have seen as the operation of the Kantian sublime. In addition, the "ability of the head of Medusa to represent what cannot be represented"—the unfathomable—also accords with the sublime.[23]

But let us consider the well-known effect of Medusa's evil eye: it turns one to stone. Need I recall the overwhelming obsession in Gautier's vision of beauty, particularly in the poetry, of immobile, stone, or marble form? Indeed, the whiteness of marble is presented here for the first time as a quality of *Paul's* skin, and the context may tell us something more about the sublimity of this aspect of the Object of desire. Paul, as the sublime Medusa, has turned his own image to stone. *Medusé*, he is a sublime object for his own gaze. Alicia's whiteness is unrepresentable not only because it embodies ideality, purity, and the Romantic convergence of desire and death, but also because it is an illustration of the effects of the "horrible and charming" power of the Medusa, a figure that is both phallic and ornamental. The purely formal aspect of her head is a hyperbolic expression of the element of the feminine always noted in the text: the tightly curled locks or spirals of hair. These locks, then, fall into the same paradigm as the Medusa's phallic snake-hair, a highly decorative frame of arabesques: yet another proof of the dangerous, seductive nature of ornament.

The Medusa implies taboo: things not to be seen with the naked eye lest one be turned to stone. Here it is not the sexual act or the mother's genitals that must not be looked at, but chaos (chaotic excess) and death, and the Romantic ideal that springs out of their conjuncture. Thus, the frequency of enveloping veils in *Jettatura* may represent the veil of taboo.[24] But Paul's gaze penetrates the veil as it penetrates itself. It penetrates another veil as well. Normally, the eye's function is to make the chaotic profusion of reality manageable; vision is selective, reductive. Here, on the other hand, the (evil) eye sees and reveals the manifold images, incomprehensible complexity, and immensity of nature.

Paul is the modern, Romantic presence. His extravagance is matched by the extravagance of Naples (the extremes of color, gesture, sound, the chaotic excess of the vegetation), the environment that provides a mirror for his attributes. But, in contrast to this bustling environment, his presence, concentrated in the gaze, is unhealthy, death-dealing. His gaze espouses and promotes death rather than life. It is the circular, self-reflexive regard of Romanticism or of narcissism.[25] In addition, even though Neapolitan society provides a mirror for Paul's evil eye, it brands him as singularly different. Indeed, it is why he is singled out as the possessor of the evil eye.[26] Already containing within him the antitheses that guarantee the Romantic character, it is when he is recognized as a *jettatore* that Paul accedes to the status of the alienated Romantic hero who is exiled from society and relegated to its margins.

But is the Romantic gaze of death necessarily a negative commodity, or does it not, conversely, enjoy the same power as does the sublime to transform negativity into pleasure? Summoned to the villa by his fiancée, Paul, now aware of the fatal consequences of his gaze, valiantly attempts to keep his eyes averted from her, but the menace in his vision is again transposed into the vitality of the personified, proliferating vegetation where the "green hand of a branch" pulls off her hat (436). The menace is immediately tied to the ornamental image of "a handful of gold sequins" scattered by the sun (ibid.). It is in this decor that Alicia insists Paul fix his gaze upon her: "Plongez vos regards dans les miens, je le veux. . . . Fixez sur moi cet oeil que vous croyez si terrible et qui m'est si doux, car j'y vois votre amour" (Gaze into my eyes, Paul, I command you. . . . Look upon me with that eye you think so terrible and which to me is so sweet, for I see your love there) (437). *L'amour* is married to *la mort, romantisme oblige*. In response to the intensity of the eye, Alicia suddenly pales with a lancing pain through her heart, and

raising the fine batiste of her handkerchief to her lips, she sees the embroidered cloth stained with a drop of blood.

Transcending the sensation of pain (but not before Paul has glimpsed the bloodstained cloth), Alicia leads her lover to a spot "où la végétation, en s'écartant, laissait apercevoir la mer comme un rêve bleu d'infini" (where the vegetation separated enough to allow one to perceive the sea like a blue dream of infinity) (438), where two forms of expansivity in the sublime meet. Alicia's beauty was, at this moment, "radieuse, alarmante, presque surnaturelle" (439), the type of beauty one would qualify as sublime. It is made up of many of the traits I have noted in the hero's ornamental vision: sparkling luminosity, white purity and flaming ardor, transparency, accented by gems (agate), and held together by the decorative design of a delicate blue tracery (the network of veins under her agate temples). Once again, this vision defies representation ("no painter ever had these colors on his palette"), for to penetrate the Object by the rays of the eye (of the ornamental gaze) in this way is to make visible her very soul. "L'âme lui venait à la peau" (Her soul rose to the skin's surface) (ibid.).

Marble and alabaster signify both art and death in the text, as Alicia Ward's apotheosis draws near. Her "whiteness" was extreme, as white, in fact, as "une statue d'albâtre sur une tombe" (an alabaster statue on a tomb) (448) (fig. 14, right). Her love for Paul is a "sublime abnégation" (449). The sublimity of Romantic art is, in fact, that it enfolds, enshrines, and frames death, an experience one might try to WARD off, while at the same time being DRAWN toward it. "Elle avait des tons nacrés près de l'oeil" (She had tints of mother-of-pearl near the eye) (446). It is as though they had been painted in. Mother-of-pearl is extremely common in decorative inlay, and we cannot forget the importance placed elsewhere in the text on the active role of Alicia's "petites dents de nacre" (little mother-of-pearl teeth). (Only ten pages later we see Alicia idly chewing on orange blossoms, which then become yellow and wilted.) In fact, this syntagm appears on the preceding page, thereby drawing together once again the woman's devouring teeth and the devouring eye. The juxtaposition "nacre, oeil, dents," may therefore be placed in the paradigm "death"; it is imbued with the terror and pleasure of being devoured by the eyes and therefore lends a graver note to the decorative image. Terror and pleasure are evoked together in this section of the text; Alicia dreams of her dead mother, and the apparition brings the excitement of "tenderness mixed with terror," "gracious terrors" and "fearful charm" (454).

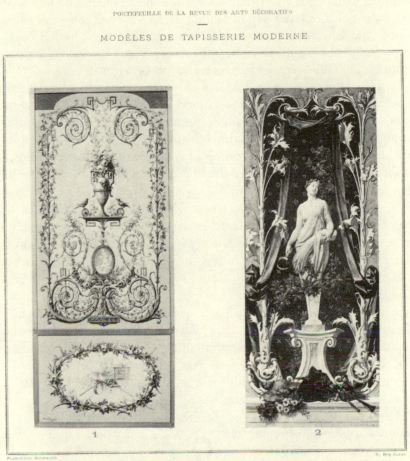

14. Thomas and Mazarolle, Beauvais tapestry works,
two decorative screens, 1885.

POMPEII

These oxymorons will soon come to rest on a specific place, one that is
dead yet curiously alive (hence, the fascination of the place): Pompeii.
Artistic representations come to life, yet still retain the eternal aspect of
immutability in time, inducing the experience of wonder and awe of the

sublime. "Pompéi, la ville morte . . . quoiqu'elle ait rejeté à demi le drap de cendre qui la couvrait depuis tant de siècles . . . reste endormie sur sa couche funèbre" (Pompeii, the dead city . . . although she has partly thrown aside the mantle of cinders that had covered her during so many centuries . . . still sleeps on her funeral pyre) (456–57).

In the analysis of ornamental form in Nerval's *Sylvie*, we observed the movement of decorative filigree around a void, a hole (which represented loss: lost childhood paradise, lost love, and so on). In Gautier the empty space is reserved for death, a death brought about by the intensity of ornamental patterns pressing in and encroaching on the framed Object of desire.[27] At Pompeii, this space is specifically shown in relation to writing. Years earlier, in the opening poem of *La Comédie de la mort*, Gautier wrote: "Mes vers sont les tombeaux tout brodées de sculptures; / Ils cachent un cadavre, et sous leurs fioritures / . . . Chacun est le cerceuil d'une illusion morte" (My verses are tombs all embroidered with sculptures; / They hide a corpse, and under their flourishes / . . . Each is the coffin of an illusion that is dead).[28] Indeed, not only is Gautier's verse "embroidered," but his metaphors are "luminous bombs" and adjectives and comparisons are a "rain of silver and gold" (Gautier, *Caprices et zigzags*, 304). Words themselves may be ornaments: "There are diamond, sapphire, ruby, emerald words, and others that shine like phosphorus when you rub them."[29] Such examples abound in Gautier's writing, but these images are enlisted in the service of a theory of vision only in *Jettatura*.

The weapon that Paul chooses for his duel with Altavilla is a pair of identical stilettos, in French *stylet*. The *stylet* is not only a stiletto, but also a stylus, an instrument for ornamental stone carving, as well as a writing implement (*poinçon de fer*) on wax tablets (hence, the modern word *stylo*). Death, ornament, and writing converge in this word.

The rivals are tied together by the handkerchief that each of them grasps blindfolded (so that Paul loses the advantage of his gaze), a fabric that is called a "trait-d'union terrible" (a terrible hyphen). In the heart of the empty, dead city, Paul reanimates death, so to speak, by killing his opponent. But before the duel takes place, the narrator must describe the dead city. The elements he chooses follow closely what has gone before. In the early-morning hours, lizards, wriggling their tails, scurry along the walls and mosaics, creating a living design of arabesques to match those in the grotesques of the wall frescoes. (See fig. 14, left, for design inspired by Pompeian grotesques.) The white feet

of the dancers painted on the walls appear to be lifting the border of their drapery like a rosy froth, in expectation of the orgies of the triclinium. Other images—Venus, satyrs, and grotesque figures—seem to come alive. Anyone familiar with Gautier's work knows the importance of the concept "life in death." An obscure plaquette he wrote on the Pompeian Palace of Napoleon III at the Rond-Point des Champs Elysées illuminates this concept with the paradox "The only things we can call new are those that have aged." In the detailed descriptions of ornamentation at the palace one finds the bacchanal to which *Jettatura* alludes: "Around [Lyaeus], bacchantes and maenads are contorting and hurling themselves about [in an] orgiastic delirium."[30] Under Pompeii's veil of ash, one discovers an agitation of ornamental form and an indication of the violent pleasures it signifies. In this study, Gautier specifically mentions that Pompeii served as a pleasure capital for wealthy Romans. One can imagine some of these pleasures' being taboo in our society and in that of the last century. And the catastrophic end met by these pleasure seekers was one of ornamental magnificence: "Ripped asunder by rapid streams and serpentine rivulets of phosphoric fire . . . in long furrows of flames. . . . Everything was swallowed up" (Gautier, *Palais Pompéien*, 7). The phrase "swallowed up" appears here for the third time in two pages: first by the more powerful Rome, then by an even more powerful decorative explosion.

The introduction to Pompeii in *Jettatura* ends with the trembling of colored shadows that allow the imagination to abandon itself to the illusion of an ancient phantasmagoria. Paul's carriage arrives at the Street of the Tombs. The narration has adroitly moved from the representation of desire through ornamental form, to the reminder that ornament is supremely capable of illusion, artifice, and finally to the final panel of its function in the text, the circumscription of death.

The prologue belonged to the narrator's point of view; now Paul's gaze takes over: "Il voyait tout" (He saw everything), states the text simply. He enters the vaulted room of the Baths where the niches support an architrave ornamented with children and leaves. The rest is as naked as a tomb. The two men agree that each must write a note attesting to the fairness of the duel; death will be marked and justified in writing, "on a leaf of Paul's notebook" (459) to be placed on the dead man's chest.

As though in answer to the void, the two figures describe corporeal arabesques in the emptiness, or "fond obscur." The piercing gesture that

finally kills Altavilla cuts through the ornamented fabric of the hand-kerchief, creating yet another pattern of void (death) and ornamental framework.

Stunned by the outcome of the duel, Paul returns to his carriage "like a walking statue" (463). He has become one with the ornamentation of Pompeii and with representations of the Medusa, as well as with her victims. By this simile, Gautier again points out the underlying bonds between decorative aesthetics and the gravity of death as consequence of the mythical power of the eye. At the same time, he shows the impulse toward representation in the novella (making Paul into a statue) to be a means of coping with the fearful idea of death. Buried Pompeii—origin of two of the most crucial and significant decorative forms in Gautier's aesthetic (the arabesque and the grotesquerie)—therefore proves to be the perfect metaphor for the underlying, underground workings of ornament: expression of violent desire and vehicle of death.

THE ORALITY OF THE EYE AND EROS/THANATOS

The hero analyzes his power as a "destructive and unconscious force" (464). With this realization he decides that his only recourse is to blind himself. But first he means to reap the maximum pleasure from his ultimate day of vision. "Contemplez, [mes yeux] . . . la voile blanche rasant l'abîme, le Vésuve . . . enivrez-vous du splendide spectacle de la création! Allez, voyez, promenez-vous. Le rideau va tomber entre vous et le décor de l'univers!" (Gaze upon all these sights . . . the white sail skimming the abyss, Vesuvius . . . intoxicate yourselves with the beauties of the earth. . . . Go on! enjoy yourselves! The curtain will soon fall between you and the decor of the universe) (464–65).

The theatrical metaphor is an apt one; the sublime often appears as an awesome spectacle.[31] But is the sublime, "splendid spectacle" only a decor? We would be forced to reverse our habitual acceptance of the role of decor had we not already done so, for decor is here granted the greatest possible expansion in becoming as limitless as the universe, and is therefore the very essence of the sublime.

A last meeting with Alicia is part of this visual "imbibing" and ecstasy. The choice of the verb "to imbibe" (465) is yet one more confirmation of the oral nature of Paul's sublime vision and the curious interrelation of the mouth and the eye in the text.[32] Yet the orality in

the text is in no way contradictory to the spiritual content of the Object. Ornamental vision is imbued with both primitive drives and metaphysical striving: "On apercevait l'âme à travers comme une lueur dans une lampe d'albâtre. Ses yeux avaient l'infini du ciel et la scintillation de l'étoile" (One could see her soul shining through the frail form like the light of an alabaster lamp) (465). Alicia's eyes reflect both the decorative sublime and the traditional sublime, while the decorative object (the lamp) now *contains* the soul. We recall that, earlier, Alicia's soul had come to the surface of her skin as a decorative design. For Gautier, the soul is itself the sublime version of the decorative that I have been describing.

The erotic benefits of possessing the evil eye—not only in terms of the *Schaulust* experienced by the Subject, but also in terms of the pleasure procured for the Object—are also finally made explicit here: "Sous ce regard ardent, Alicia, fascinée et charmée, éprouvait une sensation voluptueusement douloureuse, agréablement mortelle; sa vie s'exaltait et s'évanouissait; elle rougissait et pâlissait, devenait froide puis brûlante" (Alicia was fascinated by his burning glance and experienced a voluptuously painful, agreeably fatal sensation; the dying embers of her life were fanned into momentary flame; she turned red and white by turns, and from ice she suddenly turned to fire) (466). The evil eye awakens desire at the same time as it brings death, both states fused in the two oxymorons as they are simultaneously evoked in the pairs of opposites that follow. It will be remembered that the oxymoronic structure characterized the *jettatore* at the beginning of the tale; one page later this fact is reiterated as Paul, about to blind himself, addresses his image in the mirror: "Forme . . . où la beauté se mêle à l'horreur" (Form . . . where beauty mingles with horror); it was also the first instance in the text of the grotesque, index of the decorative and flip side of the sublime.

The colors red and white, as the opposing signs for life and death, join together in the last description of Alicia and in the dagger Paul heats to incandescence ("La mince lame arriva bientôt au rouge blanc" [The fine blade was soon red hot]). The alternation of colors heats up to a fusion of opposites and to a decorative fireworks: "La lame où s'échappait en pétillant de blanches étincelles" (The blade . . . emitted little white sparks) (467). In addition, Paul calls himself "victim and executioner" here. The culminating dramatic point of the novella— vision at its most intense turned into blindness—is also the culmination

of the oxymoronic structure. This paroxysmal figure of rhetoric is one of the most dramatic linguistic ornaments. It is also, as I have stated, the linguistic equivalent of the decorative form, the grotesque.

The fear of emptiness, up to now vitiated by the plethora of decorative form, emerges as the first terror of the blind man. "Ses yeux s'ouvraient sur le vide, sur le noir, sur le néant, comme si, enterré vivant, il se fut réveillé . . . dans un cercueil" (His eyes opened onto emptiness, onto darkness, nothingness, as if, buried alive, he had woken up . . . in a coffin) (469). Interestingly, one of the few awkward uses of the authorial intrusion occurs here: "Laissons M. d'Aspremont dans son immobilité douloureuse et occupons-nous un peu des autres personnages de notre histoire" (Let us leave M. d'Aspremont in his painful immobility and let us attend to the other characters in our story) (470). One wonders whether Gautier's own uneasiness at the thought of the void, unadorned by an ornamental vision he shares with Paul, was enough to create the need to switch to a new decor. Decorative profusion was a remedy for the ever-looming void. But Gautier was caught in a double bind: as terrifying as the idea of nothingness seems to have been for him, he must also have feared his own tendency to use the decorative artifice as a means to cover over life itself, which he often found repugnant. Excessive ornamentation offers salvation from the void, but it drains life from the objects it covers. The shifts in narrative voice and point of view are motivated, I believe, by an identification with the hero, and a desire to mask that identification because of Gautier's fear of having the evil eye.

No longer endowed with ornamental vision, it is Paul's turn to be enveloped, swallowed up by the vegetation of the garden.

> Les lauriers lui *barraient* le passage; les rosiers *s'accrochaient* à ses habits, les lianes *le prenaient aux jambes, le jardin lui disait dans sa langue muette* "Malheureux!" . . . Paul . . . se roulait dans le feuillage. . . . *Déchiré et meurtri* par les branches irritées, il arriva enfin au bout de l'allée. . . . Ses doigts tremblants effleurèrent . . . un visage pur et froid comme le marbre. (471–72; emphases mine)

> [The laurel bushes barred his way; the rosebushes *fastened themselves on his clothes*, the vines *seized him about the legs, the garden spoke to him in its mute language*: "Poor unfortunate!" . . . Paul . . . hurled himself against the shrubbery. . . . *Torn and scratched* by the broken branches, he finally reached the end of the arbor. . . . His trembling fingers touched . . . a face as pure and cold as marble.]

Paul becomes part of an ornamental design. In an earlier chapter, Gautier described the "spectacle of Neapolitan petulance" made up of incomprehensible sounds and agitated gesture, "a fury of action unknown in the North." Gautier's desire, it seems to me, is to transcribe and re-create a gestural language that signifies through syntax and visual patterning rather than through conventional, referential linguistic means. One sees this in the wild vegetation of the decor, in the projected fingers of the Neapolitans, in the tempest, and even in the "excess of coral" of Alicia's costume. This is to take painting as the model for literature, but more specifically, it is to draw upon a function of ornament, for in 1856 it was only the latter that enjoyed the privilege of abstraction, giving free rein to gesture. Ornament belongs to another order of meaning, as does the sublime. Another form that the desire to make written language into gestural language takes is ornamental prose (in the following passage, alliteration). The convulsive movements of Paul's body are performed by the twitching jerks of the repeated *c* and *s*. "Paul *c*ouvrit de baisers la main gla*c*ée d'Ali*c*ia; les *s*anglots *s*e*c*ouaient *s*on *c*orps par *s*ac*c*ades *c*onvul*s*ives. *S*a douleur attendrit même la féro*c*e Vi*c*è, qui *s*e tenait *s*ilen*c*ieuse et *s*ombre . . . veillant le dernier *s*ommeil de *s*a maître*ss*e" (472; emphases mine).

In the dramatic, concluding scene, Gautier paints the archetypal image of the Romantic sublime: the tempest. Moreover, in it the oral drive and the phallic drive (represented by the volcano) come together.

> Les vagues . . . se brisaient sur la rive avec des sanglots immenses . . . et gonflaient, sous *les plis de l'écume*, leurs poitrines désespérées. . . . Paul arriva bientôt au bord d'une roche qui surplomblait . . . et il continua sa marche sinistre, quoique sentant le vide sous son pied suspendu. Il tomba; une vague monstrueuse le saisit, le tordit quelques instants dans *sa volute et l'engloutit*. La tempête éclata alors avec furie: les lames assaillirent la plage . . . lançant à cinquante pieds en l'air des fumées d'écume; les nuages noirs . . . laiss[aient] apercevoir par leurs fissures l'ardente fournaise des éclairs; des *lueurs sulfureuses, aveuglantes . . . le sommet du Vésuve rougit*, et *un panache* de vapeur sombre . . . *ondula* au front du volcan. . . . [O]n eût dit que le chaos voulait reprendre la nature et en confondre de nouveau les éléments. (473; emphases mine)

> [The waves . . . broke on the shore with immense sobs . . . and their despairing breasts swelled under *the folds of foam*. . . . Paul was soon standing on an overhanging rock . . . and he continued on his way, al-

though he knew the abyss was beneath his feet. He fell; a monstrous wave seized him in its embrace, twisted him for a few instants *in its volute and swallowed him up*. Then the storm burst forth in all its fury; (bladelike) waves assailed the beach . . . casting the spray high into the air; the black clouds, tinged with fire, emitted a *sulphurous, blinding gleam . . . the top of Vesuvius grew red*, and a *plume* of dark vapor *undulated* at the face of the volcano. . . . It seemed as if chaos wished to reconquer nature and once more confound the elements.]

One would have to be blind to miss the numerous semantic parallels between this description of the sea and those of Paul; these parallels merge Paul with the sea: *se briser, sanglots, pli, monstrueuse, lames, aveuglantes*. Further, elements of orality, decorative fury, and the sublime all merge here. The verb "to merge" is in fact the pivot on which they do so. Paul is literally "swallowed up," as is the Subject in the experience of the sublime. But here the recuperative moment by the ideas of reason does not occur. In the poem "Jettatura," published some years later, Gautier keeps his hero at a safe remove from the catastrophe: as he witnesses the shipwreck of the sailors who had abandoned him on an island, the hero's face shows "horror and pity," as he "helplessly waves about his despairing hands." His gaze is compared to an asp, cut apart, who seeks to rejoin his "knots," and the presence of a "severed asp" in the text leads one to see the snakes of the *Medusenhaupt* in the name *As*premont. In the novella, though, the hero has forgone the safe distance from which the fearful, dynamical sublime is perceived. Becoming one with the sea's/see's ornamental excess, the Subject's fissure between inner and outer disappears entirely, and the *me* merges with the *not-me*. This is precisely what happens in the experience of the evil eye. The evil eye brings on a fever "where the dominant sense was of being merged with the objects that surrounded and overwhelmed me" (Di Stasi, *Mal Occhio*, 136). There are "intimations of some other mode of apprehension . . . me seeing myself both one with and apart from the current that had me; me both terrified of that imminent annihilation and fascinated that I was it, this cleavage and boundary of which I was both" (*Mal Occhio*, 136–37).

We now recognize the most essential meaning of the insistence in the text on borders, framing, boundaries. The border between outer and inner, *Umwelt* and *Innenwelt*, is a heady and dangerous place where one's subjectivity undergoes a dizzying expansion. This vertiginous ex-

cess in the Subject is both "terrifying and fascinating," reminding us of the sublime.

Although the image of Paul merging with the sea obliges us to reflect on the aspect of Subject/Object (con)fusion in the evil eye and the sublime, it is problematic for my interpretation of the sublime in *Jettatura*: the Subject must occupy a secure position in the face of the terrifying sublime. We must therefore take the implications of this scene a step farther. As was the case in the hero's confrontation with his reflection as the Medusa, the reader is made to take up the position of the Subject. Indeed, one is "penetrated" in spite of oneself. I believe that the authorial intrusions in the tale are a way of implicating the reader in the dynamics of the text. It is the reader who enjoys the requisite secure aesthetic distance in observing the terrible scene with which Paul has become one, and, as with the Medusa's head, it is we who are meant here to experience the sublime. But is our position really so secure? Ornamental vision is an evil eye that immobilizes the narrative. It is like the Medusa, using excess as a means of immobilization. The internal conflict in the text, Medusa/*médusé*, is mirrored in the relation of text to reader. For if the reader is *médusé*, paralyzed in the effort to proceed with the plot, forced to stop dead in the narrative path by the mass of decor/decorative detail, the negative feeling of being overwhelmed is converted into the negative pleasure of possessing the evil eye. Aided by the floating point of view in the novella, the readers adopt the point of view of the hero and enjoy his ornamental vision as though it were their own. In the end, as the final scene makes clear, *we* have the evil eye.

The ultimate painting of the sublime in *Jettatura* places the orality of the eye in the foreground in the most dramatic way possible. This underlying orality may be compared to that moment of the sublime in which the Subject feels overwhelmed, engulfed, by the excess of stimuli. Kant's *Abgrund*, or abyss, is the crowning image of *Jettatura*. And this experience, in turn, may be held up as the paradigm for the ornamental prose, decor, and imagery that swallow up the characters and plot in this text.

Gautier succinctly characterizes the unexpected fusion of the decorative and the sublime when he describes Paul Baudry's figures on the walls and ceiling of the Paris Opera as possessing "a grandiose coquetry." It has been said that Gautier preached "the Kantian doctrine of disinterested artistic pleasure through the treatment of trivialities" (Tennent, *Gautier*, 88). This is to overlook the originality of, for exam-

ple, the above idea of "coquetry." The elaboration of these "trivialities" as vehicle for the sublime is precisely what allows Gautier to express, in an underground way, the abyss embodying his terrifying fear of death (specifically, of being devoured, swallowed up), his fear of the evil eye, and the violence of his desire to incorporate the woman. The decorative in *Jettatura* is thus the vehicle for the more profound issues of death and desire.

By incorporating the system of values he had worked out in his criticism of the decorative arts into a text about the problematic of vision as evil and terrifying, Gautier gives us not only a theory of ornamental vision in literature, but a new way of thinking about the categories of the Beautiful and the Sublime.

PART II

Symbolism
and
Decadence

Trompe l'Oeil in the Poems of Mallarmé

L'ignition du feu toujours intérieur
Originellement la seule continue
Dans le joyau de l'oeil véridique ou rieur.
—*Mallarmé, "La Chevelure..."*

Imiter le Chinois au coeur limpide et fin
De qui l'extase pur et de peindre la fin
Sur ses tasses de neige à la lune ravie
D'une bizarre fleur qui parfume sa vie
Transparente, la fleur qu'il a sentie, enfant
Au filigrane bleu de l'âme se greffant.
—*Mallarmé, "Las de l'amer repos..."*

FIGURE/GROUND AND THE "CLEVER READER"

Space in architecture, in design, in decoration, is interpreted as an environment that favors "the breaking up of volumes, the play of empty space, the sudden gaps, [and] the multiple planes, colliding, that break up/shatter light" (Focillon, *Vie des formes*, 38). Mallarmé's poetic architecture is known to be structured by voids and by a complex play of reflections. Studied in the light of theories of the decorative arts, the above polarity is seen to have a directing force: ornament. It is ornament that is refracted in "multiple planes" that "shatter/refract the light." "Multiple planes" in Mallarmé's poetry may be conceived of as spatial planes and perspectives that generate various levels of meaning. Invariably, the images that go to make up these planes are ornamental. The following passage from Henri Focillon's *La Vie des formes* proposes that it is ornament, as well, that models the void. "Even before being rhythm and combination, the simplest theme in ornament, the flexion of a

curve, a scrollwork that implies an entire series of symmetries, of alter-
nances, of doublings, of windings, already encodes [*chiffre*] the void
where it appears and confers on it an original, new existence."[1]

A paradoxical interplay between ornamental overburdening and
nothingness is pushed to its outer limits in certain texts of Mallarmé.
Nothingness is figured in the text by the white spaces (*les blancs*)
between the verses, by the evocation of the void by an image, and by
the reciprocal cancelling out of words.[2] For example, in "Hérodiade,"
"abolished" is juxtaposed with the ornamental image ("Abolie. . . . Des
ors nus fustigeant l'espace cramoisi, / Une Aurore a, plumage héral-
dique") and the evocation of "La chambre singulière en un cadre, attirail
/ De siècle belliqueux, orfèvrerie éteinte, / . . . Et sa tapisserie, au lustre
nacré, plis / Inutiles . . . loin du lit vide" frames the emptiness of the bed
with the highly decorative but "extinguished" worked gold (Abol-
ished. . . . Naked golds flogging the crimson space, / A Dawn has, he-
raldic plumage . . . ; The singular bedroom in a frame, pomp / Of a
bellicose century, extinguished gold work, / And its tapestry, with
its mother-of-pearl luster, folds so / Useless . . . far from the empty
bed).[3] In the first verses, the naked "plumage" of gold acts like Focil-
lon's "planes that break light up into prisms," and simultaneously, this
ornamental Dawn is "abolished." What is the precise relationship (or
relationships) traced in Mallarmé's texts between the void and decor-
ative sumptuousness? Already in 1865, Mallarmé's envisioned work
Allégories somptueuses du Néant inextricably welded the two concepts
together in its title. Toward the end of his life, in 1894, he wrote
(regarding the all-important nature of cadence) that "toute prose
d'écrivain fastueux . . . ornementale, vaut en tant qu'un vers rompu . . .
selon un thyrse plus complexe" (the prose of any sumptuous writer . . .
an ornamental prose, is like broken verse . . . like a more complex
thyrsus) (*Oeuvres*, 644).

Rather than constructing a system of oppositions or a simple play of
contrasts, the tight interlacing of ornament/void produces a sort of
Arcimboldo painting where the eye grasps quasi-simultaneously the
vegetables with the portrait of a man, or in the present case, the gold
work of a decor carved to the utmost along with the disappearance of
the central figure/motif.[4] I am calling these sorts of designs "trompe
l'oeil"; they "fool the eye" in a way that is different from and subtler than
paintings that, at a distance, create an illusion of three-dimensional
space.[5] Other examples of the "Arcimboldo effect" are the recession
and advance in the sentence of a given word, thanks to the construction

of a perfectly ambiguous syntax (see lines 2–3 of "Ses purs ongles très haut. . ."); the simultaneous presentation and cancellation of an image accomplished by naming an absent object; and finally, the multiplication of interpretative possibilities surrounding certain words, thereby creating an overburdening of signification that ends up as a reciprocal cancelling out.

Les mots . . . s'exaltent à mainte facette . . . projetés, en parois de grotte, tant que dure leur mobilité ou principe . . .
Lire—
Cette pratique—

Et, quand s'aligna, dans une brisure, la moindre, dissémineé, le hasard vaincu mot par mot, indéfectiblement le blanc revient, tout à l'heure gratuit, certain maintenant, pour conclure que rien au-delà et authentiquer le silence—

Virginité qui solitairement, devant une transparence d'un regard adéquat, elle-même s'est comme divisée en ses fragments de candeur, l'un et l'autre, preuves nuptiales de l'Idée.

L'air ou chant sous le texte . . . y applique son motif en fleuron et cul-de-lampe invisibles. (*Oeuvres*, 386–87)

[The words . . . exalt themselves, many-prismed . . . projected in a grotto wall, as long as their mobility or principle endures . . .
To read—
This practice—

And, when aligned, in a break/gap, [even] the smallest, disseminated, chance vanquished word by word, indefectibly the white returns, a short while ago arbitrary, now certain, in order to conclude that nothing [lies] beyond and to authenticate the silence—

Virginity, which in solitary fashion, before the crystal clarity of an adequate gaze, itself has fractured into fragments of candor, each of them, nuptial proofs of the Idea.

The melody or song under the text . . . whose motif is laid on in invisible ornament and tailpiece.]

The motif of the textual song is decorative, a motif in invisible ornament/jewel and tailpiece.

Whose gaze is it that focuses on the white of the page and watches

it fracture into fragments of candor? This virginity, the white of the page that reemerges from between the words, is no longer felt to be something arbitrary and formless that intrudes on the reader, but rather a necessary absence or void that structures the poem as much as the sculpted line of painstakingly chosen words does. Once the background imposes itself on our consciousness as aesthetic form, vision begins to play with it. The architect of words and silence is the poet, but the gaze here belongs to the reader: "To read— This practice—." The work of reading, according to these passages taken from "Le Mystère dans les lettres," mimes that of the poet: to render the poem intelligible through a precise architecture that highlights the empty spaces, which in turn illuminate the contours of this architecture. No less meaningful than the verses, the white of the page is a "significatif silence qui n'est pas moins beau de composer que les vers" (meaningful silence that is no less beautiful to compose than verse).[6] The architecture, mobile but precise, can be seen only in relation to the white spaces, but their form can be perceived only in relation to the contours of the architecture: one cannot be seen without the other.[7]

But Mallarmé's artful ruse is to make the one interchangeable with the other. Obviously, this twist complicates the perception of poetic space immensely: one cannot be adequately perceived without the other, yet both cannot easily be seen at the same time. One sees this phenomenon beautifully realized in cabinetmaker-decorator André-Charles Boulle's *ornements à double jeu*, where a black ground changes roles imperceptibly with a white motif, wiping out the fundamental distinction between figure and ground (fig. 15). The void, having become the exact counterpart of the ornament by an ingenious interlacing of their contours, changes places with the latter. Mallarmé has described these sorts of designs as the flower that "s'étal[e] plus large . . . [et] se par[e] d'un lucide contour, lacune" (grows ever larger and ornaments itself with a lucid contour, lacuna) (*Oeuvres*, 56). In the preface to "Un Coup de dés," which Mallarmé addresses to the *Lecteur habile*, he refers to a "vision simultanée de la Page" (*Oeuvres*, 455).

There is another precedent for those sorts of trompe l'oeil designs in the decorative arts, and Mallarmé (who wrote three poems having to do with porcelain cups—1862, 1864, 1887) may well have read the 1885 article "La Céramique de Saint-Amand" in *La Revue des Arts Décoratifs*; the collection of ceramics of the region on display at the museum of Valenciennes (the art was at its zenith there in the mid-eighteenth century) was especially noteworthy for its pieces in *sopra bianco*, a type of

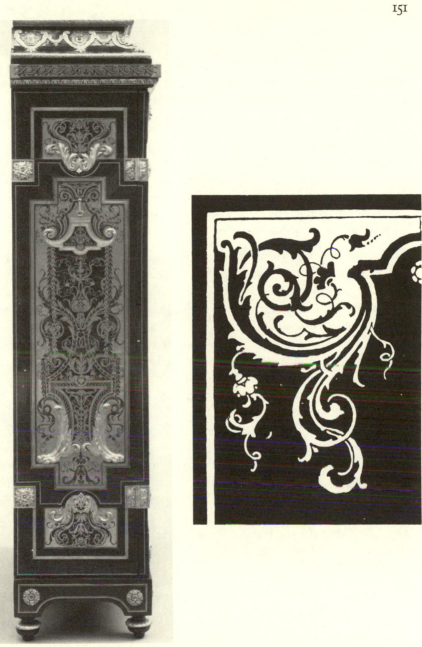

15. André-Charles Boulle: *Left*, armoire, early eighteenth century. The
Metropolitan Museum of Art, Fletcher Fund, 1959 (59.108). *Right*, ornamental
marquetry design, seventeenth century.

porcelain invented in Faenza, Italy, whose combinations of white on white were first practiced in France in Saint-Amand. The white of the design detaches itself from the slightly rosy white of the ground; in Faenza, the *sopra bianco* is used principally in the borders, but in Saint-Amand, it was used more audaciously. See, for example, this plate:

> Imagine, next to the most natural decor and amidst little flowers, two bands of lace placed in a zigzag, and nonchalantly thrown there with their airy fabric and their fine denticulations. *This lace in trompe l'oeil* is imitated with a rare perfection; it is silhouetted by delicate nuances on the surrounding enamel. . . . In the art of ceramics, surprise has always played a great role; one discovers, *thanks to this effect of white on white, a second design scarcely noticed before.* (Emphases mine)[8]

The exquisitely refined patterns in these plates remind one of another Mallarméan image: "Blanc conflit d'une guirlande avec la même" (White conflict of a garland with its twin/the same). The perception of subtle designs such as these is what Mallarmé demands of the reader: the gaze must be adequate to this work. And the reader who is trained in the (decorative) art of enjoying such visual refinements or tricks is more likely to fulfill these expectations. Let me emphasize here that my taking the decorative arts as a model for the act of reading is called for by Mallarmé's choice of image at the end of "Le Mystère dans les lettres"; the motif of the melody beneath the text (if it is beneath the text, it is formed, therefore, by the white spaces) is laid on in invisible ornament/jewel and tailpiece.

In "Une Dentelle s'abolit," the subtlety of the ornamentation (*dentelle, guirlande, se dore*), scattered at near-equidistance in the sonnet, creates a rhythm of ornament that is perfectly interlaced with the rhythm made up of images of the void (*s'abolit, absence, néant*). "Une Dentelle s'abolit" explores the "sopra bianco effect," an effect it names "this unrelieved white conflict."

> Une dentelle s'abolit
> Dans le doute du Jeu suprême
> A n'entr'ouvrir comme un blasphème
> Qu'absence eternelle de lit.
>
> Cet unanime blanc conflit
> D'une guirlande avec la même,
> Enfui contre la vitre blême
> Flotte plus qu'il n'ensevelit.

Mais, chez qui du rêve se dore
Tristement dort une mandore
Au creux néant musicien

Telle que vers quelque fenêtre
Selon nul ventre que le sien,
Filial on aurait pu naître. (*Oeuvres*, 74)

[A lace curtain is abolished
In doubt of the supreme Game
Only to unfold like a blasphemy
The eternal absence of a bed.

This unrelieved white conflict
Of a garland with its twin/the same.
Having fled up against the pale glass
Floats more than buries.

But in whoever gilds himself with dream
Sadly sleeps a mandola
Whose hollow void is musical

Such that toward some window
According to no womb but its own,
Filial one might have been born.]

The rhythms in this sonnet are made infinitely more complex by the repetition of "se DORE . . . tristeMENT DORT une MANDORE" and "LIT." For, out of the absence of the bed (*le lit*)—where the Object of desire might be located—a proliferation of LITS irradiates and creates a decorative effect: aboLIT, confLIT, enseveLIT. An absence (the bed) is carved out of a text composed as much of holes as of threads (like a piece of lace), and it is glimpsed through a pale window. In 1866, Mallarmé described the inner center of his poetic self as a place where "I sit like a sacred spider on the principal threads already spun out from my mind, threads that will help me *weave at the intersecting points marvelous lace-work* that I can feel is there and that already exists in the heart of Beauty" (emphasis mine).[9] The sonnet not only enacts the project of writing as lace making, but also illustrates the practice of reading as Mallarmé described it above. One reads in the *blancs* (in the intervals between objects and in the white objects themselves, represented here by the "blanc conflit"). Vision sinks into (*s'ensevelit*: is buried) the holes

of a lacy writing that "abolishes itself" before one's eyes almost as soon as it is perceived. "A prompt irradier ainsi qu'aile l'esprit" (Prompt to irradiate like a wing, the spirit). Before it evaporates, this vision takes the form of a decorative irradiation.

These *blancs* are not only the metaphysical Rien and Néant that center the Mallarméan discourse, but also the blanks that come out of the reader's difficulty in interpreting the text, relegating meaning to the interstices that Mallarmé has made visible through the shared ornamental contours of the poem's architecture. Gaps here are visible and disappearing at the same time, then. These gaps, set off by ornament, are the poetic manifestation of the mystery that never ceased to occupy Mallarmé: the creative power of the void.[10]

The transformation of "empty" space produces a vibratory trompe l'oeil in Mallarmé's "Surgi de la croupe et du bond" of 1887. Here, the contours of a delicately curved vase also function as the outline of two profiles: those of the poet's mother and her lover, very much like the famous Gestalt image (fig. 16).

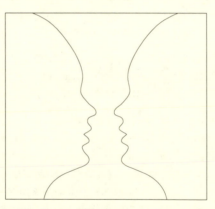

16. Gestalt, *The Impossible Kiss or the Vase*, author's sketch.

> Surgi de la croupe et du bond
> D'une verrerie ephémère
> Sans fleurir la veillée amère
> Le col ignoré s'interrompt.
>
> Je crois bien que deux bouches n'ont
> Bu, ni son amant, ni ma mère,
> Jamais à la même Chimère,
> Moi, sylphe de ce froid plafond!

Le pur vase d'aucun breuvage
Que l'inexhaustible veuvage
Agonise mais ne consent,

Naïf baiser des plus funèbres!
A rien expirer annonçant
Une rose dans les ténèbres. (*Oeuvres*, 74)

[Risen from the springing croup
Of an ephemeral glasswork
Without flowering the bitter vigil
The ignored/unseen neck is interrupted.

I believe that two mouths never
Drank, neither her lover nor my mother,
From the same Chimera,
I, sylph of this cold ceiling!

The pure vase of no potion
But the inexhaustible widowhood
Dies slowly without consenting,

Naïve kiss most funereal!
To breathe its last announcing (nothing or)
A rose in the darkness.]

 This illustration of a perceptual problem is entitled "L'Impossible baiser ou le vase" (The impossible kiss or the vase). In Mallarmé's poem, not only is the lovers' kiss absent (impossible), but the vase is the receptacle of "aucun breuvage" (no potion). The ornamental object is what separates the two lovers. In freezing their proximity in the timeless immobility Symbolism prizes, the resurgence of the vase obliterates their presence as well. This paradox elevates the physical desire of the lovers to a virtual, metaphysical desire. Again, it is out of this absence, whose contours are always represented by a decorative object, that the Ideal vision springs.

 The inspiration for such a design may well have been influenced by the decorative arts. Vases converted into lamps, Sèvres vases, and enameled vases were objects of commentary in the poet's articles on the 1871 London International Exposition. But most important was the decorative solution to the problem of interrelating figure and ground, ornament and empty space, a solution that merited a three-

page exposition in the 1884 work (republished in 1885) of Henri Mayeux, *La Composition décorative*. As Mayeux explained, Byzantine art had always been preoccupied with gracing the background areas with an ornamental contour, and Italian decorative artists of the Renaissance developed this concept in making the background an exact counterpart of the ornament.

In seventeenth-century France, as I have mentioned, Boulle stretched the viewer's perceptual capacities in his *ornements à double jeu*.[11] Clearly, Mayeux's historical progression points to a problematizing of the figure-ground relationship, where the figure no longer enjoys primacy over the ground, and the eye is made to consider a field more complex in its interrelations. If any doubt remains as to the role that the figure/ground ambiguity in the decorative arts played in the 1880s in France, one has only to read these lines, written in 1893: "Designs *à double jeu*, which some years ago were *la question du jour*, throw into high relief this selective power of the imagination" (Souriau, *Suggestion*, 79).

Decorative objects, in Mallarmé's texts, function in trompe l'oeil; fans, pieces of lace, ornate golden frames, bibelots—once transposed into this universe—enjoy a metaphysical expansion while maintaining their intimate resonance. Their disappearance or fundamental absence ("nul ptyx, aboli bibelot d'inanité sonore"; "une dentelle s'abolit" [no ptyx, abolished bibelot of sonorous inanity; a lace curtain is abolished]) functions in the poem as the central motif, which is then highlighted and surrounded by the myriad decorative forms in the decor and in the intricate and repetitive sonorities of the poem's language. The disappearance of the decorative object, elevated to the status of Symbol, at once constitutes the void and produces a proliferation of decorative effects that echo this absence at the same time as they represent its transcendence of nothingness. The immobility of these objects is transmuted in this incantation of repeated sonorities and decorative motifs, which quickly become vertiginous as the reader attempts to trace all of their internal connections within the poem. The curious nature of immobility, produced by the decorative objects and effects in the poem, is akin to the trompe l'oeil effect of the Gestalt image described earlier; a hieratic, symbolic form, seemingly frozen in space, reveals itself as a shimmering vacillation of form. The simultaneous expansion and effacement of a *dentelle, éventail* (fan), or *bibelot* is an illustration of the road to the Absolute; the sensual, concrete object gives way, *before our eyes*, to its Ideal form. And decorative form is most apt, curiously,

to represent the Ideal because it is perceived as nonsignifying and purely formal.

In 1874, Mallarmé founded, edited, and wrote most of the articles for *La Dernière Mode*, a magazine of fashion, the arts, and high society (fig. 17). (As early as 1872 he had dreamed of founding a monthly gazette to be called *L'Art Décoratif*.) This aspect of his work cannot be dismissed as trivial; indeed, Rémy de Gourmont called these articles "authentic and charming prose poems,"[12] and Mallarmé himself, in an 1885 letter to Paul Verlaine, wrote that the issues still served "to induce deep revery."[13] In the initial article he exclaims, "*La Décoration! tout est dans ce mot*" (*Decoration!* everything is in that word); and in subsequent articles his descriptions of and comments on contemporary fashion accessories—feathers, laces, diadems, fans—draw parallels between the decorative and the poetic. On feathers (*la plume* is a commonplace metonymy for the pen and the name of a Symbolist journal of the period), see, for example: "Nothing so pretty and shimmering for the eye as this ornament. . . . The feather . . . seems to wish to efface under its mad, light invasion the hard, sparkling jet." And on a diadem: "Four rows of enormous diamonds mixed in [the] shadow, lost in the black splendor [of the hair]. What a miraculous vision, a painting to imagine more than to paint: for its fugitive beauty suggests certain impressions analogous to those of the poet, profound or fugitive." The way ornament manipulates the gaze is implied in the following description: "Jet . . . attracts, condenses and holds all the richness of the Ensemble, as well as the gazes that are caught there."[14] What is suggestive for the poet (in fashion as in poetry) is the brilliant rivalry between light and darkness, the gemlike scintillations emerging out of a dark nothingness capable of spawning them.

"LE SONNET EN YX"

Eight years before *La Dernière Mode*, Mallarmé planned to dedicate twenty years to the grandiose poetic project entitled *Les Allégories somptueuses du Néant*. Two years later, his "Sonnet allégorique de lui-même" appeared, offering a veritable illustration of the emergence of sumptuousness out of the void. This dreamlike vision, stripped to its bare metaphysical bones, was recast in 1887 and entitled "Ses purs ongles très haut..." (often referred to as "Le Sonnet en yx").[15]

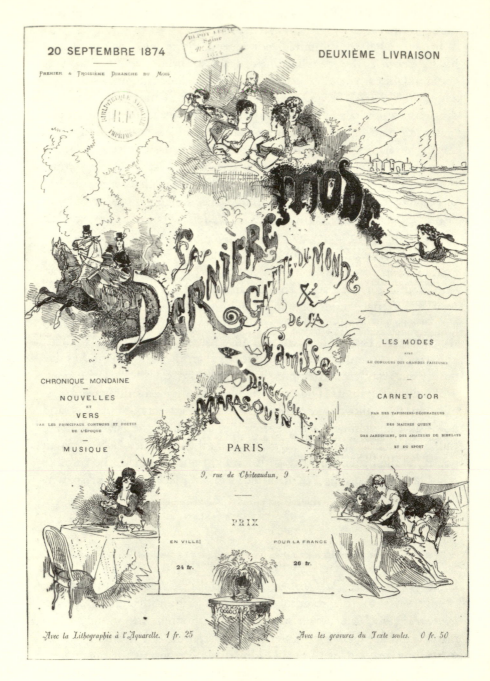

17. Frontispiece of Mallarmé's *La Dernière Mode.*

1 Ses purs ongles très h*au*t dédiant leur *onyx*
2 L'Angoi*sse*, *ce* minuit, *s*outient, lampadophore,
3 Maint rê*ve ve*spéral brûlé par le Phénix
4 *Que* ne re*cu*eille pas de *ci*néraire amphore
5 *S*ur les *c*rédences au *s*alon vide: nul *p*tyx,
6 A*boli bib*elot d'*inanité* *s*on*o*re,
7 (*C*ar le Maître est allé *p*uiser des *p*leurs au *S*tyx
8 Avec *ce* *s*eul objet dont le Néant *s*'honore).
9 Mais *p*roche la *c*roisée *au nord* vacante, *un or*
10 Agonise *s*elon *p*eut-être le *décor*
11 *Des* li*c*or*n*es *ru*ant *du* feu *c*ontre *u*ne nixe,
12 Elle, défunte *nue* en le miroir, en*c*or
13 *Que* dans l'oubli fermé par le *c*adre, *s*e fixe
14 De *s*cintilla*t*ions *s*itôt le *S*eptuor. (*Oeuvres*, 68–69)

[Her pure fingernails very high dedicating their onyx,
Anguish, this midnight, upholds, lamp bearer,
Many vesperal dreams consumed by the Phoenix
That no funerary urn collects.

On the credenzas in the empty room: no ptyx,
Abolished bibelot of sonorous inanity
(For the Master has gone to draw tears from the Styx
With this sole object by which Nothingness is honored).

But, near the window, vacant to the north, a gold
Is dying, perhaps in the decor (according to the decor)
Of unicorns kicking fire at a nixie,

She, defunct nude in the mirror, while
In the oblivion bound by the frame, are fixed
Scintillations at once the Septet.]

The visual forces at work in this poem rely heavily on decorative effects found in the paintings and ornament of the period. I have grouped these visual forces under four headings: luminosity, framing, mirroring, and trompe l'oeil.

Luminosity (and sumptuousness) out of the void: The void is represented by such words as *vide, nul, aboli, Néant, oubli,* and *vacante,* while images of emptiness are evoked by the empty funereal urn (verse line 4), the empty living room (5), the *ptyx* (whether the word is taken to mean a seashell minus the animal it once contained or whether it is taken to

be perfectly devoid—emptied out—of meaning). This absent, non-existent object acts as a mirror for the other rhymes in-*yx*. No sooner is the *ptyx* evoked than it is abolished by the remarkably incantatory phrase "Aboli bibelot d'inanité sonore." Bibelot, its apposite, also seems to function similarly as a Kantian "leere Gegenstand ohne Begriff."

Luminous objects, however, glimmer in this decor: the onyx of up-raised fingernails (1), the candelabra metaphor for Anguish (2), the gold of an ornamental frame that in its contortions figures fiery unicorns chasing a water nymph (9–11), and, of course, the scintillations of the stars, specifically, the *Septuor*—the seven stars of Ursa Major (14). In fact, the "narrative movement" of the text is constituted by the three luminous "moments": the initiatory gesture of the fingertips raised high in dedication of their onyx, and the two images in the tercets—one decorative, one cosmic—that echo their scintillation. That the cosmic is *superimposed* on the decorative object cannot escape our attention. The sumptuousness of the poem is largely auditory, and I have ital-icized some of its sonorous richness. The visual counterpart to the aud-itory sumptuousness is centered in the image of the gold frame.

Framing: The first instance of framing is that of *lampadophore*, which contains *amphore*; there follow *au nord / un or*, and *des licornes / décor*. *Ptyx* is the central object, which, if it does not fully enclose them, draws into itself the other two rhymes in -*yx* on either side of it. The window (*la croisée*) is a visual frame containing crossed lines, or *x*'s. Lines 7 and 8 are framed by parentheses. The image that sums up this operation is, once again, the ornamental frame that encloses the mirror. Since the mirror reflects part of the scene in the frame, one might say that the latter frames itself as well. A last remark: the synecdoche that denotes "frame," *un or*, is itself enclosed nine times in the poem (2, 4, 6, 8, 9, 10, 11, 12, 14). The ultimate framing operation is to frame the frame.

Mirroring: This sonnet owes much of its "attitude of Mystery" to the unsurpassed quantity and variety of internal mirrors, which Mallarmé called "reciprocal distant fires." Among the wealth of semantic and phonetic reflections are *Pleurs au Styx / leur onyx, Phénix / feu contre une nixe, ongles / onyx* (here the object metamorphoses strangely before our eyes into the luminous material of which it is made), and the most incantatory combination of repeated sonorities in the sonnet: ABOLI BIBELOT D'INANITÉ SONORE.

Trompe l'oeil: The passage from an object to its synecdoche *ongles/ onyx* (1) in the space of one line of verse operates as a trompe l'oeil (do

we visualize the object or the substance of which it is composed?). As Anguish raises its nails/onyx/glowing tips of the candelabra (fig. 18), the syntax of the poem allows us to see the three interchangeably. The words *défunte nue* (12) both function as either noun or adjective, and thus, oscillate between foreground and background. In Mallarmé's difficult image in the final tercet (12), mirror and frame, enclosed and enclosure, are shown, linguistically, as capable of a trompe l'oeil: the mirror is framed but creates a perceptual problem when it reflects that frame. The reflection in the void/*oubli*, moreover, is the scene of a shimmering undecidability between the intimate proportions of the interior decor of the room and the superimposition of the starry firmament. In the same way, the everyday, intimate furnishings of the room (credenzas, bibelots, gold frame) undergo a metaphysical expansion by virtue of the silence and immobility of the void that surrounds them. The insertion of mythic elements in the sonnet (the Phoenix, the Styx, the unicorns, and the water nymph) further removes them from the realm of the ordinary. Yet—and herein lies the trompe l'oeil effect—they never completely lose their intimate resonance.

Another manifestation of trompe l'oeil is the simultaneous appearance and disappearance of objects that are named but absent (the ptyx, the credenzas, the funerary urn).

A final "double jeu" is the link between the word *sonore*, used to qualify the bibelot, and the words *un or*, synecdoche for the frame. The abolished decorative object situated in the poem's center (6) reappears in the frame (9–13). Disappearance, transformation, and reappearance take place within the context of decorative objects. Indeed, it is the decor that contains the *or* that illuminates the scene. It is *son or* (its gold) that shimmers in the word *sonore*. The decorative frame not only encloses the absence (*oubli*) of the mirror but captures, too, the stars' scintillations in it. This jewel-like pattern is assimilated to the musical sonorities of the sonnet by the metaphor *Septuor* (septet): the French sonnet's architecture is, of course, 4 and 3 (quatrains and tercets).

The oscillation between (emptied-out) deep space in the mirror and the elaborate surface work of the frame is Mallarmé's equivalent of the ambiguous alternation of volume and flatness I have pointed out elsewhere in the painting of Gustave Moreau.[16] It is Mallarmé's very visual form of abstraction in the poem. These characteristics in Moreau's art make it a forerunner of the abstract art of the twentieth century, just as they contribute to the modernity of Mallarmé's poetry.

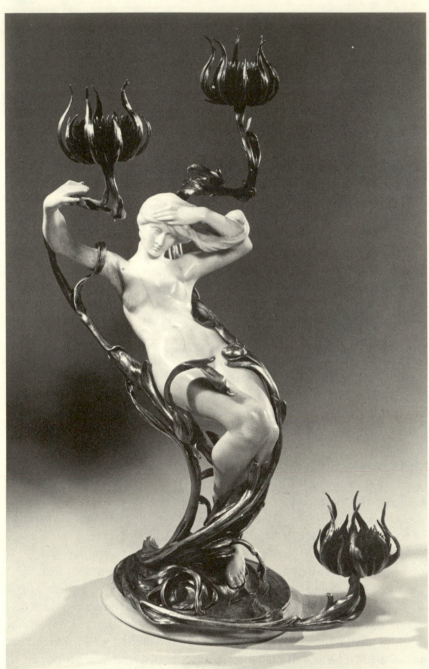

18. Egide Rombaux and Franz Hoosemans, candelabrum, Brussels, 1900.

Ornament, the perfect counterpart to the void, is what permits the void to take form, to become visible. And when it does, it manifests itself as a scintillation.

"La Coupe Vide où Souffre un Monstre d'Or"

The formal elements that have allowed me to link Mallarmé's poetry to the decorative concerns of the period also lend themselves to a psychoanalytic interpretation. I now want to show how these forms are tied to the paths of desire.

The evolution of the role played by the void in the relation of figure to ground is of central importance to both the decorative arts and to Mallarmé's poetics. The mutual dependence of the void and ornament is constructed, moreover, by well-defined contours that solicit the reader's gaze, and these in turn lend themselves to a psychoanalytic analysis of the gaze.

The heading of this section, " 'La Coupe Vide où Souffre un Monstre d'Or,' " illustrates the same dynamic of ornamental excess around a central void as I noted in "Ses purs ongles très haut...." It is pertinent that the poem from which it is taken, "Toast funèbre" à Théophile Gautier, specifically turns on different but equally intense ways of poetic seeing and looking at the world.

If there is present in paintings, as Jacques Lacan believed, a meeting of *l'objet a* and of trompe l'oeil, one then sees decorative objects in the text take on a hitherto unsuspected importance in the field of desire. For it is they that function as trompe l'oeil in those texts of Mallarmé that engage the gaze of the reader as paintings do. Although the concept of *l'objet a* (the cause of desire) has its share of Lacanian opacity, it is possible to delineate its most important qualities.

First, *l'objet a* is a form of Lost Object (the mother as primary Object, now lost to the desiring Subject, upon whom all subsequent Objects of desire are modeled). ("Elle" in the "Sonnet en yx" is "défunte" and locked in "l'oubli," thereby allowing the formation of the substitutive *objet a*.) *L'objet a* is that which "falls" or slips away from the Object (the breast, the voice, the gaze), a "riche mais chu trophée" (rich but fallen trophy).[17] It is something the Subject considers to be a lost part of the self; it is the trace of the real Other anchored in the libidinal being of the Subject. But it is also "something from which the subject, in order to constitute itself, has separated, or split off, like an organ [in this case

his own gaze]. It then functions as a symbol of lack" (Lacan, *Le Sémi-naire, XI,* 95). That is to say, *le regard,* the gaze, is alienated in the other, whether it be in the specular other (that is, in the field of the Imaginary) or in the real Other. The rapport of the Subject to what will become the *objets a,* in the period when the mother is not yet "lost," is a symmetrical relationship: the objects that satisfy the instinctual needs of the infant (the breast, the gaze of the mother) correspond to the parts of the infant's body (the mouth, the eyes) that are the loci of erotic drives. In earliest childhood, then, the Subject gains pleasure and satisfaction from the mother's gaze, with the scopic drive—a highly eroticized drive—corresponding to this pleasure. But this pleasure must one day be given up, and it then joins the other *objets a* attached to the Lost Object. The infant now searches for the pleasure/*jouissance* imagined in the mother's gaze. (*L'objet a* is therefore the trace of the real Other, and also an imaginary representation of her.) The Subject's desire is alienated in these objects, impossible to recapture. This dynamic is one of the reasons Lacan believes that the separation from the Lost Object determines the split in the Subject, that is, the split of the speaking body with the "I" of one's discourse, an "I" about whom the Subject speaks and who becomes more and more alienated from the true being. The *coupure,* or split, is, in the scopic drive, that of the eye/gaze, for the gaze that the Subject projects toward the Object to captivate or capture it escapes—slips away—from the former and comes back from the Object as other. The eye corresponds to the speaking body of the Subject, the authentic being who progressively loses the self in the chain of signifiers with which one constructs the story of one's life.[18] The gaze tied to the "I" of discourse, however, is tied to this identity anchored in the Imaginary and committed to the quest for satisfaction or *jouissance* in the other—or rather, in what the Subject thinks he or she has seized in the other. The Subject is "suspended [from the gaze] in a fundamental vacillation," as it is the gaze that is transmitted to—yet elided in—the other (*XI,* 9). In addition, the Subject doesn't see what he or she wants and asks to see returning from the Object: the gaze is thus committed to lack.

Figuration (visual expression) eludes this alienation brought by discourse with different degrees of efficacity, because there the eye, not the gaze, dominates. The more the Subject tries to possess the Object like a part of the self, the more intensity is lost in the pleasure of the scopic drive, in the act of seeing. That is why Lacan valorizes the relationship that painting demands of the Subject: "You want to look? Well, see

that!" Looking is the act of the gaze, alienated in the other, whereas seeing is part of the speaking body. The Subject is invited to lay the gaze down in front of the canvas and to rejoice in what the painting offers in "food for the eye" (*XI*, 93). And, as I have already remarked, that is the special domain of ornament: to be a feast for the eyes. Yet, if the eye takes certain pleasure in the spectacular qualities of a painting, once the gaze takes over (reinstates itself) and begins to look for itself in the object-painting, lack reappears. The place left empty by the Lost Object can then be occupied by any object at all, but that object inevitably takes the gap-filled form of *l'objet a*. Because the *objet a* gaze is always unsatisfied, it is the cause of desire, desire being founded in the quest for what remains out of reach.

Hence, *l'objet a* underlines the initial lack that constituted it, just as ornament in Mallarmé is always called upon to circumscribe a void. Like *l'objet a*, ornament seems destined to replace the Lost Object. For example, once the mother's gaze is lost, the *Schaulust* of the Subject directs itself quite naturally to those objects that are brilliant, scintillating, and beautiful and exhibit themselves to view. The pleasure that the eye finds there makes up in part for the loss of the returned gaze of the mother. This dynamic may be seen in many fictional works.[19]

The first sonnet of the 1887 triptych ("Tout Orgueil fume-t-il du soir," "Surgi de la croupe et du bond," and "Une dentelle s'abolit") will provide the first poetic illustration of the *objet a* gaze.

> Tout Orgueil fume-t-il du soir,
> Torche dans un branle étouffée
> Sans que l'immortelle bouffée
> Ne puisse à l'abandon surseoir!
>
> La chambre ancienne de l'hoir
> De maint riche mais chu trophée
> Ne serait pas même chauffée
> S'il survenait par le couloir.
>
> Affres du passé nécessaires
> Agrippant comme avec des serres
> Le sépulcre de désaveu,
>
> Sous un marbre lourd qu'elle isole
> Ne s'allume pas d'autre feu
> Que la fulgurante console.[20]

[Does all Pride turn to smoke in the evening
 (pride of the evening)
A torch snuffed out by a shake
Without the immortal puff of smoke
Being able to delay the desertion!

The old chamber of the heir
Of many a rich but fallen trophy
Would not even be heated
Were he to come through the hall.

Necessary agonies of the past
Gripping as if with claws
Disavowal's sepulchre,

Under the heavy marble it isolates
No other fire is lit
Than the flashing console.]

At the risk of brutalizing the complex subtleties of Mallarmé's sonnet, I extract the following elements. This exercise is not one of analysis, but merely an attempt to illuminate the foregoing psychoanalytic concepts and to show how resonant they are with Mallarmé's poetry. I do not view Mallarmé's texts as an unconscious to be analyzed by Lacanian theory, for I believe that Mallarmé very purposefully set these relationships down in the poetry. But just as an understanding of the decorative arts allows us to better perceive the workings of these difficult texts, so can the latter serve to illuminate Lacanian theory. The corresponding structures in Mallarmé can then reveal themselves more fully as adhering to a dynamic that has been studied systematically by psychoanalysis. The poem speaks of desertion, of Pride turning to smoke, a torch snuffed out, the old chamber of the heir, in danger of becoming inhospitably cold, an heir to rich but fallen trophies. All of this is gathered into the phrase "Necessary agonies of the past" gripping the (disavowed) desertion that has taken place. And, finally, the last image is that of a decorative object—one that appears in "Le Sonnet en yx" as well—sole recipient of the fire/desire that has expired elsewhere in the room, in the Subject, in the poem: the luminous, flashing console table. Decorative, poetic brilliance dazzles the eye and palliates to some extent the sense of utter loss. This glimmering is a sign that the desire of the Subject is still present—in the form of *l'objet a*.

Finally, the question of the painting or poem as a trap for the gaze ("un piège à regard") and as trompe l'oeil is also linked to *l'objet a*, according to Lacan. As we will see, the "Sonnet en yx" and "Surgi de la croupe et du bond..." offer themselves as explicative illustrations of these complex notions. The pleasure one gets from a trompe l'oeil is due to the fact that it offers itself as "something other than what it is" (Lacan, *Séminaire, XI*, 103). That dynamic is responsible for the "jubilation and captivation" of the Subject's gaze. We saw this function of ornament in my initial presentation of the sonnet "Surgi de la croupe et du bond..." as a poetic analogue to the Gestalt image, "L'Impossible baiser ou le vase." The analogy revealed more than simply two figures that rival each other for the privilege of being dominant in our perception. In the pulsation of this oscillation appears, seen as if behind a veil, the glimmer of a more profound level of perception, marked by the primitiveness of the essence of the gaze. This "something else," in its manner of manifesting itself, uncannily resembles *l'objet a*, a sudden eruption of the Real that lies outside the Subject yet is nonetheless tied up in the reflections of the Imaginary. The essential quality of both the trompe l'oeil and of the appearance of *l'objet a* to the Subject is evanescence. In the trompe l'oeil, the gaze allows itself to be trapped, tricked, and captivated by the Other that is the painting. The Subject has the impression of seeing like another, from another point of view: in fact the Subject does see from another place, the place of the Other. And that is precisely what is strange in the experience of the two profiles that erupt out of nothingness in "L'Impossible baiser ou le vase." The choice of the initial word, "Surgi," lends even more credence to the linking of the sonnet with the Gestalt image, a latter-day version of counterchanges in ornament. "Surge forth" or "rise" out of the void is exactly what the figures do. This experience can produce tremendous anxiety for some. Anton Ehrenzweig writes that rigid personalities react with anxiety because the "breakthrough of undifferentiated modes of vision threatens their rigidly focused surface sensibilities with sudden disruption and disintegration" (Ehrenzweig, *Hidden*, 24). Ehrenzweig even states that the experience of subjects in the face of ambiguous patterns that "dazzled their normal focusing tendencies" is comparable to "apocalyptic fears" (126–27). Annihilation does indeed have much to do with the meaning of the sonnets to be analyzed, as do the erotic drives that Ehrenzweig places in parallel development to unconscious perception (17). "Dedifferentiation," the "dynamic process by which the ego scat-

ters and represses surface imagery" (19), makes these unconscious perceptions manifest since, for a moment, the Subject perceives an object both as there (conscious) and not there (unconscious) at the same time. Undifferentiated perceptions "become invested with Id phantasy" (24). This contention will be verified by my analyses of the poetry, where in each case the unconscious perception of a shape or object is the site of sexual drives (both in the sense of Mallarmé's having situated the erotic image there, and in the sense of the viewer/reader's locating Eros in the chimerical form).

Nowhere more than in these sorts of designs is the experience of loss (when the perceived Object returns to nothingness) and recovery (when it reemerges) more intense. This particular relation of figure to ground, then, bears a precise relationship to desire: it calls on the same dynamic of nearly simultaneous lack and jubilation of discovery found in the *objet a* gaze.

For Anton Ehrenzweig, a simultaneous perception of figure and ground is possible by relaxing one's attention or focus to embrace a different form of attention that he calls "unconscious scanning." Ehrenzweig places this perceptual state with the primary processes. Like the dream work, it surges out of the unconscious.[21] This comparison is very pertinent to the work of Mallarmé, since he sought to create an opening into the dream state and used the device of trompe l'oeil to derail ordinary perception. What is more, the trompe l'oeil painting "doesn't rival appearance, it rivals what Plato designates as being beyond appearance: the Idea" (Lacan, *XI*, 103). I have demonstrated this deeper meaning of trompe l'oeil: the metaphysical stakes of Symbolism coincide precisely with certain wagers and endeavors of the decorative arts. What captivates us, finally, in the trompe l'oeil is not the appearance of reality, but the moment when it transmutes to reveal its singular function, which is to *give* this appea ance. That is also the key to understanding the very powerful effect *l'objet a* has on the Subject: the presence of the Real is felt behind the also very present veil of appearances (the demands of the gaze, the specular nature of what the Subject sees). The trompe l'oeil allows us to see a thing in the process of appearing other than what it is. It captures, in effect, what is ungraspable, for it takes place in "einer anderen Lokalität" between perception and consciousness.[22] Ornament, in counterdistinction to art that depends on mimesis and narration, sends the gaze back onto itself. In this way, it brings forth most powerfully what is at stake in seeing: the power of the visible and even the conditions of visibility. The eye revels in the sensation of Being and in

the immediacy of its meeting with the Object. Ornament is the locus where the richness of the material and the gaze of the Subject are caught together. Yet, because ornament shares so many of its characteristics with the trompe l'oeil, and because, in a second moment, it hinges on the structure of the void, it inevitably calls forth the *objet a* gaze. The marginal place often occupied by ornament—on the periphery of habitual perception—its foregrounding of the materials from which it is made, its disdain for mimesis in favor of abstraction, all make ornament a propitious ground for the drives that circulate around *l'objet a*: ornament, like *l'objet a*, is anchored in the Real (materiality, marginality) and in the Imaginary (abstraction that gives free rein to phantasy).[23] The peripheral place ornament occupies also resembles the first aspect of *l'objet a*: that which has fallen away from the essential object, or from the essential part of the thing. Ornament is a *reste*; it is often literally a *trophée chu*.

In the following analyses of the poems, I will be asking where the *objet a* regard is located: in the poem or in the reader's gaze? The gaze that the Subject is made to fasten on the poem (where void becomes ornament and vice versa) sends the gaze back as Other, something lost and then, momentarily, found.

To summarize: *l'objet a* is situated in the Real, for it takes the place of the Lost Object who exists outside of the Subject. At the same time, the phantasy of this Object that the Subject fabricates must be placed in the field of the Imaginary. *L'objet a* is therefore the trace of the real Other and an imaginary representation of this being. This trace and representation must retain in their form the constitutive lack in *l'objet a* (which has come from the Lost Object). The hole, the void, is the expression of loss and of the impossibility of representing the Real.

THE TRANSPARENCY OF THE GAZE

The mobility of Mallarmé's jewel-like words (through internal reflection) and the mobility of their meaning (through ambiguous syntax and reciprocal cancelling out, among other means) are part of a fundamentally plastic/visual aesthetic. Mobility is also, of course, the primary motor of desire. Mobility of meaning creates exactly the same sort of perceptual ambiguity one can observe in the Gestalt "L'Impossible baiser ou le vase." One could say that the "meaning" of this image hinges on the oscillation between one form and another, on the inter-

changeability of the figure with its background, or—in Mallarméan terms—on the interchangeability of the object with the void. The transformation of "empty" space into "plenitude" is accomplished by the sudden eruption of a figure that inserts itself exactly into the confines of this space. I have alluded briefly to the 1887 sonnet "Surgi de la croupe et du bond..." in this context; I would now like to analyze this poem from a psychoanalytic point of view.

The images depicted in "Surgi de la croupe et du bond..." illustrate how difficult it is to distinguish the "lacuna," or void, from the "lucid (clear, brilliant) contour." For when the "col ignoré" emerges in the first quatrain, one sees only the vase. Not so in the second quatrain, for there the vase disappears in favor of the two profiles. But does it really disappear? "Drinking from the same Chimera" keeps it present in our mind. Moreover, its "veuvage," or widowhood, evokes that of the mother, making the two sides of the contour visible at the same time. "Veuvage" continues to oscillate from one side of the contour to the other after its linkage with the profiles, for "breuvage" (drink) cannot help but resonate in "veuvage." Yet the oscillation is even more intense, since to find "drink" in "an absence of drink" (the meaning of the vase's veuvage) is to make manifest the play of presence and absence I have discussed in the context of Symbolism. To make matters more interchangeable and mobile yet, the "absence of drink" is present in the text, while the fullness is absent. Returning to the "col ignoré," it too functions doubly: as the neck of the vase or as the neck of a profile, cut off by the frame at the bottom of the Gestalt image just as the vase's neck is interrupted by the frame at the top. Naturally, the two lovers have never drunk at the same Chimera, for were they to drink from the vase, the ambiguous design (the Chimera) would necessarily be lost. The naive, extremely funereal kiss might then be that of the lovers which forever annihilates the vase. Another interpretation would emphasize the fundamental absence of the kiss (l'impossible baiser), parallel to the absence of drink circumscribed by the vase.

We have seen that Anton Ehrenzweig, for one, differs from Gestalt psychologists in believing that a simultaneous perception of figure and ground is possible by relaxing one's attention or focus on one or the other shape to embrace a different form of attention that Ehrenzweig calls "unconscious scanning." One may now wonder whether the position of the Subject in the sonnet "Surgi de la croupe et du bond..." does not imply a quest for an angle of vision that would embrace both images I have been discussing: "Moi, sylphe de ce froid plafond!"

Returning to the parallel evolution posited between this sort of perception and libido, I call attention to the fact that the perception of the Subject in the poem is fastened (as if by chance!) on the mother and her lover. Charles Mauron has interpreted the "col ignoré" that only rises to be "interrupted" as a castration phantasy.[24] Without denying the interest of this interpretation, which gains credibility when Mauron superimposes it on other poems by Mallarmé, I suggest that this decapitated phallus, if it can be directly superimposed on the vase, ends in (or is replaced by) the eye of the Subject, who sees all from the ceiling. Libido displaces itself entirely in the gaze. But is this truly a displacement? Doesn't the gaze enjoy this force and privilege from the beginning? To recall a step from the section on the scopic drive, "once the infant has given up the breast [or the gaze] it is not they that shape his erotic life but the imagined jouissance that can be concentrated in the phantasy breast [or gaze]. . . . The *objet a* . . . is not the object that satisfies desire, but the object that *causes* desire."[25] It causes desire to be focused on a new object, somehow modeled on the *objet a*. And replace it it does: in "Surgi de la croupe et du bond...," the mother's profile—whose loss to the Subject is signified by his remoteness from her on the cold ceiling as well as by the presence of her lover—is superseded by the decorative object, the vase. In "Une dentelle s'abolit..." the absent bed is replaced by the decorative proliferation of "lits," the lace curtain, and the decorative design of white on white. In "Tout Orgueil fume-t-il du soir..." the "trophée chu," the *objet a* already represented by an ornament, gives way to the polished console. Jouissance is displaced onto the decorative object or the trompe l'oeil design: this is the *objet a* gaze *in* the poem. The reader's perception of these designs is the *objet a* gaze *onto* the poem. In the following analyses, I will examine more precisely the strategies of the eroticized gaze.

In "Prose pour Des Esseintes," the experience of seeing (*la vue*) is clearly distinguished from the gaze that is prone to illusory, deceptive vision. The eye fastens on an ornamental contour that defines the object and the void simultaneously:

> Oui, dans une île que l'air charge
> *De vue et non de visions*
> Toute fleur s'étalait plus large
> Sans que nous en dévisions.
>
> Telles, immenses, que chacune
> Ordinairement *se para*

D'un lucide contour, lacune,
Qui des jardins la sépara.

Gloire du long désir, Idées
Tout en moi s'exaltait de *voir*
La famille des *iridées*
Surgir à ce nouveau devoir.[26]
 (Emphases mine)

[Yes, on an island that the air charges
With sight and not with visions
Each flower exhibited itself, growing larger
Without our speaking of it. (Pun on having visions.)

Such, immense, that each one
Ordinarily *ornamented itself*
With a lucid contour, lacuna,
Which set it off from the gardens.

Glory of long desire, Ideas
Everything in me exalted *to see*
The family of *irises* (Note the suggestion of vision in *irises*)
Rise into view to accomplish this new duty
(Arise to this new consecration).]

Four of the principal concepts that have guided my reading of Mallarmé thus far are present in these few verses: (1) The luminous contour of the ornamental object (here, an ornamental variety of flower) is inseparable from the void, as placing them in apposition to each other makes abundantly clear. Note, too, that the iris of the eye encircles a hole, the pupil. (2) Erotic desire, carried by the ornamental object, is inseparable from metaphysical desire, and this could not be rendered more perfectly than it is here by the condensation of desire and Idea in the name of the ornamental object itself: *des ir/idées*. (3) The double experience of fusion and of separation with the Object, constitutive of the *objet a* gaze, is also present. Indeed, a trompe l'oeil is created by the following ambiguity: the Subject and the Object of desire are fused into one face ("notre visage"), but the very insistence on the Object's presence casts doubt on it. The sight that surges forth before the mind and the eye is, like our Gestalt image, double ("notre visage, nous fumes deux, je le maintiens, double inconscience" [our face, we were two, I

maintain, double unconsciousness]). Moreover, the character of trompe l'oeil is made evident by the phrase "l'ère d'autorité se trouble" (the era of authority is blurred). (4) The distinction between the eye and the gaze is fundamental ("vue et non . . . visions").

Yet, this text does more than simply confirm the persistent presence in Mallarmé's poetry of the elements I have underlined in the *objet a* gaze, trompe l'oeil, and desire. In this poem about seeing, Mallarmé makes trompe l'oeil even more germane to the specific language of poetry: it is mirrored in the versification of the poem. Rich rhymes like "désir, Idées / des iridées," "pleure la rive / l'ampleur arrive," and "monotone ment / mon jeune étonnement" create the trompe l'oeil effect by making the prior words surge forth from the second formation, and then fade out in favor of the "correct" reading. Note too that this is achieved by linguistically joining or fusing what was first separate. In other words (no pun intended), the lost symbiosis with the Object of desire is recovered to some degree by the poetic power to join together words or parts of words and thereby create a new—more positive—object. This positive transformation can be seen in the last two examples given above (*pleure = ampleur; monotone ment = étonnement* [crying = amplitude; monotonously = astonishment]).

Words, like vision, are only half there (and one can pun on the fourth stanza's "on dit / De ce midi" as a *mi-dit*), partly situated in the interstices until a configuration makes them visible. These interstices are verbally described in the poem as a luminous contour that is also part of a lacuna; thus, at the place where the modalities of seeing and looking are specifically addressed, we encounter precisely the same components as I drew out of the sonnets. Even where the emphasis is decidedly on seeing (not looking) and the hyperbolic, libidinal charge that attends it, a sense of lack makes itself felt in the denial of separation between the Subject and the Object of desire, and the erotic drives are displaced from this relationship to focus instead on ornament (the flowers) and the trompe l'oeil of ornamental contour and void.

The "seeing double" of "Prose pour Des Esseintes" closely resembles that of "Surgi de la croupe et du bond..." and may be characterized as a "diaphanous gaze" (the "regard diaphane" of "Toast funèbre"). But the eye/look dialectic also yields a gaze that opens up—or falls into—spatial "holes." We observed this in "Une dentelle s'abolit." It is also represented quite explicitly in the opening verses of "Le Pitre châtié": "Yeux, lacs avec ma simple ivresse de renaître / Autre que l'histrion / . . .

J'ai troué dans le mur de toile une fenêtre" (Eyes, lakes / nets with, simply, my drunkenness to be reborn / Other than the clownish actor / . . . I bore into the canvas wall a window).[27] Whereas in the 1864 version of this poem, the "Eyes, lakes" belonged to the clown's muse, in the 1887 version they either hover independently or belong to the clown, who uses them to bore a hole/window in the canvas wall (I will return to this important shift to Objectless desire, also noted by Leo Bersani, in the next chapter). Mallarmé has placed the two ways of seeing in the eyes by apposing to them the word "lacs." For "lacs" can be read not only as "lakes" (which already evokes an abyssal structure, a hole filled with a transparent, luminous substance), but also as the interlacing of the canvas (the "toile" as painting, as circus backdrop, as "toile de fond" or ground for the figure, and as text) and the lacuna or void—the lacks—between the text of interlaced words. In order to achieve the "transparence d'un regard adéquat," both ways of seeing/looking must be present. Diaphanous, the gaze would be able to seize "the battle horse with the plane surface," as I do when I gaze at the trees in the yard behind the lace of my bedroom window's curtain. Nonetheless, in this oscillating interchange, the void is to be valorized: psychoanalytically, because the *objet a* gaze emerges out of lack and must exhibit that lack, and metaphysically, because Being must be made to emerge out of Nothingness. And by the action of that gaze, the Subject (as I noted in the perceptual experience of the trompe l'oeil) is reborn as Other.

Thus, as Symbolist precepts will have already prescribed, the creation of Being, born of Nothingness, is reduplicated in poetic creation. That this is in turn acted out in the eye/look dialectic calls for a new manner of approaching these texts. *L'Etre* is grasped through the *fen-ETRE esthétique* in the poem/painting, and this *fenêtre* is synonymous with a hole bored by the gaze through the canvas of narrative. The eroticized gaze as aesthetic contemplation through a luminous, empty window is rendered perhaps most beautifully in "L'Après-midi d'un faune": "Rieur, j'élève au ciel la grappe vide / Et, soufflant dans ses peaux lumineuses, avide / D'ivresse, jusqu'au soir je regarde au travers" (Laughing, I raise to the sky the empty cluster/ And, inflating with my breath its luminous skins, avid / For drunkenness, until evening I look through them) (*Oeuvres*, 51). *Vide* is a perfect chiasmus to *D'iv*(resse), again suggesting a mirroring or reversal of libido into void and vice versa; the object of the Faun's gaze is, in fact, this very oscillation. The aesthetic window as visual contemplation of the void is doubled by the eye's ability to empty out or make holes in the decor, presented in the

next lines: "Mon oeil, trouant les joncs, dardait chaque encolure / Immortelle" (My eye, boring holes in the rush, darted each opening / Immortal). And as the eye seeks out the splendid mass of the nymphs' hair that has disappeared into the "clartés et frissons" (brightness and shivering/thrills) of the hole/woods, the part object placed there is transformed into ornament: "O pierreries!"

Aboli Bibelot? Excess, Void, and Objectless Desire

A l'égal de créer: la notion d'un objet, échappant, qui fait défaut. . . .
y éveillant, pour décor, l'ambiguité de quelques figures belles, aux
intersections. La totale arabesque, qui les relie, a de vertigineuses
sautes en un effroi que reconnue; et d'anxieux accords.
—*Mallarmé, "La Musique et les lettres"*

MAN AS TOMBÉ, ORNAMENT AS TOMBEAU

Henri Mayeux, one of the most widely read aestheticians of the fin de
siècle, ponders the meaning of a particular type of ornament, one we
might relate to the obstinate gaze into the void I examined in the last
chapter: "How many times does one not see, in architecture as well as
in furniture, painting or bronzes, an assemblage of decorative accesso-
ries, an ornate frame bordered by figures, chimera . . . merely serve to
valorize . . . an empty medallion" (Mayeux, *Composition*, 174) (fig. 5,
top). One may say that ornament navigates, circulates around the void
so that the void might have a presence and that the critic might be able
to speak of it.

Ordinarily destined for the place left empty is the portrait in bas-
relief or the initials of the celebrant's name: that is to say, the repre-
sentation—more, the glorification—of the Subject. It is possible to
compare this specific emptying out of the center to the disappearance of
the Subject/author in Mallarmé. This valorization of ornament at the
expense of the apotheosis of man is anxiety-producing. The power and
imaginary mastery of man crumbles, evaporating into nothingness, in
favor of a discourse relegated to the margins, to the periphery of the "I,"
a discourse that circulates in the frame and finds its most propitious

guise in the frivolous contours of a bibelot or a trophy. But we know that the truth of the Subject must lie outside the field of imaginary constructs about the self, so it is in the periphery of the "I"—in what is tossed off as inconsequential or insignificant—the *déchets* of discourse, that one must seek the Real.

At the same time as the mastery of man gives way, frivolous or ordinary objects (lace, fans, bibelots, credenzas, candelabra, consoles) assume an ever greater importance, while still preserving the connotations of the intimate, of the trivial. If the famous *ptyx* is an empty conch, a *conque creuse, il sert à creuser le quelconque* (it serves to dig out the buried significance of the ordinary). All of ornament's signifying power comes from the fact that it is placed on the surface of things (one therefore takes it to be superficial), and that it is relegated to a secondary status in terms of meaning production (or to a nonsignifying role such as the one Mallarmé wanted so much to accord the *ptyx*: see *Oeuvres*, 1488–89). It is precisely thanks to its marginal status that ornament manages to carry desire that is effaced elsewhere in the text. In fact, the word *ptyx* oscillates between pure surface (bearing no meaning in the French language) and a rich underground network of meanings in Greek. The first two definitions of πτύξ have to do with ornament and the second two with writing and poetry: (1) fold of a fabric, (2) leather or metal covering for a shield, (3) writing tablet or paper, and (4) inflections, or modulations of the poet's thought (A. Bailly, Greek-French Dictionary, 9th ed. [Hachette]). *Ptyx* therefore reflects the self-reflexive couple ornament/writing, and thus mimes quite precisely the inflection of the poet's thought in the sonnet.

In "Ses purs ongles très haut...," the Master is absent (an absence that is, moreover, circumscribed by the diacritical framing of parentheses), but is this to say that mastery is absent? On the contrary, linguistic mastery is exhibited in the mirrors of the poem. What is more, all commentators of this sonnet agree that its language has become radically Other. Let us provisionally pose the hypothesis that here linguistic mastery is the equivalent of the realm of the Other. In fact, the justification for Lacan's making language the paradigm for the Symbolic is that it functions as an Other to which we cannot accede. Although we seem to possess it, we can never master its totality; on the contrary, our thoughts and the development of our identity are directed *by it*.

The mirror (here, the linguistic mirrors and the "literal" mirror of the final tercet) has the function of captivating those who see themselves in

it. In this sonnet, not only the nixie, the constellation, and the "empty" living room are caught in the mirror, but so is the reader as Subject. The mirror sends the reader's gaze back both as reflection and as something that cannot be fixed, that remains Other. At any given moment of one's confrontation, or vis-à-vis, with this text, it is the intellectual and perspectival optic / point of view of the Subject, and that point of view alone, that determines which elements will take form and consistency, and which will remain virtual. And one's perception succeeds only in capturing one possibility (of the syntactic or grammatical positions of a word) at a time (unless, of course, that reader has achieved the "transparency" of the "adequate gaze" through the practice of unconscious scanning and expansion of perceptual abilities: the art of Mallarmé clearly pushes one in this direction). The mastery of the maker, the artisan, is not, thus, a priori within reach of the onlooking Subject. However, this mastery is encouraged by the poem, for without it the text is nonsignifying. Therefore, the Subject must conceive of the self as capable of this mastery, and the reader/critic in fact does so in a dream of total comprehension; that is, the reader becomes enmeshed in the nets of the Imaginary. Nevertheless, the critic/reader knows quite well that the real mastery at work in the poem—the Other—lies outside of and beyond the reach of the Subject. In trying to accede to this confrontation with the Other, the Subject butts up against his or her own points of view, desire, gaze. This experience recalls Lacan's "mirror stage," a dynamic that has much to do with imagined mastery and with the illusory perception (or trompe l'oeil) that inspires it.

The Subject's gaze is posited by the text, not only because of the magnetism exercised by the ornamental objects it contains, but also by the multiplicity of perspectives set to work there. Didn't Henri Cazalis remark that "the eye was at grips with this sonnet as with a painting"? I have analyzed the pictorial elements in the sonnet: luminosity, structuring of the void by ornament, framing, and trompe l'oeil. Yet Mallarmé maintained that it was "not very visual (*plastique*), as you had requested it be, but at least it is as black and white as possible, and it seems to me that it lends itself to an aquatint full of Dream and Nothingness."[1] What does this mean if not that the first version of the sonnet, written to be illustrated, possesses certain qualities of the plastic arts and lends itself to translation by pictorial means (aquatint), while at the same time being "not very visual"? There is a contradiction here that merits examination. Couldn't the answer lie in a dependency on

the reader's eye and gaze to pull out the plastic capabilities of the son-
net? The tension and oscillation between the eye's erotic indulgence in
the ornamental qualities of the poem and the *objet a* gaze's projections
of desire onto the images there would create the sort of plastic configu-
ration I pulled out of "Surgi de la croupe et du bond." The reader is
given the role of illustrator.

Elsewhere, Mallarmé proposes to "évoquer dans une ombre exprès,
l'objet tu—jusqu'à ce que, certes, scintille quelque illusion égale au re-
gard" (evoke deliberately in shadow the silenced object—until, surely,
some illusion equal to the gaze scintillates).[2] The silenced object is
evoked, and the illusion of its presence is placed in parallel to an illusory
gaze. Like a painting, the "Sonnet en yx" is a "trap for the gaze." The
trompe l'oeil, the scintillation of a decorative object, and the sonnet may
all be qualified thus. I believe that the illusion of the gaze Mallarmé
refers to is precisely the intersection between the image the poem pro-
jects outward and the image the reader projects onto it. The capacity of
the poem to set in motion the various trompe l'oeil I have described
make it a place of intense activity and mobility, and give the appearance
of a gaze onto the viewer/reader. Surely we must see, through this re-
mark, that Mallarmé conceives of the objects in his poems as the site of
a perceptual exchange.

THE DRIVES ALSO CIRCULATE AROUND A VOID

I have shown how ornament traces a path around the void; this circuit
is not only that of the gaze, naturally drawn to ornamental brilliance
and complexity, but also of the scopic drive, and of the drives and desire
in general. The trajectory of the drives is circular: since the rapport with
the Other is always outside the field of consciousness (*hors-champ*), the
Subject is doomed "to turn around it" (Lacan, *Séminaire, XI,* 164). As
we have seen, what the Subject "brings back" from the Other is in fact
a version of what has been sent out, so in that sense too the trajectory
of the drives is circular. Finally, the drives follow along the circular
borders of the erogenous zones. The object upon which the drive fo-
cuses "is indeed only the presence of a hollow, of a void," which any
object can occupy, for under this object hovers the void left by the
Lost Object / *objet a.* We have seen, nonetheless, that in Mallarmé it is
invariably a decorative object that occupies this hollowed-out space or

void. The ornamental contour or frame encircles a central absence that is also represented by a decorative object (the ultimate expression of this paradigm is the abolished bibelot). André Green defines *l'objet a* as the transformation where the Object of desire goes through a final mutation: "Desire becomes the object."[3] To the disappearance of the Object corresponds the growing force of desire, and the Subject's aptitude for it. A drive can gain satisfaction only from its own activity, since the Object that inspires it is not attainable. The transformation I mentioned earlier from the first version to the final version of "Le Pitre châtié" is just such a shift from an identifiable, external Object of desire to a floating, objectless desire constructed in the Subject's own gaze. It should not escape us that the initial Object of desire was the eyes of the Muse, a figure of the mother, the Lost Object absent from the 1887 version. From the Lost Object and the *objet a* (the mother's gaze), desire shifts to shimmering fragments or objects in the poem that belong both to the decor and to the Subject. In addition, the final version has moved from the Object's eyes to the Subject's eyes, and this move is accompanied by an increased emphasis on decorative effects: "Hilare or de cymbale à des poings irrité" (Gold of a cymbal with irritated fists [the sun's rays]) and "ma fraîcheur de nacre" (coolness, newness of mother-of-pearl).

These objects are at once decorative and imbued with an unusual (even for Mallarmé) dose of Otherness in contrast to the "fard noyé" (drowned rouge, or dissimulation) of the "I." They have displaced the Muse/Object and carry the charge of sensual pleasure in the poem. In other words, the energetic mingling of the Self ("Yeux," "nacre") and Other ("Hilare or") is simply the *objet a* gaze at work that allows the clown to be reborn as Other. In the same vein, we may consider Green's statement that *l'objet a* is not so much an object as it is the path this object takes. This path, as we have seen, is to open up holes and then to circumscribe them with an ornamental border. This path is the surface of the border, which is represented twice in the tercets of the "Sonnet en yx" (see chapter 5 for translation).

> Mais proche la croisée au nord vacante, un or
> Agonise selon peut-être le décor
> Des licornes ruant du feu contre une nixe,
>
> Elle, défunte nue en le miroir, encor
> Que dans l'oubli fermé par le cadre, se fixe
> De scintillations sitôt le Septuor.

In "Ses purs ongles très haut..." the Master is absent, but not the Object of desire. And in this empty living room, the naked nixie is caught in another empty space, the surface of the mirror. This scenario forms a perfect parallel to the dynamic underlying the *objet a* gaze: the hole left by the absence of the Object subtends the specularity of the *objet a* gaze where the Subject projects his own image onto the other. The well-defined contours of this space emptied out by "forgetfulness" are aesthetically delimited by "a gold [that] / Is agonizing / dying, perhaps according to the decor / Of unicorns kicking fire at a nixie" (Des licornes ruant du feu contre une nixe"). What is portrayed here is a particularly violent desire, and the Object of this violence, as well as the full intensity of the drive that has captured her in its circuit, is contained in the golden frame (fig. 19).[4] It is pertinent to the notion of drives circulating around a void that the frame encloses the "oubli" where the nixie / Object of desire (and the absent bibelot) are mirrored. Just as the sound patterns illuminate a mirroring around the void (Aboli bibelot; décor des [li]cor[nes], where the LI is made to disappear, recalling the words aboLI and ouBLI), the void symmetrically reflects the ornamental gold work where the erotic charge—"forgotten" elsewhere in the sonnet—is lodged.

In other words, ornamentation (in this case, mirroring of sounds) empties itself into—fills up—the void (the mirror): it is the exact fit of figure and void we saw in the trompe l'oeil of "Surgi de la croupe et du bond" and of "Prose." Furthermore, the exacerbated play of sonorities created by the repetition of phonemes takes place especially within the images of the ornamental objects in the poem. That is to be expected, since repetition of motifs is the most typical trait of ornament. Let us take the exclamation of Mallarmé in the first article of *La Dernière Mode* literally: "La Décoration! tout est dans ce mot" (Decoration! everything is in that word). Once cast into the decorative sound patterns of the "Sonnet en yx," it goes to work in the following way: in "Décoration," there is not only *décor* but *or*, a color-light that lights up and trumpets in *cor*. The word *décor* makes itself heard in the manner of baroque trumpets that repeat, staccato, "décor des licornes." Is it the hunter's horn that accompanies the unicorns' hurling themselves upon the nixie? The gold of the frame, rays of the eye, according to seventeenth-century thought, and therefore a light coming from the Subject as much as from the place of the object, can moreover be heard in a remarkable quantity of words in the sonnet. Indeed, l'*or* of the decor is *sonore*, like the abolished *ptyx* that displaces itself by its unusual

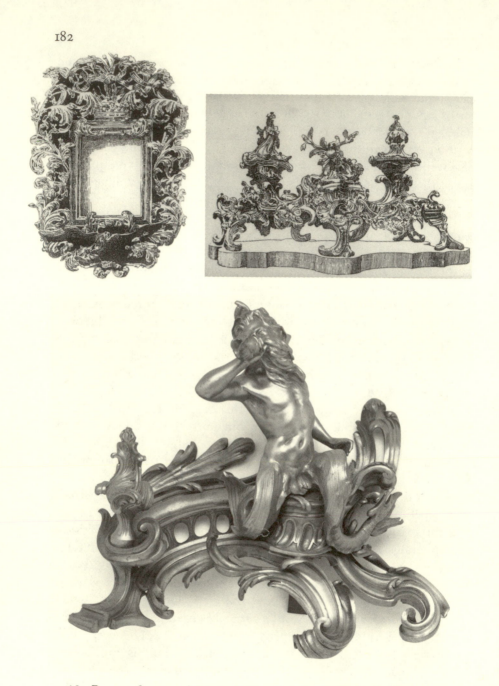

19. Rococo frame and inkstand. Drawings by A. Speltz in his *Styles of Ornament*. Andiron, French nineteenth century, gilt bronze, cast iron. Bequest of Forsyth Wickes. Forsyth Wickes Collection. Courtesy Museum of Fine Arts, Boston.

letters PT onto se*pt*uor. Ornament is transmuted into music, and the decorative object (under the text)—abolished or expiring—refuses to remain silent.

From the psychoanalytic point of view, repetition is the effort to drag something up from the depths, and is therefore the concrete mark of a failure: the failure to coalesce with reality. If the Real is destined to be missed, it is, all the same, locatable in repetition. From another point of view, the most striking repetition in the poem—its sole rhymes *or/ore* and *yx/ixe*—throws the ornamental frame into high relief. It is as though the quest for something buried—something that has slipped into the holes of discourse or of perception—had to eternally turn around these very holes. Inside this frame, around this border, then, must be situated not only eroticism and violence, the relation to the Object of desire, but, indeed, the relation to the Real.[5]

It now seems sufficiently clear that desire in the sonnet is concentrated in the borders that form the ornamental frame around a void, and that for Lacan, desire circulates around a hole, *le manque, la béance*; but it is necessary to account for a more complex architecture of desire in the poem. The frame creates a sort of invagination of the scene where one witnesses the violent action represented there reflected in the mirror. At the same time, there is an invagination of the living room in the reflecting device. This is an exchange effected between the eroticism of the frame and the metaphysical void of the room, as well as between ornamental excess and the void. However, that this lack is not only metaphysical Nothingness becomes clear when one superimposes two images—just as they are superimposed in the mirror—the violent and sexual surcharge of the framed representation with the decorative object, the bibelot, that figures in the central position and that shines by its absence (*qui brille par son absence*). After all that has been written about this *ptyx*, one must insist on the importance of its form, which is that of an invagination, be it of a fold, of an ear, or of a female sexual organ.[6] (This image is less farfetched than might appear: in "Une Négresse par le démon secouée...," the "infame bouche" [sordid mouth] is "pâle et rose comme un coquillage marin" [pale and pink like a seashell].) Its form, therefore, reflects the form of the poem: the borders are ineluctably drawn inward by the central absence and by a rhetoric of depth effected by the quasi-infinite referral of the phonemes. Lacan writes, "In this reversion, . . . the drive, in an invagination through the erogenous zone [the eye], is summoned to search for something that, each time, replies in the Other" (*Séminaire, XI,* 178). This conch that

mimes the human ear and can serve as a trumpet—it receives and sends out sound in the same way that the frame receives and projects light—this conch, by virtue of the fact that it is perhaps emptied out of all signification and signifies only by sonority, is a decorative object that is purely reflexive, like the writing of the sonnet, which aims to be purely self-reflexive.[7] The metaphorical equivalence "bibelot = poem," moreover, falls from Mallarmé's pen shortly before the publication of the "Sonnet en yx": "Bringing you a sonnet and a page of prose that I'm going to whip up . . . these two bibelots."[8]

Moreover, it is not only the *ptyx* but also the frame that is self-reflexive: the aesthetic role of a frame is to crown a painting and to indicate by the value of gold that the beauty of the painting merits being exhibited. In this respect the ornamental frame is "the sign of the self-reflexive dimension of representation, the fact that it not only represents things . . . but that it shows itself representing things."[9]

If the *ptyx* and the frame are, like the mirror and the internal mirroring of sounds, figures for the dimension of reflexivity in the poem, they also represent desire. By its shape, the first echoes the part object—hidden but central—that is evoked by the nixie's naked body. In its narrative, the second recounts the violent onslaught of the hunt for the Object of desire (like the story of the reader's gaze, in the violence of its desire to possess, probing the poem-Object for meaning) and its fatal outcome. The frame presents a story that is hidden in the central tableau, and in its function to close off representation, there dawns in it—begins to be visible—something that goes beyond the limits of what can be represented.

This junction implies that a strong relationship exists between desire and self-reflexivity in Mallarmé, and that this relationship is modulated by ornament.

In Mallarmé the framed absence is perhaps simultaneously an absence and a promise of jouissance. This jouissance is situated at the heart of the scopic drive, or more precisely, at the intersection (x) in this drive of Eros and Thanatos. In the poem, this x is "Elle, défunte, nue." This intersection or crossing is even named in the poem: the libidinal aggression against the nixie is situated "proche la croisée."[10] As for the reader, the void is in the lack of the Object, and in the *objet a* sought by our gaze. The void contains nothingness and death, but also, as we have seen, luminosity and erotic/metaphysical exaltation. The final two sections of this chapter will explore the necessity of the first experience to arrive at the second.

"Trompe l'Oeil: Cet Oeil . . . Ce Deuil"

The pleasure of the eye—derived from the undeniable sumptuousness of the poem, the oneiric exhibition of the poem as painting with its phantasmatic apparitions of gleaming objects: the onyx, the candelabrum, the Phoenix, the frame, the mirror, the window, the stars—comes back to us considerably altered as a gaze that carries with it a tableau full of *blancs* (the absent *ptyx* and amphora, the "forgetfulness" framed in the mirror). The sonnet develops a perfectly interlaced play of the libidinous eye and the gaze, the first exalting in its entry into the rich ornamentation of the scene and full of the desire to encompass all of this richness, the second carrying the vision of lack in these hole-filled or absent objects and the sense of loss (in the "défunte" Object) as well as of emptiness (in the failure to connect with the Real, the impossible totality that lies outside of the perceptual capacities of the Subject). This interplay is realized in the trompe l'oeil of *ornements à double jeu*, which, too, are "as black and white as possible," and by Gestalt images like "L'Impossible baiser ou le vase." If it is true that this vision is the "transparent gaze" promulgated by Mallarmé, as I have proposed, then it might appear strange to find that it contains so much psychological negativity. Critics have very often elaborated on the metaphysical power of the negative in Mallarmé, but the creative value of the negative as constitutive of desire, and its relation to the visual structure of the poetry, has not been addressed.

We have seen that absence mobilizes desire, and that the elusiveness of the Object and the consequent lack of satisfaction achieved by the Subject promote its continuation. There is still another aspect of desire's relation to absence—the peculiar absence/presence of the trompe l'oeil—that must be brought out. Let us recall that in the trompe l'oeil we have analyzed, the "second" figure emerges out of nothingness as though it had come from someone else's point of view. One of Lacan's major tenets is that the Subject's desire is in fact the desire of the Other, and therefore the truth of the Subject's discourse (*sa parole*) comes back in inverted form. It is the Subject's *own* message transformed and received in this way. This allows the Subject a double perception of self, necessary to integrate the split between the eye (and desire carried by the scopic drive) and the gaze (linked to the "I" of discourse, and the desire of the other which the Subject assumes). The second is the inverted form of the first, and when the Subject is able to

read this mirror image and decipher it (turn it inside out), access is gained to the deepest level of desire, hitherto hidden from consciousness: the desire of the Other (the Symbolic order, the unconscious). We can now compare this Lacanian notion and the dynamic of the trompe l'oeil with Mallarmé's own commentary on the first version of "Le Sonnet en yx," "Sonnet Allégorique de lui-même": "This sonnet [is taken] from a study on speech/discourse: it is inverted, . . . the meaning . . . evoked by a mirroring (*un mirage*) of the words themselves" (1868 letter to Cazalis, previously cited). Meaning, therefore, must emerge from the play of mirrors (not only from the internal mirroring of words Mallarmé mentions, but from the counterchange effected in the mirror of the empty salon) and from the trompe l'oeil itself, which sends the truth of the Subject's *parole*, desire, and relation back to the Object in inverted form. This inversion, if it is that of words, is also that of the gaze. The Object of desire that is the poem does not contemplate us, yet it sends our gaze back in a different form, an inverted one: it sends ornament back as hole, absence. But first, its structure captures our gaze and leads it into the inextricable complications of the ornamental over-burdening in the sonnet. This is the *dompte-regard*—the Object that brings our gaze under its domination—that presents itself under the auspices of the trompe l'oeil. This ungraspable totality, this incomprehensible perspective, constitutes the Other. The sonnet makes us feel the *béance*, the abyss, between our eye (and what it wants to see) and our gaze, caught up in the other (what we imagine as being there); this gap is the experience of lack in the ephemeral encounter with the Real, the Other.[11] As soon as we adopt a point of view in the poem, it becomes evident that that point of view is insufficient and that one would have to be elsewhere to understand the bizarre perspective that presents itself to us.

Thus, our gaze hovers in the poem without hope of a reciprocal gaze of recognition from the Other. In this, the poem takes on the aura of the Lost Object. Of the gaze's ephemeral encounter with the Other, only emptiness and specularity remain (whether it be the auto-reflection of the poem-bibelot or the reflection that sends back the Subject's own speculative interpretations). And yet, there had appeared, in the blink of an eye, in the intersection of what is caught and what is sent back, the scintillation of something else.

Indeed, what is being staged here is the radical disjunction between that eye (*cet oeil*)—ours—and that mourning (*ce deuil*) which is the

defunct hope of capturing the Other (the poem) in our gaze. It is an aggressive gaze "kicking fire at a nixie": the Object of desire, certainly, but also the negation, the *Rien*, once the silent *e*—so eminently detachable in the rhymes of the sonnet—falls away from the word *nixe*. In this way, the gaze hovers in the poem like a wing/*Aile* seeking satisfaction in the *Elle* of the Other, or in her gaze; but the extinction of that hope is marked in the specular image itself: "Elle, défunte nue." It is pertinent that one of the locutions in the sonnet functioning in trompe l'oeil (*défunte* and *nue* act as either nouns or adjectives) is placed at such a pivotal moment for the fate of the gaze. Lack as to the desired satisfaction/capture rivals the jouissance of the activity of seeing.

Thus, the trompe l'oeil presents itself as particularly apt to represent desire in Mallarmé where the birth of desire is simultaneously experienced with its abolition; hence the (very oblique) allusion to desire in "Une dentelle s'abolit..." where the birth of the Subject is abolished by the past conditional ("aurait pu naître"). Naturally, the object that generates, or gives birth to the poem—the decorative object itself (lace or *ptyx*)—is structured by absence. The final poem to be studied here situates birth and absence far more explicitly in the field of desire. From a chronological point of view, it is pertinent that the two versions of this text appear in the same two years in which all of the poems I have studied in detail were published: 1884 and 1887.

WHEN ORNAMENT SPEAKS

Negative space and the absence it represents are also central to the experience of jouissance. If the former seemed logically tied to the *lack of satisfaction* in desire, how is it possible that they also infiltrate orgasmic pleasure? Indeed, pleasure is to be distinguished from jouissance: the former is a momentary satiety of desire, whereas the latter is *an excess or lack in pleasure*. We see immediately how the couple excess/lack might fit into our concerns with ornament/void. For Lacan, jouissance (like *Schaulust*) is a surging up of unconscious thinking that informs being, felt and expressed in the body of the Subject. But the speaking Subject, it will be remembered, is alienated from pure being by virtue of the fact that one must seek meaning in the words, gaze, mirror of the other, and what is more, since language is in the realm of the Symbolic,

and language founds truth, meaning lies in the realm of the Other. Because of these ties to the other/Other, jouissance too is marked by a hole, a lack. And because jouissance strives for a symbiosis of two into One, the unattainability of the Other causes the Subject to untiringly repeat the experience (Don Juan epitomizes this form of excess. Another form of excess is represented in the ecstatic figure of Saint Teresa at the moment of jouissance with the ultimate absent Other, God).[12]

Mallarmé's "Autre éventail" (à Mlle Mallarmé) affords us a superb opportunity to see the operation of what Lacan calls the "gaping hole at the heart of jouissance." Excess and lack are placed in an atmosphere of preciosity, in which a particular decorative object is central. Contrary to the other texts considered in this chapter, the preciosity of the poem is manifested from the first verse (where the fan speaks to Mlle Mallarmé: "O Rêveuse, pour que je plonge / Au pur délice sans chemin"), only to end with the extremely precious rhyme of the last verses (CE L'EST/BraCELET). Thus, not only the decorative objects in the poem but the ornamentality of the poem is foregrounded. This heightened stress is accompanied by a pronounced emphasis on self-reflexivity. The latter is suggested by several elements: the five stanzas may be taken to be the five folds of the decorative object (recalling the seventeenth-century preciosity of the "Guirlande de Julie"); the mobility of the object evokes the Mallarméan theory of writing, while its wing (which is metonymically substituted for the fan) can be a metaphor for the sign or even for the Idea in Mallarmé's poetry (for example, in "Le Vierge, le vivace et le bel aujourd'hui"). Finally, the fact that Mallarmé offered fans embellished with his verses to his women friends complicates even more the disappearing frontier between the ornamental object and the poem. The fan is simultaneously the ornament and the verses that ornament it, a trompe l'oeil that we will soon see redoubled.

This reflexivity infiltrates even the movement depicted in the poem. In another "fan-poem" Mallarmé writes that the "futur vers se dégage" (future verse liberates itself) thanks to the beating / pulsating of the fan. Here, the five folds/stanzas espouse the movement of the ornament: the plunge, the swelling of a continuous soaring and return (*essor-retrait*), the expansion to the acme of the swell, descent, and rest: the opening and closing of the fan-poem. And this series of movements is also a rather precise transcription of the sexual act and of jouissance.

O Rêveuse, pour que je plonge
Au pur délice sans chemin,
Sache, par un subtil mensonge,
Garder mon aile dans ta main.

Une fraîcheur de crépuscule
Te vient à chaque battement
Dont le coup prisonnier recule
L'horizon délicatement.

Vertige! voici que frissonne
L'espace comme un grand baiser
Qui, fou de naître pour personne,
Ne peut jaillir ni s'apaiser.

Sens-tu le paradis farouche
Ainsi qu'un rire enseveli
Se couler du coin de ta bouche
Au fond de l'unanime pli!

Le sceptre des rivages roses
Stagnants sur les soirs d'or, ce l'est,
Ce blanc vol fermé que tu poses
Contre le feu d'un bracelet.[13]

[O Dreamer, so that I may plunge
Into the pathless pure delight,
Know, by a subtle lie,
How to keep my wing in your hand.

A twilight coolness
Comes to you with each beat
In which the imprisoned stroke
Delicately pushes back the horizon.

Vertigo! Now space is
Trembling like a giant kiss
Who, mad from being born for
No one, can neither gush forth nor be calmed.

Do you feel the wild paradise
Like a buried laugh

Flow from the corner of your mouth
To the bottom of the single fold!

The scepter of rosy banks
Stagnant on the evenings of gold, it is,
This closed white flight that you set down
Against the fire of a bracelet.]

(Is it necessary to explicate the elements of this "paradis farouche": the effort to gush forth or be relieved, a scepter, the sinking and flowing of laughter from the mouth to the depths of the fold?) Space trembles between being and nonbeing, and this suspension fills one without satiating or satisfying (just as the apparently futile beats [*battements*] signify an infinite capacity for flight, refused only in order that it might be perpetually reborn). A variant of line 11, "fier de n'être pour personne," creates a superimposition with "fou de naître," and thus an intertextual trompe l'oeil of absence/birth. The homonymy of *n'être* and *naître* again brings to the fore the interchangeability of nothingness and excess, and what is more in this text, the desire that alternates between them. (I connect excess to *naître* because the "baiser de l'espace" is born for no one, and is therefore *de trop*, excessive.) This coincidence also signals "la béance au coeur de la jouissance," the lack at the heart of this mad trembling movement that causes it to be constantly reinitiated.

The unusual stroke of making the fan—normally a body of pure enjoyment—capable of speech is resonant with the above definition of lack in jouissance: the fan thereby becomes dependent not only on Mlle Mallarmé but also on language as the expression of its petition. Finally, the pulsating movement of the fan / poem / decorative object recalls the "pulsative" character of the unconscious, and the fading out inherent in desire, a slipping away from consciousness that appears so clearly in the gaze as *objet a*. "Autre éventail" contains, once again, the convergence between reflexivity and Mallarméan writing, desire and ornament.

One could well say that the quality of evanescence in the *objet a* gaze is very nearly a function of the fan, since the play of its movement allows the woman to hide and to reveal her gaze, considerably increasing its seductiveness. There is even a variety of fan that is expressly conceived to heighten this game: the "domino" places the woman's gaze in a position of *dompte-regard* and trompe l'oeil, for it allows her to see without being seen. The play of the gaze is manifested even in the

nomenclature of the fan: the *oeil* or *yeux* are round elements that connect part of the mounting to the wooden support for the folds. Fans also have recourse to a form of trompe l'oeil typical of the period we are discussing: the creation of a material that imitates another. An important part of the fan is the *cuir*, a decorative element that imitates parchment, scrolling or unfurling on the borders of the fan to carry the inscription of a decorative motif.

Lacan's statement "There is a meeting of the *objet a* and of trompe l'oeil in painting" proved applicable to the sonnets; it is also operative in "Autre éventail." What is more, the *objet a* is pared down to its most essential event/form there, and there is a corresponding emphasis on the trompe l'oeil. Along with those already noted, there are two very different forms of trompe l'oeil: (1) like "crédence" and "bibelot," the fan enjoys a metaphysical expansion while still retaining its intimate resonance, and (2) one can imagine a landscape in twilight painted on the fan that rivals and enters into play with the "soirs d'or" represented in the poem; the "real" horizon would then be pushed back, "reculé," by the "coup prisonnier" that includes it *en abyme* ("Une fraîcheur de crepuscule / Te vient à chaque battement / Dont le coup prisonnier recule / L'horizon délicatement"). This double perspective is hardly alien to the Mallarméan spirit. In the first version of "Placet futile," one reads "Nommez-nous... —et Boucher sur un rose éventail / Me peindra flute aux mains. / Nommez-nous berger de vos sourires" (Name us... —and Boucher on a pink fan / will paint me flute in hand . . . / Name us shepherd of your smiles).[14] The Subject is *in* the decorative object *and* outside it, for this object is an artistic product like his own. (Let us recall the Chinese painter of porcelain whom Mallarmé aspires to imitate in 1864; the decorative design on the cup even contains a metaphoric eye: "Grands cils d'émeraude, roseaux" [great emerald eyelashes, reeds]). His eye creates it and he sees himself in it at the same time as he places the Object of desire in it (metonymically, *sourires*). Similarly, "L'éventail . . . cache le site pour rapporter contre les lèvres une muette fleur peinte comme le mot intact et nul de la songerie par les battements approché" (The fan hides the site in order to bring back against the lips a mute, painted flower like the intact and null word of revery brought closer by the pulsings).[15] The fan-scape safeguards unconscious thought (the "mot intact et nul" of revery), the representation of which is mute, figural, erotic ("contre les levres"). The *mise en abyme* of verses written on a fan returns in another poem dedicated to Mlle Mallarmé: "Là-bas de quelque vaste aurore / Pour que ton vol revienne vers / Ta petite

main qui s'ignore / J'ai marqué cette aile d'un vers" (Over there from
some vast dawn / So that your flight returns toward / Your unaware
little hand / I've marked this wing with a verse).[16] The trajectory of a
gaze that travels from the distant horizon to the nearness and intimacy
of the little hand is, moreover, constructed of a linguistic oscillation on
the two uses of "vers," underlined by its place at the rhyme. The *vers
poétique* is superimposed on the *vers* of mobility, the essence of Mal-
larméan verse, and therefore eminently available to representation by
the decorative object, the fan. Far more explicit in equating the move-
ment of the fan to the production of poetic language is "Eventail" (de
Madame Mallarmé):

> Avec comme pour langage
> Rien qu'un battement aux cieux
> Le futur vers se dégage
> Du logis très précieux.[17]

> [With as though for (its) language
> Nothing but a pulsation/beating in the skies
> The future verse frees itself
> From the very precious lodging.]

The very peculiar grouping of prepositions in the first line foregrounds
the Otherness of this Mallarméan fan language.

 If the gaze does not manifest itself explicitly in "Autre éventail," it is
constantly solicited by these trompe l'oeil designs in the poem. In addi-
tion, the dynamic of the *objet a* that I have sketched here is duplicated
almost exactly. The Subject in the poem is engaged in a reciprocal
va-et-vient with the "coolness of the twilight" that he makes "come to
[her] at each beat." And, in lines 9–12 cited earlier, the jouissance of
space is depicted. However, it is the decorative object, the fan, that in
the first stanza claims this jouissance for itself: "O Rêveuse, pour que je
plonge / Au pur délice sans chemin, / Sache, par un subtil mensonge,
/Garder mon aile dans ta main." Where is the subtle lie? Is the fan the
agent of pleasure procured for the dreamer (la rêveuse), or does she put
herself in the other's place (the object's place) at the moment when she
takes her pleasure? Or, on the contrary, does the ornament depend on
her in order to plunge "au pur délice"? Like the *objet a* whose undecid-
ability finds its most accomplished form in the trompe l'oeil, jouissance
is somewhere (*frissonne quelque part*) between the Subject and the
Object, in the drive that circulates between the Subject and the (imagi-

nary) other that one thinks one possesses. The "kiss of space" belongs to Mlle Mallarmé and to the fan at the same time, all the while belonging to no one! There is a last trompe l'oeil or "subtle lie." The fan calls upon the dreamer to keep hold of its wing, yet the wing *is* the fan. The metonymy is both the thing and a part of the thing, a trompe l'oeil that allows for both metaphysical and psychoanalytic interpretation. *L'objet a* is a part of the Lost Object, and at the same time a stand-in for it. The wing is in fact the fan and at the same time a concrete manifestation of one of its functions, the impulse to soar. More radically than in "Ses purs ongles très haut...," where the Object of desire disappears from the center to circulate in the frame, the Object of desire here seems to have completely disappeared in order to leave only the *cause* of desire, *l'objet a* in its purest form of desire itself, accompanied by the jouissance ("pur délice") it seeks. Mallarmé, in "Etalages," describes the fan (or the text) as "cet isolateur, avec pour vertu, mobile, de renouveler l'inconscience du délice sans cause" (this isolating element, with, as its virtue, mobile, the renewal of the unconsciousness of causeless flight) (*Oeuvres*, 373). The fan throbs, moves around an empty space, thereby creating the "kiss" in the center of this emptiness. By turns, and depending on which perspective one embraces, the fan, Mlle Mallarmé, and space are the Subject of this jouissance. The *béance*, or gap, left by an absent Object is necessary to jouissance, just as the void is necessary to decorative composition and lack is necessary to the *objet a*. The total absence of the Object in "Autre éventail" throws into high relief the pure circulation of the drives and of desire. This poem, therefore, carries the structure of void and excess even further in its ties to the pathways of desire.

Finally, the reader is implicated in "Autre éventail" not only by the trompe l'oeil's solicitation of the gaze, but also from another point of view. The interaction of the Subject and the fan brings about a "paradis farouche," compared to another burst of libido: laughter. This quatrain contains a theory of reading: we project this laughter into the text, attributing the memory of happiness to the poem.[18] The poem becomes the *objet a* of the reader.

Hérodiade Redux

In the previous chapter, I quoted a fragment from "Hérodiade" as an initial illustration of the notion of excess and void in Mallarmé. This passage contained many elements that continued to warrant com-

mentary in the analyses that followed. The image "cadre, attirail de siècle belliqueux, orfèvrerie éteinte" is clearly the inspiration for the "cadre belliqueux" of "orfèvrerie" ("Sonnet en yx," 1868 version), which mirrors the abolished bibelot, just as the couple "lit vide" / tapestry of the bedroom was again found in "Une dentelle s'abolit...." Finally, "plumage héraldique" and "plis inutiles" evoke, *après-coup*, Mallarmé's fans. Mallarmé's writing in 1866—contemporaneous with his "discovery" of Nothingness and his project to write an ambitious work called "Allégories somptueuses du Néant"—contained in embryo the essential decorative characteristics of the poetry of 1887. But a comparison of poems written in the 1860s and in the 1880s shows that decorative images were only later to be used as structuring devices. Moreover, the structuring function of ornament—its embodiment of the dynamics of lack and excess—is accompanied by its use as a substitute for the Object of desire. This evolution takes place parallel to a more and more decisive working out of the role of the gaze and its encounters with the trompe l'oeil. As I have mentioned, all of the poems analyzed in detail here were published between 1884 and 1887. In 1888, Mallarmé planned to publish an illustrated volume of prose poems decoratively entitled *Le Tiroir de laque* (it appeared in 1891 as *Pages*). The years 1896 and 1897 marked an even more insistent and explicit reflection on the decorative and metaphysical presence of the white intervals between the words (*Le Mystère dans les lettres* and "Un Coup de dés"). The poet's preoccupation with the decorative arts in the 1860s expresses itself in its fullest development in the mid-1880s and continues to inform his most subtle pronouncements on the act of reading in the 1890s.

If ornament has, since Classical times, been accused of being seductive, false, and dangerous, one understands its place in Gustave Moreau's staging of Salomé's virginal, perverse, provocative, austere, and luxuriant sensuality. In the painter's 1876 version of the "Hérodiade," *Salomé Dancing Before Herod*, ornamental arabesques wander from the decor and the frame to decorate Salomé's body (fig. 20). More, they become tattoos on the flesh and form a sinuous design that even includes grotesques in place of the pubis. *Grottesche, grotte*, hidden, absent: ornament, located at the place of jouissance, covers over quite exactly the absence of concrete sexual satisfaction. The arabesques occupy the empty place, an emptiness that has caused desire: they absorb the libidinal charge set in motion and become the focus of the *objet a* gaze. This ornamental design invades the entire canvas.

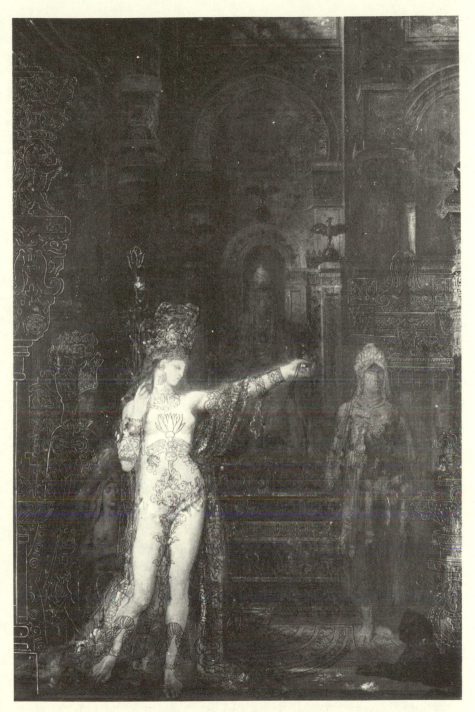

20. Gustave Moreau, *Salomé Dancing before Herod ("la Salomé tatovée")*, 1876.

Nonetheless, the rupture between, on the one hand, the thick impasto of red, turquoise, and gold that constitutes the ground, the decor, and the seductress; and on the other, the thin, hard, black tracery of arabesques plastered on top of these sensual areas of color like a veil speaks to the *coupure*/split between jouissance and the satisfaction it seeks (the knifelike edge of the line, the erasure of the sexual organ, the decapitation to come). One, though, resides in the other. In this painting, it is ornament that underlines this relationship, the "lie" inherent in jouissance (the sense of plenitude, satisfaction) and the rupture that reveals the lie. And this is accomplished by the line that cuts like a razor, revealing the lie or artifice of painting itself: the illusion of three-dimensionality. The painting reveals more than it veils, in fact, and imitating one of Mallarmé's linguistic games, one might say that here *ornement ne ment pas*, contrary to its reputation for falsehood. The jouissance of the eye is easily found in Moreau's paintings, and his term for the effect that brought about this experience was "la richesse nécessaire." The effects used were color, impasto, arabesque, and ornamental overlay, as well as what Bernard Noël has called a "pourrissement lumineux" where forms crumble underneath the overwhelming piling up of ornament. Many of these compositions have recourse to an ornamental frame. Indeed, jouissance in Moreau is also tied to death and "pourriture." In *Les Prétendants* (*The Suitors*) the bodies of young men struck down by the anger of Ulysses and Athena compose the lower border of the canvas in a representation of writhing libidinal expression, a brutal and bloody end to their erotic desire for Penelope (fig. 21). The *décor* metamorphoses into *des corps*, the *torsades* into torsos. This perfect intermingling of decorative form with the libido of the Subject furnishes an image of what Lacan refers to as the intersection in the scopic drive of sex and death.

Another Symbolist painter, Edvard Munch, has recourse to the same decorative frame that carries the message erased from the central tableau. In *Madonna* (fig. 22), spermatozoas decorate the red border that frames the very sexual Madonna of the lithograph. The woman's torso makes a hole in the black ground surrounding it, and this hole is in the shape of a phallus. But the phallus becomes visible only when the "narrative" in the frame is "read." The vital force emanating from the phallus is relegated to the frame. The decorative "trivializing" of these objects veils a "hidden" message, certainly a very different one from the traditional story of the Madonna.[19] In both *Madonna* and *Les Préten-*

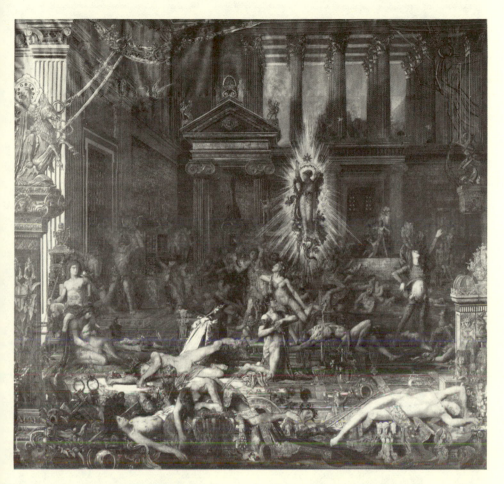

21. Gustave Moreau, *Les Prétendants*, 1852–?.

dants, where the frame was added in the late 1880s, this function of the frame is posterior to the texts of Mallarmé that use the ornamental frame in the same way.

LACKS, STRUCTURE, AND MEANING

The workings of ornament in Mallarmé's poetry illuminate the connections among the decor/frame, erotic desire, and *l'objet a*. The role of

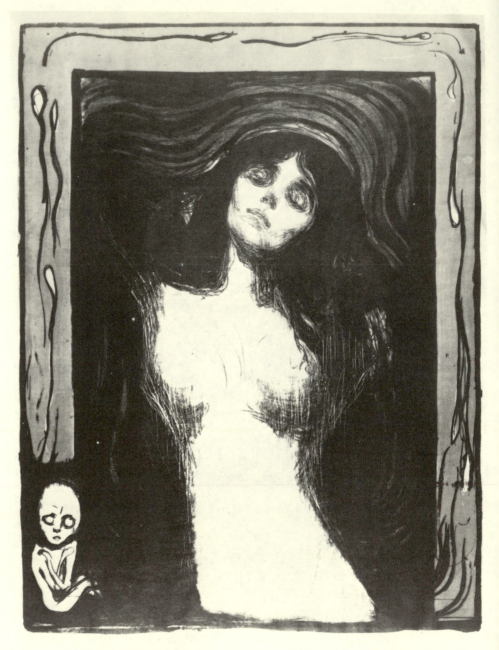

22. Edvard Munch, *Madonna*, 1895–1902. Lithograph printed in color: 23³/₄″ × 17¹/₂″. Museum of Modern Art, New York. The William B. Jaffe and Evelyn A. J. Hall Collection.

ornament in the production of meaning is thus essential, in perfect counterdistinction to its inessential or marginal status. The *quelconque* (that is, the bibelot) is revealed to be anything but *quelconque*. But this very status enables ornament to act as *objet a* that has fallen away from the essentiality of the object and that can even be a waste product. Yet, as such, it acts as trace of and conduit to the Real. The margins of attention are the place where the truth of one's discourse always resides, and as we have observed over and over again, this is the privileged space of ornament. The structural elements that have been important psycho-analytically in my reading of Mallarmé are, coincidentally, the three most prevalent structures of decorative composition: repetition, inversion, and alternation (psychoanalytically, between the look and the gaze). The decorative play of ornamental excess and void inserts itself into a metaphysics of presence and absence, carrying with it the couple *jouissance* and *béance*. These designs converge in a reading that is, avowedly, caught in the lure or *lacs* of the ornament-poem, itself become an Object of desire for the critic.

Ornament as *objet a* encircles the void and exchanges itself with the void. The gaze is confronted with a hole, the mark of the Lost Object, the Other, and thus the Subject is propelled out of the realm of the Imaginary and into the Real. The text as plastic art refuses to be a simple receptacle for our phantasies, and we accede to an existential and metaphysical perception of Being. To the abolished Subject who disappears behind the poem and to the Lost Object replies the celebrated c'est of Mallarmé: "Le langage est la fiction absolue qui dit l'être, quand, ayant usé, rongé, toutes les choses existantes, suspendu tous les êtres possibles, elle se heurte á ce résidu, inéliminable: Ce mot même: c'est" (Language is the absolute fiction that speaks being, when, having used up, eaten away, all existing things, suspended all possible beings, it bumps up against this residue, impossible to eliminate: This very word: IT IS). And this word, this pronouncement that names and creates simultaneously, finds its place, fittingly, in the field of ornament, hidden and revealed there in a trompe l'oeil.[20]

> Stagnants sur les soirs d'or, ce l'est
> Ce blanc vol fermé que tu poses
> Contre le feu d'un bracelet.

The residue of the Real, of being and presence, is manifested in the word *C'est*, in the *objet a*, and in ornament. The gold of the bracelet

worn by Mlle Mallarmé as she fans herself crowns the poem at the same time as it encircles or frames the hand that sets in motion the decorative object (or sets the poem in motion). Its gold (*son or*), like the gold of the "bellicose frame," is sonorous and thus proposes a beautiful convergence of the visual with the auditory: "L'air ou chant sous le texte . . . [qui] y applique son motif en fleuron et en cul-de-lampe invisibles." The Object itself disappears, to leave in its place a sense of presence that can only be manifested in the ephemeral design and the erotic glow of ornament.

Ornament and Hysteria: Huysmans and Rachilde

Oh! Je plains ceux qui ne connaissent pas cette lune de miel du
collectionneur avec le bibelot qu'il vient d'acheter. On le caresse de
l'oeil et de la main comme s'il était de chair.
—*Guy de Maupassant, "La Chevelure"*

Interposed between vitreous layers, formidable Hydras are glimpsed,
these microbes. . . . [Under a layer of color lies] the decorative
parasite of the paludal infection, the *Staphyloccus.*
—*Emile Gallé*, Commentary, *the Pasteur Goblet*

ABSTRACTION IN NATURALISM

In the Introduction, I stressed the importance of Islamic art in the
nineteenth century (beginning with the 1828 restoration of the Alham-
bra). We saw that the principles of this abstract, geometric art inspired
and fascinated aestheticians, architects, and writers. Indeed, the purely
abstract nature and the astounding complexity of Islamic art combined
to suggest to these admirers the ideas of apparent chaos, hidden order,
and especially infinity. In *Abstraction and Empathy*, Wilhelm Worringer
contrasts the Greek aesthetic (as paradigm of the urge to empathy) with
the aesthetics of primitive peoples and of Islam and the Far East, where
abstraction expresses the "instinct for the unfathomableness of being
that mocks all intellectual mastery." Specifically, this "unfathomable
entanglement of all the phenomena" (Worringer, *Abstraction*, 16) of the
external world inspires a great inner unrest, which translates into an
"immense spiritual dread of space" (47), or horror vacui, which leads
primitive peoples to isolate the object from nature, elevating it from the

contingencies of organic existence and lending it a necessary and immutable form (see figs. 13 and 23[a]). This aesthetic provides a "point of tranquility and a refuge from appearances" (16–17). Whereas naturalism, an aesthetic form of *self*-enjoyment, represents an urge to empathy, abstraction is "an urge to seek deliverance from the fortuitousness of humanity as a whole, from the seeming arbitrariness of organic existence in general, in the contemplation of something necessary and irrefragable" (24). One can certainly see in Huysmans's *A Rebours* a flight from organic existence to a realm outside contingency; that realm is the cloistered decor of Des Esseintes's apartments, filled with an encyclopedic collection of objects that expand the owner's sensory, aesthetic experience. Can one state that there is accordingly a greater degree of abstraction in that novel? In *En Rade*, the novel that followed *A Rebours*, "organic existence" makes a startling comeback, but descriptions of nature are so highly stylized that the organic is brought under control. My analyses will propose *En Rade* as a staging of horror vacui patterning in response to a terrifying experience of empty space. This stylization is of two sorts. "Filling-in is the immediate response to horror vacui, linking is the most sophisticated" (Gombrich, *Order*, 80). Precisely as though he were following a primer on decorative technique, Huysmans operates on both levels. The first entails a piling up of detail encrusted in the complex, highly wrought phrase one immediately recognizes as Huysmans's. (This technique is also in evidence in *A Rebours*.) The second technique, linking, is effected through an ingenious network of *métaphores filées*. Both techniques emphasize pattern over content, and are thus in the mode of abstraction.[1]

In 1889, reading *Certains*, Paul Gauguin exclaimed: "Huysmans is an artist. . . . He would like to be a painter."[2] Huysmans's well-deserved reputation as an art critic who was able to discern the qualities of originality and modernity in artists underestimated by others is attributable, I believe, to his unerring eye for the novel use of decorative characteristics in these artists' work. He accorded an unusually large place to the decorative arts in his *Salons officiels* (1880 and 1881), and his pages on Gustave Moreau and Jules Chéret are well known. Critics have often sought textual parallels to the visual arts Huysmans admired.[3] In fact, Huysmans himself did not fail to draw a parallel between literary style and painting (with the basis of comparison nearly always grounded in the decorative arts): "The style of Mr. Moreau is in fact closer to the wrought-gold language of the Goncourts."[4] And like Moreau's paintings, Lucan's verse is "plaqué d'émaux, pavé de joaillerie" (plated with

enamel, paved with jewels).[5] It seems strange that he failed to write on Gallé, an artist who was greatly admired by Mallarmé, the Goncourts, and Robert de Montesquiou. Yet his description of "L'Aquarium de Berlin" could pass for one of Gallé's pages on his own glass. Sea flora is made up of "lace flowers and plants, embroidered, worked like Alençon network . . . and fish . . . encrusted with jewels . . . slip between . . . red coral." The moss waves its "vibratile lashes," while the flowers display "the most illusory of tints and the most insane contours."[6]

One of the artist's first vases (1880) was an interpretation of a Persian design that could serve as the paradigmatic illustration of a composition with no empty space (fig. 23[a]). Gallé continued to use Persian designs throughout the 1880s (particularly between 1884 and 1889). Patterns of horror vacui emerge out of the artist's ability to perceive the infinitely minute detail. Hence Gallé turned to the magnifying glass and even the microscope. Magnification reveals the extraordinarily decorative compositions in nature. Gallé was able to use nature in a new way because (recalling Bracquemond's "ornamental principle") he was able to see the former *as decoration*.[7] "Our ornamental style in furniture . . . is the step-by-step translation of the decorative artifices of nature herself" (*Ecrits*, 274–75). Art cannot penetrate more profoundly into infinitesimal detail than we see Gallé doing in his *Coupe Pasteur*, an 1892 crystal goblet presented in homage to the scientist (fig. 23[b]). The decorative scheme is in the "form of a bacterium truly terrible for us," and under another layer of color lies "the decorative parasite of paludal infection, the *Staphylococcus* of pneumonia" (ibid., 152). Just as decorative motifs fill the void, so can they serve to cover over other frightening menaces. Readers of Huysmans will recognize in these lines striking parallels with certain passages treating illness and infection. Decoration and disease are joined in the career of the artist Cyprien, the hero of Huysmans's 1881 novel *En Ménage*; he turns from painting plates of skin lesions to producing wallpaper designs. But I will return to this fascination for the beauty of infection and decomposition. Huysmans, too, writes that the microscope again made possible the depiction in art of the "souveraine horreur," a proliferation of all sorts of creatures. It sees, whereas the human eye cannot, the universe of the infinitesimally small.[8]

Let us recall Huysmans's emphasis on ornament in his appreciations of Moreau's *Salomé*, *Hélène*, and *Galatée*. In this last canvas "a vast screen where, under the light fallen from a lapis lazuli sky, a strange mineral flora crosses its fantastic shoots and mingles the delicate lace-

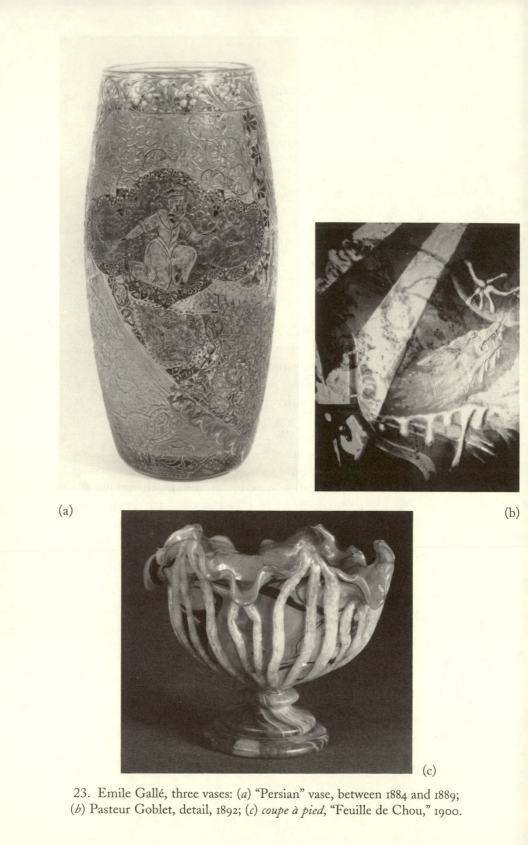

(a)

(b)

(c)

23. Emile Gallé, three vases: (*a*) "Persian" vase, between 1884 and 1889;
(*b*) Pasteur Goblet, detail, 1892; (*c*) *coupe à pied*, "Feuille de Chou," 1900.

work with its improbable leaves" ("Salon 1880"). Here too Huysmans is drawn to the sort of decor Gallé was to translate into glass some years later, a vision that seeks out the essential forms in nature and then, through stylization, emphasizes the characteristics that make them appear unreal, unnatural. This is having it both ways—these hallucinatory creatures or plants are intensely alive and unexpectedly abstract.

Gallé, along with Moreau and Chéret (two artists Huysmans "discovered"), pushed back the limits of his medium, just as Huysmans broke through the limits of the novel in *A Rebours*. Huysmans explicitly states his aim in the preface of 1903 as "the desire . . . to burst the limits of the novel, to introduce in it art, science, history, to no longer use . . . this form other than as a framework . . . to do away with the traditional plot" (*A Rebours*, 40). Reducing narrative form to a slight framework—to a marginal role—for long embellishments on art, science, and history is tantamount to reversing the normal figure-ground relationship in the novel; the narrative line becomes ground or support for the now dominant embellishment. Stylistically, the Decadent trait of inverting adjective and noun is an expression of the same figure-ground reversal. Moreover, cramming the slight narrative line full of these lengthy and divergent developments represents a desire to eliminate all gaps, ellipses, stopping places, and pauses common to narrative. If an empty ground, or at least one that is undemanding of our attention, is felt to be essential to readability in the decorative arts, the same criterion has traditionally been applied to narrative. Decor and its objects are this ground; plot and character are the figures that enliven it. Obviously, Huysmans's *A Rebours*, in reversing this hierarchy and eliminating empty space, leaps as far into our modernity as did the visual artists who made perception as much or more their subject as they did narrative content.

If the overall structure illustrates the desire to be all-inclusive, so does Huysmans's vocabulary. Des Esseintes admires Petronius for his "langue splendidement orfévrie" (splendidly wrought gold language) (60) and for the way he draws from every dialect and every language. Of course, the desire to be all-encompassing (visually or linguistically) is a form of horror vacui, and Huysmans's compendium of technical terms, slang, neologisms, archaisms, and other forms of preciosity is a perfect example of this desire. Contemporary critics of this tendency did not fail to point out the dangers of such a style. "What is the point in compiling dictionaries in a country where the language no longer has any limits, bridle, or measure? . . . As this charming work of *decomposi-*

tion won't slow up. . . . Everything will be French *ad libitum* and at each person's whim" (*au hasard de la fourchette*).[9] I have italicized the term "decomposition," for it will be a central notion in my development of the role of ornament in the fin de siècle, as will the unconscious association of it with eating (note the use of "fork" [*fourchette*] as metaphor). Eating, devouring, and difficulties of digestion will appear in all of Huysmans's novels. Ornament will become the *agent* of decomposition: physical, mental, and textual. Loss of limits—so vital to the nineteenth century's discourse on ornament—has reached an apex in the notion of horror vacui expressed both visually and linguistically.

HUYSMANS AND DECOMPOSITION

Le Drageoir aux épices presents itself as a decorative object where the subjects treated are "un choix de bric-à-brac, vieux médaillons sculptés, emaux, pastels palis" ("a choice of bric-a-brac, old sculpted medallions, enamels, faded pastels).[10] Huysmans qualifies the text itself as an ornament, as we saw Mallarmé do. And whereas each vignette is crafted like a little jewel, a fin de siècle fascination with decomposition, illness, and ugliness pervades the collection. Again, there is a strong parallel to be drawn between Huysmans and Gallé (as well as with Moreau). Gallé, unlike the other decorative artists of his time, does not shun the "ugly." The seepage of viscous stuff over the outside of a vase (for example, *La Feuille de Chou*) (fig. 23 [*c*]), the murkiness and scoring or gouging of the surface, the appliqués resembling bird droppings or mucous, the acid etching resembling invasions of dry rot: none of these are rejected in his aesthetic. All of these forms become unexpected objects of fascination for the eye.[11] At the same time (in 1900) in Vienna, Franz Wickhoff defended Gustav Klimt's painting *Philosophy* against the accusation of ugliness in his famous speech delivered to the philosophical society of the University of Vienna entitled "What Is Ugly?"[12] Compare the long botanical chapter in *A Rebours* with Gallé's vases:

> Les plantes carnivores . . . le Népenthès dépasse les limites connues des excentriques formes . . . cette extravagance de la flore . . . imitait le caoutchouc dont elle avait la feuille allongée . . . du bout [de laquelle] pendait un cordon ombilical supportant un urne verdâtre, . . . une espèce de pipe allemande en porcelaine . . . *montrant un intérieur tapissé de poils.* (165–66; emphasis mine)

[Carnivorous plants . . . the Nepenthes surpasses the known limits of eccentric form . . . this extravagance of flora . . . imitated rubber in its elongated leaf . . . at the end [of which] hung an umbilical cord holding a greenish urn, . . . a kind of German porcelain pipe . . . *displaying an interior covered with hair*].

To transcend all known limits of form is indeed what Huysmans—and some decorative artists—strives to do, and one of the ways he chooses is to embrace hitherto scorned images. In Huysmans, the "ugly" corresponds to the inside suddenly appearing on the outside. Moreover, he explicitly links these images to devouring and to disease (here, syphilis). This alliance of the decorative with decomposition and the sordid, ugly, and perverse is Huysmans's original contribution to the evolution of ornament in literature.

The rural setting of *En Rade* gives Huysmans an excellent opportunity to bring the repulsive and the beautiful into jolting convergence. For example, "Les toits si gais, avec leur teint basané piqué par le guano de mouches blanches" (The gay rooftops, with their tawny color spotted by the guano of white flies),[13] or the eye-stinging odor from the droppings of beautifully colored birds: "Un vorace fumet d'ammoniaque lui picorait le nez . . . tous les oiseaux . . . remuant . . . des dos aux reflets métalliques, des poitrails de vif-argent lustrés de vert-réséda et de rose, des gorges de satin frémissant, flamme de punch et crème, aurore et cendre" (A voracious scent of ammonia made his nose tingle . . . all the birds . . . shaking . . . backs with metallic reflections, breasts of quicksilver glazed with reseda-green and pink, satin necks rustling, flames of punch and cream, golden yellow and cinder) (70–71). Here a decorative technique mingles with another familiar odor of the countryside: "Il aspira une bouffée d'air . . . parfumée par la brusque odeur des bois mouillés à laquelle se mêlait la senteur tièdement ambrée des bouses . . . des espèces de fils vermiculés de pluie descendaient" (He inhaled a gust of air . . . perfumed by the sudden odor of humid woods in which cow dung, tepidly scented with ambergris, mingled . . . vermiculated threads of rain fell) (54). (Vermiculation consists of small, sinuous striations, employed especially in enameling.) The scene of a calf's birth is exemplary in its display of repulsive beauty. "Et tout à coup une masse gluante, énorme, déboula dans les éclaboussures de lochies et de glaires . . . la bête remise sur ses pattes et dont la vulve saignait des stalactites de morves roses" (And suddenly a sticky mass, enormous, rolled down into the splatterings of lochia and

mucus . . . the animal [was] put back on its legs and [her] vulva was bleeding stalactites of pink mucus") (94). Another manner of coupling the repugnant with the decorative is to combine Decadent preciosity— inverted adjective-noun order—with a repugnant image. "Excrémen-tielles tartes" (Excremental pies) (92) is a particularly good example of this kind of alliance.

Images of decomposition as ornament abound in *En Rade*. Almost invariably, they are in response to the contemplation of the void, or of an open space. Accumulation and filling in as a response to open space or void take on the inevitability of cause and effect in this novel. "[Jac-ques] aperçut d'immenses corridors, sans fond, sur lesquels se déga-geaient des pièces: c'était l'abandon le plus complet . . . la dissolution de murs battus par le vent" ([Jacques] saw immense corridors, without end, from which rooms led off: it was in the most complete state of abandon . . . the dissolution of walls worn by the wind) (49). The dis-covery of the desolate state of the château where Jacques and his wife, Louise, are to live is followed by an incredibly ornate dream where a similarly immense palace is filled in by an accumulation of materials, colors, and syntactic "fillers" such as anaphora and reduplication by synonym.

> Une gigantesque salle apparut pavée de porphyre, supportée par de vas-tes piliers aux chapiteaux fleuronnés de coloquintes de bronze et de lys d'or . . . d'autres colonnes s'élançaient en tournoyant jusqu'aux invisibles architraves d'un dome, perdu . . . dans l'immesurable fuite des espaces. Autour de ces colonnes réunies entre elles par des espaliers de cuivre rose, un vignoble de pierreries se dressait en tumulte, emmêlant des can-netilles d'acier, tordant des branches. . . .
>
> Partout grimpait des pampres . . . partout flambait un brasier d'in-combustibles ceps, un brasier qu'alimentaient les tisons minéraux des feuilles taillées dans les lueurs différentes du vert, dans les lueurs vert-lumière de l'émeraude, prasines du péridot, glauques de l'aigue-marine, jaunâtres du zircon, céruléennes du béryl; partout, du haut en bas, aux cimes des échalas, aux pieds des tiges, des vignes poussaient des raisins de rubis, etc. (59)
>
> [A gigantic room appeared, paved in porphyry, supported by vast pillars whose capitals were decorated with floral motifs of bronze colocynths and golden lilies . . . other columns shot up, whirling, to the invisible architraves of a dome, lost . . . in the immeasurable flight of space.

Around these columns joined together by espaliers of rose copper, a vineyard of precious gems arose in tumult, entangling steel embroidery wires, twisting its branches. . . .

Everywhere vine branches were growing . . . everywhere a clear fire of incombustible vine stock, a fire fed by mineral embers (*tisons*) of leaves carved out of different glimmers of green, in green light of emerald-green glimmers, *prasines* of chrysolite, pale green of aquamarine, yellowish glimmers of zircon, cerulean glimmers of beryl: everywhere, from top to bottom, from the tips of the vine props, to the feet of the stems, from the vines grew grapes of rubies, etc.]

The empty château is filled in precisely the same manner as the palace, albeit in a mode of decomposition. Thus, the Ideal is made equivalent to vulgar reality. Enormous spider webs ornament the kitchen "en ruine" and "des fleurs de moisissure jaspaient les cloisons arborisées par des fissures et les dalles alternées . . . du pavé se délitaient, tantôt bossus et tantôt creuses" (flowers of mildew marbled the partitions arborized by fissures and alternating flagstones . . . some of the pavement was scaling off, here buckled, here caved in) (64). Continuing his exploration of the château, Jacques enters "un salon immense, sans meubles" (an immense unfurnished living room), and the ensuing description of decomposition as ornament offers a good example of syntactic complication and accumulation. The last half of the first sentence ("des fentes . . . friable") is a fan sentence ("une phrase en éventail") in which a quaternary fanning out (*lézardaient, craquelaient, zigzaguaient, traversaient*) opens out into a ternary expansion (*dédoré, rouge, friable*):

L'humidité avait positivement éboulé les lambris de cette pièce; des boiseries entières tombaient en poudre; des éclats de parquet gisaient par terre dans de la sciure de vieux bois . . . ; des fentes lézardaient les panneaux, craquelaient les frises, zigzaguaient du haut en bas des portes, traversaient la cheminée dont la glace morte coulait dans son cadre dédoré, devenu rouge, presque friable. Par endroits, le plafond crevé décelait ses bardeaux pourris et ses lattes; . . . des infiltrations y avaient dessiné, ainsi qu'avec des traînées d'urine, d'improbables hémisphères. (65)

[The humidity had positively brought down the wainscoting of this room; entire panels were crumbling into dust; splinters of the parquet were lying on the floor among the sawdust of the old wood . . . ; crevices

split the panels, criss-crossing the friezes with small cracks, zigzagging along the doors from top to bottom, traversing the fireplace whose dull (*morte*) mirror glided in its once-gilded frame, now turned red, almost crumbly (*friable*). In some places, the caved-in ceiling let its rotten clapboard and slats be seen; . . . infiltrations had traced, along with trails of urine, improbable hemispheres.]

The vegetation outside the château is also a response to Jacques's horror vacui, to "ce silence inanimé . . . des fenêtres ouvrant sur des corridors nus et des chambres vides" (this inanimate silence . . . of windows opening onto naked corridors and empty rooms) (70). "Jacques tourna le dos au château et . . . il vit un jardin fou . . . envahi par les orties et par les ronces, de vieux rosiers . . . semant ce fouillis de vert, des rougeâtres olives, des gratte-cul naissant" (Jacques turned his back to the château and . . . he saw a wild garden . . . invaded by nettles and thorns, old rosebushes . . . sowing this jumble of green, of reddish olives, of budding brambles) (71). After a sentence of ten lines containing twenty clauses, the notion of the void nonetheless reinjects itself, sending the vegetation into spasms of serpentines: "De vieux sarments de vigne sautaient d'un bord de l'allée à l'autre *dans le vide* et, s'accrochant aux fûts des pins, grimpaient autour d'eux en serpentant . . . et agitaient de triomphales grappes de raisin vert" (Old vine branches leapt from one end of the path to the other *in the void* and, hanging on to the pine trunks, climbed around them in serpentine fashion . . . and shook triumphant clusters of green grapes) (72; emphasis mine). Here, as earlier, the link of horror vacui patterning with disease or decomposition is made: "C'était un inextricable écheveau de racines et de lianes, une invasion de chiendent, un assaut . . . de légumes incomestibles, aux pulpes laineuses, aux chairs déformées" (It was an inextricable skein of roots and vines, an invasion of couch grass, an assault . . . of inedible vegetables, with woolen pulps, with deformed flesh) (73). Similarly, the château is diseased. "En somme les infirmités d'une vieillesse horrible, l'expuition catarrhale des eaux, les couperoses du plâtre, la chassie des fenêtres, les fistules de la pierre, la lèpre des briques, toute une hémorragie d'ordures, s'étaient rué sur ce galetas qui crevait seul à l'abandon" (In short, the infirmities of a debilitated old age, the catarrhal expuition of waters, the blotches of plaster, the viscous blearedness of the windows, the fistulas of the stones, the leprosy of the bricks, an entire hemorrhage of filth, had hurled itself on this hovel that was perishing alone, abandoned) (75).

Finally, his dreams exhibit the same coupling of horror vacui design and disease. Here is the famous moon dream.

The emptiness of space:

> C'était au-delà de toutes limites, dans une fuite indéfinie de l'oeil un immense désert de plâtre sec ... dans le centre duquel se dressait un mont circulaire ... aux flancs ... troués comme des éponges ... à la crête ... évidée en forme de coupe. (107)

> [It was beyond all limit, in an unending vanishing point for the eye, an immense desert of dried plaster ... in the center of which a circular mountain ... with sides ... bored with holes like sponges ... at the crest ... emptied out in the form of a cup.]

Horror vacui design:

> Une sorte de glace givrée au-dessous de laquelle apparaissaient de vagues fougères cristallisées dont les nervures et les côtes brilliaient ainsi que des sillons de vif-argent ... des arborisations laminées. (108)

> [A sort of frosted mirror ice above which appeared vague (forms of) crystallized heather whose nerves and sides shone like rows of quicksilver ... laminated arborizations (*nervures* can also mean architectural moldings, or piping in needlework).]

Disease:

> Ils dominèrent un paysage fuyant à perte de vue, hérissé par des Alpes de plâtre ... gonflé de tubercules, boursouflé par des kystes, scorifié tel que du mâchefer. (109)

> [They commanded a landscape hurrying off as far as the eye could see, studded with plaster Alps ... swollen with tubercles, bloated with cysts, scorified like slag, iron dross.]

As the moonscape becomes more and more ornamental, the contrasting void injects itself more emphatically. On the one hand, Huysmans gives us "les bords en rocaille," "la croûte disloquée des laves," "des mâts de marbre," "rouleaux géants d'albâtre," "une exorbitante assiette de faïence craquelée," un "marais cristallisé ... ondulait, grêlé comme par une variole géante ... de fictifs ruisseaux zigzaguaient, striés ... , d'inguérissables plaies soulevaient de roses vésicules sur cette chair de minéral pâle" (rocaille shores, disjointed crusts of lava, masts of marble, giant rolls of alabaster, an exorbitant dish of cracked earthenware, an undulating, crystallized sea pockmarked as if by giant smallpox, artifi-

cial brooks zigzagging and streaked with incurable wounds, pushing up pink bladders on this pale mineral flesh) (109–111). These elements of the moonscape, treated as diseased body parts, "tumble down," "undulate," and "zigzag." And on the other hand, he emphasizes the *lack* of movement, odor, sound. "Nulle exhalaison . . . nul fumet de cadavre . . . le vide, rien, le néant de l'arôme et le néant du bruit" ("No exhalation . . . no perfume of corpse . . . the void, nothing, the total absence of aroma and noise") (111). Suddenly the paroxysmal movement depicted earlier is frozen. "Partout des cataractes de bave caillée, des avalanches pétrifiées de flots, des clameurs aphones, toute une exaspération de tempête tassée, anesthésiée d'un geste" (Everywhere there were cataracts of clotted slime, petrified avalanches of waves, of mute clamors, a complete exasperation of piled-up tempest, anesthetized with a single gesture) (112–13). The feeling of horror vacui reappears immediately. "Cela s'étendait si loin que *l'oeil dérouté perdait les mesures.* . . . Ici, . . . d'immobiles spirales . . . descendaient en *d'incomblables gouffres en léthargie*" (This stretched out so far that *the baffled eye lost all sense of measurement.* . . . Here, . . . immobile spirals . . . descended into *unfillable gulfs in a state of lethargy*) (113; emphases mine). Already, the assimilation of the moon's exasperated movement to the pathology of a human body and the representation of surgical instruments ("toutes ces villes . . . simulaient un amas d'instruments de chirugie énormes" [all of these cities . . . simulated a pile of enormous surgical instruments]) have prepared the reader for what Huysmans will now make explicit. The lexicon of disease—swelling, cysts, blisters, smallpox—has until now been considered solely in terms of its decorative possibilities. But these images are also tied to a parallel aesthetic source for Huysmans: hysteria. After traveling through a tunnel, an intestine likened to a crystal tube, Jacques and Louise come out onto the Sea of Tranquillity, whose contours resemble the white image of a stomach complete with navel and female genitals (traced by the big V of a gulf) forked by two legs, which are spread apart by the Seas of Fecundity and Nectar (112). They pass by the Marsh of Sleep and the Sea of Attacks (*la Mer des Crises*), and it is then that they come upon the above-cited vision of paralysis, aphonia, and anesthesia. There, "de convulsifs Niagaras . . . aux bonds paralysés" (convulsive Niagaras . . . of paralyzed leaps) overlook the abyss. Jacques wonders what has caused the moon, "la froide Séléné," to fall into catalepsy: "À la suite de quelle formidable compression d'ovaires avait été enrayé le mal sacré, l'épilepsie de ce monde, l'hystérie de cette planète, . . . se cabrant, bouleversée sur son lit de laves?" (Sub-

sequent to what formidable compression of the ovaries had the sacred illness skidded to a stop, the epilepsy of this world, the hysteria of this planet, . . . arching itself, shaken on its bed of lava?) (113). It is a question that the end of the last sentence of this passage seems to answer: "Dans cet indissoluble silence qui plane depuis l'éternité sous l'immuable ténèbre d'un incompréhensible ciel" (In this indissoluble silence that floats from the beginning of eternity under the immutable shadow of an incomprehensible sky) (113). One cannot come much closer to Worringer's formulation of horror vacui. Only for Huysmans the response is not only an ornamentalization and abstraction of the novel, but also a literary transcription of the bodily response of the hysteric.

HYSTERIA AS DISLOCATION AND DECOMPOSITION

Hysteria, in its most basic structure, is an alternation of an excess of movement and an absence of movement. Charcot established the "fact" that hysteria *imitates* epilepsy, and that *la grande hystérie* consists of four stages: *épileptoïde, clownisme, attitudes passionnelles, délire*. Hysterics are paradox personified: "They are (always extravagantly) hot and frigid, inert and convulsive, beaten down and hilarious, fluid and heavy, stagnant and vibratory."[14] After the convulsive stages of acrobatic contortions and spasms, come cataleptic paralysis and the hallucinatory trance where, typically, the Subject lives out terrors and anxieties (and, at times, experiences ecstasy). Erotic pleasure is experienced in the agitated stages, whereas fear is often experienced in the stages of immobility. Similarly, the excess of movement, feeling, demands, and sometimes speech in the hysteric is a response to an acute feeling of emptiness. Hysteria, therefore, may be understood as a form of horror vacui.

But there is another twist to the constellation "void, hysteria, ornament." The hysterical moon may be a decorative plaything in the void, but it too is terrifying: "Dans le vide, la colossale ossature de ce jouet inouï, la Lune épouvantait la raison" (In the void, the colossal skeleton of this extraordinary toy, the Moon terrified reason) (114). So, if the hysterical ornamentation of the moon is an attempt to cover over the void, the very lack or emptiness in the hysteric that causes this convulsive movement continually reappears to mirror the void. Thus, the abyss is "incomblable," unfillable. That is why even the fullness of the round moon encircled by a decorative image cannot hide its similarity

to a gaping abyss: "La lune surgit pleine et ronde, pareille à un puits béant descendant jusqu'au fond des abîmes, et ramenant au niveau de ses margelles d'argent des sceaux de feux pâles" (The moon rose into view full and round, the same as a gaping well descending to the bottom of the abyss, and bringing back along its silvery edges pails of pale fire) (106). On another level, the moon is terrifying because hysteria is every bit as incomprehensible as space. And hysteria is not found only in Jacques's dreams; it is present in his everyday reality. His wife is a hysteric:

> [Elle exhibait] tout un cortège de phénomènes, aboutissant à des hallu-cinations, à des syncopes, à des affaiblissements. (42)

> [(She exhibited) an entire parade of phenomena, ending in hallucina-tions, in syncopes, in loss of strength.]

> Ces ruades en avant se continuèrent, se succédant, de minutes en min-utes, précédées d'un cri; des douleurs semblables à des commotions électriques filaient dans les jambes . . . errant le long des cuisses, éclatant de nouveau en des décharges brusques. (117)

> [These wild kicks into the air continued, followed each other, minute by minute, preceded by a cry; pains comparable to electric shocks were conducted through the legs . . . wandering along the thighs, bursting forth again in sudden discharges.]

By situating hysteria in Woman (Louise, the moon), Huysmans and Jacques appear to constrain this menacing and incomprehensible phenomenon; it is in the Other, not in oneself. However, despite this strategy, Jacques too is afflicted with the same emptiness. The moon dream ends with Jacques's awakening due to that contraction of the bladder "qu'entraîne *l'angoisse prolongée du vide*" (brought on by the *pro-longed anxiety of the void*) (114; emphasis mine). This sensation of emptiness then infiltrates his entire being. "Il se sentait sous ses habits *vide* . . . mais *l'horreur* se révélait soudain de ce morne désert, de ce silence de tombe, de ce glas muet" (He felt himself *empty* under his clothing . . . but the *horror* of this bleak desert, of this tomblike silence, of this mute knell, soon revealed itself) (114–15; emphases mine). There is an example of this form of horror vacui in *A Rebours* when Des Esseintes, who can no longer absorb food normally, is given an enema. Indeed, one's first anxiety concerning the void is . . . to void.[15] Urine or excrement leaving the body threatens the child with emptiness.

Certainly the quantity of passages describing cow dung, urine stains, and bird droppings in *En Rade* is astonishing, and perhaps the most astounding metaphor in the novel is Jacques Marles's phrase "the latrines of the soul." Early on in the novel, we are told that the hero has projected his anxieties onto the landscape. "L'immense paysage . . . s'excavait maintenant comme un abîme; le fond de la vallée disparu dans le noir semblait se creuser à l'infini" (The immense landscape . . . excavated itself now like an abyss; the bottom of the valley, invisible in the darkness, seemed to hollow itself out to infinity) (44). This landscape, mirror of his inner torments, causes him to be, in turn, paralyzed (fatigued, asleep) and wildly agitated (starts, jerky trances, his fears galloping).

The third-person narration of *En Rade* also displays the alternation of paralysis and exasperated movement observed in hysteria. The latter is expressed by Huysmans's syntax. One can thus say that horror vacui appears to be felt by both Huysmans and his character. An astute analyst of the writer's style notes "the nervosity of the ascending portion, the calm unfolding of the long descending portion," "the troubling impression of a sentence suddenly arrested in its development," "the dislocated sentence," and "the sounds [that] bump up against each other in a rocky sequence, or unbearable alliterations [that] succeed one another." "Finally, the passage from narration to dialogue with no transition, the sudden changes of verb tense, the variety of rhythms, one substituted for another before the reader's ear has had the time to adapt to any of them, give to Huysmans's style *an oscillating and jerky movement*" (emphasis mine).[16] All of these traits create the alternation of spasmodic and paralyzed movement I have underlined.

He expands on a motif, complicates the syntactic line, uses "fan sentences" and "staircase sentences" so as to fill every part of the text, leaving no holes bared. Marcel Cressot analyzes in detail these particularities of style that I am calling examples of horror vacui. Reduplication occurs in the repetition of the noun with a change of article or in the doubling of a noun by its synonym (134, 149). In the "phrase à escaliers," the initial thought overflows as it seeks to render every detail; the sentence loses its rigid structure to become amorphous. Progressive ternary rhythms exhibit a fanning out, then a decline. Accumulation and enumeration are common ways used to "fill in." In the "phrase en éventail," the ascendant portion accumulates all of the picturesque circumstances of the scene (like a fan) and, through these juxtapositions, the atmosphere in which the character lives takes form. The

transformation of transitive verbs to intransitive ones endows them with an unlimited extension (while restricting their action). The embroidery of the syntactic line into a complex ramification of binaries, ternaries, and quaternaries of ever-expanding detail makes it twist and contort like the "crazed vermicelli" of Art Nouveau.[17] The contortions of syntax, the profusion of detail, the superimposition of images through metaphor, all of these elements bring about a paralysis of the narrative line, overwhelmed by the top-heaviness of this movement and superabundance. They come in answer to the terrifying prospect of being swallowed up (devoured, digested) by the void, an obsessional idea that reappears in Huysmans's novels of the 1880s and 1890s. Without the sort of penetrating, elaborate vision I have been describing, Huysmans, like Gautier, risks being swallowed up by emptiness, metaphorized by the void that inhabits the château, parts of the landscape, the dream moonscape, and the sexual organs. "Huysmans is an eye," said Rémy de Gourmont in the *Premier Livre des Masques*. In *En Rade*, Jacques Marles fears that the bird of prey he battled in the worm-eaten staircase of the deserted château might have "devoured his eyes," substituting two empty holes for the power to embellish with ornament.

"Huysmans dragged the image by the hair or by the feet down the worm-eaten staircase of terrified Syntax," Léon Bloy said. This worm-eaten, decomposing staircase—the syntax of the traditional French novel—is in the decaying château of fin de siècle civilization. Here, the violence of ornamental excess, a hysterical reaction to an acute sense of the void, overlies the old, crumbling structures. One decomposing structure metaphorizes and overlies the other.

Yet Huysmans's brand of Decadence *is* the decomposition of excessive ornament. De-cadence is a break down of cadence, or a falling away from a set, regular rhythm. In Huysmans, that is brought about by hysterical syntax and by patterns of horror vacui, a refusal to structure rhythm with gaps. Excessive decoration, in the traditional view of ornament as added on to structure, is never far from decomposing its structural underpinnings. But even in the organic view of ornament as an integral part or a natural outgrowth of structure (for example, Celtic interlace, Art Nouveau), extreme complexity threatens legibility and, therefore, perception of structure. That is perhaps why Huysmans's excessively ornamental passages stress various stages of decomposition and dilapidation. In Des Esseintes's ode to the Latin prose of the Decadence, the "enamel-plated verses" inevitably become "une langue

complètement pourrie [qui] pendait, perdant ses membres, coulant son pus, gardant à peine, dans toute la corruption de son corps, quelques parties fermes" (a completely rotten, corrupted language [that] hung there, losing its members, dripping pus, scarcely keeping, in all the corruption of its body, any firm parts) (*A Rebours*, 93). We have seen a similar excess in Gautier and Mallarmé, but it did not tend toward decomposition. What kept it from doing so was the important structuring role that the void or the frame played, even when the frame was infringed upon. One would be mistaken, however, to think of decomposition as a purely negative concept in the fin de siècle. Certainly it has traditionally been perceived as such, and the word continued to be used pejoratively in the period. Albert Wolff, for example, wrote that someone should tell Renoir that a woman's torso was not "a heap of decomposing flesh with green and purplish blotches . . . [of] putrefaction,"[18] but the virtues of decomposition are extolled at length in an article by Multatuli (the nom de plume of the Dutch writer Eduard Douwes Dekker).

> Nature functions by composition and by the *contrary* . . . : to grow old, worn-out, wither away, rot . . . die.—That is what we do. But all of that leads to putrefaction, a word that shocks us because we have a miserly view of things. One needs a certain dose of knowledge . . . to realize that in each object that is nauseatingly rotten, there is really nothing corrupted . . . the house is demolished but the materials have been preserved. . . . He who fears putrefaction is an enemy of life.[19]

Decay is a dynamic force that re-forms the surface it infiltrates; it opens out onto new creations of form. In the next decade the art historian Aloïs Riegl would revolutionize the teleological concept of artistic evolution by demonstrating how every phase of development "ends in its own dissolution." "Decadence," thus, does not exist, for decomposition harbors in itself the seeds of a vigorous new form of beauty.[20] Several of Emile Gallé's vases explore this idea: a flower is seen blooming, then the healthy bloom begins to wear off, until the same flower is finally seen wilting and dying. The circular form of the vase mutely demands that one re-create the cycle of decomposition and regeneration. Finally, the ambiguity between life and death in decomposition is another manifestation of the trompe l'oeil designs that are so prevalent in ornament of the nineteenth century.[21]

Huysmans's imagination puts putrefaction to refined artistic use in chapter 9 of *En Rade*. The recent scientific discovery of ptomaine in the

putrefaction of cadavers could be used to produce "des extraits con-
centrés d'aïeuls, des essences d'enfants, des bouquets de père. Ce serait
ce qu'on appelle, dans le commerce, l'article fin" (concentrated extracts
of ancestors, essence of children, bouquets of father. This would be
what is commercially referred to as the refined article). Of course, this
use is destined for the rich, but *les femmes du peuple* would be delighted
to buy pomade perfumed by "essence of proletariat" (183). Huysmans
immediately connects this essence of decomposed cadavers to eating,
filling one's stomach. Here is the family dinner where the child can
choose between a dessert composed of grandmother and one of grand-
father:

> Une crème aux ptomaïnes [est composée de] l'extrait des viscères
> décomposés de l'aïeul. . . . —Nan, nan, grand'père! crie le gosse qui se
> barbouille de crème ancestrale les joues et le nez. . . . De peur qu'il n'ait
> une indigestion d'amour filiale, la prévoyante mère fait enlever la crème.
> (185–86)

> [A ptomaine cream [is composed of] extract of the decomposed viscera
> of the grandfather . . . —Goody, grandfather! cries the kid who is smear-
> ing ancestral cream all over his cheeks and nose. . . . Out of fear that he
> might get an indigestion of filial love, the careful mother has the cream
> removed from the table.]

One can consume, devour, even what has decomposed.[22] The raw ma-
terials of life and death are placed at the novel's center.

In examining Decadence as a perverse revision of the traditional
syntax of the novel, and decomposition as a positive aesthetic quality,
I have considered the first technique of horror vacui, filling in. The
second technique, that of linking, is elaborated through a figure of rhet-
oric, the extended metaphor (*la métaphore filée*). Here is one example:
"Et cette bâtisse . . . coiffée d'un toit en tuiles brunes jaspées de blanc
par des fientes . . . sa peau halée des pierres . . . un coup de soleil fardait
la vieillesse du château dont les imposantes rides souriaient" (And this
ramshackle house . . . coiffed with a brown tile roof marbled with white
by the droppings . . . its tan skin of stone . . . a suntan rouged the old
age of the château whose imposing wrinkles were smiling) (69–70). The
métaphore filée, like other forms of *concetti*, is an ornamental figure. It
is, arguably, the most highly wrought of linguistic ornaments. Even
the doubleness of simple metaphor is a deviation from the straight path
of reading; extended metaphor ramifies into a complex network that

deconstructs any teleological movement of the narrative. It commands the reader's attention by its virtuosity at the expense of focus on plot; *En Rade* is an extraordinary network of interconnected *métaphores filées*.[23] This filigree, another response to horror vacui, works toward the same ends as overlay.

It is difficult to discuss decomposition in relation to ornament without mentioning Oscar Wilde's *The Picture of Dorian Gray* (1890), a book Wilde called "an essay on decorative art." It is not difficult to see that the "picture" is the decomposing underside of the decorative. Dorian's jaded mentor, Lord Henry, gives his protégé a "poisonous book" to read, from whose influence the boy can thereafter not free himself. Dorian takes pleasure in the cruelty of the hero's tragic despair, just as the view of his own decomposing features in the portrait kept hidden upstairs quickens his pleasure at his unchanging beauty seen in the mirror next to the portrait. The hero seems "a prefiguring type of himself."[24] This book is, of course, *A Rebours*. "The mere cadence of the sentences, the . . . music . . . of complex refrains and movements elaborately repeated, produced in the mind of the lad . . . a malady of dreaming" (*Dorian Gray*, 182). In fact, Lord Henry would like to write a novel "that would be as lovely as a Persian carpet, and as unreal" (198); in other words, a work of abstraction and horror vacui design, like *A Rebours*.

Perversion as Horror Vacui

There is a facet of Decadence—alluded to in *Dorian Gray*—that typifies the Decadent "movement" for most readers, and that is sexual perversion. In a reading of Huysmans's *Là-Bas*, I intend to show how sadistic inventions and the number of victims subjected to them are used to fill a metaphysical void. Horror vacui aligns itself with sexual perversion, and ornamental excess is the inevitable accompaniment to this perverse discharge of energy.

Durtal, the hero of *Là-Bas*, seeks to write a new kind of novel, one unlike anything produced by the two groups in the Parisian literary world ("the stupid bourgeois" cranking out books for monetary gain and the "phony Bohemians" found in artistic cabarets of the *Quartier Latin*). This novel would be a combination of naturalism and mysticism: naturalism, as in Mathias Grünewald's *Isenheim Altarpiece*, where Christ's bodily torture and putrefaction are unflinchingly rendered in

the most minute detail. "C'était excessif et c'était terrible."[25] But, look-
ing closely at this body, one sees a transformation take place. "De cette
tête exulcérée filtraient des lueurs . . . cette charogne éployée était celle
d'un Dieu" ("Glimmerings filtered through this ulcerated head . . . this
spread-out carrion was a very God") (*Là-Bas*, 36). All that is left of
realism is decomposition, its inner core. That essence is equivalent to its
opposite, the Ideal, as the superimposition of dream and naturalism
demonstrated in *En Rade*. Here, however, the Ideal is of a purely reli-
gious sort. Thus, Durtal undertakes a project based on the memoirs of
Gilles de Rais, known as Bluebeard, a man whose mysticism and thirst
for the Absolute led him to plunge into the depths of evil rather than
aspire to the heights of Christian charity. The "double well" of the bell
tower of St. Sulpice, which extends below Durtal's feet and above his
head, symbolizes "les deux abîmes" (55). There is another "abîme," that
of the *mise en abyme*. Durtal's thought on the state of the novel in 1891
mirrors Huysmans's, and his project is, of course, the project of *Là-Bas*.
In addition, the fascination of Gilles de Rais with the occult is con-
tagious, since, as he researches the occult, Durtal himself becomes
obsessed with it. The crimes of Gilles de Rais are not repeated by the
writer; however, the latter's lover, Mme de Chantelouve, represents a
contemporary version of sadism and perversion, as does her mentor, the
defrocked priest Docre, whose celebrations of the Black Mass—
like Chantelouve's performance of the sexual act—are *mise en scènes* of
hysteria. Hysteria in the nineteenth century is thus made to serve as a
mise en abyme of fifteenth-century atrocities and perversions.

It is essential to note that *at the same time* as Gilles de Rais's atrocities
are about to begin, the artist and man of letters are developing in him,
and they incite him to the most scholarly and delicately refined crimes.
He seeks "la chose rare" (74). The first step he takes is to surround
himself with ornament. He has his rare manuscripts illuminated with
ornate initials and with miniatures, and he learns to paint on enamel. A
specialist frames these enamels in worked gold. He becomes ecstatic at
"voluptuous silks" and old brocades. The wealth of ornament described
consists primarily of sacred objects. His religious fervor becomes a
passion for alchemy and sorcery. Once these resources begin to pale,
Gilles turns to the rape and murder of young children. The sheer num-
ber of Gilles de Rais's victims and the infinite variety of tortures he
devises for them suggest that his thirst for the Absolute in the realm of
evil is a form of horror vacui. (When rape, sodomy, and dismember-
ment cease to satisfy him, he sodomizes the corpses of the murdered

children.) But "l'au-delà du mal ne s'atteint pas. Les limites de l'imagi-
nation humaine prenaient fin; il les avait diaboliquement dépassées
même. Il haletait, *insatiable, devant le vide*" (the realm beyond evil
is unattainable. The limits of human imagination were reaching their
end point; he had in fact already reached it and diabolically gone
beyond it. He panted, *insatiable, before the void*) (199; emphasis mine).
His rage for torture becomes even more delirious, and he roams the
forests surrounding Tiffauges. There an obscene vision of nature pre-
sents itself to him: a chaos of trees fornicating, ulcerating, and decom-
posing. (Nature perverts itself before him.) It is at this moment in
the narrative that Huysmans reminds the reader that the present period
has simply replaced carnage and rape with the obsession for money.
And the insatiable lust for money and possessions is easy to envisage as
a form of horror vacui.

In bed, Chantelouve gives the impression of "une brûlure spas-
modique dans un pansement de glace" (a spasmodic burning in a
dressing of ice) (218). In the celebration of the Black Mass, Satan is
glorified as, among many other things, "Tuteur des stridentes névroses,
Tour de Plomb des Hystéries, Vase ensanglanté des Viols!" (Guardian
of strident neuroses, Lead Tower of Hysteria, bloody Vessel of Rape!)
(294). Satanism provides the filiation between Mme Chantelouve and
Gilles de Rais at the same time as it reclaims hysteria as a mystical,
religious phenomenon—possession by the Devil—and not as a medi-
cally classifiable physical malady. Hysteria is a tool of the Devil, who
uses it to wreak chaos on the world. In any case, whether it is satanically
or mentally induced, hysteria is perceived as a potent danger to order.

Thus, in this novel, Huysmans paints hysteria, perversion, and crime
as attempts to fill a metaphysical void in the period, a period marked by
a widespread avidity for commodities to a degree France had not
known before.

Hysteria is contagious. In fact, even when the movements associated
with hysteria are seen in situations that do not involve hysteria, they
have the same effect on the viewer. In discussing convulsive movements
in dance or in design, Paul Souriau remarks that they can even, "by a
kind of contagion, provoke in the viewer similar symptoms."[26] Huys-
mans, like many other Decadents, saw in hysteria a mystical, creative
force that would revitalize the novel. The hysteric refuses the role im-
posed on her of the passive, beautiful woman. Instead, she is all uncon-
trollable movement, threatening to destroy all that surrounds her, even
herself. Her contorted poses and facial grimaces are ugly and ridicule

the commonly received concept of female beauty. Then she freezes in a cataleptic pose that is a hyperbolic comment on this concept and role. As she "decomposes" her face and body, from which various bodily fluids escape, she approaches the status of pure matter. She joins the images of decomposing matter that are so central to Huysmans's conception of the novel. In *A Rebours*, we are told that only an elite of esthetes can understand and appreciate Gustave Moreau's *Salomé* (characterized, we remember, as "the goddess of immortal Hysteria" whose body is made rigid by catalepsy), only those whose "cervelles ébranlées [sont] rendues visionnaires par la névrose" (unsettled brains [are] rendered visionary by the neurosis) (116–17). Hysteria (whose final stage is hallucination) is meant to lead out onto an as yet unseen artistic vision. In this case, it is Moreau's vision Huysmans is discussing, but in a larger sense he points to a new direction for art and the novel. In attempting to re-create the very movement of the phenomenon in his syntax (his contemporaries restricted the use of hysteria to the level of theme and character), Huysmans created a new artistic order. This order of disorder could, conceivably, provoke the same disorder in the reader. Félix Fénéon wrote that Huysmans had invented a new sentence, "a *virulent* sentence, threatening and without underside, tattooed with savage metaphors, apt to *give birth to nauseating, dense and tumultuous things.*"[27] I have emphasized the elements of morbid pathology in this description.

The fascination with hysteria is part of the desire to feel and see pain in the period. Poet and café-concert singer Maurice Rollinat's voice is notable because it "cuts like a razor," and acrobats and cancan dancers outdo one another in extremes of painful contortions that rival those of hysteria.[28] Pain is an awareness that one at least exists and is thus in defiance of the void. For Schopenhauer, the most influential philosopher in France's fin de siècle, the Will is marked by striving, and since this striving will be largely unsatisfied, pain and suffering are essential to all life. As consciousness develops, pain increases.[29] Pain and torture will continue to be linked to ornament in the period, and in the pages that follow I want to examine the way in which they manifested themselves in the texts of a very popular *femme-écrivain* of the fin de siècle: Rachilde.

Ornament, now foregrounded in the novel and *explicitly* linked to passion, can no longer express desire. It can only attempt to do so through explicit annexation with drives and perversions like sadomasochism and fetishism. It will be remembered that sadism and voyeur-

ism entered into the desire expressed through ornament in Gautier and Mallarmé (the evil eye in *Jettatura* and the decorative frame of the "Sonnet en yx"). In the novels of Huysmans, however, the hero's sexuality is clearly portrayed in a state of decay. Despite the effort to stimulate desire through sadomasochistic phantasies, he remains impotent. What Huysmans portrays is not desire, but rather the decomposition of desire.

Art and Madness; or, Who Put the "Mental" in Ornamental?

Synesthesia reached its paroxysm in literature with Des Esseintes, whose experimentation with the mouth organ of liqueurs is the paradigmatic synesthetic experience. We know to what extent interior decoration is important to him and to the novel. I will now develop a connection between the two that was slowly being established throughout the latter half of the century and was finally "elucidated" by psychiatry.[30]

Synesthesia, as Jean D'Udine writes, can be either normal or pathological. When it takes on the objective character of a hallucination, it is the mark of a morbid sensibility. Interestingly, the example D'Udine chooses involves a decorative pattern. While listening to the changing chords on a piano, a financier (thus, "little given to artistic exaltation"!) actually *sees* certain colors take shape according to the notes played. This is an "unhealthy phenomenon of nervous origin." "On the white background of the wall, colored vapors [formed] . . . trembled, transparent, . . . and changed constantly with the harmonies."[31] In fact, the interior decoration of the period *encouraged* such hallucinations, for the decorator took "pleasure in multiplying ornaments so as to distort form. . . . [In the] modern apartment, [one sees] artifices [*mensonges*] of form and color everywhere" (Souriau, *Imagination*, 24).

Visions such as these are described in psychiatric studies. Dr. Gatian de Clérambault, for example, states categorically that hysteria particularly predisposes one to synesthetic experiences. But synesthesia is not the only form of decorative hallucination in psychiatric patients.[32] Hallucinations that focus on a small surface are the most characteristic sort, and this may be related to Charcot's finding that hysterics suffer a diminution of the field of vision. Charcot's dazzling scotoma, which appears in the hysteric's field of vision during severe migraine head-

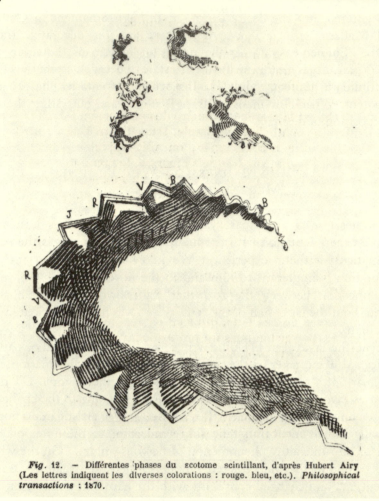

Fig. 12. — Différentes phases du scotome scintillant, d'après Hubert **Airy** (Les lettres indiquent les diverses colorations : rouge. bleu, etc.). *Philosophical transactions* : 1870.

24. J.-M. Charcot, dazzling scotoma, in *Leçons sur les maladies du système nerveux.*

aches, is another form of decorative display: a luminous figure at first circular, then semicircular, then in the form of a zigzag. In addition to its decorative shape, it is phosphorescent or made up of several colors (fig. 24).[33] Here is a hallucination cited by Clérambault, who—curiously enough—studied for two years at the Ecole des Arts Décoratifs and taught a course at the Ecole des Beaux Arts on his theory of drapery in women's clothing:

There are insects, *threads, geometric forms, ornaments*, inscriptions, scraps
of clothing. The contours are remarkably well defined, often angular.
The space around the figures is itself filled with little lines ... *stripes,
fluting, compositions based on the trellis (wicker, filigree, grillwork)* ... ver-
tical lines, *suspended threads, small suspended insects, aquatic plants, a green
thing, hanging leeches* ... most of the images are *flat*. The patient identi-
fies them as "*Fabric applied to the walls, pasted-on drawings, flowers ...
the work of decorative painters ... crushed spiders.*" (*Oeuvre*, 179–80;
emphases mine)

Within the confines of the home, interior surfaces with decorative pat-
terns scintillate and vibrate (fig. 25). This remarkable confirmation of
the importance ornament attained in the realm of the Imaginary in the
nineteenth century is equaled only by the parallel evolution of its patho-
logical nature. Ornament as the expression of emotion has moved from
the underground conduits I have analyzed in Nerval, Gautier, and Mal-
larmé to an overt status via madness.

Clérambault's most exotic contribution to the notion of ornament
and madness, though, resides in a series of observations of women who
were hospitalized for kleptomania and sexual perversion. These
women, some of whom were classified as hysterics, uncontrollably stole
decorative fabric (silk, satin, and velvet) in order to masturbate with it.[34]

I preferred silk faille, it's silkier and it cries out [*ça crie*] ... the rumpling
of silk ... excites you, you feel yourself getting wet; no other sexual
orgasm equals that one for me. But the orgasm is especially intense
when I've stolen [the fabric] ... I feel myself dizzyingly compelled [to
steal]. Silk attracts me. ... When I feel the rumpling ... it starts with a
prickling sensation under the fingernails ... [and it ends with] a breath-
taking orgasm; it's as though I were drunk ... I tremble. (Clérambault,
Oeuvre, 694)

The degree of erotic intensity that decorative fabrics evoke in these
women is pathological. In normal persons, fabrics, perfumes, and so on,
may enhance the sexual act, but only in pathological cases will they
suffice to bring one to orgasm. Clérambault notes the connection of
this auto-sufficiency with hysteria, a tie formed by the underlying,
concurrent phenomenon of synesthesia. This pathology is particularly
developed in hysterical women because synesthetic phenomena are
constantly found in them. "The pathological characteristics of synes-

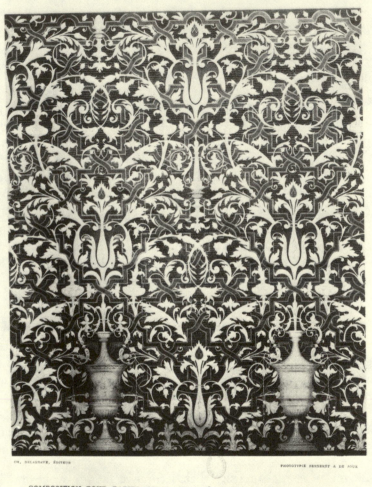

COMPOSITION POUR PAPIER PEINT, DESTINÉ AU CHATEAU DE SAINT-ROCH

(Par M. LECHEVALLIER-CHEVIGNARD)

25. Lechevallier-Chevignard, wallpaper, 1885.

thesia, considered as a reflex, reside in its intensity, its spontaneity, its independence" (*Oeuvre*, 702). Clérambault goes so far as to state that among the phenomena of disintegration (or decomposition) caused by

illness, "synesthesia is in the forefront" (703). (The analogy between synesthesia and hysteria is, of course, natural, since both hinge on metaphor. In the former as artistic experience, sound can equal color, odor can equal touch, and so forth; in the latter, the "wandering womb" makes strangulation of the throat or paralysis of the leg metaphors for the repressed sensation in the sexual organs.)

Thanks to synesthesia, then, hysterics are able to bypass the male partner entirely. Here, synesthesia consists "in repercussions on the genitalia of quite banal sensations of the epidermus" (701). (The visual, auditory, and tactile qualities of fabric are equivalent to the sensation of sexual excitation.) Despite the connections one might establish between these fabrics and a feminine presence, these women did not exhibit a lesbian desire. Many of Clérambault's patients had gone without sexual relations for several years, substituting in their place decorative fabrics. "I've always felt an aversion for the sexual act. . . . I suffered from attacks of hysteria . . . in 1881, at the age of 24 [I committed] my first theft. . . . Silk gives me an astonishing, voluptuous spasm. . . . I'd like to sleep with silk on, but . . . it would burn my skin" (695–96). The sexual self-sufficiency of the women afflicted by this syndrome is perhaps its most disturbing feature in the eyes of the psychiatrist. Hysterics enjoy an increased sensitivity (hyperesthesia), as well as a remarkable facility for auto-suggestion, and thus the memory of an intense, "genitally voluptuous" first contact would have repercussions on future sexual experiences.

Putting aside the psychiatrist's observations for a moment in favor of an example taken from literature, we find perhaps the most hyperbolic and ludicrous representation of a decorative object replacing the male partner ever invented. I am referring to one of the dozens of Decadent novels produced by Rachilde (pseudonym for Marguerite Eméry Valette), *La Jongleuse*. The text dates from 1900 (Clérambault's case histories focus on the period 1895–1905).

Eliante Donalger, a mysterious, wealthy sophisticate, picks up a young medical student at a ball and brings him home to her mansion. Midway through the novel her willful chasteness in the face of an evident ardent erotic desire on her part causes him to prognosticate that "médicalement, les personnes de ton sexe qui se permettent le luxe d'un physique *surnaturel* . . . finissent par des maladies dont le moins horrible est la *danse de Saint-Guy* . . . en attendant qu'elles fassent de la paralysie générale" (medically speaking, persons of your sex who allow themselves the luxury of a supernatural constitution . . . wind up with

illnesses the least of which is Saint-Vitus's dance . . . before they finish
in total paralysis).[35] This, of course, is a diagnosis of hysteria. In fact,
Eliante exhibits many hysterical symptoms: she claims to be the
incarnation of Eros ("On a chaud comme cela quand on est *L'Amour*"
[One is that hot when one is *Love*] [159]); she is both "chaste et passion-
née" (129); pain and pleasure are intermingled in her "divinity": she is
"le fond de la douleur et le fond du plaisir" (the essence of pleasure
and pain) (175–76); certain postures evoke the specific contortions of
hysterics ("Eliante . . . se tendit comme un arc de la nuque aux talons"
[Eliante . . . stretched out like an arc from neck to heels] [32]): this is
called "l'arc en cercle" by psychiatrists). She even experiences the erotic
excitation in satin in the way Clérambault's patients do: "Je crois que
[j'aime en toi] ce satin blanc; mes ongles à le toucher frémissent comme
à toucher le fil de mes couteaux" (I think I love [in you] this white satin;
my fingernails shiver when I touch it just as they do when I touch the
blade of my knives) (156). But, above all, it is the revulsion she feels for
the sexual act between man and woman and the resultant choice of a
decorative object with which to replace the male that aligns Rachilde's
character with the above case studies.

> 'Ce vase miraculeux est pâle de la volupté d'être lui-même.' . . . La jeune
> femme, l'oeil mi-clos, s'attacha davantage au col de l'amphore. Elle
> pressa ses deux bras autour du bourrelet de cette chair de pierre, s'inclina
> sur l'ouverture en corolle, baissant le vide: . . . 'Je voulais vous mener ici
> pour vous prouver que je n'ai pas besoin du caresse humain pour arriver
> au spasme. . . . J'ai le dégoût de l'union qui détruit ma force. . . . Pour
> que ma chair s'émeuve et conçoive *l'infini du plaisir*, je n'ai pas besoin de
> chercher un sexe à l'objet de mon amour!. . . . Une flamme? C'est trop
> peu pour celle qui est la fournaise' . . . elle se donnait au vase d'albâtre,
> . . . un léger frisson courut le long de son corps . . . et elle eut un petit râle
> de joie imperceptible, le souffle même du spasme. . . .
> Il fut ébloui, ravi, indigné.
> —C'est scandaleux! Là . . . devant moi . . . sans moi? Non! c'est abom-
> inable! (28–33; emphasis mine)

> ["This miraculous vase is pale with the voluptuousness of being itself."
> . . . The young woman, eyes half-closed, pressed herself closer to the
> neck of the amphora. She hugged her two arms around the bulge at the
> mouth of this flesh of stone, leaned over the opening in the form of
> corolla, kissing the void: . . . "I wanted to bring you here to prove to you

that I have no need of human caresses to come to orgasm. . . . The sort of union that destroys my strength disgusts me. . . . For my flesh to thrill and for it to conceive *infinite pleasure*, I don't need to look for a gender or a sexual organ as the object of my love! . . . A flame? That is too little for she who is the furnace" . . . she gave herself to the alabaster vase, . . . a slight shiver ran along her body . . . and she let out an imperceptible little groan of joy, the very breath of the orgasmic spasm. . . .

He was dazzled, enraptured, indignant.

"This is scandalous! There. . . in front of me . . . without me? No, it's abominable!"]

This communion with a vase allows Eliante to be "heureuse toute seule . . . les cuisses jointes hermétiquement" (happy all by herself . . . her thighs hermetically joined) (176). The amphora, too, is "adorably chaste" in its "virginal lines," at the same time as its self-reflexive nature is underlined in the Mallarméan "pale with the voluptuousness of being itself." Similarly, Clérambault notes that phantasy and dream are usually absent from masturbation with fabric, because decorative fabric appears to "act by its intrinsic qualities" (699). It is thus synesthetic. The latter would include not only its tactile qualities, but also the sound it makes and its shimmer (indeed, the sound is a kind of "brightness" akin to the luminosity observed in the decorative arts). But I will return to the identification of sexual perversion with ornament, predicated on the latter's self-sufficiency. Before Eliante's suitor understands the particular *manner* in which she is an art lover, he admiringly reflects on her "sens artistique très développé" (30).

Clérambault, too, notes the proximity of the "erotic passion for fabrics" to a highly developed artistic sensibility. "Elective tactile hyperesthesia is only a pathological fact here by its intensity, for it is normally encountered . . . in nearly all refined individuals, *one might even say that it is a component of artistic sensitivity*" (*Oeuvre*, 697). There is reason to believe that decadent refinement of taste—for ornament in particular— leads logically to narcissism, perversion, and madness. The tactile qualities of the fabrics in question are "subtle, complicated, innumerable, for a refined epidermis; they are certainly duplicated by aesthetic qualities of a wider class" (699).

Here, in fact, is one of the most dramatic aspects of the culmination of the function of ornament in the nineteenth century: the intersection it establishes between extreme refinement and regression to very primitive drives. Ornament, in the nineteenth century, is the intersection of

an excessively refined aesthetic taste and a regression to the chaos of unstructured reality, such as one finds represented in the grotesque, in the sublime, or in hysteria.

Rachilde's first novel, *Monsieur Vénus*, was defined by Rachilde herself as "the most marvelous product of hysteria having reached the paroxysm of chastity in a depraved milieu." Ten years before the action of the novel begins, a doctor had diagnosed the heroine, Raoule de Vénérande, as "un cas spécial. . . . Elle ne connaît pas le vice, mais elle l'invente!" (a special case. . . . She doesn't know what vice is, but she invents it).[36] What is dangerous is not the actual commission of vice, but the overwrought imagination that hysterical personalities exhibit. Maurice Barrès, in the preface to the first edition of the novel, writes that *Monsieur Vénus* "signals, in women, one of the most interesting forms [of the century's malady] . . . an excessive nervous fatigue and . . . an arrogance up until then unheard of." In fact, Rachilde is of interest to us because of her willingness to commit to paper the hyperbolic— even impossible—perverse phantasies that a woman of the fin de siècle was allowed only under the guise of hysteria. Barrès goes on to remark that certain of these temperaments dream of "an asexual being" (and these imaginations "smell of death"). The novel is a "very meaningful symptom," and rightly so, he concludes, for modern critics (of the 1880s) have substituted in the place of a literary curiosity a pathological one. With these observations in mind, I think one can safely extrapolate from the text certain psychological symptoms. The first would be to propose that the asexual being who, for Rachilde (and others), is to be the object of sexual desire is not so much Jacques Silvert, but this person *transformed into a decorative object*. (The scandal of this project resides, of course, in the reversal of tradition: it is the woman who is meant to be "the ornament of the court," as, for example, in *La Princesse de Clèves*.)

The first appearance of Jacques (soon to become Monsieur Vénus) is already a vision of a being inseparably intertwined with ornamentation. "Autour de son torse, sur la blouse flottante, courait en spirale une guirlande de roses, des roses fort larges *de satin chair* velouté de grenat, *qui lui passaient entre les jambes*, filaient jusqu'aux épaules et venaient s'enrouler au col" (Around his torso, on the flowing blouse, a garland of roses spiraled up, quite large roses of *flesh-colored satin and velvety red, that passed between his legs*, went up to his shoulders and then curled around his neck) (24; emphasis mine). It is significant that what Jacques has between his legs is "mere (if extravagantly developed) decoration,"

and the rest of the novel will make this abundantly clear. Jacques and Raoule's love is to be consummated never in the usual way, but rather in forms that will allow Raoule to assume the male role. The first thing she does to effect the metamorphosis of the decorator and painter of ornamental flowers into a god of love is to surround him with a more refined ornamental decor. "Ainsi, on le mettait chez lui, avec des pinceaux, des couleurs, des tapis, . . . du velours, beaucoup de dorures, beaucoup de dentelles" (Thus, she set him up in an apartment, with brushes, paints, carpets, . . . velvet, a lot of gilt, a lot of lace) (46). The antique clock "spreads vice," as the figures adorning it assume lascivious poses (49). This strategy does not fail to exercise its power over the Subject's desire:

> Depuis une minute, il avait le corps tout chatouillé par le désir de la soie. . . . Il se vautra, baissant les houpes et les capitons, serrant le dossier, frottant son front contre les coussins, suivant de l'index leur dessins arabes, fou d'une folie de fiancée en présence de son trousseau de femme, léchant jusqu'aux roulettes, à travers les franges multicolores. (50)

> [For the last minute, his body was being excited by the desire for silk. . . . He lolled around, kissing the tassels and padded silk, squeezing the back of the couch, rubbing his forehead against the cushions, following their Arabic designs with his index finger, mad with the madness of the fiancée in the presence of her trousseau, licking everything down to the casters between the multicolored fringes.]

(I have emphasized the decorative alliteration to bring out the sounds *f* and *s* that might be heard to reproduce the *FroiSSement*, or rumpling, of silk.) A critic writing on Gustav Klimt states that his ornament is "wanton, where it is not positively perverse."[37] In France, J. F. Raffaelli railed against "the spread of sodomy encouraged by Liberty fabrics."[38] Let us recall Adolf Loos's view that in addition to ornament's primitive nature, "all art is erotic [ornament being the source of art] . . . but the man of this century who feels the urge to cover walls with erotic symbols is a criminal or a degenerate" (Loos, *Ornament*, 100). Rachilde's text goes far to lending credibility to these pronouncements. The presence in this decor of "furniture with twisted legs" is mirrored by the frequent appearance of the words *tordre and tordu* to describe Raoule and Jacques. Raoule wears a "chignon tordu . . . vêtue d'un fourreau de drap noir à queue tortueuse" (twisted chignon . . . dressed in a black fur with a tortuous tail) (51), and she feverishly awaits the moment when

she will make him her master and "il tordra mon âme sous son corps" (he'll twist my soul under his body) (56). Jacques "se tordait, câlin, dans les bras de Raoule" (twisted, cajoling, in Raoule's arms) (195). But the verb is most often the expression of the masochistic pleasure Jacques obtains from his lover.

> Raoule l'embrassait sur ses cheveux d'or fins comme des effilures de gaze, voulant lui insuffler sa passion monstre à travers le crâne. Ses lèvres impérieuses lui firent courber la tête en avant, et derrière la nuque elle le mordit à pleine bouche. . . . Jacques se tordit avec un cri d'amoureuse douleur. (101)

> [Raoule kissed him on his hair of fine gold resembling unraveled threads of gauze, wanting to breathe her monstrous passion in through the cranium. Her imperious lips forced him to bend his head forward, and behind the neck she bit him hard. . . . Jacques writhed, contorted with a cry of loving pain.]

In a sadistic scene of truly grotesque proportions—the sort of scene one finds in nearly every novel of the Decadence—Raoule tears off the bandages with which she has just lovingly wrapped the wounds inflicted upon Jacques by a merciless beating applied by her other lover, de Raittolbe: "Elle mordit ses chairs marbrées, . . . les égratigna de ses ongles affilés. . . . Jacques se tordait, perdant son sang par de véritables entailles que Raoule ouvrait davantage avec un raffinement de sadique plaisir . . . sur des membres tordus" (She bit the marbled flesh, . . . scratched it with her pointed nails. . . . Jacques twisted, bleeding from the gashes that Raoule was opening up with a refinement of sadistic pleasure . . . on his twisted members) (145). Thus, Jacques is "sa chose, une sorte d'être inerte qui se laissait aimer" (her thing, a sort of inert being who let himself be made love to). The role of ornament in making him into such a love object is far from negligible. The decor sets off the decorative qualities of Jacques's person: "Le lit aux brocatelles soyeuses garnies de guipures de Venise. Sa tête ébouriffée reposait dans la batiste fine . . . et son bras rond . . . ressortait comme un beau marbre le long de la courtine de satin" (The bed with its silky brocade embellished with Venetian lace. His ruffled head rested in the fine batiste . . . and his round arm . . . was outlined like a beautiful marble along the satin curtain) (111). Jacques is constantly metaphorized as a statue or as other decorative objects: "Elle forçait Jacques à se rouler dans son bonheur comme une perle dans sa nacre" (She forced Jacques to roll up in his

happiness like a pearl in its mother-of-pearl) (108). In the bridal cham-
ber, the decor is "magical" and a "subtle, incomprehensible vertigo"
emanates from it (191). A three-page description of decorative objects is
dominated by a statue of Eros and a bust of Antinoüs. Desire is in-
scribed in the most decorative material of the bust: "Des yeux d'émail
luisants de désirs" (Enamel eyes glittering with desire) (83).[39] The rela-
tionship between ornament and desire is reciprocal: "Il ne faut pas quit-
ter ce temple de longtemps, pour que notre amour pénètre chaque objet,
chaque étoffe, chaque ornement de caresses folles" (We must not leave
this temple for a long time, so that our love can penetrate each object,
each fabric, each ornament, with mad caresses) (194).

Raoule has constructed this decorative fantasy not only out of her
sexual needs, but also out of her artistic vision; for she is a painter. "Je
représente ici . . . l'élite des femmes de notre époque. Un échantillon du
féminin artiste et du féminin grande dame . . . nous désirons l'impossi-
ble, tant vous nous aimez mal" (I represent here . . . the elite of women
of our period. A specimen of the feminine as artist and as grande dame
. . . we crave the impossible, you love us / make love to us so poorly)
(86). She propounds the following philosophy: "Il serait permis d'être
vicieux, en devenant créateur. . . . Moi, si je créais une dépravation nou-
velle, je serais prêtresse" (Being corrupt would be permitted if it were
creative. . . . If *I* created a new depravation, I would be a priestess) (87).
Her work of art is, simply, Monsieur Vénus, Jacques, "dont le corps
était un poème" (whose body was a poem) (139). Clearly, the new depra-
vation in question is the creation of Monsieur Vénus, a new species,
neither male nor female, but a kind of living ornament.

Just as she did with Jacques's surroundings, Raoule makes of him a
more refined, exquisite decorative object. In the beginning, "Cette
femme l'avait tiré de ses gerbes de fleurs fausses, comme on tire des
fleurs vraies l'insecte curieux qu'on veut poser, *en joyau, sur une parure*"
(This woman had plucked him off of his artificial flowers, as one plucks
off of real flowers the curious insect that one wishes to place, *as a jewel,
on an ornament*) (57; emphasis mine). Later in the novel, Jacques is seen
executing ornamental initials on letter paper. At the same time, his
body has become a field for the inscription of Raoule's decorative de-
signs scratched with her nails and teeth. At the end of the novel, after
de Raittolbe has killed Jacques in a duel, Raoule makes an effigy of her
lover, artistically inlaying the actual hair, nails, and teeth removed from
his body. Placed in a room that is "entirely blue without a cloud"—that
is, in the ether of the Absolute where she first situated her desire for the

impossible—the wax dummy receives nocturnal visits from Raoule, dressed sometimes as a woman, sometimes as a man. A clever mechanical device allows the lips to respond to her passionate kisses, and the artisanry of his enamel eyes lends them a lifelike character: "Les yeux en émail ont un adorable regard" (The enamel eyes have an adorable gaze). Her "story"—"mon récit ne peut pas être fait d'une manière raisonnable" (my narration can't be told in a rational manner) (84)—is complete, and it cannot be better described than to call it writing as a sadomasochistic pathology of ornament.

The convergence in the period of the fascination with hysteria and of the importance of the decorative produces a new model for desire: the body perceived as decorative object and as mute language of perversion (fig. 26).[40]

An article in *La Revue des Arts Décoratifs* on furniture composed of twisted wood bespeaks the fascination the form held for the fin de siècle (fig. 27).[41] Might we see all of these "meubles à pieds tordus" along with the accompanying whiplash line in stairways, wallpaper, and so on, as an unconscious figuration of contorted body language? This twisting movement is the essence of Art Nouveau design, just as it is used to epitomize pleasure through pain. In fact, the etymology of *torture* is from Vulgar Latin *tortura*, the action of twisting, *tordre*. The eruption of hysteria in the body is an attempt to express and exorcize fears, but perhaps also to exhibit and glorify pain and "ugliness." In its will to express an unnameable desire, the body breaks the bounds assigned to it, and its life force contorts and extends to fill the space around it, exhibiting the inside (the psyche) on the outside. An analogy with Art Nouveau architecture's contortionist twisting of space readily comes to mind. The inside (nerves, organic growth, cellular expansion) is now on the outside in wood, walls, ironwork, and so on, providing a mirror for the psyche and for the drives within (fig. 28).[42]

The expressivity of line has been described perhaps most passionately by the great Belgian Art Nouveau architect and decorator Henry van de Velde. There is an energy that "emanates from *inside* the form," and this energy is made perceptible by the various tensions in the line. These tensions also indicate the places where ornament is meant to spring forth. Ornament, conceived thus, is the *prolongation* of form, and its function is to "structure" form, not to "embellish" it. Ornament is "the image of the play of internal forces";[43] it renders the internal logic of the form visible. In addition, the line borrows its force from "the energy of he who traced it" ("Die Lignie," 63); the expressivity of line is

Les légendes du dessin :

POINTILLISME TACHISME SERPENTINISME SYMBOLISME

— Pourquoi prenez-vous, charmante miss?

— J'avais commandé mon portrait à quatre modernistes; le premier m'a représentée comme de la retombée selon comme à prames, le troisième toute que et le quatrième toquée — et c'est ce qui pourrait.

26. H. Avelot, "A Travers les Quat'-z-arts," 1896. The third style depicted, "Serpentinism," is "hysterical."

27. Barreau and Croisé, wood 28. Victor Horta, Tassel House stairway,
table in *simili-courbes*, 1880. detail, Brussels, 1892–93.

therefore an exteriorizing of the Subject's psychic energy. Because of
this ability to exhibit the inside on the outside, "line speaks louder than
the written word" (71).

 In this passage, van de Velde calls upon the characteristics I discussed
in Huysmans's *Là-Bas* and in Rachilde.

> Byzantine Line: one has manifestly done violence to it, caught in the vice of a hieratic order that protects it badly, however, against the advances of a lasciviousness that makes it burn with desire . . . in one direction, frozen, icy and sterile straight lines, and in another, the flamboyant curves of unleashed passion. ("Die Lignie," 73)

Byzantium was, of course, the most envied and emulated period of the past by Decadent writers and artists. Van de Velde's analysis shows one reason that was so: replace the word *Byzantine* with *hysterical* and you have a precise description of the latter.

We have moved from ornament as tortuous, sinuous form in Nerval and Gautier to ornament as torturing in Huysmans, Rachilde, and hysteria. The arranger or inscriber of ornament (such as Raoule de Vénérande and Gilles de Rais) is not always required for inflicting pain: ornament alone can be sufficiently "torturing," thanks to the degree of one's overt psychological investment in it.[44] The self-sufficiency of the Subject in obtaining jouissance, and the substitution of ornament for the human partner (in Clérambault and Rachilde, but already suggested in Gautier), forms the logical conclusion to the evolution I have traced of ornament's relation to desire in the nineteenth century. The focus on the sadomasochistic interaction of the Subject with the Object as ornament allows for a certain titillation in Huysmans and Rachilde, but one that is devoid of any psychic energy due to the foregrounding of ornament and the Subject's control over the latter. That is why Rachilde's eroticism is cerebral and her sensuality factitious, despite the Byzantine decors.[45]

But let us recall the passages from Paul Souriau quoted in the Introduction. The intermingling and confusion of artifice and reality in decorative patterns and objects had long been encouraged in the century. And the dangers inherent in this form of perceptual play were also apparent. In his chapter on decorative art, Paul Souriau states that in the very principle of decoration with figures, he finds "something irrational and like a slight fissure, which is decidedly very characteristic of this art" (*L'Imagination*, 22–23). "What a lot of monsters, of chimera, of fantastic forms! . . . a set purpose of caprice, of paradox, of the improbable. . . . Certainly, this art is not the product of pure reason" (22). The decorator's love of paradox includes the varieties of trompe l'oeil I have analyzed here. "When one pays attention, the impression can become troubling. . . . Where does its strange charm come from? What is this *fancy that haunts our homes, leaving on every object that surrounds*

us the imprint of its caprice?" (26; emphasis mine). Souriau, a reader of psychiatric studies, is aware that one can move from a "voluntary play of illusion," such as the illusions he described in *La Suggestion dans l'art,* to "true hallucinations [that] transform the very principles of vision."[46] Art and literature of the period offer stark examples: Ensor's skeletal self-portraits emanating from the wood grain of dining-room furniture; Maupassant's antique wardrobe in "La Chevelure" which seduces, troubles, and invades the Subject's mind "like a woman's face." Clérambault, who owned twenty thousand photographs of exotic draperies and was the only psychiatrist to have studied at the Ecole des Arts Décoratifs and to teach a course on drapery at the Beaux Arts, committed suicide in what was thought to be an attack of neurasthenia. There is, in all of these phenomena, a risky pleasure and a vague but palpable danger that Souriau writes around. These are the dangers I outlined in the Introduction; only now, they are specifically aligned with madness.[47]

Throughout the nineteenth century, ornament's ability to intermingle mimesis and fantasy had intrigued writers. In the Romantic writers analyzed here, the mix represented the interplay between reality and subjective phantasy. But in the fin de siècle, the status of reality was put into question in a different and more radical way than it had been in French Romanticism. The Schopenhauerian idea of the world as *appearance* and idea (the visible world a transitory and "unsubstantial semblance, comparable to the *optical illusion* and the dream"), embraced by French writers long after the philosopher's death, bequeathed on ornament a new status: that of uniquely stressing the factitious (for example, in trompe l'oeil designs). The "lies" or "chimerical delights" that were "like real ones" (Souriau, *La Suggestion,* 51) evoked not only evanescence of vision and of desire, but also of the world itself. This view was widespread and formed the basis of contemporary psychology, for example, the notion that the only authority for determining reality is immediate experience and that physical objects are only complexes of sensation.

I have returned several times to different ways of producing a verbal trompe l'oeil effect similar to those effects used in the decorative arts. Nerval's labyrinthine patterns of lace and legerdemain, Gautier's evil eye, Mallarmé's Arcimboldo effects, the metamorphosis of the beautiful into the repulsive, and the use of metaphor in Huysmans: all are forms of trompe l'oeil. One might see transvestism in Rachilde as trompe l'oeil as well. Paul Souriau (who discussed metaphor as a

trompe l'oeil) makes the point that the decorative object itself—any decorative object—provides the occasion for the *dessin à double jeu* effect. When we gaze at the decoration, the object disappears, but when we concentrate on the object, the figures flatten out. The exploration of ambiguity, and in a larger sense, of the problems of perception, has proven to be central to both the decorative arts and to the texts studied here. As I have shown, nineteenth-century ornament became more and more the forum for these problems. Ornament, in ways paralleling contemporary psychology and philosophy, moved ever farther from perceptual certainties and thus, subjective stability, toward a Schopenhauerian "I don't see what is; what is, is what I see."[48] Schopenhauer's comparison of the world to an optical illusion lends a graver note to the period's obsessional interest in trompe l'oeil (Mallarmé and Huysmans were readers of the philosopher). In this book I have underscored the seriousness of trompe l'oeil in describing the metaphysical and psychoanalytic resonances of decorative techniques.

We have nonetheless witnessed a contrast in the use of these phenomena. In Nerval's interlace, one moved simultaneously toward the thing itself (*ad rem*) and toward absence (*ad rien*). In his arabesque, we saw a double movement toward death and self-realization. In Mallarmé, the object both appeared and disappeared in the same design. Gautier's use of these designs is, on the other hand, at the source of Decadent syntax, an effort to cheat absence by having proliferating ornamentation invade the void. Nevertheless, death reemerges at the center of this composition in *Jettatura*.

There is a concurrent distinction in the *function* of ornament and the effect sought on the reader. At the end of *La Suggestion dans l'art*, Paul Souriau calls on writers and artists to take their "moral responsibility" seriously and to use the power of suggestion (self-hypnosis), fascination, and ambiguity not to "deconcert the soul," but to move it in a noble way; "not to fill the soul with the hallucinations of troubling and feverish dreams, but to elevate it toward the ideal" (314). The second function of ornament would be that embraced by Symbolism, whereas the first would be that seized upon by the writers I have studied in this chapter.

❧ CONCLUSION ❧

Les engins primitifs délaissés comme utilitaires, sont recherchés par nous modernes comme décoratifs.—Maurice Griveau

L'art doit se montrer lui-même, en même temps qu'il fait voir la nature. Il n'est pas un miroir.—Bracquemond

The qualities of ornament that I have brought out implicate the reader in the process of discovery of form, migrating (as Norman Bryson puts it) from the (writer's) moment of founding perception to the moment of reception.[1] Each chapter in this book has evoked a new way in which the reader is propelled to re-create the ornamental structure of the text. One's perception of the "total arabesque" or of the arrangement of the elements in the text is the moment when one seizes the textual means of production, the crafting of the text. That is why ornament is so often an aspect of the self-reflexive text.

How does the question of self-reflexivity relate to the notion of "pure art" in ornamental objects? What is their place in the field of desire as it is expressed in ornament?

Aesthetics was a new branch of philosophy in nineteenth-century France, and Victor Cousin was the first to explore and popularize the idea that ideal form could be expressive. The assimilation of pure form into ornament and their link to expressivity are clearly formulated by Maurice Denis at the century's end. "I think that above all else a painting *should be an ornament*. The choice of subjects for scenes means nothing. It is through colored surfaces, through the . . . harmony of lines, that I attempt to reach the mind and *arouse the emotions*" (cited in Gombrich, *Order*, 58; emphases mine). For ideal form to be perceived as expressive, the mimetic must be devalued. At the same time, artisanry, as a focus on the means of production, was elevated. However, as I have also noted (see chaps. 2 and 3), the crafts tradition in France was in decline from around 1840. As Gombrich remarks, "Decoration caused a malaise in the 19th Century; this malaise was rooted in the decline of the crafts tradition and led to reflections on the nature of decoration" (Gombrich, *Order*, 180). Thus, at the same time as it was being elevated

as an aesthetic ideal, artisanry was disappearing in France. This allowed
ornament to become part of the topos of loss that characterizes Roman-
ticism, and to become especially important to writers like Nerval and
Gautier. Moreover, in addition to their journalistic writing on orna-
ment, these writers attempted to recover techniques of craftsmanship in
literary texts that self-consciously highlighted their own means of pro-
duction. Thus, the move to self-reflexivity in the nineteenth century is
tied to ornament for not only formal but also sociological and meta-
physical reasons.

Nonetheless, at the same time as ornament in literature is tied to an
attempt to recover or conserve traditions, wherever we see radical inno-
vation and palpable shifts of direction in French literature of the period,
we see writers using techniques and composition theorized and applied
in the decorative arts (for example, the focus on the means of produc-
tion, the valorizing of arrangement over subject, the tension between
frame and tableau, trompe l'oeil patterns that play with figure and
ground, and the "hysterical syntax" of horror vacui). Thus, ornament
looks both to the past and to the future.

Ornament's tendency is to abstraction and not to mimesis. The
moment that natural forms become the property of a work of art, they
acquire an entirely new set of values. For most people, this foreign
quality (foreign to nature) is not easily accepted, and they are "always
tempted to look for another meaning in form" (Focillon, *Vie des formes*,
4). But, as Henri Focillon points out, "The sign signifies, whereas form
signifies itself" (ibid.). Gautier reminded readers in 1847 of his 1834 for-
mulations on *l'art pour l'art*: "Art for art signifies . . . a work freed from
all considerations other than that of beauty in itself."[2] Gautier was
speaking here of art in general, but, as we have seen, he believed that
ornament was the most propitious field for the realization of this pro-
gram. The shift from content to form was a factor in distinguishing the
decorative arts from the fine arts from around 1850. At that time it was
decided that the "direct imitation of Nature, of natural appearances,
[was] proper to the Fine Arts and [was] a 'vice' in decoration" (Gom-
brich, *Order*, 37, citing Ralph Wornum). This "restriction" in fact led to
greater freedom and modernity for the decorative arts.

Even when it is simply charged with embellishing a naturalistic rep-
resentation, ornament often overwhelms the subject and imposes itself
on the viewer/reader at the expense of naturalistic content. "Poetic form
in our modern age," writes Eugene Vinaver, "proclaims its own autono-
mous value . . . and this insurrection can be traced at least as far back as

Victor Hugo."[3] Quoting Jean Gaudon, he writes: "From a certain moment of lyrical exaltation, decoration having become its own raison d'être . . . imposes a new mode of structuration. It becomes aggression against that which it had the task of embellishing . . . useless proliferation. . . . It is this gigantic paradox: an artifice that introduces into art the only true naturalism" (ibid.). This is the idea of chaos I explored in Schlegel's and Nerval's arabesque.

Abstract ornament, in the complications of its proliferating lines, can represent nature more truthfully than naturalistic representations. It can also, as we have seen, represent the world of subjective phantasy as no other art form can. It appears in texts as an "impulsive scrawl and profoundly significant" (Gautier, "Du Beau dans l'art"). "Art is a desire!" (Gautier, "Salon of 1844"). Thus, it is called upon by Nerval, Nodier, Gautier, Hoffmann, and Poe to evoke the fantastic, the marvelous, and unconscious desire.

I have continually tried to show why ornamental figures are able to express desire where verbal constructs cannot. J.-F. Lyotard, in his brilliant and ground-breaking study *Discours, Figure*, wrote that the figural is an event that "erupts" in our awareness like the forms of primary-process thinking (condensation, displacement, and representation in visual images). "The event cannot be posited elsewhere than in the vacant space opened up by desire. Desire is truly unacceptable, one cannot pretend to accept it, to accept it is still to reject it, it will surge up elsewhere."[4] The event—the disruptive event of the unconscious—cannot be removed from the empty space left by repression. This is why ornament, circumscribing and defining the void, itself situated in the "empty space" of peripheral perception (Souriau, Ehrenzweig), is most apt to figure desire. In the first case (circumscription of the void), ornamental patterns are a symbol of unconscious desire that is characterized by lack. However, once the unconscious event is accepted (as we saw in Rachilde, for example), it is automatically removed from this position. Ornament, in becoming the conscious expression of desire, loses the capacity to represent it. Thus it obfuscates or eradicates the void (as in designs of horror vacui) in a de-cadence or loss of rhythmic cadence of ornament and void. When the unconscious desire is "accepted" and foregrounded as it was in "Omphale," *Là-Bas, Monsieur Venus*, and *La Jongleuse*, not only is ornament self-reflexive in the sense that it is a metaphor for the text, but, as fetish, it is a narcissistic reflection of the Subject. Fin de siècle collectors of bibelots are fond of "the art object in which they can recognize the admirable complexities and contortions of

their mind" (Van de Velde, *Formules*, 13). The object is no longer char-
acterized by lack and elusiveness. The loss of this quality—so seductive
in ornament because of its stimulating effect on the imagination—is
also responsible for the failure of the decorative object become Object
of desire to seduce the reader. Thus, when ornament is omnipresent, as
it is in the fin de siècle, it loses its power to represent desire in the
subterranean ways I have studied here.

Ornament, in its abstraction, stimulates and encourages both fantasy
and subjective phantasy. The Subject projects fantasies onto the object,
or introjects those images or patterns into psychic life. In both cases, the
decorative object is "used" as a means of enriching, deepening, or work-
ing through unconscious phantasies. Ornament moves outside itself, as
it allows the Subject to move inside the self through the mediation of
an object that exists in the outside world. Decorative pattern can func-
tion both projectively and introjectively. Because fin de siècle ornament
is (as Adolf Loos put it) "tortured, laboriously extracted and *pathologi-
cal*" (emphasis mine), the person who uses it in the second mode can
only be led to mime and incorporate these characteristics. The question
of *choice*, of voluntary illusion over a loss of control in the face of illu-
sionism, is central to the evolution of ornament's role in the nineteenth-
century Imaginary. The large place that ornament occupies in the latter
becomes troubling only when the Subject is no longer the manipulator
of ornament, but its victim. Illusion becomes delusion. Just as the
Imaginary and illusion are needed to construct the Real (we analyzed
this idea in Winnicott as well as in Lacan), so can they also come to
destroy the Subject's ties to the outside world.

Gautier's use of ornament was pathological in a different way. The
Object was placed *entirely* under the Subject's control as a fetish that
could be manipulated at will, and as an *oeuvre d'art* (namely, the text or
the drawing of the narrator). Ornament detaches itself from the Object
and entirely replaces it. Thus, Gautier bypassed the need for a sexual
partner in a way similar to Clérambault's patients and Rachilde's hero-
ines. The substitution of ornament for the human partner forms the
logical conclusion to the evolution I have traced of ornament's role in
desire in the nineteenth century. Self-reflexive ornament can stimulate
a self-reflexive, masturbatory desire. The charm of ornament is the
charm of the self-contained object—the "useless" bibelot—that, in its
perfection and self-sufficiency, radically excludes us. The Subject of the
fin de siècle is determined to control that object and make it a fetish.[5]
Thus the Object is dehumanized.[6] In Mallarmé, the erotic was also

located in purely self-reflexive ornamental objects. However, these objects defied attempts at mastery, eluding the Subject's control (the Subject here represented by the reader, not the writer, as in Gautier's stories). Thus, the Object of desire never lent itself to fetishizing. For Mallarmé, the bond between desire and self-reflexivity resides in the elusiveness of the auto-reflexive ornamental object.

Gautier's *femme-tapisserie* and *femme-cafetière* will become the *femme-fleur* of Art Nouveau. But Gautier's women transformed into decorative objects remained resolutely implanted, not in nature, but in a universe of artifice (as befits a fetish). A goal of Romanticism was to animate the inanimate. This desire is trivialized in "Omphale," and in the Decadence the animation of inanimate art objects is accompanied by a desire to make the animate inanimate: real flowers imitate artificial flowers and Monsieur Vénus becomes a wax dummy. Life imitates art. The decorative, as we saw, can be a source of creative power or of decomposition and disease.

Yet, even in the most acute instances of a hysterical need to master and control the outside, the Other, one senses that the Subject is using ornament to seek answers to the most profound enigmas. In the chaos of ornamental pattern, in the chaos of the Subject's cultivation of, and abandonment to, hysteria, there is a contact with the Real that otherwise eludes the self. Out of this chaos emerges not only a new image of literature, but a new image of the Subject—images of extreme refinement and of regression to a very primitive state of being—and therein lies the two-pronged modernity of the ornamental text.[7]

Appendix

PRÉCIS OF NERVAL'S *SYLVIE*

The novella begins and ends in a theater. The decor is deeply signifi-cant, for there the hero is both actor and spectator, and this sort of doubling is the text's most prominent feature. The self-reflexive, ironic regard the narrator casts on himself as hero allows Nerval to complicate what might otherwise appear as a straightforward account of the hero's mature acceptance of "reality." The writer's manipulation of the various layers of the temporal schema also renders the plot far more complex than the simple series of events related in this précis would initially indicate.

The hero/narrator attends the same theater each night in order to enter into an imaginary communion with the actress, Aurélie. She re-mains an ideal whom he admires from afar. One evening, an announce-ment in the newspaper brings back the memory of the *fête de l'arc*, an annual celebration in the village where he was raised. He returns home where, in a state of half-wakefulness, a scene from childhood appears vividly before him: he is participating in a round dance with the village children and the young aristocrat, Adrienne. At one point, they are in the middle of the circle together, and they exchange a kiss. Adrienne must sing in order to rejoin the dance. After her song, the young hero offers her a braided crown of laurels. She becomes the model for his Ideal and for his desire; soon afterward, she is sent to a convent. Star-tled out of his revery by the awareness that Adrienne is the model for his desire for Aurélie, the hero realizes that the two uncannily resemble each other, and this thought seems to him dangerously close to mad-ness. "What if the actress and the nun were the same?" he asks. He also remembers the little village girl, Sylvie, who until the round dance had been the object of his affections, and he impulsively hires a carriage to take him to the *fête*. In the four hours it takes to travel from Paris to Loisy, he relives four memories from his youth in the Valois, each

taking a chapter to recount. In the first, he manages to win back Sylvie's love by offering her a crown of garlands at the *fête*. The next chapter involves the hero's "visit" to the convent walls behind which Adrienne is hidden, and his arrival at the village where Sylvie, now a lace maker, lives. The third memory is of the two fifteen-year-olds dressing up in the wedding clothes of Sylvie's aunt and uncle and celebrating a mock marriage to the delight of the old aunt. The last memory is of a mystery play where Adrienne plays the role of a Spirit commanding a panoply of angels. The hero/narrator is so affected by the intensity of this vision that he is unable to determine whether it is based on reality or whether he has dreamed it. "Fortunately," he arrives at Loisy at this very moment, at dawn, just as the *fête* is ending. The next five chapters trace the realization that the childhood paradise is lost. As the hero revisits the same places that formed the decor for the five scenes of childhood and adolescence, he finds nothing but absence and loss. Sylvie no longer makes lace or sings the old songs, and she plans to marry the hero's *frère-de-lait*. He returns to Paris, leaves a note and bouquet presenting himself to the actress, then leaves for Germany. Upon his return, he offers Aurélie a play he has written based (on a symbolic level) on his love for Adrienne. She accepts the lead role, and they form a romantic liaison. During a tour, he brings Aurélie to the Valois and explains that his love for her has as its source his old love for Adrienne. This revelation abruptly ends the brief affair.

The last chapter of *Sylvie* is a last return to the Valois, where the hero visits Sylvie, her husband, and little children. It is only then, on attending a play starring Aurélie in Sylvie's company, that he learns that Adrienne has died in the convent.

"These are the chimeras that charm and lead one astray." This remains perhaps the most precise description of the novella's effect on the reader.

PRÉCIS OF GAUTIER'S *JETTATURA*

Paul d'Aspremont, a young French nobleman, debarks in Naples to rejoin his fiancée, Alicia Ward. A sudden illness had forced her to leave England for southern climes some months earlier. When Paul arrives at the Ward villa, he is greeted enthusiastically by Alicia and her uncle. But Alicia's newly recovered, rosy glow of health abruptly disappears under the hero's intense gaze.

The next day's visit to the villa introduces a new character, Count Altavilla, a Neapolitan dandy who is enamored of Alicia. After meeting his rival, he has a gigantic pair of bull's horns sent to the villa. The next day, in answer to Alicia's question, the count explains that the horns are protection against the *fascino* of a *jettatore*, the evil eye. A debate on superstition and science ensues, and Alicia's uncle demands to know who the supposed possessor of the *fascino* might be, but Altavilla politely refuses to pronounce the name.

In the meantime, Paul cannot help but notice that the Neapolitans respond to his presence with fear or suspicion. They make strange gestures and exclaim "Jettatore!" as he passes. At a bookseller's, he chances upon a treatise on the evil eye which reveals the answer. Staring at his reflection in the mirror, he suddenly comprehends the previously inexplicable incidents of his life: the drowning death of a school friend, the death by burning of a London ballerina, Alicia's illness, and other catastrophes. Now convinced that his gaze caused these events, he views himself as a monster.

Alicia tries to combat this idea in Paul, but in fact his gaze causes her to pale and cough blood. Her resolve to marry Paul renders her "radiantly, dangerously, beautiful." The count intervenes, forcing Paul to accept a duel. Paul insists on fighting blindfolded so as not to have an unfair advantage, but he still succeeds in killing his opponent. In despair, he resolves to put out his eyes, but before doing so goes to see Alicia one last time; then he returns to his hotel and blinds himself with a red-hot dagger. When he makes his way back to the villa, Alicia is dead. The novella ends when Paul hurls himself off the edge of a cliff into the stormy sea below.

Précis of Huysmans's *En Rade*

Jacques Marles and his wife, Louise, in serious financial difficulties, seek refuge from the problems of their Parisian existence in a château looked after by country cousins. Soon after their arrival in the crumbling, desolate château of Lourps, they discover how little hope there is of finding respite there. They are besieged by skin irritations, dampness, insects, the avarice of their cousins, rancid food, troubling dreams, Louise's attacks of hysteria, repulsive odors and sights, and an overwhelming sense of disintegration.

The setting offers Huysmans many opportunities to paint elaborately

detailed tableaux of the château and the surrounding vegetation, of farm life, and of the local villagers. In each of the couple's encounters with the above, the reader is made to feel their growing sense of despair and their alienation from this unwelcoming environment. Interspersed with these scenes are a series of dreams where Jacques's psyche tries to work out his anxieties and desires related to his life in the château. If the hero's encounters with nature involve decay, so do the dreams: from the erotic, idealized dream of Esther, to the dream of a frozen, barren, and hysterical moonscape, to the dream of the well/tower in the Church St. Sulpice where a beautiful young woman becomes a terrifying old whore, Jacques's psyche is caught in the downward spiral of decomposition.

At the novel's end, the mangy cat that Louise has adopted dies a horrible death whose spasmodic agonies resemble only too well Louise's attacks of hysteria. The couple return to Paris.

Notes

An Introduction to Ornament

1. This is how the *Petit Robert* defines ornament: "That which ornaments or *is added on* to an ensemble in order to embellish it or give it a certain character. . . . An *accessory* motif to a composition. . . . Manner of expression that embellishes discourse (figures of rhetoric, etc.)." (Emphases mine.) Except where noted, all translations in this book are my own. With rare exceptions, the French text is given for fictional or poetic texts only. The best-known indictment on moral grounds is the architect Adolf Loos's *Ornament und Verbrechen* (Ornament and crime) (1908) (see n. 50). His Viennese compatriot Karl Kraus waged a parallel campaign to restore the purity of written language by ridding it of all embellishment. I will discuss these attitudes as they manifested themselves in the nineteenth century.

2. The problem has received considerable attention in recent decades as it pertains to the hierarchy of tenor and vehicle in metaphor. Yet even in 1893, a French aesthetician saw that the reception of *figuré* and *propre* was simultaneous and formed a composite entity that could not be disjoined. What is more, he saw that the "figurative" and the "proper" meanings, in terms of their subjective importance, were capable of trading places. The image he chose to illustrate this phenomenon is one that came to my mind as well when studying Mallarmé's poetry: ornamental counterchanges (*ornements à double jeu*). There are good reasons that an ornamental pattern should best figure complex linguistic play, and each chapter of this book examines at least one of them. See Paul Souriau, *La Suggestion dans l'art* (Paris: Alcan, 1893 and 1909), 210–15.

3. Paul Gasnault makes the distinction thus: "Indeed, if the *ornament*, pure and simple, with its ingeniously varied combinations . . . can be self-sufficient, decoration, a more general and more complex term, supposes an ensemble in which the architectural or painted ornament is the indispensable accompaniment" ("Exposition de Tableaux anciens, de décoration et d'ornement au musée des arts décoratifs," *La Revue des Arts Décoratifs* 1 [1880–1881]). In Jules Bourgoin's *Théorie de l'Ornement* (Paris: Duchet et cie, 1883), the distinction is made on the basis of the primacy of certain elements in either ornament or decoration; in the former, they are order and form, whereas in the latter they are color and relief.

4. Théophile Gautier, "Manufactures nationales de Beauvais et des Gobelins, *La Presse* (10 September 1849); emphasis mine.

5. Félix Bracquemond, *Du Dessin et de la couleur* (Paris: Charpentier, 1885), 216.

6. Wilhelm Worringer, *Abstraction and Empathy: A Contribution to the Psychology of Style* (New York: International University Presses, 1953), Michael Bullock's translation of *Abstraktion und Einfühlung: Ein Beitrag zur Stilpsychologie* (Munich: R. Piper, 1908).

7. Félix Bracquemond, *Apropos des Manufactures nationales de céramique et de tapisserie* (Paris: Chamerot and Renouard, 1891), 12–13. Worringer, too, underlines the essential difference in the nature of ornament and the decorative: "Vischer . . . does not reach complete understanding [of the Byzantine style] because he gives to the word 'decorative' only the superficial interpretation we are accustomed to, and thus overlooks the deeper content of this artistic volition [*Kunstwollen*], which would be more fittingly designated 'ornamental' " (*Abstraction*, 100–101).

8. Gautier, "L'Imitation de Jésus-Christ," *L'Artiste* (28 February 1858). Philippe de Chennevières, director of Beaux Arts and founder of *La Revue des Arts Décoratifs*, remonstrated that "France, the first nation to recognize the necessity of the unity of the arts in 1851, is today the most recalcitrant!" (*La Revue* 1 [1880]). Both in 1873 and in 1883, Jules Bourgoin noted the tyranny of opinion that continued to "subordinate all the branches of art, whether theoretically, to the elevated doctrine of the fine arts, or practically, to the compromise of the vulgar . . . condition of so-called industrial art" (*Théorie*, 1). Henri Mayeux, the writer of the most widely read book on decorative composition, begins that book with the same observation. "One is often led to consider *decorative art* as occupying an inferior rung in the hierarchy of the beaux arts" (*La Composition décorative* [Paris, A. Quantin, 1884]).

9. Jules Ziegler, *Etudes céramiques: Recherches des principes du beau dans l'architecture, l'art céramique, et la forme en général* (Paris: Mathias, 1850). He writes, "In a profound and comparative study of the essential conditions of the two arts [literature and ceramics] . . . the laws of analogy that tie together the products of human creation must certainly appear" (25). At the publication of Ziegler's book, Gautier wrote that "the aesthetics of ceramics is practically unknown, and with the exception of a few pages we wrote some years ago in *La Revue de Paris*, and the very remarkable book of M. Ziegler . . . we've read nothing precise on this important subject" ("Porcelaine, Vitraux, Emaux, Tapis, Tapisseries," *La Presse*, 1 June 1850). Six years earlier, Gautier had written that "the potter's art entertains a relationship with music, in that the forms it takes have no model in nature" ("L'Exposition des Manufactures royales de Sévres, des Gobelins et de Beauvais," *La Revue de Paris*, 21 June 1844).

10. I explore this idea in chapter 2, much of which originally appeared in

the form of an article, "Dentelle: Métaphore du texte dans *Sylvie*," *Romanic Review* 73, no. 1 (January 1982), as well as in "*Sylvie:* Texte-dentelle (unpublished diss., University of California, Los Angeles, 1981). Naomi Schor asks the same question in her study of *Salammbô* in *Breaking the Chain: Women, Theory, and French Realist Fiction* (New York: Columbia University Press, 1985). Her recent book *Reading in Detail: Aesthetics and the Feminine* (New York and London: Methuen, 1987) engages some of the same questions as I do here. An elegant, eclectic, and sometimes brilliant book, it does not attempt to examine in a systematic way the concept of ornament, but rather concentrates on the notion of the detail (a different and broader aesthetic category) in various cultures, philosophies, and literatures. As the title indicates, the book's focus is on the relation of this sort of aesthetic category to the feminine, a relation I have chosen to explore from a purely psychoanalytic point of view. The fact that ornament has been trivialized *because* of its associations with the feminine is an important cultural component of its history, and Schor has dealt well with this aspect of the decorative in her engaging book.

11. Nerval published several articles pertaining specifically to the decorative arts, and many others that call on the decorative arts as comparisons to dance, song, and theater. In the first category, in *Le Messager* of 1838, one finds "Embellissement de Paris" (30–31 July) and "De la grille du Palais-Royal" (3 August). "Exposition des produits de l'industrie" (a review of furniture designed by MM. Tahan and Giroux) appeared in *L'Artiste* (April 1849) under the pseudonym Lord Pilgrim. "Deux Statues brabançonnes" appeared in *La Charte de 1830* (25 October 1836) and "Des Tentures de cuir doré et leur fabrication" in the *Cabinet de l'Amateur et de l'Antiquaire* 1 (1842). Nerval also collaborated with Gautier on many of the latter's articles for *La Presse* and *L'Artiste*. In the second category, dozens of articles can be cited. Whenever the "magical" or spiritual aspect of musical/theatrical performance is evoked, Nerval emphasizes the ornamental in costumes, coiffures, vocal trills and flourishes, or dance steps. This correlation is made in his fiction as well. As founder and editor of *Le Monde Dramatique*, his choice of articles and illustrations demonstrates a fine appreciation of the decorative. Two of these illustrators (Camille Rogier and Célestin Nanteuil) shared a rococo apartment with Nerval in the Impasse de la Doyenné and did decorative paintings on its woodwork and mirror frames, which Nerval bought after the demolition of the quarter. Nerval's profound interest in artisanry is evidenced by frequent allusions to it in his fiction (to basket makers in "Chansons et légendes du Valois," to embroidery in "Angélique" and "Octavie," to lace making in *Sylvie*, and to Ziegler's ceramics in "La Bohème galante"). He also expresses his interest in ceramics in a letter written a little more than a year before his death. "At Creil we have the fine factory of opaque porcelain, where I would like to see art objects produced as they were in the past" (18 August 1852). As for Gautier, his articles on the

decorative arts are far too numerous to list, as are the allusions to ornament in his articles on the fine arts and in his fiction. I will cite passages from several important articles in this Introduction and in the chapter on Gautier. Mallarmé's journalistic contributions to the decorative arts consist of the "Trois Lettres sur l'exposition internationale de Londres" (1871), one letter on the second season (May to October 1872), and, of course, *La Dernière Mode*, the fashion magazine he founded, edited, and wrote between 6 September and 20 December 1874. Since 1872, Mallarmé had "dreamed of founding" a monthly magazine entitled *L'Art Décoratif*, which never came to fruition. Huysmans's writings on art deal primarily with painting but are heavily imbued with ideas gleaned from the decorative arts. His famous article on Gustave Moreau is an excellent example of this. The articles published between 1879 and 1882 were collected in *L'Art moderne*, and those from 1882 to 1889 were, for the most part, published in *Certains*. These two volumes do not include articles from the Belgian journals to which he contributed, *Le Gaulois*, or those that were later to appear in *De Tout*. In *Certains*, Huysmans lauds the decorative artist Chéret but deplores the proposed creation of "Le Musée des Arts décoratifs" (because of the lowering of standards of fabrication and consumption of these arts for the masses). The importance of the decorative, both in decor and in syntax, is present in Huysmans's fiction from *Le Drageoir aux épices* in 1874 to the post-1900 "Catholic" novels. Although Rachilde's close friend, Félix Fénéon, was a major figure in the aesthetic theory of the fin de siècle, she herself made no journalistic contributions to this domain. There is, however, an interesting—if ironic—correlation between the decorative arts and her writing career. In her autobiographical *Quand j'étais jeune*, she recounts being sent to Paris, at her artistic debut, to meet a cousin who had founded a "serious journal, destined to educate women, and concerning itself primarily with their wardrobe and their handiwork" (Paris: Mercure de France, 1947, 104). I have nonetheless included her here because her texts provide an outstanding example of the paroxysm and impasse reached by ornament as desire at the century's end.

Rachilde excepted, the writers considered here share not only an intense interest, but a concrete involvement in the decorative arts. The "Grands Absents" of this study are Victor Hugo, Charles Baudelaire, and the brothers Goncourt, writers whose stock in the decorative arts also involved a role as maker of decorative objects or as commentator on them. It is interesting to note, for example, that Hugo made decorative frames for his intensely moody and brilliant watercolors, as well as a series of decorative panels in chinoiserie for the dining room of his mistress, Juliette Drouet. The grotesque, his most famous contribution to Romantic theory, is an ornamental construct. The Goncourts' drawings, their collection of bibelots, and their collaboration with the Marquis de Chennevières on a project for a journal of decorative arts

might well be looked at in the context of their *Ecriture artiste*. Their contribution to the rapport between late-nineteenth-century psychology and literature is examined by Debora Silverman (see chap. 7, n. 42). But this study has no pretension to exhaustiveness. A study of the arabesque alone would have to include more than twenty writers to have any claim to being exhaustive. It is hoped that the connections made here will inspire further research, not only in French literature, but in other literatures as well.

12. The Petit Cénacle consisted principally of Gautier, Nerval, Philothée O'Neddy, Pétrus Borel, Jehan Duseigneur, Célestin Nanteuil, Alphonse Karr, Arsène Houssaye, and Camille Rogier. A parallel group, to which Nerval and Gautier belonged, *Les Jeune-France*, was directly connected with the launching and promoting of the troubadour style.

13. Viollet-le-Duc, "L'Architecture et les architectes au XIXe siècle," *L'Artiste* (May–August 1858): 266.

14. See Jules François-Félix Champfleury, *Bibliothèque céramique* (Paris: A. Quantin), 1881.

15. See Misook Song, *Theories of Charles Blanc* (Ann Arbor: University of Michigan Press, 1984).

16. "The idea of movement, associated with the idea of speed, but isolated from the idea of force, is the basis of practical cinematics, or of the mechanics of the artisan" (1883, 7). Bourgoin is also the author of *Eléments des arts arabes: Le trait des entrelacs* (Paris: Morel, 1867, 1873, 1890).

17. Jean D'Udine [Albert Cozanet], *L'Art et le geste* (Paris: Alcan, 1910), 86. Later research in this tradition, while difficult to view seriously, attests to the strength of the desire to draw strict correlations between ornament and music; see, for example, Etienne Souriau's "Philosophie des procédés artistiques," *Revue des Cours et conférences*, no. 29 (30 December 1928), where the plastic arabesque is described as "mute music." (Etienne Souriau is the son of Paul Souriau.) See E. H. Gombrich, *The Sense of Order: A Study in the Psychology of Decorative Art* (Ithaca: Cornell University Press, 1979), 286–87, for a discussion of midcentury musical analogies formulated by Gottfried Semper and Ralph Wornum.

18. Théophile Gautier, "Un Plafond de M. Cabanel," *L'Artiste* (25 July 1858). And in 1836: "Constraint makes talent spring to new heights" ("De l'application de l'art à la vie usuelle," *La Presse* [13 December 1836]).

19. Eugène Véron, *L'Esthétique* (Paris: Reinwald et cie, 1878), 130, 136.

20. Ralph Wornum, *Analysis of Ornament: The Characteristics of Style* (London: Chapman and Hall, 1873), 14.

21. Charles Blanc, *L'Art de la parure et du vêtement* (Paris: Renouard, 1875), 57–58. The same principles are restated in *Grammaire des Arts-décoratifs* (Paris: Renouard, 1882).

22. Gautier, "Les Barbares modernes: A l'Exposition Universelle de

Londres," in *Oeuvres complètes* (Geneva: Slatkine, 1978), 354 (excerpted from *Caprices et zigzags* [Paris: Lecou, 1852]).

23. Fechner is the founder of psychophysics (see his *Elemente der Psychophysik* [1860, 1889]). His *Vorschule der Ästhetik* (1876) is an attempt to determine scientifically the abstract principles of beauty.

24. Huysmans goes into the Christian symbolism of gemstones at some length in the preface to *A Rebours* written twenty years after the novel.

25. Henry van de Velde, *Was Ich will* (1901), quoted in Gabriele Steiner's *Art Nouveau* (Woodbury, N.Y.: Barron's, 1982), 31.

26. Gautier, "Le Chêne de Roche de Théodore Rousseau," in *L'Abécédaire du Salon de 1861* (Paris: Dentu, 1861).

27. De Noirmont, "Au Palais de l'Industrie: Art, luxe et fantaisie," *La Revue des Arts Décoratifs* 1 (1880).

28. "When it radically decomposes a body, this deformation is formation. . . . The image emanates so to speak from the ornamental structure" (Jorgis Baltrušaitis, *La Stylistique ornementale dans la sculpture romane* [Paris: Librairie Ernst Leroux, 1931], 274).

29. Emile Gallé, "Le Décor Symbolique," Discours de Réception at the Stanislas Academy in May 1900.

30. Charles Blanc, *Grammaire des Arts-Décoratifs: La décoration intérieur de la maison* (Paris: Renouard, 1882), 72–73.

31. Henri Focillon, *Vie des formes*, 7th ed. (Paris: Presses Universitaires de France, 1981), 8.

32. I use the British spelling (as in *phantasmatic*) to distinguish Id *phantasy* (unconscious projection, incorporation, oral aggression, and other forms of relating to the Object that emanate from the drives) from *fantasy* (imaginary constructs, flights of fancy, normally conceived of as capricious, light, and so on).

33. Souriau, *L'Imagination de l'artiste* (Paris: Hachette, 1901), 271. His son, Etienne, wrote that "our taste as Westerners, steeped in anthropomorphism and Greek naturalism, too often leads us to misunderstand the importance . . . of [the arabesque]. Numerous are they who pass before [pure ornament] without looking" ("La Philosophie," 117).

34. Anton Ehrenzweig, *The Psychoanalysis of Artistic Vision and Hearing* (London: Routledge and Paul, 1953), xii. See also his *Hidden Order of Art* (Berkeley and Los Angeles: University of California Press, 1976).

35. J.-K. Huysmans, *Lettres à Théo Hannon* (Paris: Pirot, 1985), 284. The letter is dated 17 October 1878.

36. See Annette Kahn, *J.-K. Huysmans: Novelist, Poet, and Art Critic* (Ann Arbor: University of Michigan Press, 1987).

37. Maxime Du Camp, preface to *Les Chants Modernes* (Paris: Michel Levy, 1855).

38. Walter Bagehot, *Literary Studies by the Late Walter Bagehot*, ed. Richard Holt Hutton, 2 vols. (London: Longman, Green, 1879), 352. Subsequent references are in the text.

39. Twenty-five years later, Oscar Wilde's *Picture of Dorian Gray* drew the same ire: "A truer art would have avoided the glittering conceits, which bedeck the body of the story, and the unsavoury suggestiveness which lurks in its spirit" (*A Defence of "The Picture of Dorian Gray*," ed. Stuart Mason [London: Jacobs, 1908], 98–99).

40. "Decorative excess" nonetheless received extremely bad press in the nineteenth century because, among other reasons, it was perceived as typifying middle-class tastes. The middle class had only recently been able to buy, collect, and display decorative pieces thanks to mass production and a sharp decline in prices. The corresponding decline in the quality of design, craftsmanship, and "truth to materials" in much of the period's decoration made it easy to associate the middle-class taste for excess and showiness with cheaply and badly made ornament. "Luxury" was only the appearance of luxury, a "luxe menteur." Decorative excess was also seen as a sign of artistic decadence (Maxime du Camp's statements exemplify this position). Despite these attitudes, the renewal of artistic vision toward the end of the century in the decorative arts was due precisely to a reaffirmation of the value of "richness," "inexhaustibility," and "luxuriousness," terms that appear again and again in reviews of exhibits in the 1880s.

41. Albert Jacquemart, "Les Ornements de Polydore de Caravage," *La Gazette des Beaux-Arts* 6 (April–June 1860): 336.

42. Some of the qualities prized in the decorative arts might even be rendered more forcefully in writing. Souriau gives as an example Gautier's "hallucinatory images" in *Spirite*; there, effects of excessive luminosity which would be too bright to look at therefore procure a stronger impression on the written page than in a painting (*La Suggestion*, 197).

43. Viollet-le-Duc, "Présentation," in Jules Bourgoin, *Arts arabes* (1873), 3.

44. In *Combinaisons ornementales* (1896), the Art Nouveau designer Victor Mucha drew a parallel between ornamental composition and the kaleidoscope. This nineteenth-century invention also seems modeled on the visual patterns generated by the brain.

45. Gautier, *Les Beaux-Arts en Europe* (Paris: Michel Levy, 1855), 57.

46. Ludwig Hevesi, referring to the decorative sensuality of Gustav Klimt's paintings in *Acht Jahr Secession*, 450, quoted in Werner Hofmann, *Gustav Klimt* (Greenwich: New York Graphic Society, 1974), 44.

47. Barbara M. Stafford, "State of Research in Eighteenth-Century Studies," *Art Bulletin* 70, no. 1 (March 1988).

48. J.-J. Rousseau, *Discours sur les arts et les sciences* (Paris: Gallimard, Folio, 1986), 4.

49. Adolf Loos, "The Luxury Vehicle," in *Spoken in the Void: Collected Essays, 1897–1900*, trans. Jane O. Newman and John H. Smith (Cambridge, Mass.: M.I.T. Press, 1982), 40.

50. "Ornament and Crime," in *The Architecture of Adolf Loos*, an Arts Council Exhibition, Great Britain, trans. Y. Safran and W. Wang (London: Arts Council, 1985), 100.

51. Gautier, "Meissonier," *La Gazette des Beaux-Arts*, 1 May 1862.

52. Henry van de Velde, *Déblaiement d'art* (Brussels: Monnom, 1894), 21.

53. Didier Coste makes the same observation about relationships in the poetry of Robert de Montesquiou. Montesquiou's "furious taste for decorative arrangements" and "decorative ideas about distribution, assembling [and] arrangement" carried over into attitudes toward poetry, attitudes that Mallarmé had already and supremely put into practice. See Didier Coste, "Robert de Montesquiou et Emile Gallé: La cristallisation du décoratif," *Romantisme*, no. 42 (1983).

54. Henry van de Velde, "Die Lignie," *Formules de la Beauté architectonique moderne* (essays 1902–1912) (Brussels: Archives d'architecture moderne, 1979), 66. This article first appeared in the German journal *Die Zukunft* in September 1902, but the ideas in it can be dated from 1894–1895, the period when van de Velde was discussing art with Mallarmé and designing Paris façades.

CHAPTER 1. THE ENCHANTED HAND

1. Gérard de Nerval, *Aurélia*, in *Oeuvres* 1 (Paris: Bibliothèque de la Pléiade, Gallimard, 1974), 383.

2. For a discussion of Romantic irony, see Hans Eichner, *Friedrich Schlegel* (New York: Twayne Series, 1970), who emphasizes irony's primary characteristic as the "constant alternation of self-creation and self-destruction." See also Philippe Lacoue-Labarthe and J.-L. Nancy, *L'Absolu littéraire* (Paris: Le Seuil, 1978), and, more recently, Lilian R. Furst, *Fictions of Romantic Irony* (Cambridge, Mass: Harvard University Press, 1984). Furst underlines the distinctions between traditional and Romantic irony. In the latter, for example, irony is situated between the narrator and his narrative (as opposed to the location of irony between the narrator and a protagonist, wherein the reader is in collusion with the narrator). Romantic irony is unstable, with no "truth" to ground it; it creates a mobility of meaning and the reader finds it impossible to grasp the narrative in its totality (cf. the arabesque as "infinite"). Furst also underscores the "wholly new metaphysical status" that Schlegel grants to irony. Irony not only creates and destroys fictional illusion, but signifies the artist's freedom to "annihilate" what he has created in order to transcend it and then to re-create it (see especially pp. 26–28). The form of the arabesque conforms to that of an endless series of digressions or offshoots, and Schlegel defined

irony as—among other things—a "permanent digression." Also pertinent to a design of arabesques is his definition of irony as "the clear consciousness [and agility] of infinitely full chaos" ("Ironie ist klares Bewusstsein der ewigen Agilität des unendlich vollen Chaos" [*Ideen*, 69]).

3. Friedrich Schlegel, *Gesprach über die Poesie*, "Brief über den Roman," in *Kritische Friedrich-Schlegel-Ausgabe* 2 (Munich: Schöningh, 1958–1967), 337. Translated in Ernst Behler and Roman Struc, *Dialogue on Poetry and Literary Aphorisms* (University Park: Pennsylvania State University Press, 1968), 103. See also Athenäumsfragment no. 116. Friedrich Schlegel (1772–1829), in three collections of philosophical fragments to which Novalis, Schliermacher, and A. W. Schlegel also contributed, set forth the notions that still best serve to define Romanticism: *Lyceum, Athenäum*, and *Ideen*. Literary references to the arabesque do not begin with Schlegel, but he is the first to extrapolate the variety of functions and associations that I will explore. More important, without specifically describing the arabesque's plastic characteristics, he propounds a poetics based on these attributes. The arabesque, as he intends it, was used before him as a structuring device by Cervantes, Sterne, Diderot, Dante, Boccaccio, and Shakespeare. If the aesthetic writings of Kant and Schiller, along with the *Wissenschaftslehre* of Fichte, were a strong formative influence on Schlegel's thought, and if Goethe's *Von Arabesken* made him aware of the form in the plastic arts, Schlegel was the first to compare the decorative form in art to the essential aims of literature. After him, the term *arabesque* is seen more frequently, and often carries the meanings he accorded it, particularly in Romantic writing. The principal texts are Gogol's *Arabesques*, a collection of short stories (including "Nevsky Prospekt," "The Portrait," and essays on art) (1835), Edgar Allan Poe's *Tales of the Grotesque and Arabesque* (1840), and the aesthetic writings of Charles Baudelaire (for example, in "Le Peintre de la vie moderne," "L'Essence du rire," "Le Thyrse," and *Fusées*). The form permeates Gautier's work. It becomes extremely important to Symbolist and Decadent aesthetics of the fin de siècle, specifically in the writings of Paul Gauguin, Gustave Moreau, Félix Fénéon, Robert de Montesquiou, Henry van de Velde, and Stéphane Mallarmé.

4. Aloïs Riegl, *Stilfragen: Grundlegungen zu einer Geschichte der Ornamantik* (Berlin, G. Siemens, 1893). In the eighteenth century, the arabesque was omnipresent in its rococo incarnation, rocaille, an ornamental style using forms based on shells and water-worn rocks and characterized by elaborate scrolls.

5. "Im Orient müssen wir das höchste Romantische suchen," claimed Schlegel (*Poesie*, "Rede über die Mythologie," *KA* 2:320). "In the Orient we must look for the most sublime form of the Romantic" (Behler, 87). The question of Schlegel's influence on Nerval's work remains vague, but Gautier, in 1872, affirmed that "the Schlegels' erudition in Sanskrit . . . had long prepared [Nerval's imagination] for the poetic magic of the Orient" (*Souvenirs romantiques* [Paris: Garnier, 1929], 240–41). Only two critics from our own century

have tried to pinpoint this relationship further. Marcel Françon writes, "Nerval remains profoundly influenced by Friedrich Schlegel, and an analysis of his ideas on poetry would confirm this" ("A Source of G. de Nerval," *Modern Language Review* 54 [1959], reiterated in *Romance Notes* 8 [1966]). Otto Weise notes Nerval's unacknowledged citation in *Choix des Poésies de Ronsard* (1830) from Schlegel's *Geschichte der alten und neuen Literatur*, prompting the critic's belief that Nerval had adopted many of the Jena writer's views on poetry (*G. de Nerval: Romantik und Symbolismus* [Halle: Akademischer Verlag, 1936]). Copious documentation of Nerval's other German sources may be found in Charles Dédéyan, *G. de Nerval et l'Allemagne* (Paris: Société d'enseignement Supérieur, 1957); Albert Béguin, *L'Ame romantique et le rêve* (Paris: Corti, 1946); Alfred Dubruck, *G. de Nerval and the German Heritage* (The Hague: Mouton, 1965). One need only be reminded that Nerval—translator of Goethe's *Faust I* at the age of nineteen—was affectionately referred to as the "traveling salesman between Germany and France."

6. For an exhaustive work on Schlegel's arabesque, see K. K. Polheim, *Die Arabeske: Ansichten und Ideen aus F. Schlegels Poetik* (Paderborn: Schöningh, 1966).

7. Friedrich Schlegel, Athenäumsfragment no. 116, transl. Peter Firchow, *F. Schlegel's Lucinde and the Fragments* (Minneapolis: University of Minnesota Press, 1971), 175.

8. Ernst Kühnel, *The Arabesque: Meaning and Transformation of an Ornament* (*Die Arabeske* [Wiesbaden: Dietrich'sche Verlag, 1949]), trans. E. A. Bowring (Graz: Verlag für Sammler, 1976), 12.

9. Nerval, *Voyage en Orient*, in *Oeuvres* 2 (Paris: Gallimard, 1978), 509.

10. C. Boutereau, *Nouveau manuel complet du dessinateur* (Paris: Roret, 1847), 284.

11. This preface to the 1829 French translation of the *Tales of Hoffmann* (ed. Renduel), which Nerval most certainly read, is quoted by Jules Marsan in his introduction to Nerval's short stories "La Main enchantée" and "Le Monstre vert" in *Contes et facéties* (Paris, n.d.). Hoffmann's "Der goldne Topf" (1813) had appeared in the *Revue de Paris* on 17 May 1829. Hoffmann's and Scott's texts, then, appeared in French just three years before Nerval wrote "La Main enchantée."

12. Sir Walter Scott, "On the Supernatural in Fictitious Composition and particularly on the works of E.T.W. Hoffmann," *Fortnightly Review* (July 1827) (published in the *Revue de Paris* on 5 April 1829 as "Du merveilleux dans le roman").

13. Nerval, "La Main enchantée," *Oeuvres* 1:479. This text first appeared in the *Cabinet de lecture* of 24 September 1832 as "Histoire macaronique de la Main de Gloire" and was reprinted a year later in *La Revue pittoresque*. A slightly different version, entitled "La Main enchantée," was published in *Contes et facéties* in 1852. Subsequent references to "La Main enchantée" appear in

the text. Nerval also planned to write an opera, *La Main enchantée*, the first draft of which can be found in Nerval, *Oeuvres complémentaires*, ed. Jean Richer (Paris: Minard, 1965).

Very little critical attention has been accorded this text, as the prevailing opinion seems to have been that it "was an early work of imitation . . . a light, almost superficial effort . . . highly mannered and artificial . . . and reveals no personal or emotional involvement" (Dubruck, *Nerval and Heritage*, 54).

14. Nerval, "Les Nuits d'octobre," in *Oeuvres* 1:111; *Le Marquis de Fayolle*, 597; *Aurélia*, 376; "Réveil en voiture," 15. The return to childhood haunts in Nervalian texts furnishes a point of departure for wandering, both geographic and textual. These digressions almost always lead to further returns into the past, so the double movement of return and expansion is, once again, found in the arabesque, here in its incarnation as digression. The superimposition of wandering and writing as circling around or taking detours can be found in the word *parchemin* (*par chemins*), which occurs frequently in Nerval. Parchment also reminds one of the the evolution of the arabesque from the scroll motif.

15. Javotte is occupied working at her embroidery, *des noeuds d'aiguillettes*, a knotting that prefigures the knot to be tied around Eustache's neck. This dexterity links her to the juggler and his ability to manipulate language. Indeed, embroidering is alternated with successfully hawking the draper's wares, a talent in which "she was second to none" (489). In addition, the roll of fabric calls to mind a scroll of parchment that, as we have seen, was the decorative motif out of which the arabesque evolved. As we will see in the next chapter, weaving, embroidering, and lace making are Nervalian metaphors for writing. In this context, it is interesting to juxtapose the title of the present tale with Nerval's project to write "La Tapisserie enchantée."

16. "In all its descriptions, the [transcendental] poetry should describe itself and always be simultaneously poetry and the poetry of poetry"; "and it can also . . . hover at the midpoint between the portrayed and the portrayer, free of all real and ideal interest, on the wings of poetic reflection" (Athenäumsfragment nos. 238 and 116 [Firchow, *Lucinde*, 175, 195]).

17. The expression *main de gloire* was a form in the Middle Ages for *mandragore* (mandrake), a plant whose purported magical properties were said to cure impotence. It was supposed to grow under the gallows of hanged men (because of their ejaculation just before death). A 1752 definition cited in *Trésor de la Langue Française* adds that it is also "the dried hand of a hanged man which thieves use to paralyze their victims" (Paris: Gallimard, 1985).

18. On this important Romantic theme, see Victor Brombert, *The Romantic Prison* (Princeton: Princeton University Press, 1978).

19. Nerval, letter to Madame Alexandre Dumas, 9 November 1841, *Oeuvres* 1:913.

20. Reproduced in Jean Richer, *Nerval: Expérience et création* (Paris: Hachette, 1963), and in *Les Cahiers de l'Herne* 37.

CHAPTER 2. LACE AS TEXTUAL METAPHOR IN NERVAL'S *SYLVIE*

1. Among the studies on Nerval that share a common bias regarding either the self-reflexive nature of Nerval's writing or the dynamics of repetition and lack are Shoshana Felman's "Lyrisme et répétition," *Romantisme* 6 (1973); J.-P. Richard's "Nerval Patronyme," *Saggi e ricerche di Letteratura Francese* 14 (1975); Henri Bonnet's *"Sylvie" de Gérard de Nerval* (Paris: Hachette, 1975); Michel Jeanneret's *La Lettre perdue: Ecriture et folie dans l'oeuvre de Gérard de Nerval* (Paris: Flammarion, 1978). In the last work, one finds lace making listed along with a dozen other activities considered self-reflexive. Among critical works on textual metaphor which examine the analogy of text to fabric in detail, see Roland Barthes's *S/Z* (Paris: Le Seuil, 1970); Jacques Derrida's "La Double Séance" in *La Dissémination* (Paris: Le Seuil, 1972); Lucien Dällenbach's *Le Récit spéculaire* (Paris: Le Seuil, 1977); and Lucette Finas's essay on Claudel in *Le Bruit d'Iris* (Paris: Flammarion, 1979).

2. *Promenades et souvenirs*, published in installments between 30 December 1854 and 3 February 1855, is very likely composed of "leftover" pieces of *Sylvie*. A letter that Nerval wrote to his publisher, Victorien de Mars, seems to confirm this: "I'm sure of the story, but not about shortening it. After all, we could make another piece out of it under another title" (29 July 1853). It is not mere coincidence that this evolution takes place alongside a parallel refinement of form (from the sketch to the collage of fragments to the polished, finished novella). In addition to the above-mentioned heroines, the wife in "Le Monstre vert" is a seamstress, and Octavie and Emilie in the short stories of the same name are embroiderers.

3. See, for example, Uri Eisenzweig, *"Sylvie" de Gérard de Nerval: L'espace imaginaire d'un récit* (Geneva: La Baconnière, 1976).

4. The text in fact proposes an antithesis to the aesthetic object: food. In chapter 12, entitled "Le Père Dodu" (*dodu* means plump), the narrator mentions onion soup, café au lait, and his "milk-brother," who plans to open a pastry shop once he and Sylvie are married. It is not by chance that this chapter follows those that recount the decline of the lace industry, of ritual, and of the folk song. In contrast, the two chapters dominated by the act of writing follow chapter 7. In the *tapisserie* of chapter 14 (hung in the narrator's room at the inn, during the last return to the Valois), we can see a reversal and cancellation of *pâtisserie*. Many elements support this observation: the word *tapisserie* is surrounded by the words *Image* and *glace*; the place names Eve and Ver in the same passage reverse themselves anagramatically into *Rêve*; Père Dodu recites biblical verses backward (and it is he who announces that the hero's rival will marry Sylvie and open a pastry shop). In contrast to the banal earthly nourishment of chapter 12 is that of aesthetic transcendence: "J'ai passé par tous les

cercles de ces lieux d'épreuves qu'on appelle théâtres. J'ai mangé du tambour et bu de la cymbale" (I have passed through all the circles of these places of initiation that one calls theaters. I have eaten of the drum and drunk of the cymbal) (chap. 13).

5. Nerval, *Sylvie*, in *Oeuvres* I (Paris: Gallimard, Bibliothèque de la Pléiade, 1974), 241. Subsequent references are to this edition and are given in the text. I have occasionally referred to a translation of *Sylvie* by Lucie Page (Portland, Maine: T. B. Mosher 1896).

6. The accumulation of doubles (Aurélie-Adrienne, Sylvie-Sylvain, the hero–his *frère-de-lait*, Sylvie's old aunt–the hero's old uncle) is the most noticeable aspect of repetition in *Sylvie*.

7. Most of these technical details are taken from Thérèse de Dillmont's *Encyclopédie des Ouvrages des Dames* (Dornach [Alsace]: Dillmont, n.d.), a book that enjoyed great popularity at the beginning of the twentieth century; it was published in English and German as well as in French.

8. In crowning Adrienne with laurel branches after her song, the young hero mingles the identity of his muse with his future identity as poet: she resembled Dante's Beatrice, "qui sourit au poète errant sur la lisière des saintes demeures" (who smiles at the poet wandering on the edge of sacred abodes). The vocabulary in this passage carries many associations with lace: "La pelouse était couverte de faibles vapeurs condensées, qui déroulaient leurs blancs flocons sur les pointes des herbes ... branches tressées en couronne et nouées d'un ruban ... cet ornement dont les feuilles lustrées éclataient sur les cheveux blonds aux rayons pâles de la lune" (The lawn was lightly veiled with vapor that unrolled its white flakes over the blades of grass ... branches braided into a crown and knotted with ribbon ... this ornament whose lustrous leaves sparkled on the blond hair in the pale rays of the moon) (245–46).

Another means of crossing the threads is to invert the sequence of actions in the narrative. In chapters 2 and 4, a kiss is exchanged, a crown is offered, and there is a loss of affective reciprocity; these actions appear in the above order in chapter 2 and this order is inverted in chapter 4.

9. Few writers have gone as far as Nerval in the practice of auto-citation, of collage, and of the wandering of fragments from one text to another. Nonchalance, *Wiederholungszwang*, pure utilitarianism for financial reasons, or a novel and highly modern conception of narrative?

10. Proust wrote in *Contre Sainte-Beuve*: "One is obliged at every moment to turn back to the preceding pages to see where one is, if it is the present or if it is an evocation of the past."

11. These two letters (11 February and 29 July 1853) are addressed to Victorien de Mars at the *Revue des Deux Mondes* (*Oeuvres* 1, 1052, 1064). A letter dated August 1852, also describing the composition of *Sylvie* (in its early

stages), shows how Nerval intends to take the fragments and "sew" the pieces together. It also indicates that he does not suspect the complexity of the work to come. "As far as I am concerned, it's done, that is to say, written in pencil on a multitude of pieces of paper that I have only to rewrite: a stringing together that will take three or four days" (*Oeuvres* 1, 1071).

12. See Nerval's "Correspondance générale" (*Oeuvres* 1), his journalistic writing, and his "Chansons et légendes du Valois," which immediately follows *Sylvie* in *Les Filles du feu*. For Nerval's involvement in the oral tradition, see also Paul Benichou, *Nerval et la chanson folklorique* (Paris: Corti, 1970).

13. The repetition of phonemes in *Sylvie* creates a cadence that is close to cadences in folk songs. One of the most frequent structures in this music involves the repetition of each couplet, while, very often, the second couplet takes up the last line of the first and adds a new line to it, which is taken up in the third couplet, and so forth. This movement of *reprise* is found in lace making and in the construction of *Sylvie*. The parallels between song and lace, as well as the implications for the transcription of the oral tradition in fictional writing, are examined in greater detail in my "*Sylvie*: La voix dans l'écriture," in *Oralità: Cultura, Letteratura, Discorso*, ed. Bruno Gentili and P. Paioni (Rome: Ateneo Press, 1985).

14. An incantation of repeated sounds appears to direct the insertion of certain words in the text: for example, Por/por/a and, elsewhere in the novellas, Is/is. This incantatory rhythm is that sought in the prose of *Sylvie*.

15. Nerval, "Les Nuits d'octobre," in *Oeuvres* 1:92.

16. Nerval, *Promenades et souvenirs*, in *Oeuvres* 1:130.

17. Nerval, "Corilla," in *Oeuvres* 1:307.

18. The verb *dérouler* appears twice in *Sylvie*, each time associated with an image of lace or of an embroidered object. See the passage quoted in note 8 and in chapter 6: "'Si je trouve les bas brodés!' Un instant après, nous déroulions des bas de soie rose tendre à coins verts" ("If I find the embroidered stockings!" An instant later, we were unrolling the pale pink silk stockings with green tips) (255).

19. Laurence Porter has suggested to me that Chateaubriand's pagan heroine, Velléda, would be associated in Nerval's mind with the "race of fire," of Cainite rebels to which he thought he and "the daughters of fire" belonged, the lost past par excellence.

20. Wordplay was an activity in which Nerval reveled, often dissecting words for their affective or mystical correspondences. His nom de plume, for example, is an anagram of Laurent, his dead mother's maiden name. The pseudonym later "allowed" him to trace his ancestry to the emperor Nerva. The famous inscription on a photograph taken of him also contains a coded message within his name: "Cigne allemand: Feu geai rare Je suis l'Autre" (German swan/Description [*signalement*]: The late rare jaybird [*Gérard*] I am the Other).

21. Two chapters later, these festoons are repeated in the arcades that frame Adrienne's last appearance. "Cette vieille retraite n'offre plus à l'admiration que les ruines de son cloître aux *arcades byzantines*, dont la dernière rangée *se découpe* encore sur les étangs . . . et l'on respire un parfum de la Renaissance sous les arcs des chapelles à fines nervures" (This old retreat no longer presents for admiration anything but the ruins of its cloisters and its *Byzantine arcades*, of which the last row still *stands out* against the pond . . . and one breathes a perfume of the Renaissance under the finely molded ribs of the chapel arches) (257; emphases mine).

In this passage, the adjective *fines* is picked up and tied to *nervures*; this syntagm describes an identical sensibility and configuration to *fines dentelles*. Once again, I am underlining the desire to transcribe or translate a vision of the world to which lace (like Renaissance architecture here, and landscape descriptions elsewhere) appears to refer. There are other examples of the alternation *découper/festonner* on pp. 241 and 257.

22. The image of intertwining vine branches also comes to Nerval's mind as he reviews an 1849 exhibit of decorative arts: "This lady's desk is a desk of a princess or fairy by the ideal lightness of the sculpture that runs across it with the grace of vine branches. . . . M. Tahan exhibits a great science of ornamentation." (The figures of princess, queen, and fairy are also present in "El Desdichado" and in *Sylvie*.) The cabinetmaker André-Charles Boulle is also mentioned in this article ("Exposition des produits de l'industrie," *L'Artiste*, 5th ser. [April 1849]).

23. Many critics have circled around the metaphor /lace = text/ in embellishing their own prose, without, however, drawing out the stylistic implications of the analogy. For example, François Constans writes of "this work that appears at first glance to be all misty poetry and a lacework of caprice and grace" ("*Sylvie* et ses énigmes," *Revue des Sciences Humaines* [1962]); Julien Gracq writes of "this masterpiece woven with the vapors and pearls of the morning"; while Anita Grossvogel refers to "the transparent cloth of illusion" (*Le Pouvoir du nom* [Paris: Corti, 1972]). I believe that the frequent recourse to this sort of vocabulary is not without meaning for the deep structures of the narrative.

24. Nerval, *Aurélia*, in *Oeuvres* 1:425.

25. The ties between weaving and textuality carry the force of myth. In Africa, for example, language and symbolic representations are accorded a divine origin, and their revelation is often linked to the revelation of weaving: "The invention of most African writing [is tied to weaving]." See G. Calame-Griaule, *Semiotica* 1, no. 3 (1969). In classical mythology, weaving is the symbolic representation for life: Clotho is the Fate who cuts the thread forever. It is not surprising that Nerval, whose worldview and writing were so grounded in myth, should be drawn to this metaphor.

CHAPTER 3. TRILLS, FRILLS, AND DECORATIVE FRAMES
FOR THE OBJECT OF DESIRE

1. D. W. Winnicott, *Playing and Reality* (New York: Basic Books, 1971), 11. Subsequent references are in the text.

2. Nerval often underlines the fact that the experiences I will describe in this chapter are lived out by his heroes in a state of *demi-somnolence*, or in a memory *à demi-rêvé*.

3. Nerval's translation is in *Oeuvres* 2:892. In an unpublished dissertation, I have compared Schiller's *Spieltrieb* to Winnicott's transitional phenomena ("*Sylvie* de G. de Nerval: Texte-dentelle," University of California, Los Angeles, 1981). Among Nerval's references to Schiller, two that might concern us here are the play mentioned at the end of *Sylvie* and the visit to Schiller's home, where he makes a special note of embroideries, tapestries, and the piano.

4. Julia Kristeva (basing her theory on Fonagy's psychoanalytic model of phonetics) has proposed that phonemes in a text produce a supplementary, underlying network of signification. Alliteration in particular is a signal of libidinal activity or instinctual drives that express themselves by condensation and displacement. See I. Fonagy, "Le Langage poétique: Forme et fonction," *Diogène* 51 (1965).

5. Nerval, *Promenades et souvenirs*, in *Oeuvres* 1:135. Intertwining forms, and particularly the arabesque, can be seen as a response to this form of loss in the autobiographical novella, where the hero expresses his longing for a home. The natural forms he selects from the landscape are arabesque: "la grande butte où serpentent des ravines et des sentiers . . . des chèvres qui broutent l'acanthe suspendue aux rochers" (the great knoll where ravines and paths snake along . . . goats that graze on acanthus hanging from the rocks) (ibid., 122). Only there is no acanthus in Montmartre, nor was there any in the 1850s. Its insertion is purely symbolic, and its function is to supply the sentiment of wholeness, of lacking ties with others in the Romantic hero. The angst of unconnectedness is revealed clearly by the phrase that precedes the reference to acanthus: "Des plaines vertes coupées de précipices" (Green plains cut apart by precipices) (ibid.).

6. Nerval, *La Charte de 1830*, 7 December 1837.

7. Nerval, "Jenny Colon," *Le Monde dramatique* 2 (1835): 345–46.

8. Cited by Gautier in *La Presse*, 1 January 1844.

9. Jacques Lacan, *Le Séminaire, XI* (Paris: Le Seuil, 1978), 60.

10. In *Théorie de l'ornement*, Jules Bourgoin writes: "We would like to devote a little interest to the world of artisanry: a world that is quite obscure and quite modest, but full of genius, about which all of our fine gentlemen, artists or intellectuals, captains of industry or merchants, . . . seem to know nothing.

This is in fact because *this world has disappeared, leaving only a background of commonplace industry where science supplants life*" (1; emphasis mine). See the Introduction for a complete reference. On the following page, Bourgoin states that his generation is witnessing "the decline of the aesthetic evolution of the modern spirit," and that this decline is due in large part to the disappearance of artisanry.

11. Nerval, "Chansons et légendes du Valois," *Oeuvres* 1:274. Similarly, in "Les Nuits d'octobre," the narrator apostrophizes a young singer: "O jeune fille à la voix perlée! . . . ce timbre jeune, ces désinences tremblées à la façon des chants naïfs de nos aïeules, me remplissent d'un certain charme! On va conseiller à ta mère de t'envoyer chez un maître de chant, et dès lors te voilà perdue. . . . Adieu, adieu, et pour jamais adieu (Oh young girl with the pearly voice! . . . this young timbre, these inflections quivering in the style of the naive songs of our grandmothers fill me with a certain charm! . . . They're going to advise your mother to send you to a singing teacher, and from then on, there you are, lost. . . . Farewell, farewell, and forever farewell) (ibid., 92).

12. See G. B. Doni, *Trattato della musica scenica* (Florence, 1640), or Carol MacClintock, "Caccini's Trillo: a Re-evaluation," *Nats Bulletin* (October 1976).

13. Jacques Lacan, *Le Séminaire, XX* (Paris: Le Seuil, 1975), 103.

14. See Pierre David, "Psychanalyse et poétique," *Langue française*, no. 23 (1974).

15. Melanie Klein, "Notes on Some Schizoid Mechanisms," in *Envy and Gratitude and Other Works, 1946–1963* (New York: The Free Press, 1975), 6.

16. Winnicott states that the function of the transitional object is taken up by playing, and finally by art and religion.

17. Gautier, *Souvenirs romantiques* (Paris: Garnier, 1929), 216.

18. Nerval, "La Pandora," in *Oeuvres* 1:347. Subsequent references appear in the text.

19. The wording of this definition comes from Jeffrey Mehlman in "Huysmans: Conversion, Hysteria, and the French Unconscious," in *Notebooks for Cultural Analysis*, vol. 2 (Durham: Duke University Press, 1985).

20. Anthony Wilden, commentary on Lacan's *The Language of the Self: The Function of Language in Psychoanalysis* (New York: Dell, 1968), 187. Freud's article, "Fetishism," dates from 1927.

21. Jules Champfleury, *Nouvelles études sur l'art et la littérature romantique: Le Drame amoureux de Célestin Nanteuil* (Paris: Dentu, 1887), 5.

22. Meyer Schapiro, "On Some Problems in the Semiotics of Visual Art: Field and Vehicle in Image-Signs," *Semiotica* 1, no. 3 (1969). In Kant's *Critique of Judgement*, the frame is an ornament, a parergon, like the clothing on a statue. Therefore, the frame is likely to function in ways I have already analyzed.

23. Gautier, *Emaux et camées* (Paris: Girard, n.d.), 33; the collection of poems appeared in 1852.

24. See Ross Chambers's fine article on the evolution of the nineteenth-century writer's erection of feminine clothing as an object of male desire. In addition to subtle analyses of "vestimentary fetishism," Chambers also points out that the myth of the Muse ties language to desire, and the erotic to the aesthetic ("La Poétique du vêtement," *Michigan Romance Studies* 1 [1980]).

25. Gautier, "Omphale: Histoire rococo," in *Récits fantastiques* (Paris: Flammarion, 1981), 104. "Omphale" was first published as "Omphale ou la tapisserie amoureuse" in 1834 in the *Journal des Gens du Monde*. I have used (and altered in some places) the English translation of Lafcadio Hearn in *One of Cleopatra's Nights and Other Fantastic Romances* (New York: R. Worthington, 1882). Subsequent references are given in the text.

26. In a clinical case study, Roger Dorey describes the patient, a fetishist, as living in a closed system, over which the shadow of death hovers. "In this profoundly narcissistic universe, the Other does not exist, not having been recognized in his radical alterity." See "Le Fétiche, l'image et le signifiant," *Nouvelle Revue de Psychanalyse* 39 (Spring 1989).

27. The legend can also be seen as conforming to Freud's theory of the fetish: Omphale would thus be endowed with a phantasy phallus, represented by Hercules' staff wound with thread, the threads of which Omphale is composed.

28. Gautier, "La Cafetière," *Récits fantastiques* (Paris: Flammarion, 1981), 57, 59. The story first appeared in *Le Cabinet de Lecture* in 1832. Subsequent references are in the text.

29. J.-K. Huysmans wrote that "only . . . the eighteenth century knew how to envelop woman in an atmosphere of lust, molding the furniture according to the form of her charms, imitating the contractions of her pleasure, the volutes of her spasms, undulations, the twisting of wood and copper" (*A Rebours* [Paris: Union Générale d'Editions, 1975], 129–30).

30. For a study of narcissism in Gautier, see Marie-Claude Schapira's *Le Regard de Narcisse: Romans et nouvelles de Théophile Gautier* (Lyon: CNRS, 1984).

31. Gautier, "Le Club des hachichins," *Récits fantastiques* (Paris: Flammarion, 1981), 227.

32. Victor Smirnoff, "La Transaction fétichique," *Nouvelle Revue de Psychanalyse*, no. 2 (1970).

CHAPTER 4. THE EVIL EYE

1. Théophile Gautier, "Jettatura," in *Récits fantastiques* (Paris: Flammarion, 1981), 427. *Jettatura* first appeared in installments in *Le Moniteur universel* (June–July 1856). It was published both in Paris and in Brussels the following year and was included in *Romans et contes* in 1863. Subsequent references

appear in the text. I have used an 1888 translation by one "M. de L..." (in *Three Romances* [Paris: Brentano's, 1888]), which I have modified only slightly.

2. For a recent analysis of the grotesque, see G. G. Harpham, *On the Grotesque: Strategies of Contradiction in Art and Literature* (Princeton: Princeton University Press, 1982). Harpham's book also provides an excellent presentation and discussion of the issues surrounding ornament in general.

3. "If the objects of horror, in which the terrible grotesque finds its materials, were contemplated in their true light, and with the entire energy of the soul, they would cease to be grotesque and would be altogether sublime" (John Ruskin, quoted in Wolfgang Kayser, *The Grotesque in Art and Literature* [Toronto and New York: McGraw-Hill, 1966], 165).

4. Immanuel Kant, "The Analytic of the Sublime," bk. 2 of *The Critique of Judgement*, in *Kant's Critique of Aesthetic Judgement*, trans. James Creed Meredith (Oxford, Clarendon Press, 1911), 101.

5. See Jacques Derrida's discussion of the "presque-trop-grand" and the colossal in *La Vérité en peinture* (Paris: Flammarion, 1978), 146–52.

6. See P. E. Tennant, *Théophile Gautier* (London: Athlone Press, 1975), 25.

7. Gautier, *L'Artiste*, 14 December 1856. Claudine Lacoste-Veysseyre has provided an excellent reference work on Gautier's art criticism: *La Critique d'art de T. Gautier* (Montpellier: Société Recherches Scientifiques, 1985).

8. Gautier, "L'Imitation de Jésus Christ," *L'Artiste*, 28 February 1858.

9. Gautier, "Salon de 1850–51," *La Presse*, 19 April 1851.

10. Gautier, "Salon de 1848," *La Presse*, 23 April 1848.

11. Gautier, "L'Exposition de l'Industrie," *Le Musée des familles*, July 1844.

12. Gautier, "Froment-Meurice," *Histoire du Romantisme* (Paris: Editions d'Aujourd'hui, 1978), 242.

13. "The mysterious essence of beauty only serves to hide its emptiness. Even marble . . . is in reality only the protective shell of something unrepresentable: the black hole," writes Carlo Pasi in "Le Fantastique archéologique de Gautier," *Bulletin de la Société Théophile Gautier*, no. 6 (1984).

14. This description was entirely eliminated by the translator, as were many others in the text.

15. Kant writes, "The proper mental mood for a feeling of the sublime postulates the mind's susceptibility for ideas, since it is precisely in the failure of nature to attain to these—and consequently only under presupposition of this susceptibility and of the straining of the imagination to use nature as a schema for ideas—that there is something forbidding to sensibility, but which, for all that, has an attraction for us, arising from the fact of its being a dominion which reason exercises over sensibility with a view to extending it . . . and letting it look out beyond itself into the infinite, for which it is an abyss" (*Critique*, 129).

16. The narrator and hero consistently note the ornamental aspects of feminine hair styles: "golden spirals," "black spirals," "tightly curled hair," "hair intertwined with braided coral," "lustrous, silken hair," and so on. The *mano*

cornuta is a gesture in which the hand is extended toward the person suspected of having the evil eye and, with the two middle fingers folded back to the palm, the index and baby finger are pointed outward.

17. This precept is most clearly presented in "Une Nuit de Cléopatre." After the unimaginable splendor and sublime pleasures of one night as Cleopatra's lover, Meiamoun can only die. Several descriptions of this night to end all nights attest to Gautier's stock in the sublime: "The banquet-hall was of enormous and Babylonian dimensions; the eye could not penetrate its immeasurable depth; monstrous columns. . . . A colossal sphinx. . . . the sky yawned like a blue gulf." The text attests as well to the immense difficulty of transcribing this experience in writing: "We have now to describe a supreme orgy, a banquet beside which Belshazzar's feast must pale,—one of Cleopatra's nights! How can we picture forth in this French tongue, so chaste, so icily prudish, that unbounded transport of passions . . . those furious outbursts of insatiate pleasure, madly leaping toward the Impossible" (translated by Lafcadio Hearn, in *One of Cleopatra's Nights and Other Fantastic Romances* [New York: R. Worthington, 1882]).

18. See translator's introduction to Kant's *Observations on the Feeling of the Beautiful and Sublime* (1763), trans. John T. Goldthwait (Berkeley and Los Angeles: University of California Press, 1960), 18.

19. Gautier, "Paul Baudry, Les Peintures décoratives du grand foyer de l'Opéra," *Gazette de Paris*, 23 January 1872.

20. Thomas Weiskel, *The Romantic Sublime: Studies in the Structure and Psychology of Transcendence* (Baltimore: Johns Hopkins University Press, 1976), 22. Weiskel's psychological model of the Kantian sublime has much in common with my dynamics of the evil eye's relation to the sublime: internalization, identification, projection, and the anxiety of engulfment.

21. This information was garnered from Lawrence Di Stasi's *Mal Occhio: The Underside of Vision* (San Francisco: North Point Press, 1981), 43–44.

22. Sigmund Freud, "Das Medusenhaupt" (1922), in *The Standard Edition of the Complete Psychological Works of Sigmund Freud*, ed. James Strachey in collaboration with Anna Freud, vol. 18 (London: Hogarth Press, 1953–1974), 273–74.

23. See Tobin Siebers, *The Mirror of Medusa* (Berkeley and Los Angeles: University of California Press, 1983), 41. Reversing that dynamic, Louis Marin uses Caravaggio's "Testa di Medusa" in *Détruire la peinture* (Paris: Galilée, 1977) to show that excessive representation becomes nonrepresentational.

24. See Di Stasi (n. 21) for a discussion of the "veil of taboo."

25. See Marie-Claude Schapira, *Le Regard de Narcisse: Romans et nouvelles de Gautier* (Lyon: Presses Universitaires de Lyon, 1984), and Siebers, *Medusa*.

26. In his illuminating chapter on *Jettatura*, Siebers proposes an extremely cogent reading of the evil eye as a superstitious phenomenon in the eye of the (Neapolitan) beholder; Paul is driven mad to the point where he believes he has the evil eye. See note 23.

27. The eye first bores a hole in the Object, then surrounds it with the decorative forms that will devour it.

28. Gautier, "Le Portail," in *La Comédie de la mort* (Brussels: E. Laurent, 1838).

29. Gautier, *Souvenirs*. Cited in Tennant, *Gautier*.

30. Gautier, Arsène Houssaye, and Charles Coligny, *Le Palais Pompéien: Etudes sur la maison gréco-romaine, ancienne résidence du prince Napoléon III*. (Paris: At the Palais Pompéien, 1866), 17.

31. For the relation of the theatrical spectacle and the sublime, see Neil Hertz's fine analysis of Wordsworth in *The End of the Line: Essays on Psychoanalysis and the Sublime* (Baltimore: Johns Hopkins University Press, 1985).

32. Several versions of "Jettatura" exist. See *Poésies complètes*, vol. 2 (Paris: Charpentier, 1877), and Spoelberch de Lovenjoul, *Histoire des Oeuvres de Théophile Gautier*, vol. 2 (Paris: Charpentier, 1887).

CHAPTER 5. TROMPE L'OEIL IN THE POEMS OF MALLARMÉ

1. The French verb *chiffrer* is unusual here; the closest translation is to encode or to encrypt. Focillon may be using it in the sense Pascal did when he proposed the use of figures of rhetoric as a mode of encrypting meaning. Ornament, then, not only allows the void to be perceived as form, but confers a hidden meaning onto it (Focillon, 27).

2. This mutual cancelling out of words can be envisioned as "des ronds de fumée abolis en d'autres ronds" ("Toute l'Ame résumée. . .").

3. "Hérodiade," in *Oeuvres* (Paris, Gallimard, 1945), 41–49. "Hérodiade" was composed in 1864 and 1867.

4. Giuseppe Arcimboldo (1527–1593) was a Milanese artist and Viennese court painter whose portraits of men were composed of vegetables, fish, birds, and so on.

5. E. H. Gombrich's position regarding these phenomena is that we cannot actually "see" ambiguity but, rather, "switch" from one reading to the other (for example, just as we cannot see both the rabbit and the duck of the famous Gestalt image simultaneously, we cannot see "both the plane surface and the battle horse at the same time"). But clearly, this is the direction in which Mallarmé pushes us (Gombrich, *Art and Illusion* [New York: Pantheon, 1965], 69).

6. Mallarmé, "Réponses à des enquêtes," in *Oeuvres*, 872. It is understandable that counterchanges in ornament would interest the first poet to place such great value on the white of the page.

7. Leo Bersani is also interested in the intersection of "the shapes of poetic language" and the "gaps," the spaces that separate poetry from material reality. "The sense established by words always slips into the intervals between words,

and intervallic sense is that continuous disappearing presence which in Mallarmé is made visible in an unprecedented manner" (Leo Bersani, *The Death of Stéphane Mallarmé* [Cambridge: Cambridge University Press, 1982], 69–71). His analyses differ from mine in that the gaps I locate as plastic form within the poem are precisely described as decorative and as Object of desire.

8. Antony Valabrègue, "La Céramique de Saint-Amand," *La Revue des Arts Décoratifs* 6 (1885–1886).

9. Mallarmé, letter to Théodore Aubanel, *Correspondance 1862–1871*, ed. H. Mondor (Paris: Gallimard, 1959), 224–25. Here is another example of writing as decorative composition: "At Versailles there are scrollwork panels, so lovely they make one cry; shells, volutes, curves, repeated motifs. This is how the sentence I toss onto the paper first appears to me in an abstract design" (letter from Mallarmé to Maurice Guillemot, cited by Jacques Derrida in *La Dissémination*, 206).

10. In *Igitur*, the original movement of expansion comes out of a glimmering of light, suspended in the night. As it reflects back on itself, it becomes the diamond, "le foyer, le pur et dur résumé du non-être" (the foyer, the pure and hard summary of nonbeing) (*Oeuvres*, 187).

11. According to Gautier, Boulle (1642–1732) was rediscovered by the Romantics; his sphere of influence would thus cover quite precisely the periods under consideration in this book.

12. Rémy de Gourmont, *Promenades littéraires*, 2d ser. (Paris: Mercure de France, 1906), 34.

13. Mallarmé, "Autobiographie," in *Oeuvres*, 664.

14. La Dernière Mode, 20 September, 20 December, and 1 November 1874, in *Oeuvres*, 729, 832, 782. In the last citation, Mallarmé calls jet "this talisman" that draws the gaze to it, a choice of words that cannot help but evoke the use of ornament in the context of the evil eye (see chapter 4).

15. The analyses of this poem are legion, and my own reading owes a debt to Claude Abastado's "Lecture inverse d'un Sonnet nul," *Littérature*, no. 6 (May 1972). Another important study shares an interest in perspective and ambiguity: Ellen Burt's "Mallarmé's 'Sonnet en yx': The Ambiguity of Speculation," *Yale French Studies*, no. 54 (1977).

16. See my "Aboli Bibelot? The Influence of the Decorative Arts in Gustave Moreau and Stéphane Mallarmé," *Art Journal* 45, no. 2 (Summer 1985). In this article, I examined the importance of *La Dernière Mode* and of the journalistic articles on the London Universal Exposition for the evolution of Mallarmé's aesthetic of ornament, at the same time proposing that an apprenticeship in the techniques of mosaic, enameling, and tapestry was the basis of a parallel aesthetic in Gustave Moreau.

17. *Choir* is the verb Lacan uses. Not only do the *objets a* fall away from the Object of desire, but the Subject "falls into" these Objects. For example, "The gaze can contain in itself *objet a* . . . where the subject comes to fall,

and which is specific to the scopic drive" (*Le Séminaire, XI* [Paris: Le Seuil, 1973], 73).

18. "The split in the subject springs from an originary separation" (*XI*, 78). If this division begins with the Lost Object, it receives visual consistency with the infant's identification of itself in the mirror. In contrast to the infant's self-image as *corps morcelé*, the body seen in the mirror comes back to the infant as an image of wholeness and mastery. Therefore, in the assumption of this image, the Subject begins along the path of self-deception, illusion, and alienation from a true identity. The ego is, from the first, constituted as other. Desire is now alienated in the other, in the imaginary relation to the specular image. See Lacan, *Ecrits, I* (Paris: Le Seuil, 1966), 79–97, and *Le Séminaire, I* (Paris: Le Seuil, 1975), 192–93. This split in the Subject occurs before the acquisition of language. However, when the Subject speaks of the self, the stories woven about this "I" are a further alienation: "The discourse of the subject, as much as it fails to achieve this fullness of discourse where its unconscious basis should reveal itself . . . is buoyed by this alienated form of being that one calls the ego" (*I*, 63).

19. Here is an example from Colette: "Long awake, he was careful not to stir. . . . He was afraid that, in moving, he might crumble away the remains of joy, the visual pleasure that he tasted in the glowing pink of the curtains, in the scrollwork, steel and copper, of the bed sparkling in the colored air of the room. Last night's great happiness seemed to him to have taken refuge, melted and tiny, in the iridescence of a crystal vase" (*Chéri* [Paris: Calmann-Levy, 1920], 173).

20. Mallarmé, *Oeuvres*, 73. Translation in Bersani, *Death*.

21. Primary-process thinking is constituted by those forms of representation that prevail in the unconscious, where psychic energy is unbound, free to become invested in any zone that allows for its discharge, thereby producing pleasure. Like this energy, the forms of representation in the unconscious operate for the benefit of the pleasure principle (whose energy is bound by censorship and associations under the control of the ego). The free (unbound) movements of unconscious energy are described by Freud as condensation and displacement. These forms of expression—analyzed extensively in dreams—violate linguistic laws of syntax and semantics. Freud characterizes secondary-process thinking as governed by perception, motor response, and articulated language.

22. Lacan, *Séminaire, XI*, 55. The phrase "einer anderen Lokalität" comes to Lacan from Fechner by way of Freud.

23. In that the Real always eludes us, and in that it appears only in slips by our perception or in what falls from our discourse as something insignificant, it is marginal (to the central considerations that guide us in life and to our perception of reality, both immersed in the Imaginary).

24. See Charles Mauron, *Mallarmé l'obscur* (Paris: Corti, 1967).

25. Lacan writes, "It is as substitutes for the Other that these objects—the object of sucking, of excretion, of the gaze, and of the voice—are called to act and are made the cause of desire" (*Séminaire, XX*, 114).

26. "Prose" was written in 1884 and published in January 1885 in Fénéon's *La Revue Indépendante*. I have cited stanzas 6 through 8 and quoted from stanzas 3 and 4.

27. Mallarmé, *Oeuvres*, 31. The idea of eyes that are nets or are woven like a text is in perfect harmony with the common etymology—*rete*—of *rets* (net, network, trap) and *rétine*, the membrane that transmits luminous impressions to the optical nerve. In a brilliant reading of this poem, Lucette Finas has also seen the "pièges à regard" (the traps for the gaze) of the trompe l'oeil. In analyzing "J'ai troué dans le mur de toile une fenêtre," she writes, "The text of Mallarmé resembles those drawings that sometimes appear convex and sometimes concave, according to the bent of the gaze" (Finas, *Le Bruit d'Iris* [Paris: Flammarion, 1978], 153).

CHAPTER 6. ABOLI BIBELOT?

1. Mallarmé, letter 141 to Henri Cazalis, *Correspondance, 1862–1871*, vol. 1, 278–79.

2. Mallarmé, "Magie," in *Oeuvres*, 400.

3. André Green, "L'Objet (a) de Jacques Lacan," *Cahiers pour l'analyse*, no. 3 (1966).

4. See Eric Gans, "Mallarmé anthropologue," *Romanic Review* 72, no. 3 (1981), for a provocative analysis of violence, sacrifice, and desire in this text and in "Mes Bouquins renfermés sur le nom de Paphos."

5. The Subject's confrontation with truth—the Other that is nonidentical to the Subject—is as with something unknowable (because of its radical difference), except by the trace or *blanc* that designates its place (and which negates the Subject) or by repetition (the resurfacing in discourse of the repressed unconscious thought).

6. Every commentator of the sonnet has lingered, perplexed, intrigued, or waxing ingenious, over the word *ptyx*. See Burt, "Mallarmé's 'Sonnet en yx' "; Emilie Noulet, *Vingt Poèmes de Stéphane Mallarmé* (Geneva: Droz, 1967); Charles Chassé, *Les Clés de Mallarmé* (Paris: Montaigne, 1954); Gretchen Kromer, "The Redoubtable Ptyx," *Modern Language Notes*, no. 86 (1971). In a recent article, Catherine Lowe, like Burt, approaches the poem from the point of view of its incontrovertible ambiguity, emphasizing two principal dynamics: convergence and crossing or reversal. It is the absent object, the *ptyx*, that presents the stumbling block preventing the reader from progressing beyond

the first quatrain in the quest for narrative coherence. Lowe brilliantly develops the idea that the function of the word *ptyx* is to be there and not there; this "sound of silence" is the hidden signification of the sonnet, its very manner of poetic creation (*Poétique*, no. 59 [1984]).

7. The first version of the poem, we remember, was entitled "Sonnet Allégorique de lui-même." Lucienne Frappier-Mazur discusses the "in-signi-fiant" in *La Dernière Mode* ("le vide de la parure"), comparing its "futile and serious" nature with the essence of Mallarmé's poetry. See her "Narcisse travesti: Poétique et idéologie dans *La Dernière Mode* de Mallarmé," *French Forum* 11, no. 1 (January 1986).

8. Mallarmé, "Autobiographie," à Verlaine, in *Oeuvres*, 665. In the 1898 edition of *Vers et Prose*, Mallarmé also refers to certain texts as "pieces thrown in flourish or tailpiece in the margins" (*Oeuvres*, 77).

9. Louis Marin, "Du cadre au décor ou la question de l'ornement dans la peinture," *La Rivista di Estetica*, special issue on ornament entitled *Ornamento*, no. 12 (1982).

10. Obliquely, one can ascribe a subjective charge to the crossing of drives: Mallarmé's favorite nom de plume in *La Dernière Mode* was *Ix*.

11. I am using Lacan's distinction between other (the Subject's relation to the other in the field of the Imaginary: for example, as a mirror) and Other (the unknowable Other outside the self in the field of the Symbolic: for example, God, the totality of a language, and woman).

12. This summary of excess and lack in jouissance is extracted from Lacan's *Séminaire, XX* (Paris: Le Seuil, 1975). See especially 12–15 and 100–105.

13. Mallarmé, "Autre eventail," in *Oeuvres*, 58.

14. "Placet" was the first poem published by Mallarmé (1862), later revised in 1887 as "Placet futile" (*Oeuvres*, 30).

15. Mallarmé, "Etalages," in *Oeuvres*, 373.

16. This is number seven of eighteen fan-poems grouped together in Mallarmé, *Oeuvres*, 107–10.

17. "Eventail" first appeared in *La Conque* on 15 March 1891. The original text is written in red ink on a silver fan ornamented with white daisies (collection of the Fonds Jacques Doucet).

18. For this interpretation I am indebted to James Lawler.

19. Munch, who worked in Paris in the early nineties, is generally considered an Expressionist artist. But see Robert Goldwater, *Symbolism* (New York: Harper and Row, 1979), and Reinhold Heller, *Edvard Munch: His Life and Work* (Chicago: University of Chicago Press, 1984), for a discussion of the Symbolist character of Munch's work and for the showing of his work in Paris.

20. Mallarmé's *C'EST* is similar to Lacan's *objet a*: both are that which has fallen away from and what remains of the Real.

Chapter 7. Ornament and Hysteria

1. Allan H. Pasco has recently and ingeniously proposed that the novel is structured around a decorative pattern, that of an intaglio. See his *Novel Configurations: A Study of French Fiction* (Birmingham, Ala.: Summa, 1987).

2. Paul Gauguin, *The Writings of a Savage*, ed. Daniel Guérin, trans. Eleanor Levieux (New York: Viking Press, 1978). Gauguin champions the decorative and expresses his debt to ceramics as an art that gave him greater room for creativity than painting. "Decoration involves so much more poetry. Yes, gentlemen, it takes a tremendous imagination to decorate any surface tastefully, and it is a far more abstract art than the servile imitation of nature" (ibid., 30, from an 1889 article in *Le Moderniste*).

3. See especially Helen Trudgian, *L'Esthétique de J.-K. Huysmans* (Geneva: Slatkine Reprints, 1970); Ruth Antosh, *Reality and Illusion in the Novels of J.-K. Huysmans* (Amsterdam: Rodopi, 1986); and Kahn, *J.-K. Huysmans*.

4. J.-K. Huysmans, "Salon Officiel de 1880," *L'Art Moderne/Certains* (Paris: Union Générale des Editions, 1975), 146. Huysmans's art criticism is given in English only, unlike citations from his fiction.

5. J.-K. Huysmans, *A Rebours/Le Drageoir aux épices* (Paris: Union Générale des Editions, 1975), 59. (Original publication date: 1884.)

6. J.-K. Huysmans, "L'Aquarium de Berlin," *De Tout* (Paris: Plon, 1902), 3d ed., 206–207.

7. In an essay on furniture design, Gallé describes the transition from natural form to its use as moldings: "Study the striations that furrow the [leaves of certain Umbelliferae]. . . . Examine them under strong magnification. They have the look of veritable cabinetmaker's, architect's moldings" (*Ecrits pour l'art* [Marseille: Lafitte Reprints, 1980], translated by William Warmus in *Emile Gallé: Dreams into Glass* (New York: Corning Museum of Glass, 1984), 22.

8. J.-K. Huysmans, "Le Monstre," *L'Art moderne/Certains* (Paris: Union Générale d'Editions, 1975), 388.

9. Pierre Véron, *Le Journal Amusant*, 27 January 1889.

10. J.-K. Huysmans, *Le Drageoir aux épices*, "Sonnet liminaire," in *A Rebours/Le drageoir aux épices* (Paris: Union Générale d'Editions, 1975), 343. (Original publication date: 1875.)

11. In this respect, see also Gallé's vases, "Deep Sea, Deep Sea" (1889), "Sea Lily" (1895–1904), and "L'Orchidée" (1900). Roger Marx comments on a "caressing and rare harmony obtained with materials scorned and reputed to be vulgar" (*La Décoration et l'art industriel à l'Exposition Universelle de 1889* [Paris: A. Quantin, 1890], 16).

12. Wickhoff claimed that the notion of the ugly derived from deep biosocial origins; for example, primitive people saw as ugly "those forms which

seemed harmful to the continuation of the species" (See Carl Schorske, *Fin-de-siècle Vienna: Politics and Culture* (New York: Knopf, 1980), 235.

13. Huysmans, *En Rade* (Paris: Gallimard [Folio], 1984), 75. (Original publication date: 1886.) Subsequent references are to this edition and are cited in the text.

14. Georges Didi-Huberman, *Invention de l'hystérie: Charcot et l'iconographie photographique de la Salpêtrière* (Paris: Macula, 1982), 76.

15. Didier Anzieu, "Naissance du concept de vide chez Pascal," *Nouvelle Revue de Psychanalyse* 11 (Spring 1975).

16. Marcel Cressot, *La Phrase et le vocabulaire de Huysmans: Contribution à l'histoire de la langue française pendant le dernier quart du XIXe siècle* (Paris: Droz, 1938), 131–32. Subsequent references are cited in the text.

17. The expression is Emile Gallé's.

18. Albert Wolff on the Salon of 1876, *Le Figaro*, 3 April 1876.

19. Multatuli, *La Revue Blanche*, Tome 12 (1897; Geneva: Slatkine Reprints, 1968), 683.

20. See Riegl's *Stilfragen*, and especially his *Spätrömische Kunstindustrie* (Vienna: Druck und Verlag der Kaiserlich-Königlichen Staatsdruckerei, 1901).

21. The Gestalt figure referred to by Freud, "Fiancée or Mother-in-Law," might be thought of in this way.

22. The relation between eating and attempting to fill a void is rendered again and again in Huysmans's earlier novel, *A Vau-l'eau* (1882). There, the hero, Folantin, goes from one bistro to another in desperation, never able to find a digestible meal. The utter emptiness of his existence is, along with this quest, the subject of the novel.

Digestive problems are extremely common in the early stages of hysteria, according to late-nineteenth-century psychiatrists. The hysteria of the heroes both of *A Rebours* and *En Rade* involves difficulties and anomalies in digestion.

23. See my "Function of the *Métaphore filée* in Huysmans's *En Rade*," to appear in *Nineteenth-Century French Studies*, 1993.

24. Oscar Wilde, *The Picture of Dorian Gray* (London: Nash and Grayson, n.d.), 183. Wilde wrote in defense of this text to the *Daily Chronicle* (2 July 1890): "My story is an essay on decorative art. It re-acts against the crude brutality of plain realism. It is poisonous, if you like, but you cannot deny that it is also perfect."

25. J.-K. Huysmans, *Là-Bas* (Paris: Gallimard, 1985), 36. The first edition of the novel dates from 1891. Subsequent references appear in the text.

26. Paul Souriau, *L'Esthétique du mouvement*, trans. Manon Souriau (Amherst: University of Massachusetts Press, 1983), 120 (originally published in 1889).

27. Félix Fénéon, *Oeuvres*, Introduction by Jean Paulhan (Paris: Gallimard, 1948), 201.

28. I have proposed elsewhere that gesture in the café-concert is a reflection of hysteria. See R. B. Gordon, "Le Caf'conc' et l'hystérie," *Romantisme* 64 (1989).

29. Wherever one casts one's gaze, according to Schopenhauer, one sees "man suffering . . . and a world eternally vanishing." Jean Moréas, in his "Notes sur Schopenhauer," *La Revue Indépendante*, goes on to state that "the wind of pain" makes the poet's lyre vibrate as the poet sings "of the fallacious illusion, of puerile vanity, of physical Torture" (1:390).

30. Even before Baudelaire's "Correspondances," nineteenth-century interest in synesthetic analogies was apparent. An 1833 article in *Le Magasin pittoresque* (to which both Nerval and Gautier contributed) discusses the eighteenth-century theories of Père Castel (*le clavecin oculaire*) and Abbé Poncelet (*l'orgue des saveurs*). Baudelaire's and Nerval's analogies, Rimbaud's "Voyelles," and René Ghil's *Traité du Verbe* are only the most well-known expressions of a pervasive interest in sensory analogies. In his texts on his hashish experiences, Gautier emphasized the transpositions of taste, color, and sound. "I heard the noise of colors" (1843). And these experiences approached madness: "Madness came and left my brain, which it finally completely invaded. Hallucination, this strange guest, had made itself at home in me" (1846), in Louise B. Dillingham, "The Creative Imagination of Théophile Gautier: A Study in Literary Psychology" (Ph. D. diss., Bryn Mawr College, 1927), 306. Synesthesia seldom is described in terms of madness, rather, it is one of the more commonly sought aesthetic experiences. By the fin de siècle, however, scientific inquiry into "audition colorée" and other physiologically determined synesthetic experiences would bolster the psychiatric research evoked in this chapter.

31. Jean D'Udine [Albert Cozanet], *L'Art et le geste* (Paris: Alcan, 1910), 39. D'Udine was a disciple of Félix Le Dantec and held that all works of art have their origin in synesthesia. He tried to demonstrate that combinations of line excite the same internal attitudes or emotions as "comparable" harmonies in music. In regard to pathological versus normal synesthesia, he quotes Victor Segalen, *Mercure de France*, 1 April 1902.

32. Gaëtan Gatian de Clérambault, *L'Oeuvre psychiatrique* (Paris: Presses Universitaires de France, 1942), 719.

33. Jean-Martin Charcot, "Leçons sur les maladies du système nerveux," in *Oeuvres complètes*, vol. 3 (Paris: Publications du Progrès Médical, Lecrosnier et Babé, 1883), 74–75.

34. Clérambault, "La Passion érotique des étoffes chez la femme," in *Oeuvre psychiatrique*. This article was first published in June 1908; the previous observation is from a 1910 article entitled "Chloral." The shimmer of satin or silk, in addition to sumptuousness, is the decorative quality. This quality, we remember, was constantly underlined in Gautier's art criticism. Nerval and Célestin Nanteuil were equally drawn to it in visual or textual representations.

But note that, in Huysmans and Clérambault, ornament alone can no longer procure pleasure; it must be accompanied by a perversion. The relation of fabric-inspired sexual perversion to the materialism and consumerism of the fin de siècle is remarkably drawn by Emile Zola in *Au Bonheur des dames* (1883): "La clientèle [du grand magasin] . . . violée, . . . avec la volupté assouvie et la sourde honte d'un désir contenté au fond d'un hôtel louche" (The clientele [of the department store] . . . violated, raped, . . . with their voluptuousness satiated and the shame of a desire satisfied in the depths of a sordid hotel).

35. Rachilde, *La Jongleuse* (Paris: Mercure de France, 1900), 127–28. Subsequent references appear in the text.

36. Rachilde, *Monsieur Vénus: Roman matérialiste* (Paris: Flammarion, 1977), 40–41 (originally published in 1884). Subsequent references to the novel appear in the text.

37. Ludwig Hevesi, *Acht Jahre Secession*, 450, cited in Werner Hofmann, *Gustav Klimt*, trans. Inge Goodwin (Greenwich, Conn.: New York Graphic Society, 1974), 48. Hofmann compares Hevesi's remark with the ideas of Karl Kraus, to whom perversion seems "the culture of sexual unfreedom," like the perversion of "artistic unfreedom—stylization, enslaved by ornament."

38. Reported by Edmond de Goncourt, cited by J.-P. Bouillon, *Art Nouveau* (New York: Rizzoli International, 1985).

39. See also Rachilde's *L'Heure sexuelle*, where the Object of desire, a prostitute, is like a "Chinese art object" and shines all the more brilliantly because, as art object, she is "all the more dead."

40. The body as ornamental object is not always the location of erotic violence, as the examples of the *femme-fleur* show. But see Emily Apter's "Hysterical Vision: The Scopophilic Garden from Monet to Mirbeau," *October* 47 (Winter 1988) for a fascinating discussion of the *femme fleur* in relation to perversion and fetishism. Nonetheless, the presence of pain seems necessary to stimulate desire, and the expression of this pain is often subtly worked out in decorative line or pattern.

41. "Meubles en bois simili-courbes," *Revue des Arts-Décoratifs* 1 (1880–1881): 7. This article, for example, applauds the furniture of MM. Bareau et Croisé, who invented designs where multiple segments of straight lines appear curved, thus producing "unbelievably picturesque effects."

42. Despite the frequent references to neuropsychiatry in art criticism and aesthetic theory between 1880 and 1900, to my knowledge, the only other scholar to have uncovered and explored this correlation is Debora Silverman, whose work I read in 1990 after having arrived at the same conclusions (in 1984) via a different path. She draws attention to, for example, Charcot's and Mme Charcot's artistic production and provides a masterful analysis of neuropsychiatry and Art Nouveau in Gallé and Rodin. See her *Art Nouveau in Fin-de-Siècle France: Politics, Psychoanalysis, and Style* (Berkeley and Los Angeles: University of California Press, 1989).

43. Henry van de Velde, "Die Lignie." "Line speaks . . . and tells more than the written word, and thanks to it, nothing of what has contributed to the specific character or sensibility of nations . . . has remained foreign to us."

44. Mallarmé's friend Henri Cazalis (pseud. Jean Lahor) expresses the debt French style owes to the Belgian architect Victor Horta, but complains of "excessive copiers" who took and exaggerated Horta's whiplash line until it "became mad . . . invading all the furniture, the entire house, ending by contortions . . . this delirium of curves . . . often the torture of our eyes" (*L'Art Nouveau: Son histoire, l'art nouveau étranger à l'Exposition, l'art nouveau au point de vue social* [Paris: Lemerre, 1901], 13).

45. See Ernest Gaubert, *Rachilde* (Paris: Sansot, 1907).

46. In *A Rebours*, Huysmans instructs that "everything is in . . . knowing how to concentrate one's mind on a single point, on knowing how to sufficiently abstract oneself to bring on the hallucination and to be capable of substituting the dream of reality for reality itself." This technique triggers Jacques Marles's first dream in *En Rade*, where the trellis design of the wallpaper "becomes" the palace. The psychiatrist Paul Dheur examined this sort of shift in his comprehensive study *Les Hallucinations volontaires* (Paris: Société des Editions Scientifiques, 1899).

47. Poe's stories offer earlier extraordinary examples of the same phenomena (see especially "Ligeia" and "Berenice" where the narrator's mind is, in the first, guided by the arabesque decor, and, in the second, by the contemplation of "trivia": ornaments in book margins, carpet designs, and so forth). See my "Interior Decoration in Poe and Gilman," *Literature, Interpretation, Theory* 3, no. 1 (1991).

48. Rémy de Gourmont, summarizing the 1888 French translation of *The World as Will and Idea* in *Le Premier Livre des Masques* (Paris: Société du Mercure de France, 1896).

CONCLUSION

1. See Norman Bryson, *Vision and Painting* (Cambridge: Cambridge University Press), 119.

2. Gautier, "Du Beau dans l'art," *La Revue des Deux Mondes* 19 (1847).

3. Eugene Vinaver, *The Rise of Romance* (Oxford: Clarendon Press, 1971), 98.

4. Jean-François Lyotard, *Discours, Figure* (Paris: Klincksieck, 1974), 22–23.

5. "[These excessively refined collectors] . . . caress every part of these . . . forms, . . . [they are] somewhat shaken physically, which makes them conclude that they possess [the object] totally" (van de Velde, *Formules*, 13).

6. See Baudrillard, "Fétiche et idéologie," *Nouvelle Revue de Psychanalyse*. The appropriation of Islamic patterns of horror vacui is another way of incorporating and fetishizing the exotic other.

7. Maurice Denis expressed it thus: "In fact, we returned to childhood, we played the fool. . . . Our art was an art of savages, of primitives. The movement of 1890 simultaneously had the elements of a state of extreme decadence and a fermentation of renewal" (Denis, "De Gauguin et de Van Gogh au classicisme," *L'Occident* [May 1909], reprinted in *Théories, 1890–1910*, [Paris: L. Rouart and J. Watelin, 1920], 254–55).

Index